CONFRONTING MODERNITY

Confronting Modernity

Art and Society in Louisiana

Richard B. Megraw

UNIVERSITY PRESS OF MISSISSIPPI JACKSON

www.upress.state.ms.us

The University Press of Mississippi is a member
of the Association of American University Presses.

First printing 2008
Library of Congress Cataloging-in-Publication Data

Megraw, Richard.
 Confronting modernity : art and society in Louisiana / Richard Megraw.
 p. cm.
 Includes bibliographical references and index.
 ISBN 978-1-57806-417-5 (cloth : alk. paper) 1. Arts and society—Louisiana—History—20th
century. 2. Arts, American—Louisiana—20th century. 3. Woodward, Ellsworth, 1861–1939—Po-
litical and social views. 4. Saxon, Lyle, 1891–1946—Political and social views. I. Title.
 NX510.L8M44 2008
 700.1'030976309041—dc22

 2007028022
British Library Cataloging-in-Publication Data available

For my parents, Sue and Art
And my sons, Rob and Michael
Memory, Hope, and Love
Always

Contents

Acknowledgments

All of the following provided crucial funding support without which the writing and publication of this work could not have been possible: The Research Grants Committee, University of Alabama; Dean James D. Yarbrough, College of Arts & Sciences, University of Alabama; Dean Robert F. Olin, College of Arts & Sciences, University of Alabama; and the Carla and Cleophus Thomas American Studies Support Fund.

Numerous people assisted the collection of source materials, but especially Mrs. Carolyn Wells and Ms. Mary Linn Wernet, directors of the Cammie G. Henry Research Center, Eugene P. Watson Memorial Library, Northwestern State University of Louisiana, and Mr. Ken Hagar of the National Archives. Additionally, my sincere gratitude to the staffs of the following archives, libraries, and research facilities: the Louisiana State Archives; the Louisiana State Library; the Howard-Tilton Memorial Library, Tulane University; the Louisiana and Lower Mississippi Collections, Hill Memorial Library, Louisiana State University; Earl K. Long Library, University of New Orleans; Department of Curatorials, The Historic New Orleans Collection; the New Orleans Public Library; the New Orleans Museum of Art; the interlibrary loan office of the Amelia Gorgas Library, University of Alabama; and the Library Of Congress. Merrily Harris, cream of the Dozier Finishing School, provided crucial help in collecting the last, elusive, illustrations for this manuscript. Veronica Winn typed a portion of the index.

Several people at the University Press of Mississippi merit recognition for the Jovian patience they showed this project, including Seetha Srinivasan; Anne Stascavage; the anonymous reader who provided an invaluable series of suggestions and criticisms; Tammy Rastoder, whose skillful copyediting saved many errors; and Shane Gong, who so ably assisted the final editing process.

My most substantial intellectual debt is owed to Burl Noggle, professor emeritus, Louisiana State University, who directed the dissertation from

which this project grew. Throughout that experience and over the years since, he has continued to embody the model scholar and teacher. Though doubtless unattainable, his example still inspires, or as Red Smith once wrote of a certain Red Sox pitcher sold to the New York Yankees: "Never another like him." Many thanks, too, to the other members of that dissertation committee: Robert A. Becker, the late Sally Hunter Graham, Karl Roider, and especially Gaines M. Foster for his perceptive criticism and uncanny ability to coax an argument from tentative conclusion and suggest the means of its development. Since then, I appreciate sincerely, the support shown for this project by John Lowe, Townsend Ludington, and Mathew Mancini.

Several professional colleagues, many of whom double as friends, also shaped this project in various beneficial ways. They include Paul Gorman and Larry Kohl, who could not have been more generous in offering their time, insights and criticisms, support, encouragement, and enthusiasm. They also include the unindicted co-conspirators with whom I have shared or still share space at the Department of American Studies, University of Alabama: Lynne Adrian, Reid Badger, Ralph Bogardus, and Rose Gladney, Micki McElya, Stacy Morgan, and Edward Tang, all of whom offered advice, insight, and the occasional soft shoulder, but especially Jim Salem, peerless editor, skilled teacher, and the finest manager I've ever played for.

Other friends who generously shared time, talent, and accommodation include John and Carol Wallin, Tom Trice, John Beeler, Tammy Horn, and especially John Smylie, devoted friend and brother lo these many years.

My final acknowledgment is to my family broadly conceived, associations of the heart and mind scattered through time, across space, and beyond bloodline. They know who they are as I know what they mean, even if I may never know completely, much less express, just how very much.

CONFRONTING MODERNITY

Introduction

"A Whirl of Modernisms"

[I]n the United States, . . . immigration from many lands, rapid mobility within the country itself, the lack of established classes or castes to act as brakes on social changes, the tendency to seize upon new types of machines, rich natural resources and vast driving power, have hurried us dizzily away from the days of the frontier into a whirl of modernisms which almost passes belief."—*Recent Social Trends*, 1933, President's Research Committee on Social Trends

It is hard to go there and remain unaffected by it. In Louisiana, an alluvial tabletop rolls down the levee and races for the horizon. Summer heat and humidity manifest themselves in fat cumulus clouds waddled up from the Gulf to burst with comforting regularity and alarming intensity. Spring blooms warm and colorful. Fall and winter are indistinguishable. Both are wet and drab. Bayous carve a sodden topiary of blind alley and cul-de-sac across the Atchafalaya. Above Alexandria, the piney woods appear and the Plains approach. Below Baton Rouge, along either side of the river loom Greek Revival reminders. In New Orleans, where streetcars run and gumbo simmers, wrought iron balconies and interior courtyards display and conceal the far side of Canal. All over Louisiana, it seems, the senses sustain an inescapable conclusion: this place is like no other. Louisiana looks different. It tastes different, sounds different, feels different. It *is* different, or so insist many who consider this hybrid society of exotic cuisines, colorful locales, and festival culture the least American place in America. Its sometimes byzantine and often corrupt politics once led A. J. Liebling to consider it either "westernmost of the Arab states or northernmost of the Banana Republics." Spanish moss and dueling oaks, pillared mansions and twisting bayous, the courtyard charm and backstreet ebullience of Carnival New Orleans—all seem to set this place apart, swelling local pride and filling tourist pamphlets.

Yet what seems to make Louisiana exceptional also makes it microcosmic. It is an American crossroads in the fullest sense, where the river meets the Gulf and South touches West, where all the races converge and the street connects Jackson Square with Congo Square. Louisiana is an amalgam, a composite of elite white and hill folk, African, Creole and Acadian, Catholic and Baptist and Pentecostal, factory and farm, opera and jazz with a historical experience equally convoluted. It was French, then Spanish, then both English (most of it) and French (the key to it) again—just briefly. The Americans held it for nearly sixty years until it joined the Southern Confederacy—also briefly. It was restored to the Union, thrown out and restored a second time, as part of the last sectional compromise of the nineteenth century. By then it had already been the object of Jeffersonian ambition, Burr conspiracy, and Sam Houston's last stop on his way to Texas. Solomon Northup had been sold there, following his kidnap, to the place where Abraham Lincoln tested Reconstruction and Jefferson Davis died. Homer Plessy's case began in Louisiana and was settled just two years before Louis Armstrong's birth in New Orleans. Later, Louisiana became the place where the political ambitions of Huey Long and David Duke stirred national controversy. Look once, and it seems the least American of places. Look again, and it seems the most. Because of its varied historical experiences, Louisiana excites scholarly interest in all fields and every period; but its early-twentieth-century development is especially revealing to students of modern America. By the 1930s, to borrow Barry Karl's phrase, few states were more "uneasy" than Louisiana. Incipient industrialism, the collapse of tenantry, mechanized agriculture, and a nascent civil rights movement had begun to transform its economy and social order. Meanwhile, Huey Long, that hurricane loose in the Gulf, just as destructive if more unpredictable, came to power by forging a coalition from the disparate cliques and factions dotting the Louisiana political map, many of them entrenched at the parish level. He then attracted industry (though maintaining rhetorical postures against it) and built roads, bridges, and a new campus for the state university. He brought free textbooks to public schools, built charity hospitals, and paid for the plan by taxing wealth, ushering into Louisiana a new political era.

Wherever he went and whatever he did, within the state and without, Long's ends and means provoked confrontation. His national political ambitions instigated a quarrel between himself and the Roosevelt administration so acrimonious that by the time Long died New Deal agencies withheld relief money from Louisiana while federal accountants probed his tax records with the same enthusiasm they had shown Al Capone's. Meanwhile, on the night he was shot, Long was in the legislature trying to fence FDR out of his state by wrapping himself in the tenth amendment. Inside Louisiana, too, condi-

tions smoldered. In some respects, Long's career since 1928 anticipated the New Deal building programs and tax policy. Louisiana elites abhorred such developments, and although they could not brand Long a traitor to their class as they would FDR, the same assertions of a class besieged that characterized conservative reactions to the New Deal appeared earlier in Louisiana. Encompassed in the space of a short lifetime and turbulent political career, the rapid physical, social, and political modernization of Louisiana mirrored in years the larger contours of the longest American tale already centuries old.

From the moment of its discovery, America has always been modernizing, a term used here to link its varied historical experiences. By "modernization," I mean the collective effort of Europeans first, Americans later, to create, expand, and extend the web of Mediterranean commerce, initially across the Atlantic, later across North America, and finally around the globe. We might properly consider modernization as the creation of a global capitalist order, surely the defining influence of the previous five centuries of human experience. Columbus sailed west on a capitalist mission and returned with a capitalist reading of the New World. So did the English adventurers who founded Jamestown, the Puritans who settled New England, the pathfinders who crossed the Appalachians, the pioneers who trekked the Plains, and the advocates of Pacific empire. Their cumulative efforts literally moved heaven and earth, incorporating the continent into the system of global commodities exchange by either coercing, compelling, or otherwise inducing human labor to extract raw materials, produce agricultural surpluses, and manufacture, distribute, and consume finished goods. American modernization connotes the growth of this system in North America, its continuous and continuing evolution, the way landscape was shaped to serve its agenda and the way human beings were taught to internalize its values. When I speak of modernization, I have in mind every road built or canal dug, every railroad spike driven, every city grid platted, every mine opened or square acre converted from open space to agricultural enterprise. Modernization is the telegraph, the telephone, and the internet, cities and factories, radio, television, and the movies. It is clock discipline and its host of homilies about pennies saved, early birds, and the necessity, should we fail, to try, try again. In the fullest sense, modernization is the very air we breathe, but I think it important to understand it as a cumulative set of experiences traceable over time, and as such, the transcendent theme of the American experience.

Let me explain verbally what I yearn to show my classes visually. I teach a course on the nineteenth-century American West, emphasizing the velocity and scale of western expansion or "modernization." While colonial and early Americans took two centuries to cross the Appalachians, their children and grandchildren covered twice the distance in half the time, converting that

space and connecting it to markets back east and around the world. They transformed the prairie into pastures, and replaced buffalo with cattle and Indians with farmers and ranchers and miners. They created homesteads, towns, and cities in a host of interrelated activities, as William Cronon so persuasively argues, largely directed by the outward radiation of Chicago's influence. To show both the size of the undertaking and the speed with which it was accomplished I implore my students to beg, borrow, steal, or design the CD-rom technology that enables a single mouse click to set in motion the iron web of railroad directed growth spinning out of Chicago and stretching for either coast. Out west, towns and cities develop, transforming the landscape around them and the behaviors of people within them until such point, by century's close, when Western consolidation is an accomplished fact. This is what I mean by modernization—the tumbling of countless capitalist dominoes all across the continent that began for the Americans with Columbus and continues still.[1]

Scholars frequently use the term "modernity" to indicate a decisive moment in the process of American modernization. If only roughly, they describe modernity through its characteristic features and signifying structures—cities and skyscrapers, machines, industrial productivity, and rational planning, social differentiation, and bureaucratic management—and mark its "emergence" as a maturing system toward the close of the nineteenth century. Of course, not all of America became modern all at once, nor did all Americans. Still, by 1890 for a steadily widening number of them, modernity meant a more complex society with new relationships, behaviors, standards of success, and acceptable means of its achievement. Experiencing modernity, as someone recently arrived in the city or factory, or in its new managerial form, or as someone drawn into its industrial relationships as either worker or consumer, might offer new excitements but only in exchange for new stresses and anxieties. Here, clearly, was a world more dynamic and less personal, one whose pace could overwhelm and whose complexity could mystify. Modernity spanned greater distance in less time, made the world at once more intimate and distant. It grew with astonishing velocity and alarming disorder, forcing many to wonder what had been sacrificed for what gain, for while modernity transformed landscapes and disrupted habits, it also altered the very cognitive process, imposing its own logic on the way people understood and responded to their radically altered circumstances.

Modernity might have initiated an epoch of unparalleled if unevenly distributed material progress, but it also generated substantial doubt and discontent. By the turn of the century, in Europe and America, a widening number of thoughtful people were having a harder time making things make sense, and a good part of their concerns extended the philosophical debates of

the Enlightenment, focusing on the ability, increasingly suspect, of people to "know" what they thought they knew. According to this new critique, human experience was far less certain and far more subjective than earlier positivists had decreed—a notion casting long shadows over rosy visions of progressive civilization.

Generally, we term these doubters "modernists," though more recent scholarship has devised a series of separate subcategories. In her essay "Modernism Reconsidered," Dorothy Ross distinguishes between "cognitive modernists," turn-of-the-century scientists who recognized "the subjectivity of perception and cognition"; "aesthetic modernists," artists whose alienation from modernity turned them inward in search of a meaningful, if artificial, world created through art; and "agnostic modernists," figures such as Sigmund Freud and Max Weber, who struggled to "accept both rational order and cognitive doubt, to hold both hope and anxiety in balance." Other scholars use different categories. Donald Hollinger, for example, separates "knowers" (cognitive modernists) from "artificers" (aesthetic modernists). Literary critics frequently divide "canonical" or "high modernists" from the avant-garde, and Andreas Huyssen explores the boundary between modernist art and mass culture. Like many of his colleagues, Huyssen also works with an eye toward further clarifying an even more elusive term: "postmodernism."[2]

The result of such broad efforts in various disciplines has produced a literature of modernism noteworthy for its size, complexity, and lack of consensus. Since midcentury, at least, the academy has recognized modernism as a worthy category of investigation, though agreement over what kind of category and how best the inquiry should proceed hardly exists. While some authors posit a manageable "model of modernism," others disagree, insisting that the only way to impose order on the variety of early-twentieth-century intellectual activity and artistic expression is through categories generalized to the point of meaninglessness. Additional controversies abound, some political, others pedagogical. To which political camp, for instance, does modernism owe its greatest allegiance? Did modernism's high formalism and concern for absolute control ally it with fascist political movements (which usually denounced modernist art as decadent)? Or does modernism's contempt for modernity's elites make it the people's defender, despite the cultural snobbery so many modernists practiced? Moreover, how best are we to approach modernism, much less interpret its legacy: as a cultural movement rooted in a historical moment, a creature of the very history it sought to escape, or should we sweep away history in favor of the hypertextuality the movement itself promoted and postmodernists defend? Exciting and provocative as these debates remain, my own purpose is neither to revise nor extend the discussion of modernism as an episode in Western intellectual history or as a paradigm

of literary and/or art criticism. Instead, what interests me are the implications of key modernist concerns (subjectivity, fragmentation, and dynamism, to name a few), together with aesthetic modernist motifs (montage, juxtaposition, irony, among others), making their way out of scientific discourse, philosophic speculation, anthropological inquiry, artistic expression, and literary criticism, and into Main Street American perception. In terms of semantics, then, if only further to compound issues and confound colleagues, we may well call this "popular modernism"—less, I think, the oxymoron it may appear to be.[3]

Despite current scholarly interest in dissolving categorical differences between disciplines, subjects, and nations, Dorothy Ross warns us about taking these arguments too far. Introducing a series of essays seeking at least to narrow if not erase the margin between cognitive and aesthetic modernists, she nonetheless asserts that "The roots of modernism and its varied permutations are now seen to be embedded in the longer standing processes of modernity and national culture."[4] I agree for two reasons. First, problematic terms though they have been, modernism and modernity are as inseparable one from another as together they are central to discussions of twentieth-century America. Though some observers place the two at opposite poles, positing aesthetic modernism as an extreme form of alienation from, perhaps the very negation of, modernity, clearly the subjects modernist artists depicted, even the very methods of that depiction, reveal their deep engagement with modernity. Modernism flourished in urban settings, modernity's physical space, just as its tenets reached wider audiences because of modernity's technological sophistication. One is struck, moreover, not only by how consistently aesthetic modernists made modernity the subject of their art, but also modernity's power to influence their methods and perspectives. As Cecelia Tichi has argued, what she calls the "gear and girder" thinking of engineering, modernity's master craft, exerted a profound influence over the writing of such modernist authors as Ezra Pound, Ernest Hemingway, John Dos Passos, and William Carlos Williams. James Joyce, we know, helped to construct his own key to facilitate the reading of *Ulysses*, a modernist literary schematic. Even the recurrent words we use in critical discussions of this material—"structures," "design," "blueprint," "mapping"—reveal the power of modernity to permeate our work. In this fashion, for instance, Bonnie Kime Scott begins her discussion of Virginia Woolf, Rebecca West, and Djuna Barnes, her modernist "Women of 1928," with not one but two illustrations tracing the myriad connections among and between "A Tangled Mesh of Modernists" and a "Triple Web of Attachments." I do not wish to oversimplify Scott's analysis of feminine modernist "webs" and masculine modernist "structures," only to remark on the visual similarity of her web to the cables suspending Brooklyn

Bridge or the maps from our own time charting the paths of submarine fiber-optic cables.[5]

It is equally necessary to explore modernism and modernity as creatures of their own time and place. Though much has and should be made of the broad trends that transformed societies in Europe and America, or of the trans-Atlantic intellectual exchange, modernism followed different courses in different places at different times, effecting different people in different ways not so much according to its own internal logic but rather as a matter of specific social experience. What provoked despair and detachment in fin-de-siècle Paris and Vienna often produced excitement, sometimes even euphoria, in twenties Manhattan, a difference attributable to American society and the timing of modernism's arrival. In this regard, Gertrude Stein was right when she asserted that early-twentieth-century America was the oldest newest society, meaning the one most modern for the longest time. Democracy, individualism, and industrialism, the driving forces of nineteenth-century American life, had by century's close produced the very combinations of fragmentation and momentum that characterized modernity and provoked modernism's response. For where was life more fluid and less predictable, or the pace faster, the people more mobile, or society less homogenous? Who had struggled longer with depersonalized relationships, individual alienation, and the artificial character of urban life, or worried more about the issues of individual authenticity and representation? Who more than Americans had based a popular culture and, in some cases, even national identity on admixture and extemporaneous display? Perhaps nowhere on earth, then, did more fertile soil exist for modernist seeds to fall.

Perhaps the dominant theme of the half-century following 1890, then, involves the way Americans coped with modernity, how they perceived its transformations and adjusted to its demands by gradually internalizing ideas and values we often associate with modernism. Again, place and time are crucial. Modernism's wave crested on American shores as much as a quarter century after emerging in Europe. By then, many of its opportunities had already been established and its pitfalls exposed, leaving Americans free to do what they had always done with European systems of thought, especially one so amorphous as modernism. American modernists picked and chose according to personal need and desire. After all, modernism's own strictures against historicism seemed to invite mix and match methods and constant experiment. How else but through trial and error and personal adjustment could one expect to achieve the grand modernist discovery, the different self within? Then, too, modernism arrived in America just in time for use by people with specific applications for its anti-traditional assertions. It provided young Americans as much ammunition as they ever needed in the quarrel with their genteel

parents. And while we cannot explain all of American modernism as antigenteel reaction, neither should we ignore the specific uses to which many of its ideas were put. Faith in strict and unbending moral law, the assurance of a "knowable" universe, the moral didacticism of art, the immutability of social categories—all lodestars of their forebears' cosmos—American modernists assaulted each, making possible in the process a most unmodernist consequence.

If Americans have been habitual and eclectic borrowers, they have also been inveterate popularizers, something that happened to modernism too, despite the best formalist efforts of some and the elitist resistance of others. For as Paul Gorman reminds us, ordinary people who were not artists and intellectuals felt the same disruptions in their lives and were forced to devise their own strategies of coping with modernity. These people understood that urban society, giant corporations, bureaucratic decision making, and the routinization of labor demanded adjustments and accommodations in their daily routines and beliefs. Their methods varied from scientists and artists, to be sure, but over time in America new understandings of self and society based on key modernist principles gained acceptance among a widening number of people. This did not happen overnight, nor did it occur without substantial upheaval and acrimony. How else to comprehend the cultural confrontations of twenties America, or the value crisis instigated by the Great Depression? Nor does it mean that all of modernism, with its capacity for the antisocial, its ambiguous political message, or its many paradoxes could, much less did, serve as the basis for a worldview accepted by all Americans. It is to suggest, however, again following Stein, that between the wars, like so many other things, modernism was "Americanized," that is to say made popular.[6]

Three modernist assumptions, dynamism, "reality," and complexity, became the basis of a cultural perspective popularized in America after World War I. Where modernist science posited a world far less stable than previously assumed, where uncertainty and velocity replaced assurance and fixity, other observers read the same dynamism into the human condition. Findings in the newly established social sciences suggested that if possible human beings were even less predictable than the planet they inhabited. Life was both fluid and situational, undermining faith in overarching historicist explanation or inflexible moral codes. "A new, dynamic kind of moral relativism was needed," writes Gorman, "a requirement that individuals evaluate their changing circumstances constantly and come to the most useful (if temporary) direction through continuing trial and error." Conditional rather than constant, the radical fluidity of life and earth betrayed notions of "knowledge" and "know-

ing." Modernists had exposed the temporary nature of what their genteel predecessors considered permanent, a discovery with multiple repercussions.[7]

Puncturing genteel faiths in permanence, modernists inverted several of their key assumptions. Knowledge, what their predecessors considered the liberating power of individuals and societies, became in modernist estimation merely a deceptive fraud. General laws and fixed categories might be well and good for those who created them, but for people forced to live with their consequences they only confined and oppressed. The world the Victorians made, both the cultural truths they proclaimed and the corresponding physical designs they erected, were as false as the staff used to build the White City—and as easily pierced. Sweeping away Genteel facades, striking through "the pasteboard mask," thus became the modernist mission. Social disorder and individual deviance were not to be concealed or disregarded. Their existence demanded exposure and invited exploration, and on the other side of the facade lay a world as inaccessible to Victorian imagination as it was to their vocabulary, a situation demanding not only new perspectives but new words stripped of their euphemizing power, coined or invoked for the express purpose of experiencing the real rather than protecting the innocent or upholding the ideal. If life was raw and chaotic, so should the words be chosen to describe it and the art created to depict it. People didn't "get sick," H. L. Mencken insisted, they "vomited." A male chicken was a "cock" and not a "rooster." It was "goddamn" and not "gosh darn," "Lord" instead of "Lawsy." Anything short of that was, to use another term favored by modernists, "bullshit." In this fashion, too, aesthetic modernists proposed to confront reality head-on, while F. R. Leavis and I. A. Richards in England and Cleanth Brooks and Robert Penn Warren in America approached literary criticism as the stark confrontation between reader and authorial text.[8]

Both dynamic and disordered, the world the modernists described was also vastly more complex. While Victorians placed things in polar opposition and spoke of progress as the movement from one to another, modernists insisted on life's multidimensionality and chance jumblings. They challenged the social categories they inherited where individuals and societies were either civilized or savage, white or black, male or female, emotional or intellectual, animal or human. Rather, pieces of all existed in each, modernists insisted, though rarely in the same combinations and never with the same results. "Integration of all the supposed opposites became the modernists' crusade," observes Gorman, "and they tried to test all the boundaries surrounding race, gender, sexuality, the human mind, and differences in culture." Life was a kaleidoscope and living the constant whirl of shape and color, a collision of

discordant objects joined together if only momentarily in the perpetual attachment and division of things beyond the power of rational design. Surely this effect was what modernists aspired to in their principal motifs: montage and juxtaposition.[9]

After 1920, a widening number of Americans embraced as the normative patterns of modern life the dynamism and dissonance modernists placed at the heart of the human condition. We can hardly expect otherwise from people driven there, it seems, by the sheer force of historical circumstance, for seldom had American life been more volcanic or perplexing than during the quarter-century following 1900. Change piled upon change, so much seemed so uprooted, and so little seemed coherent. People moved in unprecedented numbers farther and faster than ever before. Rural Americans moved to cities. African Americans moved north. People from all over the world moved to America, where, after 1903, they entered a society shaped by Henry Ford who managed simultaneously to expand and restrict their movements. If his assembly line aimed at the total control of a worker's motion, the finished product of this labor, the automobile, promised a license most Americans had never experienced. While expanded wages, reduced hours, wider consumer choice, and faster movement all seemed to expand individual opportunities, they coincided with corporate giantism, mechanization, bureaucratic decision making, and the decline of face-to-face relationships characteristic of earlier, more localized American life. Modern times not only disrupted their lives and challenged traditional assumptions, they changed people's institutions too: political parties, schools, families, labor unions, prisons all felt the impact of modernity's transforming power.[10]

By then, too, Americans encountered the fragmentation and momentum of modern life as part of their daily visual experience. Newspapers and pulp magazines devoted greater attention to the bizarre and scandalous. Even more upscale serials placed before the reader's eye a fragmented visual plane where article, editorial comment, illustration, and advertisement all coexisted, sometimes with jarring effect. By the 1930s, such mass circulation magazines as *Life*, *Look*, and *Survey Graphic* introduced the photo-essay, a montage of narrative and photograph on an infinite variety of subjects. Already, of course, the influential voices of mass advertising, motion pictures, and radio had all been established. Indeed, as Terry Smith suggests, an entire visual order deeply connected to modernity and modernism came into being during this period. "A distinctive machinery of representation emerged in the United States during the 1920s and 1930s," Smith writes, one specifically connected with "the so-called second industrial revolution."[11] Yet if the subject was modernity, the manipulation of visual objects designed to create new ways of "seeing" was modernist. For in concert with magazines, film, advertising strategy, and pho-

to-essays, the visual reordering Smith discusses was part and parcel with the increasing subjectivity of American life.[12]

The Great Depression only accelerated modernism's popularization in America. In many respects, of course, the economic collapse seemed to confirm the essential correctness of traditional values and deepen the conservatism of an already conservative society. By and large ordinary Americans tended to internalize hard times, to blame themselves for their misfortune. Yet at the same time, the simultaneous catastrophes of Dust Bowl and depression, revealed the fundamental inability of these values either to explain the complexity of modern times or to assist individuals struggling to withstand its rigors. Rational coherence, it seems, had vanished just as quickly as prosperity had soured and as irrevocably as rural life on the southern plains. People now went hungry in a society whose national government paid farmers not to grow crops. Down South a similar absurdity prevailed. Fewer cotton plants meant less cotton, and less cotton meant fewer jobs in the textile mills, and that meant fewer coats for more people freezing in winter. Irony and improbability abounded, making possible, as Lawrence Levine argues, a new genre of irrational humor, the screwball comedy of radio skit and Hollywood film.[13]

The depression also brought to Washington a political administration whose experimentalism and communicative style matched modernist assumption and utilized modern methods. What some hail as FDR's pragmatic political style, his ability to determine legislative action by locking conflicting viewpoints in the same room until consensus emerged, betrays the modernist faith in reconciling irreconcilables. So, too, the New Deal's overall willingness to innovate and improvise—the way it recognized itself in a fluid situation calling for trial, error, and adjustment. Moreover, in perhaps its most lasting legacy, the administration embraced all the modern methods of mass communication, addressing modern concerns through modern means. Franklin Roosevelt mastered the radio address to soothe "fear," what Madison Avenue executives already considered one of the keys to manipulating modern behavior. Meanwhile, with President as symbol, the New Deal displayed itself according to the new iconography of mass advertising. It acquired an early logo, the blue eagle, and a series of slogans: "We Do Our Part," "This Work Pays Your Community," and in its wartime phase, among others, "Loose Lips Sink Ships." Finally, however accidentally, the administration sanctioned a thoroughly modernist enterprise. Among the many characteristics Norman Cantor identifies with modernism is "the conviction that humanity is in its most authentic, truly human condition when," as opposed to the nineteenth-century veneration of moral action, "it is involved with the arts." "The modernists replaced the superiority of the ethical dimension with the primacy not

only of artistic creation," writes Cantor, "but also of common entitlement to participation in and consumption of art. This meant that the positive purpose of government and social institutions was not the fostering of a moral code but the provision of opportunities for the realization of entitlement to art."[14]

Making art accessible to more Americans was precisely what the New Dealers did, and not just any art. The army of artists and writers who set out during the 1930s "to chart America and possess it," were composed largely of practicing modernists. In this regard, Alfred Kazin's summary of their efforts—itself a statement steeped in modernist assumption—was not only lyrical but apt. As he insisted, writers (and other artists too) "fell on the face of America . . . to make a living record of contemporary American experience." They focused their talents, throughout the thirties on the modern American landscape, utilizing modern techniques to reach modernist conclusions. In the plastic arts, American Scene painters might have been far more representational than their expressionist colleagues, but their art, clearly modern, embraced conflict and criticism, exposed fault, and explored irony. Similarly, in literature, film, and photography, through music, dance, and theater, aesthetic modernists rendered America, many at federal expense. And if the artists themselves were modernist, then so was the portrait of America created through their art. The aesthetic expression of the 1930s celebrated a modernist vision of America, a complex, dynamic society championed for the infinite variety of its places and peoples, its ethnic mix and regional distinctions. America, these artists insisted, was the rich blend of youth and age, tradition and innovation, giant cities and small towns. America was smokestacks and haystacks, tenements and farmsteads, rich people and poor, black and white, east and west. It was indigenous folk and immigrant stock who sometimes succeeded and other times failed, never according to type but rather owing to circumstance. America was boom and bust, a place frequently erased and rewritten in perpetual flux, constantly changing. Sometimes it made sense, other times it did not; it was as apt to irritate as it was to inspire, this sprawling of so many things all at once. Here was a modernist vision of modernized America.

The key questions, of course, remain beyond our ability to resolve. How many Americans can we identify as modernists and how much of modernism did Americans internalize between the wars? Which of its basic assumptions did most Americans accept and what was the basis for their acceptance? What were modernism's most influential voices, the ones Americans listened to most consistently and believed? So many tantalizing questions, but if we can't know them, we do at least know this. After Pearl Harbor, home-front Americans followed the war primarily through modern means: newspapers, radios, motion pictures, and *Life* photo-essays, where collections of GIs were

depicted in modernist hues doing modernized things. American rifle companies and bomber crews symbolized national diversity. Collected from all walks of life and every corner of the country, they held different views and divergent faiths, separate pasts but a common goal. They were going to win the war with machinelike precision, every soldier a separate skill, each unique and equally valuable to group success and collective survival, none superior to the next. Meanwhile, as men in combat immediately understood, the dissonance could not have been greater between the imagined war at home and the one they actually fought—an experience often summed by their great acronymatic contribution to the language of World War II, one betraying a thoroughly modernist sensibility: SNAFU. Perhaps it was difficult to find atheists in foxholes because they were so crowded with modernists in the making.

While modernizing America transformed space and altered perception, it also challenged tradition, especially the historic American commitment to localism. Modernity incorporated discrete spaces into larger networks, often though not always displacing local authority, disrupting local autonomy, and reconfiguring local landscape. It emphasized connection and exchange, linking things to facilitate the transfer of everything or anything one person, community, or corporation wished to send another. What has been or might be exchanged comprises an endless list always expanding, everything from microbes and material goods to habits, thoughts, and values. But building such exchange networks—creating modernity—was not only disruptive, it obliged Americans constantly to grapple with its consequences. Modernity produced combinations of wealth and influence and concentrations of power difficult to reconcile with earlier American beliefs. It almost assured inequity and conflict, a gulf between wealth and poverty not only glaring but growing, and continuous strife between capitalists and laborers, producers and consumers. Its demand for cheap labor helped initiate the global population shift that made America the most demographically complex society on earth. Its spatial expression, the manufacturing city, not only excited cultural concern, its complexity baffled attempts to curb its excesses. Its acids dissolved social ties; its demands multiplied social problems; its disorders animated a turn-of-the-century reform movement determined to make modernity more manageable—itself an additional challenge to local autonomy.

To manage modernity Progressive reformers imitated its goals and methods. Something so large and complex, they concluded, demanded analogous efforts on a commensurate scale, and though they often divided over means and ends, as Morton Keller concludes, Progressives "had a shared sense that the good society was efficient, organized, [and] cohesive."[15] Achieving order, however, proved easier to hope for than realize because America turned out

to be a place more complex and fragmented than previously assumed. More-over, achieving modern efficiency meant overcoming resistance to consolida-tion, something encountered in the two great tests of early-twentieth-century reform organization: World War I and the Great Depression. Each situation demanded national articulation and stimulated the growth of bureaucratized federal supervision, and both produced the same, ironic result. The Great War and the depression made federal power a presence in an unprecedented number of American lives, forging new relationships between citizens and administrators. As Thomas Bender suggests, people accustomed to the face-to-face relationships of localized America found themselves required to learn different patterns of more depersonalized association, meaning that often as not reformers further complicated the already complex society they sought to streamline. Worse, initial contacts between hinterland folk and the ordering movement served all too frequently to deepen the traditionalism reformers sought to diminish.[16]

Despite resistance, both modernity itself and the organizational impera-tives of early-twentieth-century reformers continued to touch a widening number of Americans, especially after 1933. New Deal relief efforts reached virtually every American community in some form or another where, espe-cially in the case of the arts projects, they further undermined local autono-my. The artistic ferment of the depression decade created the myth of modern America, as much a national ordering effort as the administration that, in part, sponsored it. The myth was an artistic construct, subjective and fluid, and in it locale lost its concreteness. Rendered by thirties artists, local places usually became either one of the country's component parts, something best understood in relation to the others, or as a small place in which to glimpse the larger whole, the totality of America. In this fashion, however else we might distinguish between them, modernist artists, New Deal administrators, and modernizers, the people who made modernity, resembled one another if only in their lack of enthusiasm for specific locale or isolated space. Mod-ernizers systematized. They identified isolated areas for development, calcu-lating in ways that abstracted the value of specific places into raw materials extracted, agricultural surplus harvested, labor pool tapped, transportation node erected, or market penetrated. But it had no intrinsic worth all its own. Meanwhile, New Dealers struggled for national administrative coherence, of-ten through correspondence frequently using "provincial" as pejorative. Simi-larly, aesthetic modernists reserved especial venom for the term. They were legendary nomads tied to no particular place whose determination to cover physical, psychological, and temporal distances bordered on the obsessive. In this sense, modernizers, relief administrators, and aesthetic modernists iden-

tified isolation as the crucial problem, the challenge of the incomplete system, the inefficient society, or the terror of the detached self where "all that is solid melts into air."[17]

This challenge was not welcome news among local elites, especially in the American South, where external consolidation or internal organization had always posed a common threat. The British ministry, the abolitionist press, the Republican Party, Union regiments, railroads, Populist agitators, labor organizers, chain stores, and radio waves—all exposed the fragile character of local autonomy and, given the contours of southern demographics, each excited ancient fears of what might follow the eclipse of local white supremacy. Issues that had defined the antebellum southern experience thus continued after the war, when a period of national consolidation did not merely coincide with but provoked renewed determination among southern elites to retain local social control. By no coincidence, then, did the South segregate while America consolidated.[18] Now, after the turn of the century, modernized methods nationalized modernist assumptions, among them new conceptions of race certain to provoke fear and reaction. Worse, while outside modernizers rushed into the South, southern modernists rushed out, replacing the literary ideal of the self-contained plantation with a new image of a universal South, less concrete and more unstable. In either event, here was a region in flux, especially in one of its most compelling if least consistent corners.

After 1865, external consolidation and internal connection is what Louisiana was all about. A port city and alluvial soil along a riverine corridor made it possible early on to produce such agricultural staples as sugar, rice, and cotton by coercing the labor of captured Africans. Yet however "modern" this might have been, more of Louisiana remained outside of the system than in until after the Civil War when railroad builders opened other extractive industries, first timber and later oil and gas, multiplying the connections between Louisiana and the rest of the country. By 1920, virtually the entire history of modernizing America lay visible there. Sharecropping had replaced slavery, but in some parishes along the river the difference was virtually indistinguishable and the activity, the accumulation of agricultural surplus, had not changed at all. Meanwhile, downstream in Baton Rouge, Standard Oil of New Jersey had just completed the world's largest petroleum refinery. Local politicians, entrepreneurs, and cultural arbiters had always viewed the multiplying connections warily, constantly weighing increased profits against diminished local hegemony with the race issue always lurking, especially when New Orleans's own native son, George Washington Cable, not only thought the unthinkable but published it.

In several short stories published before the turn of the century Cable

explored the lives of fictional black Creoles, touching off a firestorm among the local literary elite. Always a slippery term, "Creole" was then a concept being redefined for a Jim Crow society. Though it originally distinguished between people of foreign parentage born in Louisiana and recently arrived Americans, after Reconstruction it no longer connoted ethnic variety but racial purity, or so asserted its chief defenders—New Orleans Creoles anxious about their social niche in a city whose long history of race mixing made segregation more than problematic. When Cable's stories threatened to upset the apple cart, Creole critics vilified him, among them Charles Gayerre, the aging historian, his protégé, Alcee Fortier, and the novelist Grace King, who had all but grown up in the Gayerre household. Moreover, just before and just after Cable's exile, the sentiments that drove him there received institutional expression with the establishment of L'Athenee Louisianais in 1876, and the Louisiana Association of the American Folk-Lore society sixteen years later. Dominated by Creole interests, the two organizations worked either side of the same street. While L'Athenee sought to preserve the racial purity of Creole culture by attacking miscegenation and upholding French tradition, the Louisiana Folk-Lore Society utilized "Negro lore" to emphasize the "otherness" and justify the exclusion of African belief, practices, and people.

Cable might have been vanquished and Creole purity established, but within a generation his cultural apostasy widened into Huey Long's political earthquake, and with the same implication. Building roads and bridges, he linked places within the state while others improved their access to it, further blending what was already one of the country's most creole societies. Moreover, although privately he held conventional racial attitudes, publicly Long straddled the Klan issue, and constantly chafed at accusations of race friendliness, Long's political appeal always rested on class antagonism and not racist hostility. Still, for all his political savvy, one suspects that not even the Kingfish himself grasped the full irony of a nickname he appropriated from white performers playing black to a national radio audience.[19]

Nor, for that matter, have observers grasped the fullest implications of Long's demise. Fewer than thirty days after his funeral, the federal relief spigot was on again, a rapprochement between state politicians and New Deal administrators pundits immediately dubbed "the Second Louisiana Purchase." Most accounts include the tale as a postscript, ending the Roosevelt-Long controversy; but the story was far from over. When relief dollars returned to Louisiana they not only established programs to build parks and post offices or subsidize farmers; they also patronized art in ways designed to incorporate Louisiana into a national art community—the cultural analog of New Deal political intentions. Concentrated in Washington, the arts projects sought to develop a nationwide network of art education, production, and display, hop-

ing among other things, to translate art interest into consumer enthusiasm. The result, predictably, was a good deal of conflict and resentment, for in politics and art alike New Deal managers confronted deep-seated traditions of local autonomy, forcing numerous confrontations and many adjustments between past convention and current necessity.

Louisiana marks a case in point. The same people who managed the Longite opposition, primarily men of wealth and social position in New Orleans, also patronized Louisiana art. In this fashion, quite literally, the same shot that ended their fracas with Huey Long began one with New Deal art administrators. From the perspective of local promoters and patrons, new perceptions of art and society embraced by federal organizers posed the same kinds of challenges in the arts that Long had embodied at the polls. And while their opposition to the federal art idea was never so vituperative as their opposition to Long, it was as deeply entrenched. Americans had long associated refinement and social power, relying on art to sort out the chaos of a newly emergent capitalist democratic social order, and here, especially, Louisiana did not differ from the country at large. Art made good people, the logic ran, and was vital to the creation and maintenance of social cohesion. An appreciation for art identified elites and justified their power, just as fine art itself contributed to proper values and better behaviors among more common citizens. Now, however, in what is rightly seen as the modern phase of a long-standing American desire to use art as a way to create cohesion, provide identity, and enact a vision of the good society, the nationalizing trends and egalitarian emphasis of the New Deal art program threatened local elites on at least two counts. By appropriating the power to define art, New Dealers gained the ability to define society, something with ominous implications from the elites' perspective. Worse, the New Dealers were making the wrong sort of art for the wrong reasons and sharing it with the wrong kinds of people, since democratizing art might undermine previous justifications for power and prestige. A simultaneous threat from without and within, here was potential for fresh controversy quickly realized there and elsewhere long before anyone ever heard of the NEH or Robert Mapplethorpe.

In Louisiana, the opposition centered in New Orleans, chiefly in the persons of two local artists whose lives and careers spanned these decisive years. At first glance, Ellsworth Woodward and Lyle Saxon could not have been more different. They were born more than thirty years apart on separate coasts, and although each lived in New Orleans, some people might suggest that when they died there, a greater distance separated them than at their birth. Woodward lived quietly uptown in the Garden District while Saxon maintained a French Quarter salon. Woodward was a painter and college professor, a genteel patrician and institution builder who rarely questioned the

social hierarchies of his day. Saxon was a writer and bohemian, a reluctant modernist and literary celebrity who both resisted and exploited those hierarchies. Woodward was by far the more disciplined thinker, someone whose adult life centered on his determination to reform society through art. Saxon had neither Woodward's single-mindedness of purpose nor his commitment to public service. If Woodward was a man of almost no diversions, Saxon was one of many. While one built, the other rebelled; where one joined, the other withdrew. Yet these two very different lives, stretching from two weeks before First Bull Run to eight months after World War II, shared at least one common conviction.

Both Ellsworth Woodward and Lyle Saxon believed in the exceptional character of New Orleans and Louisiana. For Woodward, aesthetic localism was the logical conclusion of genteel conviction. Environment shaped character and influenced values, he believed, for artists and ordinary citizens alike. And because art improved surroundings, uplifted individuals, and contributed to a better society, it was inescapable to presume that the worthiest rendering of specific places could only be done by artists born there, the people most intimately attuned to the surrounding world that had made them who they were. Europeans, he insisted, could not paint America, just as northern artists wasted their time and squandered their talent lugging easels south. To prove his point, Woodward established a pottery where he supervised the transformation of local clay into finished pieces decorated by local designers rendering local scenes on objects of everyday use. Through his pottery's guiding influence, Woodward would civilize machine manufactures and improve household environments. But along the way, these local objects acquired world renown, and trouble swiftly ensued.

Lyle Saxon's localism was far more personal and conflicted, the product of a mind determined to put modernist insight to antimodern use. Always someone of troubled identity, he constructed a public persona tied to two local places, both of them isolated and each of them insular, and this was no accident. These places not only defined persona, through them Saxon masked private truths he wished to conceal, making their continued isolation a paramount concern—the point where his trouble began. Saxon gained national acclaim in 1927 for his coverage of the Mississippi River flood and his insistence that because the river could not be controlled locally it must be supervised nationally. Thereafter, he spent the balance of his life as both the definitive and most incongruous tour guide to New Orleans and Louisiana, inviting the country to the very places he was determined to save from modern transformation, meaning outside penetration. Yet he persisted right to the end, hoping to convince Americans that this geographical and cultural

crossroads, something he himself celebrated, remained separate and distinct from the rest of the country in time and as place.

For such different reasons and from such differing perspectives, Woodward and Saxon also shared a common experience. Both men worked with New Deal cultural programs, where each man found the limits of his aesthetic localism. As an active presence, a shadow participant, or a vocal opponent, Woodward had some connection to each of the plastic arts projects funded by the federal government during the 1930s. He supervised Region Six of the Public Works of Art Project (PWAP) between December 1933 and May 1934. Thereafter he corresponded with Edward Bruce, who not only organized PWAP but supervised the Treasury Section of Painting and Sculpture from 1934 to 1943. Then in 1935, Gideon Stanton, Woodward's friend and colleague, assumed directorship of the Louisiana Federal Arts Project (LAP/FAP), the largest and, from Woodward's perspective, least palatable of the New Deal art experiments. Stanton spent the next three years opposing FAP ideas along what clearly were Woodwardian lines of resistance. After that, two of Woodward's students directed FAP efforts in Louisiana in ways suggesting just how attenuated their mentor's assumptions had grown.

Woodward's declining influence coincided with Saxon's mounting frustration. In 1935 he joined the Federal Writers' Project (FWP) as the first and only state director of its Louisiana office. He spent the next eight years working for the WPA, one of only four people to supervise a state writers' project from start to finish. But like Ellsworth Woodward, the work undermined his localized art. Saxon was a model bureaucrat, someone with no previous managerial experience who nonetheless maintained smooth relations with all concerned, despite Louisiana's highly charged political atmosphere. Instead, he overcame long-standing mutual suspicions within the state to organize an efficient and productive literary unit that contributed three major publications to the American Guide Program. Yet the efforts and their results only emphasized Saxon's inability to save either New Orleans or Louisiana from transformations he resented. Indeed, read closely enough, his WPA experiences suggest how much a part of him hastened changes the rest of him resisted.

These two lives and their chosen forms were also tied to the artistic medium most destructive to their localist convictions. Lyle Saxon maintained a lifelong interest in photography, a form Woodward disparaged. To Woodward, photography was not art but mechanics. It did not interpret; it merely recorded. And because a negative could be reproduced ad infinitum, it was cheap and therefore dangerous. One photograph of an ugly thing could be copied endlessly, he admonished, retarding social refinement by corrupting

the aesthetic environment, and as he often asked, had cheap manufactured items not done enough of that already? Saxon disagreed. He appreciated photography as art and often used the camera to create portraits of his constructed self. So while he edited guidebooks, Saxon also entertained Farm Security Administration photographers, suggesting possible stories they could shoot and arranging for local contacts to facilitate their travel. Once, he even accompanied Russell Lee to Crowley for the annual Rice Festival. Later, he convinced Marion Post to photograph Melrose Plantation, a place as dear to Saxon as the Quarter. Though his intent was preservation, to save on film things rapidly disappearing, the results differed altogether, for perhaps nothing contributed more to the modernist portrait of modernized America than FSA photography. Modernist artists established its style while modernized methods broadcast its results, wrenching things out of local contexts for use as national icons, the faces and places of a new vision of America. For Ellsworth Woodward and Lyle Saxon, the combination of modern connection and modernist creation shattered assumptions once as solid as the ground beneath their feet.

In the end, this place and this period are best understood, I think, as a thick accumulation of geographic, temporal, and social intersections, some real, others imagined, all pertinent. If Louisiana is where Gulf and continent collide and South and West converge, it is also where all the American boundaries collect: urban and rural, factory and farm, race, religion, and ethnicity, class, gender, culture, and sexuality. Between 1890 and 1945, Louisiana is also where tradition met modernity, revealing the best and worst of both. Quintessentially American, this creole society was simultaneously open and closed, the place where some of the most egregious episodes in the history of American ethnic violence occurred and (perhaps more accurately because) it was also the place where the color line was most easily crossed. French, African, Irish, German, Creole, Cajun, Jewish, Italian, Slavic, and Asian—all lived there, some determined to assimilate, others fiercely resistant, a society both cosmopolitan and provincial, fluid and fixed. In New Orleans, during this period, at almost the exact same time in almost the exact same place jazz broke out while the French Opera House burned down.

Here, too, in both city and state, various landscapes converged over time. One was physical and always changing, the product of mules and muscle building levees, sawing lumber, laying rails and bricks, stringing wire, picking cotton, cutting cane, or tending docks. Another, equally protean, was social, the vast array of individuals and groups, some well-known, most anonymous, who in turn shaped their land and were shaped by it. Finally, there is a landscape of the imagination, fashioned by people who struggled through art to render the changing physical world around them, to order what was being created, or to record what was vanishing. Through pottery and painting, in

literature and photography, artists alternately celebrated or mourned as they explored the contradictions they found between localized beliefs, relationships, and experiences and the new world of machines, factories, cities, and a national culture built on consumerism, mass media, and technological consolidation. Not that Louisiana disappeared in this process; it did not. Instead, it acquired yet another set of intersections, new variations on old themes, in ways revealing the multiple identities of modern society in a place renowned for its ability simultaneously to amass them and to mask them. This is why, though Louisiana has often been promoted as somewhere to lose oneself, it is also a good place to find America.

CHAPTER ONE

"The Most Perfect Expressions of Locality"

1. Americanizing Louisiana

Much separates Louisiana, not only from the South and America, but from itself as well. Geography, culture, and commerce divide the state into three competing subregions whose forced coalition still causes frequent collision. Most of north Louisiana is piney woods hill country inhabited, chiefly, by poor white farmers. Then in Pointe Coupee parish, at the inside angle of Louisiana's "L," the Red River joins the Mississippi to form an immense drainage basin stretching south to the Gulf. Here, unlike the South proper, antebellum Louisiana produced not one but two cash crops: cotton and sugar. Along the river, broad alluvial bottomland supported large-scale, labor-intensive cultivation by planters comparable to those found in the Mississippi Delta. But the traditional relationships between planters and farmers were also complicated by New Orleans, the regional metropolis. Cultural variety made for even greater political complexity. While the hill country was largely Anglo-Saxon and Protestant, the southern parishes were overwhelmingly French and Catholic—an exceedingly delicate set of class and ethnocultural considerations always simmering and easily brought to boil. Amidst the swamps and fevers and sweltering humidity, in a place of rotting palms and corrupt politics where the graves are above ground and the air is filled with voodoo chants and the howl of Loup Garou, it is small wonder observer, scholar, and pundit alike have often made Louisiana a regional anomaly or the nation's bastard child.[1]

Yet clearly, by the close of the nineteenth century, measured virtually by any means, Louisiana was a place rapidly Americanizing. After the war, the introduction of rice cultivation in the southwestern parishes expanded the state's agricultural base. Likewise, its raw materials—primarily timber—became part of the national manufacturing network. In 1905, for example, the

Goodyear family established the town of Bogalusa where it built "the world's largest sawmill on a site along the Pearl River, in one of the last great tracts of virgin timber in the United States." Fewer than fifteen years later, the Great Southern Lumber Company had cleared a timber swath stretching "from Lake Ponchartrain northward 130 miles into central Mississippi."[2] This was a familiar pattern. Not far from Bogalusa, the Illinois Central Railroad established Hammond, Louisiana, overseeing its construction and supervising its peopling. West of New Orleans, across Acadiana, the nineteenth-century railroad boom determined the physical shape and economic activity of the region. As the new century began, the rush for timber was accompanied by the race for newly discovered sources of oil and gas that brought Standard Oil to Baton Rouge in 1919.[3]

Louisiana race relations also followed larger regional and national patterns. For all of the presumed racial openness of antebellum New Orleans, despite the size of its free black population or its legacy of race mixing, segregation began during Reconstruction and radicalized thereafter. Disfranchisement followed, and sporadic violence enforced systems of political exclusion, economic peonage, and social separateness. Three race riots rocked the city between 1866 and 1900. There, too, in a less violent if equally telling development, a raging debate redefined the term "Creole," purging it of racial taint and equating it with white purity. Less is known about the postwar black community outside New Orleans, but as numerous scholars have shown, the central issues and concerns of free blacks in New Orleans fit a pattern common throughout the urban South. Beyond the city and across the parishes, like the region at large and the nation which acquiesced, the nadir of Louisiana's race relations coincided with the dawn of the new century.[4]

Conclusions on race in Louisiana also apply to its politics. Certain anomalies distinguish the state from region and nation; still, these are differences of degree and not kind. The men who held power, the interests they represented, the focus of their rhetoric, and the issues that compelled their attention fit patterns common across late nineteenth- and early-twentieth-century America. Like the rest of the South, Louisiana remained a one-party state until 1928, when the election of Huey Long began its bifactional political era. Like the rest of the South, too, race determined the tenor of most campaigns and guided the rhetoric of most politicians. Though Louisiana Bourbons successfully deflected the Populist political insurgency found in other Gulf South states during the 1890s, this is not to say that Populist sentiment did not exist in Louisiana; it did. Rather, unlike the rest of the Gulf South, where every state elected at least one Populist governor, conservative repression of popular agitation was more brutal and effective. Other aspects of Louisiana's political history follow more closely the broader patterns of American politics. Com-

mercial opportunity and agricultural wealth drove state politics, as successive combinations of alluvial parish planters and New Orleans merchants retained a power exercised according to their interests. Corruption there was aplenty but, in patterns typical of the South proper and the nation at large, boodle and bigotry guided behavior and shaped dialogue.[5]

What sometimes complicated state political calculations also typified national urban trends. Between 1896 and 1920, the Choctaw Club or Regular Democratic Organization of New Orleans operated the most formidable urban political machine in the South. Their opposition, when it existed, usually came from temporary reform coalitions led by wealthy elites. Still, despite appeals to workers and ethnics, the men who ran the Choctaw Club did not differ substantially from their reform opponents. Upwardly mobile businessmen and professionals established it, and ward bosses ran it, utilizing typical techniques and tactics. Even their organizational name was chosen consciously to follow examples set by similar organizations in New York (Tammany) and Chicago (Iriquois), and the Choctaws administered a city beset by the usual municipal concerns. Gilded Age New Orleans, the second largest immigrant entry port in America, was a densely packed city where ethnic tensions spawned occasional violence. City docks were the scene of persistent labor strife and the focus of both union organizers and socialist agitators. Meanwhile, the Regulars struggled with issues common to any turn-of-the-century American urban center—principally public health and transportation, albeit ones complicated by their determination to uphold the canons of white supremacy in a population of unusual racial complexity.[6]

Several other aspects of New Orleans life at the turn of the century fit larger national patterns. During the thirty years between 1890 and 1920, urban engineers orchestrated the physical expansion crucial to New Orleans's development as a modern radial city. Typically, growth begat segmentation. The city developed ethnic neighborhoods and concentrated its commercial concerns in the Central Business District downtown. Elite spaces in the newly established Lakefront complemented the Garden District along St. Charles Avenue. Less powerful groups were pushed to the city fringe, occupying marginal space often poorly drained or otherwise beyond reclamation. And until 1917, when closed by federal edict, a commercial vice center, Storyville, flourished in its own discrete space adjacent the Central Business District. Other forms of commercial leisure also prospered. At the turn of the century, New Orleans was something of a sports mecca, a baseball town, and, before its demise at the end of the century, a prize-fighting center. Even Carnival, what seemed to many observers as the city's most unique feature, Americanized throughout the period. Revived as a means of satirizing Reconstruction, by century's close Mardi Gras had adjusted itself to accommodate the tastes of a

national tourist trade. The organizers of the newly established Krewe of Rex, writes Reid Mitchell, imposed order, hierarchy, and planning upon what had formerly been spontaneous, popular, and individualized—"values that were very much those of their class and times, not just in the South, but in Gilded Age America."[7]

If the physical growth of New Orleans reflected its social development, so too did the conflicting agendas of its segmented forms of artistic expression. Turn-of-the-century New Orleans had become a hotbed of jazz music, the modern American music form still in its infancy. Scholars since have debated its influences and evolution, and while its exact point of origin is still conjectural, this much is understood: Jazz is fusion, a synthesis of many forms and influences, African, European, and American. Jazz is eclectic and elastic; it borrows and bends. It is improvisational, cross-cultural, polyphonic, highly mobile, and easily adaptive, a blending of sounds and experiences whose earliest stirrings emerged simultaneously in such urban centers as St. Louis, Kansas City, Chicago, and New Orleans. "That early jazzmen were influenced by African music is of course unquestionable," one scholar asserts, whose elaboration of their other influences fills a paragraph:

> Starting with a background of West African culture, for about two centuries they had heard and made music at Saturday night dances, weddings, baptisms, candy stews, corn shuckings, evening gatherings, picnics, parties and funerals; they knew work songs, love songs, devil songs, jigs, quadrilles, and stomps. They had heard the folk tunes of Scotland, Ireland, and England, the art songs of Italy and Spain, the melodies of French operatic arias, and the bright tunes of minstrel shows. The heat of plantation religion brought them the spirituals based on the simple harmonies and ardent spirit of the evangelical hymn. And above all they knew the blues. Add to these ragtime . . . and all the ingredients are gathered in.[8]

Collected from so many peoples and so many pasts, this was the sound of the American future. Jazz spread with a velocity only modern Americans could have managed. By 1917, when it was first recorded, it was already too late to say precisely where it had first emerged—exactly the point. The national transportation system had helped to produce a sound that owed its existence to nowhere and everywhere. That jazz attracted modernist applause is equally unsurprising; after all it was audible confirmation of inner assumptions: discordant, poly-sided, and constantly adjusting to time, place, performer, and audience. Popular and commercial, modernist and modernized, it represented one side of the central debate over the American cultural future.[9]

While jazz incubated in New Orleans and elsewhere, several local writers struggled with the assumptions and implications the new music represented. They were not responding to jazz *per se*, but however obliquely, they were ad-

dressing the salient issues the new form raised. Unlike the jazzmen, who were mostly poor and black, they were white and Creole elite. Their form was not music but literature, and their intent not the creation of a popular, mobile, cross-cultural sound, but the preservation of a closed, hierarchical, race-based social order. Some were historians, like Charles Gayarré, the Creole "father of Louisiana history," whose three-volume *Histoire de la Louisiane* harkened for the lost world of John C. Calhoun. Others such as Alcee Fortier took an institutional approach. In 1892, Fortier, a professor of Romance languages at Tulane University, established the Louisiana Association of the American Folk-Lore Society with a membership drawn from the New Orleans social elite, including such popular local color authors as Mollie Moore Davis and Ruth McEnery Stuart. Other prominent New Orleans women joined too, reflecting a growing local women's movement; however, the guiding issue of Fortier's association was not gender but race, and its principal focus "'Negro stories' and Louisiana stories 'of African origin.'" The Association included several members, Fortier among them, engaged in sanitizing the term "Creole" of any mixed-race taint. Previously, such interest had animated their attacks on George Washington Cable's Creole romances. Now, as Jordan and deCaro suggest, "The very act of 'collecting folklore' (indeed their very literacy) set up the collectors as socially superior." So, too, did their material, emphasizing themes of black primitiveness and inferiority in ways that underscored the socially conservative core of the local color message.

In many ways, the association's method and message revealed the hard choices its members faced in modernizing America. To bolster local claims of racial superiority, Fortier's group joined a national folklore organization. Some of his members, Moore and Stuart especially, then contributed local researches in the form of dialect stories to the national press. But reaching out also risked the possibility that others might one day reach in, and because racial supremacy depended on local autonomy, this was risky business. Southerners usually linked "agitation" to "outside" or "organized," and often both when describing their nineteenth-century hobgoblins: slave insurrection, abolitionist tract, Republican Party, Union regiment, Populist Movement, and labor union. Even the boll weevil came from Mexico. As the twentieth century began, the connection between external influence and internal disruption remained especially strong in Louisiana, always a place of uneasy alliances, where new assumptions in the arts and a national reform movement—Progressivism—shaped local cultural expression and political calculation. For the next twenty years, Louisiana's social elite, most of them Orleanians, pursued various political and social reforms with mixed results. As Dewey Grantham suggests, together with other southerners Louisiana reformers struggled to reconcile progress and tradition, and while their efforts have been the sub-

ject of considerable scholarly attention, one aspect of this movement remains outside its proper context.[10] In 1894, a transplanted Yankee named Ellsworth Woodward organized a pottery on the campus of Sophie Newcomb College, recently opened in the New Orleans Garden District, where Woodward taught art. The aesthetic values that governed its creation and the external circumstances that guided its evolution paralleled the contours of early-twentieth-century American experience in city, state, and nation alike.

2. Brassbound Idealism

Ellsworth Woodward had not one career but three, and though they sometimes conflicted, more often they overlapped and intersected in ways that by 1933 made him the patriarch of the New Orleans art world. For fifty years he had been a tireless painter, promoter and teacher of art, a living embodiment of the Arts and Crafts ideal. Born half a continent away—in Massachusetts—three-quarters of a century earlier—two weeks before First Bull Run, he had first come South to New Orleans in 1885, fresh from the Rhode Island School of Design, to join his brother William on the faculty of Tulane University. Together, the brothers developed one of the first collegiate art curricula of its kind. Then in 1889, Ellsworth became the instructor of art at Sophie Newcomb College, a newly created women's academy affiliated with Tulane. Two years later he became director of the Newcomb School of Art, a position he held until his retirement in 1931, managing somehow not only to reconcile the demands of his classroom schedule with his own artistic expression but also to devote countless hours to the institutional development and promotion of art in New Orleans and across the South.[11]

He was a study in New England rectitude, cool and erect, with a riveting gaze and a strong jawline ending in a goateed chin. An even temper ruled him, broken only rarely by the utterance of oaths no stronger than "Jumpin' Jehosaphat!" He had elegant tastes and fastidious habits. He rose early and retired late. Even late in life he left his home on Pine Street in uptown New Orleans no later than 6:30 every morning, walked a few blocks to the Zimple Market, "made" the daily groceries, then returned for breakfast and the morning paper. At 7:30 he headed for the Newcomb campus, and remained in his classroom until four in the afternoon, spelled only by a thirty-minute lunch. Often following the dinner hour he returned to Newcomb where he taught various night classes.[12]

His outward dignity masked an energetic soul that awed his students. "God on roller skates," one recalled. Eyes flashing, he flitted birdlike among them. "Look here," he often said," and I will show you something worth seven dollars someday." Most remembered his unflinching devotion to the highest

standards, others his unflagging patience. None forgot his classroom presence. His energy filled the lecture hall, enormous hands clutching fistfuls of air as he wrestled for words. Corded muscles on each hand knotted around the knuckles. His brow furrowed into an inverted "V" above the nose. The work absorbed him, and he attacked it with a zealot's singleness of purpose within the classroom and without. He was at once teacher, practitioner, and promoter of art, a man with no hobbies to speak of, no favored diversions. He joined the Round Table Club but attended infrequently. Instead, his one pastime seemed to be the sound of his wife's voice. Mary often read to him long into the evening, covering a wealth of subjects in various forms: biographies, romances, novels, and histories. "She is my theater," he once asserted, "my opera and everything else rolled into one."[13]

Ellsworth Woodward held dominion over the local art scene in a benevolent suzerainty spanning four decades. The Woodwards had no children. Instead they drew his Newcomb students around them in familial embrace, often calling them to tea or to dinner or along on sketching trips into the hinterland, where the master divided his time, offering advice and criticism and encouragement, while refining his own craft. He painted all his life in the impressionist style, studied briefly abroad, in Munich, under the tutelage of Carl Marr and Richard Fehr, and did most of his work in watercolor. Some said the crush of his teaching duties and other art-related activities prevented studies in more painstaking media, though he did produce a substantial number of etchings. His work sold well and received critical applause; but Woodward never achieved distinction as a great artistic innovator. Instead he left his mark as a teacher and promoter of art—the zealous center of far-flung activities pursued with a missionary's faith in the promise of art. Prophesying the dawn of a new epoch in American art and a new role in society for the American artist, he venerated beauty, revered locale, and remained an unyielding environmental determinist. But above all Ellsworth Woodward was a passionate idealist whose character traits and social thought comprise an aesthetic bible he thumped for fifty years.[14]

For the most part, Woodward wrote within the conventions of his day, grounding an aesthetic vision and social outlook on widely held assumptions of beauty, environment, and education. He believed that every living soul craved the civilizing influence of beauty, a regenerative social force throughout history but especially in industrial America since it offered a necessary alternative to "debasing materialism." "It is therefore no light matter," he often warned, "this gospel of the holiness of beauty."[15] Influenced by John Ruskin and William Morris, he shared an anxiety deepened by the pace of machine-driven America. Industrialization, he believed, threatened nature, the source of all beauty, subverting each by creating cheaply made objects offensive to

the eye and damaging to the spirit. The manufacturing process lowered art tastes, he believed, retarding the progress of civilization, permitting the machine to co-opt a place once reserved to artisans and skilled craftsmen, and opening an unnatural breach between the lesser and higher arts.[16]

Yet, like so many Americans who wrote on the subject, Woodward would not follow the hard line taken by William Morris. He neither damned industrialization as an unregenerate evil nor embraced the socialist ideal Morris championed as the alternative to a capitalist manufacturing order. Rather, sharing a pervasive American ambiguity, Woodward regarded industrialization as a misdirected force of great potential value. Industry, he explained, represented the necessary foundation of any great art center in the modern era. "Art is the child of busy industrial cities," he reasoned, since enlightened arts thrived upon the rivalry between patrons competing to obtain objects of the highest artistic value. Wealth obtained through industrial progress would draw the best artists in America to its manufacturing centers where each, compelled by the unregulated marketplace, would produce his very best art. Schools would then develop to train lesser talents and to instruct the general public in the lessons of art appreciation. Museums and galleries would be established for public viewing. Higher standards of art would evolve within the community, and beauty would flourish within the heart of the industrial beast. Made to lie down together, commerce and art, the lion and the lamb, would become the complementary forces of modern industrial life.[17]

The issue turned on the promise of industrial design. To refine the crudities of earlier years, Woodward planned to reconcile art and industry through the application of elegant design to the manufacturing process. "The struggle for industrial survival, not to mention national expression, is pitched not in the world of easel pictures," he asserted, "but in the immeasurable field of art lending beauty to industry." Working in tandem, the craftsman and the industrialist could forge an alliance of untold benefits, one capable of placing quality art within the grasp of every American citizen. Industrial designers would staunch the hemorrhage of ugly objects pumped into the national marketplace, salve wounds inflicted by ugliness upon the public spirit, and demolish the artificial barrier between practitioners of the lesser and higher arts. The craftsman would reclaim his traditional role in society as practitioner and promoter of art; better still, Woodward argued, industrial design promised to create a national environment conducive to an appreciation of beauty, an essential basis for social uplift.[18]

Here was the heart of the matter. Nothing in all of Woodward's teachings ever surpassed the importance he placed on environment, keystone of his aesthetic edifice. "Art begins at home," he repeatedly insisted. "We are learning that the museum and the picture gallery are not the natural and ex-

clusive home of art, but that civilized life demands it in its daily routine." Nothing would do for him but decoration with finely woven drapes hung properly, silverware of the finest craftsmanship, or harmony between the architectural structure of the house and the interior furnishings of the home. Here, he reasoned, were taken the first rudimentary steps along the path to a higher appreciation of art. For him it was reasonable "to conclude that when the interests of the community are largely embarked in artistic manufactures, that appreciation and sympathy with the art idea should be greatly expanded and prepared to understand that higher forms of art which find expression in painting, sculpture, and noble architecture." This was a vital lesson. Woodward considered an appreciation for the lesser arts exhibited in the home to be far more than a modest axiom for better living. Nor did it simply represent a means toward understanding higher forms of art. It was instead a tenet of public virtue. "You as citizens may be indirectly responsible for the low standards of public taste if you patronize the ill-conditioned products of tasteless manufactures," he charged. Such neglect depressed the public spirit. It also depressed Ellsworth Woodward. Few experiences saddened him more than "a contemplative walk through a neighborhood where well-to-do people live in total forgetfulness of the happiness that may be added to living through harmonious form, order, and a thrift regard for cleanly streets." "Somehow," he concluded, "moral health is more possible with fitting environment." Once Americans began to appreciate art in the home, Woodward prophesied, there would blossom nationwide an all-encompassing public aesthetic of magisterial elegance, something on the order of the Chicago Public Library, whose refinement he reveled in:

> simplicity, permanency, dignity, beauty, national honor and power typified in couchant lions guarding the giant staircase, whose glowing marble is inscribed with the names and deeds of heroes. The walls pictured with mystic allegory where poets, sages, and artists, each through the agency of his genius wait upon inspiration. Religion manifested in majesty more eloquent than words, upon walls which speak of the imagination as did those of the mother church. Vast rooms for the student every furnishing of which leads the mind away from the sordid and common. Rooms for children where entire freedom and association with the beautiful exert their benign influence[,] this treasure house which has sculptured upon its frontal: Built By the People and Dedicated to Learning.[19]

Woodward's environmentalism also made him an implacable localist. Environment, he believed, not only led the citizen to higher appreciations of the "art idea," it also determined the character of an artist's work. "The beginnings of all great and viril [*sic*] epochs of artistic expression have been at home and have dealt with life and environment as it lay at hand," Woodward

once wrote. He raised the subject often in gallery talks and organizational speeches and made it a guiding tenet of classroom lectures and studio discussions. He called this environmental determinism the "genius loci," a phrase borrowed from Violet Piaget, who wrote under the pseudonym of Vernon Lee. Piaget defined the term as "a substance of the heart and mind, a spiritual reality," describing the attachment of a sensitive soul to a specific locale. "I have compared the feelings we can have for places with the feelings awakened in us by certain of our friends," she wrote, "feelings of love and gratitude—and have the effect of turning locality from a geographical expression into something of one's very own."[20] Woodward not only treasured such assertions, he elevated the emotionalism of the genius loci into aesthetic principle. Since artists were products of their own locale, he reasoned, they were best suited to interpret their immediate environment. Outsiders could appreciate the beauty of a given place, but they could not render it artistically without exhibiting the severe limitations of alien sensibilities:

> In a country as immense as ours in which climatic conditions and geographical place differences exert their influences, it is, or should be, manifest that art expression will assume a wide variety of application. Out of these conditions which background our lives, grows love and loyalty to locality—the genius loci which is the essence of art as well as patriotism. The land of the palm and orange, of arid plains and towering mountains must find their true expression through the hearts of their indwellers.[21]

While such beliefs made Woodward something of an artistic nationalist, insisting that American artists, products of the American environment, were superior interpreters of American subjects, his general theorem also included a sectional corollary.[22] Speaking to a meeting of the Southern States Art League, he asserted the folly of artists working beyond their native region. "When you southerners go to Cape Cod, Providence, [and] Cape Gloucester, you can paint your heads off, but New England artists can paint these scenes better than you ever will." Such logic also applied below the Mason-Dixon Line. "No Yankee artist, however skillful, can paint the South," he continued. "He has never known the sights and sounds and scents in his childhood as you have," a conviction held so firmly he even applied it to himself: "I have spent fifty years in the South—I'm more southern than Jeff Davis in some respects—and when I make annual pilgrimages to various parts of the South . . . and wake up in a Pullman in the morning and see the lovely Southern scene with its incomparable trees and flowers . . . I think what masterpieces I could paint—if only I were a Southerner-born!"[23]

Ellsworth Woodward's aesthetic assumptions allied him with the burgeoning turn-of-the-century Arts and Crafts movement. Like Woodward,

the movement championed the reconciliation of art and industry through tastefully designed objects of everyday use. It was an Atlantic phenomenon, begun in England, but one whose zeal quickly swept westward. Local crafts clubs soon appeared in most American cities, evangelizing on behalf of the movement, either through gallery talks or display rooms exhibiting the fruits of local labors. Woodward delighted in such places. In his estimation they were not merely dispensing centers for "hand-wrought articles" but essential places "where people of taste may find something of rare individual beauty," places "where the artist may find the opportunity to escape the narrow convention-ridden demands of commercial manufacture," places Woodward himself sought to establish in Louisiana. In 1909 when his friend and frequent correspondent, E. L. Stephens, founder and president of the Southwestern Training Institute in nearby Lafayette, dedicated an arts and crafts building at the school, Woodward could scarcely contain his enthusiasm. "Ho-o-o-rah for your noble ideal!" he rejoiced to Stephens. "The world is full of a number of things but none of them is more certain than that art and handicraft are Siamese twins."[24]

By then, Woodward himself had already made great strides for the movement in New Orleans. He had joined the Newcomb Committee on Public Grounds, and in order to create the proper atmosphere for artistic study had directed a campus beautification project. His classroom became a forum for the theory and practice of art appreciation, and his studio a handicrafts center. He installed looms for weaving and presses and tools for book-binding. He added anvils and punches for metalworking and leathercrafts. He engaged a silversmith with all the necessary accouterments, and the Newcomb women went to work on a host of the applied arts. They made vases and bowls, plates and inkwells, watch fobs and mugs, and lamp shades and stands of brass and glass. They made fire screens, candlesticks, three-handled loving cups, rose jars, chocolate and tea services, and calendars of fine calligraphy. They made all these and more, anything of domestic use, eventually gaining international renown for the quality and variety of Newcomb's arts and crafts activities. Still, nothing drew more attention or wider acclaim than Woodward's first foray into the practical arts made in 1894 when he set out to revive earlier attempts to found a campus pottery.[25]

Given local circumstance and larger context, a pottery made an ideal choice. New Orleans was already the home of commercial and amateur pottery projects. Two ceramic companies operated in the city, and there were already, close at hand, additional people who shared with Woodward a common artistic vision as well as the specialized skills, space, and apparatus the medium demanded. Between 1885 and 1890, Woodward's older brother, Wil-

liam, headed the New Orleans Art Pottery Club, which operated a small pottery on Baronne Street in the French Quarter. The club's membership included at least two experienced craftsmen, one of whom designed and built the kiln used at the Baronne Street facility. Such practical considerations only complemented Woodward's artistic values. Pottery was among the oldest of crafts, one whose ancient traditions and complex demands often produced mysterious results. No doubt the pottery process appealed to Woodward's aesthetic idealism—his defense of artistic craftsmanship and his determination to elevate the quality of everyday life through handmade objects of unquestioned beauty. It even matched his aesthetic localism. Recipes for mixing clays varied according to potter and had to be adjusted through painstaking trial and error to accommodate local climate and condition. Similarly, the secrets of kiln construction, as jealously guarded and perpetually altered as clay recipes, had been handed down across generations of specialized builders. Nor could any machine impose its standardizing influences on such individualized pieces of artistic creation. Pots were thrown by hand in a creative process virtually guaranteed to defy the cookie cutter regularity of machine production. Fluctuations in kiln temperatures, in clay compositions, and in artistic glazes made each object distinctive, the result of a unique series of chemical interactions whose steps, even when repeated exactly, rarely produced identical results. The degree of experimental range, of artistic license, was limitless, the threat of an oppressive uniformity nonexistent, and the availability of local designers and local subjects virtually endless. "Newcomb [P]ottery makes its first and perhaps its noteworthy appeal by its artistic quality: it is beautiful," Woodward summarized, "moreover, [it is] wholly indigenous. The clay is found in St. Tammany Parish, Louisiana. The designers are southern women educated in the School of Art of Newcomb College, New Orleans; the land of the orange and palm, the magnolia and jasmine, the bearded cypress, the noble oak, and the stately yellow pine."[26]

Such circumstances made pottery an attractive choice to Arts and Crafts movements nationwide, yet even from the start, innovations within the medium, as well as Woodward's institutional intentions for his pottery, created areas of potential conflict. For all its apparent traditionalism, pottery itself was in transition. Books of standardized mixing recipes would soon replace the "home-brewed" secrets of individual potters. The first courses on the technical aspects of pottery creation had begun to appear in American college curricula. Technological developments in kiln design and finishing processes would soon pit the innovations of trained specialists against tradition-directed craftsmen. Then, too, conflicting gender assumptions and relationships reflecting the larger tensions of Progressive America quickly surfaced at the pot-

tery. As envisioned by one of its earliest members, the Newcomb experiment not only aspired to aesthetic achievement, it envisioned an ideal of communal cohesion:

> The life of a pottery is usually composed of many parts, many people contributing to its success or otherwise. All are mutually dependent upon one another, from the potters who prepare the crude clays, form the vases, [and] do the firing, perhaps, to the designers who work day after day solving new problems of color and design, and to the directors who determine its general policy. Each I say, dependent on the other, contributing to the success of the finished vase.[27]

Attaining this ideal, however, meant reconciling conflicting visions of gender and professionalism. Newcomb organized its division of labor according to conventional nineteenth-century gender assumptions. Because "the general opinion among the students and the public was that the actual throwing of the ware on the wheel was not genteel enough," explained a contemporary account of the pottery, such activities were reserved to men. This arrangement carried an additional, if more implicit, affirmation of prevailing gender standards. It reserved the mixing of clays and throwing of pots to men who had dedicated their lives to the craft as opposed to women designers for whom the work was, presumably, mere prelude to the higher roles of spouse, mother, and guardian of domestic civility. What men made with sweat and mud, women were to cover with a decorative veneer. Put more bluntly by one observer, the division of labor operated on the premise that "life [is] so short and the craft so hard to learn."

Woodward ascribed only partially to such assumptions. "I would be the last man to put a profession in the way of what I think to be a woman's mission—to make the right man happy," he once explained to his friend E. L. Stephens. Yet he was also concerned about finding a proper social sphere for women outside the home. If a single woman was left alone in the world "to fight for herself" and measured up to his grueling aesthetic standards, then he considered her fully entitled not only to the social honors of a craftsman but the economic rewards of a laborer.[28]

Woodward no doubt considered such roles complementary, but not everyone at the pottery agreed, especially the three people who played the crucial roles in its establishment, early direction, and ultimate success. Even before Newcomb's establishment, Joseph Fortune Meyer was the preeminent figure in pottery circles along the Mississippi Gulf Coast. Born in France, the son of a potter, he emigrated to America before he was ten. Though he had no formal education, he read voraciously and astonished most observers with the extent

and range of his retention. He had learned his father's trade and gone into business with him, selling their handmade wares in the commercial roil of the New Orleans street market. Eventually, utilizing the techniques and recipes passed across generations of French peasants through his father, he became a master craftsman, "the foundation," according to one estimate, "for all that has been done in fine ceramics along the entire Gulf Coast." He impressed others as well. Some recall his "genuine appreciation for truly artistic things," others his technical acumen, and none forgot his striking presence and forceful personality. "Meyer made an impressive appearance," wrote one observer, "in the flowing beard that gave him the patriarchal mien traditional among older potters of his day." "Voltaire could not have been more caustic," wrote another, "Rabelais lived again in him, [and] Clemenceau is understandable when Meyer is remembered." Whatever else, he was Ellsworth Woodward's first and most influential ceramist, throwing "every wheel piece that the girls at Newcomb decorated," from the inception of the project until 1925 when forced by illness into retirement.[29]

Two others made pivotal contributions to the pottery's development. One was George Ohr, the "Mad Potter of Biloxi," widely known for an unruly shock of hair he kept pinned in a bow on top of his head, an equally flowing beard, usually tucked into his shirt front, and a set of mustaches he could stretch to full length and wrap around his ears like a pair of glasses. "An eccentric and accomplished man," he was prone to fits of wanderlust and held opinions with an unsettling zeal, chief among them the conviction that he was "a second Palissy and that his wares were worth their weight in gold." His "non-conformity" provoked no end of turmoil among those around him (and no small trouble for Woodward); nevertheless, despite their many differences, Joseph Meyer liked Ohr enough to train him and include him first in the Baronne Street Venture and later at the Newcomb Pottery. They were joined there by Mary Sheerer, Woodward's codirector, who first established and then maintained the pottery's artistic standards. A graduate of the Cincinnati Art Academy, Sheerer was no novice to the form. In Cincinnati, working as a decorator at the Rookwood Pottery, she had been exposed to the artistic ferment and innovative techniques that made it the preeminent institution of its day. Later, she had trained at the Art Student's League and then come to Newcomb to enrich the art department and to assist with the development of Woodward's fledgling pottery. Like her codirector, Sheerer's arrival in the spring of 1894 commenced a life's work. "She made Newcomb her career," writes Robert W. Blassberg, and in the process made a lasting mark not only on the pottery but in the field of American art. "The resourcefulness she displayed carried the project through the protracted discouragements of its beginning, and guided

it ably through its later phases," Blassberg continues. "She ranks among the many prominent women whose presence distinguished the American art pottery movement from its male-dominated European counterpart."[30]

Mary Sheerer's "resourcefulness" may well have been born of necessity, just as her "presence," almost certainly, was hard won. She came to New Orleans with an academic background, the temperament of an "individualist," and a thorough knowledge of the pottery craft. She also came to begin a career in art education. Yet no sooner had she arrived than her duties required her to spend long hours in cramped spaces enduring frustrating setbacks at work with someone almost certainly opposed to her very presence. This was Joseph Meyer, the embodiment of the "male-dominated European counterpart" of the American pottery movement, whose boss was Mary Sheerer. How deep the hostilities of either ran is uncertain, and its effects may only be inferred. Meyer obviously remained master of his wheel, throwing every ware decorated at the pottery for the first thirty years of its existence. Meanwhile, Sheerer focused her energies and innovations on decoration, experimenting with glazes, of which Meyer knew little, and developing what became the color palette that soon distinguished Newcomb craftsmanship. Tensions implicit in the training, temperament, and artistic focus of these two surface in the recollections of at least one of their colleagues. "Professor Sheerer was an individualist and resented the need for the services of Joseph Meyer in production of ware by a college for women," remembered Paul Cox, who suggested that her feelings may well have determined her role at Newcomb. "Therefore, she developed the work in modeled pottery, placing emphasis on this form of craft with her students."[31]

Aside from whatever tensions existed between Mary Sheerer and Joseph Meyer, it is even clearer that Cox's own arrival at Newcomb in 1910 caused additional complications. He was a ceramic chemist, among the very first of his kind, and his arrival in New Orleans is generally regarded as a pivotal moment in the pottery's development. Cox had left his boyhood home in Indiana to fight the "Splendid Little War" and then turned his interests to art. He studied with Charles F. Binns at Alfred University's New York College of Ceramics, where he became only the "second graduate of the second college of ceramics in America" and someone with precisely the kinds of skills Ellsworth Woodward was looking for. Cox helped refine the clay mixtures used at the pottery, resolving many of the quirks and inconsistencies produced by Meyer's recipes, but his real contribution was a newly developed mat-glaze popular among American potteries. The innovation, part of a "new professionalism" that transformed Newcomb wares in several fundamental ways, also provoked additional tension among the staff. Specifically, George Ohr had no use for any "pencil potter," as he disparaged Cox, ridiculing the chemist's efforts in

doggerel verse deriding technical innovation and defending craft tradition. Still, for all the bombast, Newcomb's future was clear. "After Cox was hired," writes one scholar, "all Newcomb technicians were drawn from the college at Alfred."[32]

Despite the conflicts of staff and intent, and despite a host of technical failures and frustrations in its early years, Ellsworth Woodward made good his ambition to establish a pottery at Newcomb College. His first results, exhibited in 1896, drew squeals of local delight. Soon the pottery gained a wider audience. Several exhibitions were made in northern cities. Critical approval followed, and awards and accolades began to accumulate. Eventually, Newcomb wares were exhibited in Europe, where in 1901 the pottery won the Bronze Medal at the Paris Exhibition, marking a pivotal moment in its development. Since its inception, Woodward's venture had supported itself through limited sales of its wares. But the Paris award trebled orders, and to meet the demand Woodward reorganized the production process. Previously, his designers had labored in piecework fashion, paying for the costs of each pot before having it thrown and not realizing any of the investment until a sale was made. This might have produced award-winning art, but it made for risky speculation on the part of the artist. Pots often crumbled during the firing process, and even finished products were subject to the buyer's fancy. The new arrangement established a corporation within the college to underwrite the costs of production. "In other words," announced Woodward in the next annual catalog, "an effort has been made whereby the designs of the kiln will be placed on the market, the industry regulated, and the losses maintained in the future." Production then moved forward in assembly-line fashion. Meyer threw pots according to one of several standard shapes chosen by the designer, who then executed her decoration and submitted the piece to the kiln master for firing. Woodward and Sheerer upheld the quality of production by enforcing exacting standards of technical skill. The new system worked. By 1908 sufficient profit had accrued to permit the hiring of a salaried employee to run the campus display and sales room. Soon technical innovation and a larger working space permitted additional increases in production. Still, orders continued to swamp the project. Between 1918 and 1930 the Newcomb Pottery produced nearly fifty thousand pieces, marketed by an ever-increasing sales staff. By 1931, the year Woodward retired, fifty-four agents working out of twenty states directed the national and international distribution of Newcomb products.[33]

The pottery was the fullest institutional expression of Ellsworth Woodward's artistic idealism. Ethel Hutson, a Newcomb alumna and later a professional colleague, spoke for them both when she called the pottery "a new movement for greater beauty, simplicity, and freedom of design—a reaction against that slavery to the machine which was characteristic of the last cen-

tury."[34] In its evolution, the experiment also reflected Woodward's guiding faith in environment. When the pottery expanded in 1901, it moved to a new location chosen by its master because it typified the local surroundings of New Orleans. The structure itself reflected Woodward's close study of French Quarter architecture and repeated many of its forms. Inside, his artistic spirit abided. The workshop, spacious and neatly appointed, fostered a solemn atmosphere, a hushed reverence for beauty in the making. It also reflected Woodward's aesthetic localism. Although he believed that artistic liberty governed his experiment, local surroundings were the unspoken rule of decorative design. "No special haste is felt to be needed in fixing upon the character that the wares shall assume," he explained, since "the belief is entertained that if no formative pressure is employed, its development will proceed along lines of the least resistance, and arrive finally at the most natural expression of locality." Here was the logic of the genius loci, a matching of design to material. Because Newcomb pots were thrown from mud fetched up from nearby bayous, it followed naturally to Woodward that the only suitable designs for local clays were studies of local nature: fleur-de-lis, crepe myrtle, white Cherokee rose, chinaberries, wild iris, moss-draped cypress and live oak, dogwood, water lily, cotton plants, jonquils, and wild jasmine.[35] Ideally the designer, too, was born and bred locally. Once a young student approached Woodward, concerned that her skills would not match his exacting standards. When he asked her where she was from and was told "Louisiana," he smiled softly and told her that she was more qualified to decorate the pottery than he was. "There's a good deal of bosh in that of course," she wrote her mother, "but I'm glad I was born in Baton Rouge."[36]

Here, then, was art for the American Century, the aesthetic counterpart to political Progressivism. Arts and Crafts experiments such as Woodward's were urban and middle-class in character and composition, narrow in outlook if reformist in spirit, environmentalist in approach, and elitist in structure. Art would revolutionize American tastes, elevating from the bottom up through homes adhering to standards handed from the top down. There were additional conflicting impulses. The experimenters were zealous idealists devoted to Truth and practitioners of handicrafts they considered imperiled by machines. Yet they retained a firm faith in the blessings of an industrialized future, either rejecting outright or refusing to acknowledge basic conflicts between art and commerce. Nor did Woodward or the Movement reconcile the tension between local production and national reform. Each prophesied the elevation of American art standards. Each trumpeted the creation of indigenous forms of national expression, but neither overcame the attachment to locale. Arts and Crafts movements flourished in cities across America throughout the first decade of the twentieth century. They exchanged annual

exhibitions and fraternal good wishes. They applauded the other's efforts, yet none suggested national coalition. Instead they arrayed themselves as constellations in the night sky with the Southern Cross flickering over uptown New Orleans. By no accident did the Newcomb Pottery burst upon the international art scene from the heart of the New Orleans Garden District. This was the geographical center of the Louisiana reform impulse in politics as in art. Several prominent members of the Good Government League made their home near the Newcomb campus, among them John M. Parker, future governor and chief southern political advisor to Theodore Roosevelt. Cream of the New Orleans gentry, Woodward's young women flocked to his classrooms, where he led them out beneath the moss-draped elegance of the campus grounds to contemplate nature. Most, he reasoned, would benefit from the experience by going out into the world to establish homes and families guided by aesthetic principles taught in his classroom. The very best he hoped to employ in his pottery, earning for a small coterie of talented designers some means of income suited to a woman of taste and gaining for them, too, a vital role in society, one bearing all the respect and responsibility freighted in the word "professional. "[37]

Guided by these faiths, Woodward's "natural expressions of locality" earned wide praise. In 1907 Newcomb Pottery won the Gold Prize at an arts and crafts exhibition held in Jamestown, New York. "You know this puts us in the front rank," he wrote jubilantly to his friend, Stephens. "It is a real distinction taking us out of the provincial and amateur class and ranking us as a world power." Greater honors awaited. At the Panama-Pacific Exposition held at San Francisco in 1915 the pottery won five separate awards, including two grand prizes. By then Newcomb ranked second only to Rookwood of Cincinnati as the largest American producer of individually decorated pottery. But the emergence as a "world power" brought additional burdens and unforeseen developments. Critical acclaim always stimulated demand, and demand always stretched the facility's productive capabilities, and under the pressure, a fissure first opened in 1901 widened into a fault line running between the artistic purpose of the project and its expanding commercial appeal.[38]

Woodward insisted that business decisions should never overshadow the aesthetic concerns of the project. "It is never a question of 'salability,'" [sic] he insisted; "death lies that way for the artist." Instead he clung to the faith that art and commerce were complementary forces held in delicate equipoise by the pursuit of knowledge and the quest for beauty, a utilitarian creed he called "industrial commercialism":

> Art has been transformed before the eyes of an indifferent public from a subject
> of ornamental trifling to one of serious economic meaning. And let me say to

those who think that the college is no place for industrial commercialism that the test of all education lies in its application to the needs of life. Pure philosophy and pure theory are pure moonshine unless they square with the lives we have to live enabling us the better to perform the duties that we cannot and do not wish to escape. If we wish our subject to be repeated we must show that it is capable of doing the world's work.[39]

Nevertheless, there were already clear indications that considerations of the marketplace had gained ascendancy over issues of artistic integrity. When Paul Cox arrived in 1910 his mat-glaze provoked a noticeable boost in sales. As Cox had intended, and for the first time in Newcomb's history, he boasted, the designers enjoyed more than a modest salary. Changing public tastes also hastened the transformation. Cox's influence helped initiate a more conservative, highly romanticized representational style of design. The decorations evoked images of the South similar in theme and spirit to popular film and fiction. Muted tones, softened by Cox's glazes, depicted moonlight through magnolias and live oaks dripping with Spanish moss. They became the most popular designs ever created at Newcomb, ones repeated to the point of tedium by designers fully aware that the decorations were aesthetically unsuited to the angular shape of the pots. "The standard ware . . . has become more or less stereotyped in color, decorative treatment, and design," wrote one contemporary observer. "This style is so entrenched on the buying public that it has become a 'hall mark' of Newcomb Pottery to the extent that when the decorators make a piece even in the same technique but using another color than the traditional soft blue and greens, it will stay on the shelves unnoticed or unrecognized as real Newcomb pottery."[40]

The altered style allowed the pottery to outlive the Arts and Crafts movement, but only by adopting practices contradicting Woodward's idealism. High tide for both the movement and the pottery came in 1915. Unable to match the productivity of the manufacturing process, deeply divided over the relationship between art and commerce, the movement failed to overcome the machine's momentum. Its leaders were dying and its practitioners turning elsewhere. Fittingly, it slipped from the scene amidst the industrial carnage of the Great War. The San Francisco exhibit, scene of Newcomb's greatest triumph, was the last major showing of its kind. Still, the pottery's wares sold well, but Woodward's designers no longer shaped popular tastes—they had become prisoners to it. Designers no longer handed down "glimpses of divine beauty" for the enlightenment and uplift of the general public. Rather, they received orders to satisfy taste as it already existed produced in new kilns designed to accommodate volume. Nor were the wares used for their intended purpose. They did not become articles for household use, the stuff of everyday

art. As awards accumulated so did value and price. Private collectors hoarded the pieces, making them coveted objects of privileged display and not popular use.[41]

Newcomb Pottery never became exclusively a business enterprise. Woodward was too much an idealist to permit it. Instead, it occupied a position somewhere between the lecture hall and the sales office, an awkwardness even the master recognized. "What shall a teacher do with a manufacturing business?" he asked a group of executives in 1930. "It doesn't seem right, I was going to say almost indecent." By then, Newcomb wares were fully standardized products despite two late attempts to recapture the experimentalism of earlier days. The pottery had lost its envied reputation for innovative design. It had even left the Garden District when the college moved further uptown to its present location adjacent to Tulane. Worse, with the onset of the depression the pottery suffered the fate of all industrial America. When production outstripped consumption, sales began to slip and never recovered. A year after his address to the businessmen Woodward retired in a tearful farewell, heightened, no doubt, by the sense that more than the man was passing.[42]

In spirit, institutional intention, and unforeseen result, Newcomb Pottery typified turn-of-the-century American reform efforts. Animated by his concern over industrialization, Ellsworth Woodward's reform enthusiasm linked art and social progress to prevailing assumptions of aesthetics, gender, and localism. Industry, he always admonished, represented both peril and promise. The machine would either flood the nation with shoddy goods, undermining society by corrupting "beauty," or provide the very mechanism of uplift, especially in his adopted region. Where industrial capital flowed, he observed, art patronage followed, beauty flourished, and society progressed. It remained only to develop a hand able to guide industrial design, an ideal role for the women of Newcomb College. From the campus generally, from his pottery specifically, Woodward believed, two groups of women would emerge. Most were destined to cultivate beauty in their domestic sphere while a far smaller group of professional craftsmen pursued similar ends in society at large. However they worked, as wives and mothers or as industrial designers, Woodward confidently assumed that his craftsmen could not fail to improve society by following his canons of aesthetic localism.

Woodward's experience at Newcomb Pottery revealed the limits of such aesthetic idealism and his inability to achieve intended reforms. He had hoped to reconcile art and machine manufactures by combining the best of each and avoiding the worst of either. But wherever he sought stability through synthesis—between art and industry, men and women, professionals and amateurs, locale, region, and nation—division, dissent, and disruption ensued.

His designers did not, in fact, lend beauty to manufactures on anything like the scale he prophesied. Instead, the logic, demands, and methods of industrial manufacturing continued to dominate American society, transforming people, places, and institutions, Newcomb Pottery included. Here production influenced design, not the reverse as he intended. Here, too, the hand in glove ideal of women and men working harmoniously in "natural spheres" proved impossible to attain. Moreover, popular demand froze Newcomb's style, standardizing for national and international taste what was supposed to remain a decorative style directed by local circumstance. Finally, for all its critical acclaim, Newcomb Pottery never fulfilled its egalitarian promise by becoming objects of everyday use for ordinary Americans. Instead, much like its sister Arts and Crafts projects, the pottery remained an insular institution attuned to little more than the sound of its own voice. Here the irony is most suggestive. Early-twentieth-century New Orleans was a very noisy place, a roiling cacophony of ethnic and racial voices, and an early hotbed (some say cradle) of a distinctly modern musical sound. Yet nothing indicates that Ellsworth Woodward ever so much as heard jazz performed, or if he had, would have found it tolerable in any way.

Given his extraordinary energy and determination, it seems only fitting that Woodward's retirement proved so short-lived. In late fall 1933 he obliged the summons of New Deal relief administrators to join an effort designed to aid needy artists. For the venerable teacher, the national calamity represented one final opportunity to realize ideals held for nearly fifty years. But once again, as foreshadowed by the Newcomb years, Woodward would face an overwhelming series of insoluble conflicts between local initiative and national demand, traditional method and modern innovation. In the coming months, the distinction emerged most clearly between the society he envisioned and the one America was rapidly becoming.

CHAPTER TWO

American Scene

1. "A Native Product"

It began with a jolt. Two sharp whistle blasts and the engine lurched for-ward. The train hovered for a moment between rest and motion; then, each in turn, cars snapped forward clanging tautened couplers. The *Southern Crescent* creaked slowly out of Union Station in New Orleans. Bil-lowing black smoke spewed bits of undigested coal and sprays of warm water. Well-wishers and passersby slid backward along coach windows. Black men in white coats muscled bags into overhead racks. Conductors called for tickets. As the train clicked faster, chugging north along the convex arc between New Orleans and New York, Ellsworth Woodward sat in a Pullman berth, hands folded in his lap. At age seventy-two, he had been called out of retirement and summoned to Washington by the industrial calamity of the Great Depression. This was in December 1933.

The trip afforded Woodward ample time for reflection and anticipation. A half-century of efforts failed thus far to initiate the revolution in art he prophesied in younger days. For all its critical acclaim, Newcomb Pottery did not arrest the hum of the machine or the effusion of cheaply made goods into the marketplace. The manufacturing process had not become the mechanism of social refinement. Nor had Woodward won for artists an esteemed place in American communities. Still, the faith persisted. Even in retirement he con-tinued with the same relentless energy to preach his message of social im-provement through beauty. Then, in 1933, a movement within the American art community gained the attention and support of the new administration in Washington. Espousing ideals similar to Woodward's own, it proposed a meeting in Washington of American art interests to develop an emergency work program to help artists weather the depression. Woodward received an invitation as the staunchest friend of art in his region. Now he steamed north toward the capital at his own expense aboard a swaying Pullman coach. While no record exists of how exactly he passed his trip or what he thought about watching the southern landscape roll by, there remains the impression of sun-

light streaking through the window and Woodward's reflection on the glass as though the two faces told the story, one clear and sharply defined, eyes bright with anticipation, the other a soft reflection of previous efforts.[1]

The meeting was held in the home of Edward Bruce, chief architect and guiding spirit of the proposed program. A stocky figure, jowly and energetic, Bruce was then fifty-six, a man whose career had included both finance and fine art. In 1922, when his Asian business prospects soured, he traveled to Europe where, under the tutelage of his friend, Maurice Sterne, Bruce learned to paint. He destroyed his earliest efforts, but within two years his paintings showed successfully and sold. The work acquired international acclaim, but after six years spent painting in Italy and disillusioned by the Fascists, Bruce returned to the United States in 1929. He continued to work, but like so many of his fellow artists, he found former patrons increasingly hesitant to speculate on contemporary art. Few had the money, fewer still the inclination. So Edward Bruce retraced his steps, exchanged his smock for a suit, and returned to the business world as a Washington lobbyist. Eventually, he fell in with the New Dealers in whose social circle he mixed comfortably, and before long he led a growing coalition determined to use the relief apparatus in the service of American art. Through the heat of summertime Washington, Bruce huddled with New Deal lawyers, untying legal knots and sorting out lines of administrative responsibility. He buttonholed key administration figures and won valuable supporters, among them Rexford Tugwell, Frances Perkins, Harry Hopkins, and Henry Morganthau. A series of dinners held in the Bruce home that autumn wooed over Jerome Frank, Jacob Baker, and Harlan Fiske Stone. Now remained the task of persuading the leaders of American art, without whose cooperation success would be impossible.[2]

Years later Olin Dows still remembered the intensity of the December organizational meeting. Dows, who would eventually direct the Treasury Relief Art Project (TRAP), first met the Bruces, "a vital pair," at the apartment of Andrew Mellon where each had come to admire the former treasury secretary's extensive art collection. A friendship grew, Dows gravitated into Bruce's circle and agreed to attend the organizational meeting. "It was an outstanding group," he recalled, who despite the difficulty of the circumstances and the press for time, filled the room with a sense of hope. After luncheon in Bruce's home, Eleanor Roosevelt stressed the urgency of preserving the arts despite the current emergency. Discussion then began in earnest. Bruce explained his plan and entertained questions. Talk grew animated and debate continued. Many future points of contention were ignored or glossed over in the desire simply to "do something," and by late afternoon consensus emerged supporting the plan. The impressions of the participants ranged from guarded optimism to outright enthusiasm. "We should not be afraid to make a mistake,"

observed Tugwell, "[though] we may have to whitewash a lot of walls and take down a lot of sculpture when we get through." Homer St. Gaudens, director of the Carnegie Institute, waxed far more sanguine. "For the first time in our land," he gushed, "the artist will be given heart by knowing that the government is back of him in a material way and feels that he is taken into the national soul." In the evening, following a celebratory dinner Bruce sponsored at his club, his guests made their way home singly and in groups. Many returned to hotels and packed for the trip home. Finally, all retired but Edward Bruce, who drove home, locked himself in his study, and wrote the first press release announcing the establishment and organization of the Public Works of Art Project.[3]

PWAP combined the two courses of Bruce's career, reflecting his experience and values in both administration and aesthetics. To direct his national art concern, he appointed sixteen regional directors to hire needy artists and supervise their activities. Regional subcommittees were to assist his directors, expediting the search for artists, evaluating their completed works and, it was hoped, stimulating local enthusiasm for art. In the more remote regions a third administrative tier, regional subcommittees, stretched federal fingertips into the nation's furthest corners. Great hopes swung on the regional hinge. Like Ellsworth Woodward before him, Edward Bruce planned to revolutionize American art by hiring 2,500 artists and paying them a craftsman's weekly wage. Throughout the twenties, explained Forbes Watson, art critic and PWAP's technical director, the artist, like the stockbroker, became entrapped in a spiraling vortex of overspeculation. "New oil fields or new artists," he observed, "the only real difference in the promotional methods was that in the case of oil the purpose of the manipulators was more frankly stated."[4] In art circles the speculation created a privileged club of artists raised to prominence more by the whims of the marketplace than through natural talent or hard work. Bruce and Watson were convinced that conversion to the wage scale would redress the imbalance and correct the structural deficiencies of the system. Steady wages, they insisted, would arrest the speculative spiral and provide recovery for the artist. Older talents lain fallow since the art market collapsed would receive stimulation and rehabilitation. New talents were bound to be discovered and developed.[5]

By stretching their bureaucratic apparatus deep into the national hinterland, project officials hoped to create a widespread popular appreciation for art. This, they reasoned, would inaugurate a simultaneous process of social uplift and economic rejuvenation with far-ranging results. Art disseminated throughout the land would strengthen spirits weakened by depression uncertainty. It would also stimulate art sales. Working diligently in their government studios, PWAP artists could ensure a steady flow of works to this

newly expanded market, matching supply to demand and keeping prices low. Economic innovation would also transform the artist's social role. His new-found patron, the American public, would force the artist to attune himself to national spiritual values. Artists would be swept out of seedy garrets and exclusive galleries into the American streets, there to mix with fellow citizens and assume civic responsibilities long ignored. Bruce promised hope, abundance, and uplift—all for the price of a modest government subsidy. In art, as in the general economy, recovery required priming the pump. Still, as Bruce understood, organization was only half the issue.[6]

Because PWAP intended to stimulate art enthusiasm by decorating public buildings at public expense, success rode ultimately on the popularity of those decorations. Unlike Ellsworth Woodward, an artist first and businessman later, Edward Bruce, a businessman first and artist later, never undertook to shape public taste. Instead, he planned to cater to it through the representational style of American Scene painting. "More now than at any time during the past fifteen years," Bruce wrote, "the American artist is contemplating the American scene . . . [and] looking at and into the life of his own land."[7] The choice reflected his own aesthetic preferences and artistic experience. From his mentor, Sterne, Bruce learned to appreciate nature and value artistic craftsmanship. His representational style, like his choice for PWAP's aesthetic standard, eschewed either extreme. He rejected both academic formalism and the avant-garde, reasoning that neither classical allegory and Eurocentrism nor experiments in modernist abstraction offered anything to average Americans suffering the living reality of industrial depression. More important, Bruce the businessman considered no other style more palatable to the American public, and frankly admitted the importance of "selling" his program, something requiring a means of mass appeal suitable to the most and offensive to the fewest, conveying themes none could misconstrue. In this fashion America Scene painting became a marketing vehicle, something Bruce himself revealed, perhaps unintentionally, when he defended his aesthetic choice by calling it "a native product."[8]

Art academicians greeted Bruce's choice with the same enthusiasm the business sector showed the National Recovery Act. To them the style was modern and therefore unfit for public display, especially in the classical structures of the federal capital. In conservative estimations, American Scene painting, not only pedestrian but vulgar, promised to ruin what slim chances the future held for art in America, a position summed by Paul Honore, a distraught member of the Society of Mural Painters, when he wired Bruce for mercy: FOR THE LOVE AND RESPECT OF WHAT ART WE HAVE SO FAR DEVELOPED IN THE UNITED STATES DO NOT CARRY THROUGH THIS PROPOSED PLAN . . . WHICH CAN BE NOTHING BUT A REPROACH

TO THE SANITY OF THIS GENERATION IN TIME TO COME STOP. . . ."[9] Bruce anticipated the criticism and prepared to defend his choice. "They are boiling mad because they haven't been consulted and because the government leaned towards modern art," he confided to his diary, "and lastly because the government may cut into their swill by allowing starving artists to do murals at $35 a week." The public heard a milder explanation designed to soothe fears over abandoned traditions and radical departures. "While of course [American Scene painting] shows the signs of a definite art tradition and an art background, it is free of isms and fads and so-called modern art influences," he wrote. "The word 'modern' in connection with art has been badly misused. It conveys to the minds of most people merely invention which has been substituted for art in so many centers." Meanwhile, Bruce loosed Watson to a populist counterattack, lampooning the "morning-coated horror" of conservatives whose narrowness of view, Watson intimated, rendered them superfluous. Many, he charged, "looked so continuously from their pedestals up to the skies that they did not see what [was] going on in the world."[10]

Yet neither Bruce's calm nor Watson's storm could mask the importance of their choice. Through PWAP, Bruce and Watson intended to rationalize the American art market, systematizing production, stimulating consumer interest, and establishing a national art style to depict American life. It is only fitting, then, that these modernizers sought such ends through a modern aesthetic. Sprung to the limelight in the exhibition season of 1930–31, American Scene painting had been adopted by the federal government, wealthiest patron in the land, where not even Bruce's diplomacy could hide its innovative character. It embraced modernist assumptions by confronting reality directly and elevating the vulgar and vernacular to worthy subjects of artistic exploration. American Scene painting was precisely that: a survey of the contemporary moment, paralleling the movement toward stylistic realism throughout all the arts during the 1930s. In this regard, the aesthetic echoed Gustave Courbet's assertion uttered a century earlier that "realism is democracy in art." American Scene painters offered an unblinking exploration of things as they existed shorn of genteel guise and disconnected from timeless allegory, producing results as varied as the democratic culture they explored. The approach was more than the sum of its parts, not only regionalism and social realism, or clean, streamlined canvases either underscoring such modern values as order and efficiency or exploring modernity's darker side. It was also found in more innovative experiments in abstraction, for example in works by Stuart Davis, and as such, considering its polychronic nature, catholic subjects, and varied styles, viewed collectively, American Scene painting represented a kind of visual jazz, highly eclectic, frequently borrowed, and routinely adapted across the country to time, place, and need. During the 1930s, American Scene paint-

ing became the national style, a means of artistic expression as protean as the country itself. Once dismissed as the misguided experiment of isolated painters, more recently popularized in film and advertising, modern art in America had reached the far side of the Milvian Bridge, though not, it turns out, without Indian Summer for the genius loci.[11]

2. "One Hell of a Job"

Ellsworth Woodward returned from Washington with barely enough time to unpack. Once PWAP became reality Woodward assumed responsibilities for Region Six, composed of three gulf states, Alabama, Mississippi, and Louisiana, plus a fourth, Arkansas. His career as artist and teacher and his location in New Orleans, a regional PWAP headquarters, made Woodward's selection the logical choice. His name, by then, personified art promotion across the South. In 1900 he cofounded the New Orleans Art Association and was currently its president. Twelve years later, when the Isaac Delgado Museum of Art was established in New Orleans, Woodward chaired the art committee. He became the museum's director in 1924, a position he still held, and in 1920 he cofounded the Southern States Art League, became its president in 1926, and was president still. His cooperation was vital for the Bruce plan to meet with any success in the region.[12]

Both Bruce and Woodward understood the difficulties they faced in the South. Region Six included some of the more barren stretches of the Sahara of the Bozart, an opinion Woodward never disputed. It was a problem, he explained, with deep historical roots. Woodward accepted the image of the Old South crafted by plantation idealists. Antebellum homes, he asserted, were self-contained agrarian arcadies, the very antithesis of the industrialized city. The isolated self-sufficiency of the plantation system forced aspiring southern artists out of the region for training and patronage. A modest art flourished, nonetheless, but it vanished during the Civil War, whose widespread destruction forced upon the South a hardscrabble existence more concerned with the rudiments of survival than the higher yearnings of the soul. Worse, the region staked its recovery on agriculture. Without the industrial catalyst, Woodward lamented, art would not flourish in the region, and the exodus of native-born talent would continue. Prevailing conditions seemed to bear him out. No prominent museums existed in the region, no centers of instruction. Only a handful of organizations cultivated art tastes. Southern artists were scattered along back country roads and rural villages. They worked in solitude, some with great talent, most with no training. Louisiana was a case in point.[13]

After fifty years of unceasing promotion Woodward could survey the art resources of his adopted state in a single paragraph. Three universities operat-

ed art departments (Newcomb, Tulane, and Louisiana State) but the program in Baton Rouge still had the dew on it. Two museums were located in New Orleans, the Isaac Delgado in City Park and the Louisiana State Museum in the Cabildo on Jackson Square. Only a sprinkling of organizations supplemented the work of Woodward's New Orleans Art Association. These included the Fine Arts Club formed in 1902 as a circle of "cultivated women" devoted to study through lecture and reading; the New Orleans Art League formed by a band of professional artists to boost sales; and the Arts and Crafts Club, established in 1921 with a showroom and a school in the Quarter, the only center of art training in the state outside of the colleges. Beyond New Orleans there were pine hills to the north and swamps to the west and precious little in between. One or two clubs promoted art in Shreveport. Every summer a small colony of painters assembled in Natchitoches. In the diplomatic estimation of Edward Bruce, Region Six represented a "somewhat uncultivated . . . but not barren land." His regional director took no exception. Instead the lukewarm appraisal of each man received formal administrative expression when Bruce set his PWAP budget. From Hopkins Bruce had received slightly more than one million dollars to foment his revolution in American art. To advance the cause on its exposed southern flank he dispatched less than twelve thousand dollars, roughly 5 percent of the appropriation awarded PWAP efforts in New York and a budget whose diminutive size was matched only in Atlanta and Dallas.[14]

There was much hope if little else. Woodward left Washington convinced that the project foretold tremendous benefits for the artist and the nation. He blamed much of the depression on a dangerous imbalance of values, or in his phrase, "materialism run amok." The people needed more than the immediate help of direct relief, he insisted; they required the sort of spiritual rejuvenation PWAP offered. He and Bruce envisioned the assimilation of the artist into society as an interpreter of national values and ideals. "There are dignity and hope and vast potentialities in this project," he insisted, "[and] . . . a breaking down of the barriers which have shut out too much genius from the community."[15]

Still, there would be no smooth transition from hope to action. By night letter of December 10, Bruce ordered his directors forward with time only for a hasty summary of the basic procedural details outlined at the Washington meeting. He encouraged Woodward and the others to complete preliminary arrangements sometime Monday so that hiring could begin by Tuesday. Employment quotas assigned on the basis of an informal census of regional art population authorized Woodward to hire fifty artists divided into two groups according to skill and need. They would receive $42.00 and $25.00 respectively per thirty-hour work week. Torn between the desire for immediate action and

the need for close adherence to administrative procedure, the letter reflected the urgency of the moment. Artists needed immediate help. The Hopkins fund was scheduled to expire in the middle of the coming February. Yet there was so little room for error. Project success depended upon the economical production of a satisfying commodity. Overlooking the smallest detail might ruin six months of hard work and dash the hopes of thousands of artists. Such conflicting impulses wrung from Bruce conflicting instructions, who urged his directors to refer even the smallest uncertainties to the central office while at the same time promising each broad discretionary power.[16]

Confusion was virtually assured as similar pressures overwhelmed the director of Region Six. Ellsworth Woodward, whose temperament abhorred rash action and headlong rushes, was reserved almost to a fault. When a local news item erroneously identified him as the architect of PWAP, he hurried off an immediate apology to Edward Bruce: "Incidentally, Mr. Woodward did not say that `he had plans underway for putting needy artists to work.' I trust I have more tact."[17] Though characteristic, such formality made for an especially timid bureaucrat. Woodward had a faith in the written word and a caution with language that made him anxious to cultivate a favorable press. Mistakes, oversights, or any incaution at so crucial a juncture might doom the whole project, so Woodward inched his way through Bruce's procedural maze. In what became the first round in a continuous ten-day cycle, he summarized his understanding of Bruce's instructions and forwarded a copy to Washington, requesting confirmation of his interpretation. In this fashion, over the next fortnight, the director received instructions, interpreted them, and appealed for further clarification. Communications were agonizingly slow. Intermittent silences only deepened Woodward's anxiety. Often, additional instructions merely compounded his confusion and renewed the cycle.[18]

Meanwhile, Woodward began his search for needy artists on Monday, December 11. He hired a stenographer out of his own pocket and moved into a small office on the Newcomb campus donated by the college. From there he mailed a "circular" based on his understanding of the Bruce letter to a hastily assembled list of seventy-five artists in his jurisdiction, most in Louisiana. Copies published in local presses to notify artists not on the list brought immediate results. During the first week Woodward hired a total of eighteen artists: four muralists, nine painters, two sculptors, and a pictorial draftsman. For a substantial portion of this group the trip to Woodward's office began a long association with the government art experiment. These included Louis Reynaud, a painter and future post office muralist, the sculptor Albert Reicke, and painters Jane Ninas and Clarence Millet, all of whom would work in Louisiana on the Federal Art Project sponsored by the WPA. Two future directors

of this organization were also among the group. One was the sculptor Angela Gregory, a Newcomb alumna and the first person Woodward hired. The other was a close colleague, the painter Gideon Stanton.[19]

The project was afoot but still very wobbly. Woodward continued to plead for direction with a renewed sense of urgency. Since the depression began, there had been widespread discussion of need among local artists. Now Woodward had the objects of all the talk before him. There in his office he sounded the true depths of the emergency, and what he saw appalled him. "I am already overwhelmed by the reality of need that is brought to my knowledge," he wrote to Edward Bruce. "Artists are desperate and driven beyond endurance. They chew the cud of hope deferred, sometimes without bread to chew with it." Waiting for Washington's instructions, Woodward received a parade of daily visitors anxious for some word he felt unable to give. Many were friends and acquaintances. Some were former students. There was so much need, such frustrated hope, so many eyes averted. Woodward's mood blackened. "The situation uncovered here is acute," he confessed, "and in some cases heartbreaking."[20]

Woodward's devotion to artistic standards only compounded his anxiety. His aesthetic values forbade shoddy workmanship, the inevitable yield of the undisciplined artist. But need transcended skill; it ignored training and existed in abundance throughout the art community, forcing Woodward to the cruelest choice. He could either subsidize poor art, or turn needy people into the street. Sensing the teacher's dilemma, Bruce issued strict instructions. "It is going to take a fine sense of discrimination [by us all] to select only those needy artists whose ability is worthy of their employment," he cautioned. "I think we all ought to remember that we are putting artists to work and not trying to make artists out of bums." Woodward grasped the point. "The problem is nicely poised between benevolence on the one hand and artistic ability on the other," he replied. Yet reconciling this difference, as Woodward learned, required any number of painful decisions, especially for a man so sensitive.[21]

Ellsworth Woodward never hardened himself to the desperate situation his artists faced, and because of that he consistently refused compensation for his services. Late in January 1934, a 20 percent employment cut across the Civil Works Agency (CWA) forced Woodward to trim his payroll. He started by firing two artists of negligible talent, ones retained, he insisted, only through acts of "pure benevolence." Nevertheless, it prompted the unburdening of a troubled conscience.

> If you were in my place you would at once realize the delicacy required. If a person claims to be a professional artist and asserts that he has been making

his living . . . from his art, on the face of it his claim is valid. If his work, however, shows him to be the veriest amateur and shows him moreover to have no right . . . to be on the public payroll, you are at once put into a very unpleasant position of deciding whether or not he may be admitted in spite of his obvious inabilities.[22]

This kind of uncertainty plagued Woodward to the end. "Nothing that I say to myself in support of my judgment is ever quite enough to give me a completely easy conscience," he lamented just six weeks before the project closed. "If you do not mind my saying so in plain terms, this has been one hell of a job."[23]

While Edward Bruce sympathized with the director's plight, he never relaxed his demand for quality artwork. Instead, he insisted that the future of the government art experiment depended upon the value of work produced by PWAP artists. The good of all, Bruce asserted, relied upon the skill of each. "I think [our] duty to the artists as a whole is higher than any duty we owe to the individual case," he explained, for "in the long run no kindness to any human being is shown by letting him think that he is an artist if you do not think he has the quality to succeed." It was a momentous issue, this question of standards, one debated in every quarter of the nation since it cut fundamentally to a changing conception of America itself.[24]

Bruce and Woodward focused their vision of the good society on the promise of quality artwork. Art, they agreed, represented a civilizing force in life, a means of social uplift. Good art made better citizens, they assumed, and the best citizens were those with the highest appreciation of art, a circumstance mirrored by the structure of American society. People of wealth, breeding, and education, each believed, were not by accident the staunchest allies of art. For this reason Woodward's most anxious moments were those contemplative walks through well-to-do neighborhoods unguided by aesthetic principle. He never degraded the laboring districts whose ramshackle appearance, like the chronic poverty of their inhabitants, represented to him an immutable circumstance of American life. In art as in society, Woodward believed, the poor shall always be with us, sentiments Edward Bruce echoed when advising directors on the proper composition of regional committees. "I think it is important for us to enlist in the movement as many people of culture and refinement and genuine interest in art as we can," he asserted, something certain to ensure the participation of "the right kind of people in each community." Woodward agreed. Two weeks later he notified Bruce that he had contacted fifteen "citizens of the first rank and influence" in his region.[25]

These were curious methods for self-proclaimed revolutionaries, and they produced glaring contradictions. PWAP officials hoped to instigate a na-

tionwide demand for art, a popular movement directed by the "best people in each community" dedicated to the highest artistic and social standards. Yet by eschewing relief for quality artwork, Bruce countered prevailing political currents. His seeming indifference to relief administration drew exasperated protests from Harry Hopkins, who once supported the program but was now convinced that PWAP violated the New Deal's reform spirit. Bruce's elitism also undermined the image of the artist as citizen, loosed among the people to record their ideals on canvas. The PWAP intended to make the artist a full participant in the democratic mass, yet somehow keep him aloof from it in accordance with traditional professional standards. Somehow, Bruce's artists were to touch common values without soiling their fingers and render them in a manner agreeable to critic and citizen alike. Most important, repeated defenses of art standards ignored the basic implication of converting art production to the wage scale. Hoping to revive slumping sales, PWAP yielded to the consumer the ultimate power to judge the quality of art. Artistic methods, regardless of perceived standard, would have to adjust accordingly. This had been Woodward's experience in the waning days of his academic career, as though the whole Newcomb experiment were a rehearsal for his PWAP service. But if his tenure as director of Region Six stirred any ironic memories of his years at the pottery, Woodward kept these to himself. Instead he continued to seek out needy artists and put them to work on a series of projects he had devised, ones soon affected by this great transformation in American art.

3. "The Dying Scenes of the South"

Despite the director's anxiety, his regional office took gradual shape. Woodward hired a chief clerk, John D. Britton, who, with an additional clerk, John Jacomest Jr., rounded out his office staff. These two men deciphered procedural codes and put the office on a business footing. Britton contacted Warren Kearney, collector of the Port of New Orleans and disbursing agent for Region Six, to arrange for the release of the first weekly checks. Their arrival, beamed Woodward, cheered his artists beyond description. Additional administrative bumps were smoothed when Woodward finally received the sort of close supervisory attention he had requested since returning from Washington. It came in the form of W. C. Cram, chief assistant to Treasury Undersecretary L. W. Robert, who arrived in New Orleans two days after Christmas. Cram made an extensive review of project operations, met with Kearney, and gave the artists a pep talk. He entertained questions, offered criticisms, and finally, pronounced the effort sound. Woodward, both delighted and relieved, wrote effusive thanks to Bruce, who responded in kind. "Mr. Cram brings back from New Orleans a glowing account of the splendid work you are doing for the

artists, and the unique position as guide, philosopher, and friend you occupy there," he replied. "My only fear is that in your affection for them and enthusiasm for the movement you are going to worry yourself sick."[26]

While the compliments conveyed faith in a regional director desperate for support, Bruce's letter also attempted to reconcile fundamental differences between them. These were issues germane not only to the art world but society at large, and the first among them focused on the meaning of the word "region." For Ellsworth Woodward, "region" represented the heart of the genius loci, a guiding inspiration of artistic expression. The regions, he insisted, were self-contained. They possessed unique characteristics and lived under differing circumstances. Each posed problems no national policy could address without imposing artificial standards, an argument Bruce consistently deflected. Bruce considered regionalism not as a bedrock aesthetic faith but a management principle, a method of controlling the manufacture and distribution of a product for national consumption. Satisfying a national demand meant overcoming the very regional barriers Woodward sought to reinforce—diverging viewpoints evident in their very first discussion. At the organizational meeting the previous December, Woodward asked Bruce if it were possible to use portions of the Hopkins fund to purchase works of art already created by a seventy-five-year-old "genius" working in his region. "No," Bruce said, "but you can set that genius to work next week to paint another." "And can I use my artists to depict the dying scenes of the Old South, the Negro shanties, the wooden plows, the stills?" Woodward inquired. "Yes," Bruce replied, "but remember the eighteenth amendment is repealed. It's a new deal in art and liquor." So characteristic of each man, the exchange contained the seeds of future misunderstanding.[27]

Over the next ten days Edward Bruce and Ellsworth Woodward opened questions never resolved during the ensuing ten-year collaboration between art and government. The issue, ostensibly, concerned the way Woodward intended to use his artists. But the stakes, ultimately, involved contrasting perceptions of society, something large enough for Woodward to lose all of his bureaucratic timidity. The circular announcing the project contained a review of the subject matter he intended his artists to treat, one of five separate proposals including murals; paintings recording such local industries as cotton, lumber, rice, and sugar; portraits either painted or sculpted depicting "personages deserving of historic remembrance, who by public act or scholarship deserve a place in public galleries"; architectural studies in various media of historic streets and buildings in New Orleans; and, finally, "eulogistic" memorials honoring signal events in the regional past. Additional projects soon broadened the original series. Just after he opened his project, a delegation of local museum directors and librarians, all representing institutions whose

archival collections included maps decaying rapidly, convinced Woodward to hire an artist to copy disintegrating originals. He forwarded the ideas to Washington, seeking approval for these proposals and two others, each of personal concern. The first suggested a revival of Newcomb Pottery, centerpiece of Woodward's academic career. The other concerned the Delgado Museum of Art when a current *Museum News* article urging the PWAP to use funds for art museum preservation struck a responsive chord. The Delgado badly needed an internal facelift, and certainly, Woodward wrote Forbes Watson, it must be possible to hire two women to clean oil paintings and to rearrange museum displays fallen into disrepair.[28]

Woodward defended his proposals for their ability to reconcile national directive and local circumstance. He endorsed American Scene painting, despite reservations reflecting his academic conservatism. "I am all for the American Scene," he explained, "but refuse to believe . . . that bad drawing and slatternly technique lend the Scene any charm." The projects were also mindful of the talents and limitations of Woodward's artists. His proposals embraced the widest possible variety of local talents, he reasoned, everyone from craftsmen to painters, reconciling his own aesthetic values with the urgency of the moment. Yet because so many of his artists came from the classrooms of the Arts and Crafts Club whose variety of scholarships had drawn from the hinterland the aspiring but mostly untutored, their work in Woodward's judgment showed "a great deal of erratic talent" but little artistic discipline. Here, he thought, the need for training and the emphasis on the American Scene fit nicely. Representational projects offered valuable lessons in design and composition in addition to the material benefits of a weekly paycheck. The portraiture project held similar advantages. Portrait painters constituted a disproportionate number of the local art population, one decimated by the economic collapse. Employing the painters in their accustomed manner, Woodward reasoned, would not only obtain worthy objects of educational value but prevent further deterioration of artistic skills.[29]

Yet the Woodward plan contemplated more than relief and professional training. These projects were not unrelated ideas thrown together. Instead, as tiles in a mosaic, they fit Woodward's artistic values and social beliefs. His intention to record "the dying scenes of the South" was no remark made off the cuff. He could see the transition in the fading agricultural traditions of the rural parishes and in the Vieux Carre, where the architectural heritage of three centuries stood crumbling. Thus, he arrayed his artists in strategic positions to record the moment and salvage for the future the best of a vanishing past. Yet, what stirred Woodward's artistic soul also offended his patrician spirit. During the heyday of the Newcomb Pottery he had worked in vain to establish standards of public taste. Now, under PWAP auspices came a second

chance, perhaps the last a man already in his seventies might expect. Utilizing the Scene may have been a concession. Still, by stuffing the public buildings with "glimpses of divine beauty," by preserving the Great Deeds in silver and the Great Men in oil, by recording the fine architecture of the past, Woodward sought to shore up a social world he saw passing from the scene. Studies of regional industry destined to hang in public school classrooms would not only record the rising mechanization of southern life but preserve glimpses of its agrarian heritage. Art would still instruct as it also uplifted. Portrait subjects, men whose public acts earned honorable places in the public memory, would exemplify lessons in civic virtue Woodward saw threatened not only in the art community but in society at large. From his perspective, radical experiments in modern art threatened to destroy essential traditions, in this case the training and discipline he had championed over the course of a lifetime. Beyond the classroom and the museum, the same issue remained—a point made nowhere more clearly than in Woodward's own Louisiana, where seventy miles north of his office in New Orleans, in the epicenter of the most profound social earthquake in state history, Huey Long was busy knocking from pedestals of power and privilege the very busts Woodward proposed to create.

Because whirling events made time crucial, Woodward rushed his artists to their assignments. The day he hired Louis Reynaud, Woodward handed the painter bus fare and sent him into the central parishes to record scenes of the sugar industry. He dispatched another artist to Honduras to observe banana production from harvest to market on the wharves of New Orleans. An etcher commenced work on historical markers. By special arrangement six students of the Arts and Crafts Club began a cooperative mural design under the direction of club president, Charles Bien. In her studio Angela Gregory modeled a bust of John McDonough, nineteenth-century patron of New Orleans public education. A second sculptor, Albert Reicke, shaped the goateed features of Creole historian, Charles Gayarré, while Woodward sent other artists into the streets. Jack Edwards recorded scenes along the riverfront. Alberta Kinsey positioned her easel on Decatur Street to study the Old French Market, already doomed to the wrecker's ball. At least five other artists depicted the Cabildo from various angles in differing media.[30]

Yet almost immediately, to Woodward's lasting chagrin, his mosaic began to crumble. As early as December 16, Edward Bruce advised him to suspend the portraiture project. Woodward could scarcely contain his dismay. He had already hired four portraitists, nearly a third of his present contingent, and the loss, he insisted, would be grievous. "I implore you to give the regional directors liberal freedom in the choice of subjects and assignments," he protested to Bruce. Three days of silence deepened the anxiety and prompted renewed appeals for regional authority. "I cannot myself see anything but discrimina-

tion in accepting two or three lines of artistic endeavor and excluding half a dozen others," he complained. "I hope I may secure this liberty for all regional directors. . . . If you think about it you will perceive that there is no one else upon whom you can depend with so much assurance in your whole organization relating to this project." Later, in a note to Forbes Watson, Woodward left no room for misinterpretation:

> Certain categories of work had been discussed and generally agreed upon among them portraiture. . . . I accordingly set to work some five or six artists working in this field. I then received word by wire that I had better not include portraiture. I am sorry for this, but will, of course, be guided by your decision. Nevertheless it leaves a very great hiatus which can be filled only by portrait painters who need employment and whose services could be used and legitimately be paid for. I am anxious, of course, that this ruling should not be made retroactive; indeed if it should be made retroactive, I should find myself in so embarrassing a position that I could not willingly go on.[31]

By threatening to resign, Woodward won back the portraitists but little else. The recommendation to suspend portraiture, explained Watson, rested on the suspicion that it might accumulate "a good many lemons," but if Woodward could assure the quality of the work then the artists could stay. Ed Rowan admonished Woodward further to have his painters depict a broader range of social subjects, not just great and near great public officials, but all types of native characters—advice flatly ignored. It was Woodward's one success and small compensation given what followed. Ultimately, the Washington office rejected each of Woodward's proposals beyond his original five. Some were denied by pleading fiscal stringency, but one rebuff must have galled especially. In a letter dashing hope for a Newcomb revival, Rowan warned that the production of cheap "gift shop" wares would not be tolerated.[32]

During their brief association, Edward Bruce and Ellsworth Woodward never bridged the regional gulf. Though each professed common goals, among them the elevation of American art tastes and the restoration of the artist to a position of public stewardship, they never harmonized conflicting means. This was true not only choosing artistic projects but also in discussing the regional director's organizational role. Woodward preferred to ride the circuit and said so at a meeting of regional directors held in February 1934. There he asked Bruce to appointment a regional vice-chairman to oversee technical and administrative details while Woodward visited the remote corners of his district. He could offer advice and criticism to artists working in the severest isolation, he explained, poor substitutes for formal training, but under the circumstances his only recourse. Because it compromised his management style, of course, Bruce politely refused. To him, Woodward's rightful place was

in New Orleans, where he could reach any point in his region through the arm of the regional committee system. This was a quiet disagreement between two gentlemen without acrimony or recrimination. Each had warm words for the other in an amicable correspondence continued after PWAP ceased to function. Yet the impasse remained throughout the period, a major theme of American concern, echoed here in minor key when Bruce and Woodward debated the best means of distributing the artistic fruits of PWAP labors.[33]

The topic hung fire all spring and climaxed toward the close of the project in April 1934. "You know allocating these pictures is going to be a major problem," Woodward cautioned Bruce. Already, he reported, the regional office had received numerous inquiries from eligible recipients including one from the Allen Parish School District requesting 113 paintings—more than the total produced by Woodward's artists. "I suppose you will want to send them at least one," quipped Bruce. Still no easy solution surfaced, though Woodward offered a characteristic suggestion. Since local artists were engaged rendering local scenes, he reasoned, it seemed only natural to allocate these works to regional institutions, so he proposed a lottery to divide the spoils. Eligible recipients in each state would compete for the work of its native artists. Certainly the plan had merit, conforming to earlier project intentions by ensuring the artwork's broad distribution. It also represented, as Woodward insisted, the most democratic method available. But Edward Bruce had other ideas. By then he had begun his long struggle to create a permanent institutional bond between art and government and could not resist the promotional value of PWAP paintings. Rather than disperse these among the regions, Bruce now proposed to collect the very best in Washington for a major showing whose pieces he then intended to distribute among influential congressmen. Bruce announced his intentions precisely as Woodward busied himself arranging a local exhibition designed to curry favor among local art interests. He needed as much of his own region's work as he could obtain, Woodward explained, pleading to keep local in art in local hands. Two weeks later, all appeals denied, a crestfallen Woodward shipped off more than forty of his best works. "I want to tell you it takes some loyalty not to withhold my best pictures with which I hoped to impress our home people," he lamented. Most never returned.[34]

4. Voyage of the *Torrent*

The Public Works of Art Project closed at the end of April 1934, amidst the sort of hectic activity that marked its beginning. Arrangements made through the state Emergency Relief Administration offices provided temporary sponsorship for unfinished projects nearing completion. Another program, de-

vised the previous January, provided for transfer of selected PWAP artists to Civilian Conservation Corps (CCC) camps. These artists, all men, were chosen on the basis of outdoor experience and general hardiness and dispatched to record scenes of camp life. Jack Kelly finished his series of riverfront oils, packed his easel, and headed for a post at Camp S.P.2 in Creston, Louisiana, near Natchitoches. His colleague, Louis Reynaud, quit the sugar parishes for a CCC camp in Mississippi. Other efforts focused on closing down the administrative headquarters of each region, discharging the artists, compiling reports of completed works, and overseeing the allocation of artwork.[35]

Meanwhile, national project officials trumpeted PWAP's accomplishments. Forbes Watson believed that the experiment had fundamentally transformed the social role of the American artist. He pointed with others to the critical and popular success of a PWAP showing at the Corcoran Gallery in Washington, to the number and variety of artists employed by the project, and to their prolific output. Nearly 2,500 artists, he boasted, created over 15,000 works of art in little better than four and one half months. These included virtually all the media: bas reliefs, carvings, drawings, etchings, lithographs, murals, portraits, pastels, prints, sculpture, sketches, watercolors, and wood blocks, scores of each and all for less than $1.5 million. By sheer dint of volume, announced one PWAP bulletin, the American artist had made his voice heard as never before in the democratic community. "In other words," concluded L. W. Robert, "our figures show that the Government's agreement to employ artists at craftsmen's wages acted as a tremendous stimulant to the artists' creative powers."[36]

Woodward's artists shared the enthusiasm. He had hired a total of 109 of them, some thankful for personal relief, others more philosophical if less restrained. While Catherine Howell, a painter, credited her success to two men, her brother who had supported her and her two children since the depression's early days and "the gentleman in the White House," Gideon Stanton sounded grander notes. "Expeditions succeed each other to explore into the ruins of past civilizations and to excavate for works of art of remote ages," he intoned, "but these are as nothing as to have one's own Government reach out to the corners of this country to set in motion an art movement that the Old World, with its centuries of culture, including Italy and her Renaissance, might be proud of."[37] Somewhere between the extremes consensus emerged among Woodward's artists, who expressed gratitude for both a living wage and the opportunity to work in their chosen craft. Most believed Bruce's revolutionary rhetoric, seeing themselves as participants in a national movement whose solidarity many expressed through martial imagery. "I do feel a genuine thrill in being one of the army of 2500 American artists planting the seeds for the

cultural expression of my nation," wrote Angela Gregory. "Now we have an army of . . . enthusiastic, patriotic, trained men and women expressing what they yearned to do," added Gardner Reed, as if to finish Gregory's thought.[38]

Surely much was done with little at hand, though no revolution occurred in Region Six. Mobile, Birmingham, Montgomery, Shreveport, and Jackson, even H. L Mencken's former whipping post, Dothan, Alabama—all had artists working in their area among people glad to have them. When Joe Greenburg painted a mural on the wall of city hall in Bogalusa, Louisiana, onlookers clustered so thickly around his scaffold and raised so many questions that he offered free evening art lessons in exchange for the quiet needed to finish his work. Beyond this, exhibitions were held in cities across the region, including two large showings in New Orleans. On the whole, the work had been well received, though neither the ends sought nor the means adopted had brought Ellsworth Woodward any nearer the fulfillment of lifelong dreams. Woodward's efforts to curry favor with the local press all failed, and while no great publicity scandals rocked his region as they did others, his artists labored in a silence he found equally disconcerting. Nor had the allocation of PWAP art suited Woodward's beliefs. Local institutions did not become repositories of local scenes executed by native artists. Most of his best work went to Washington where it stayed. Pieces not selected by the various congressional delegations were used to decorate the offices of proliferating New Deal agencies, and after that only thin pickings remained. Woodward forwarded twelve paintings to the Brooklyn Navy Yard to decorate the destroyer *New Orleans*. He dispatched others to colleges and universities within his region and to several state offices; but he never realized the ambition of spreading artwork on an unprecedented scale across the Gulf South.[39]

Woodward's local disappointments were compounded by trends confirmed by the national organization. Since 1934, observers have stressed two vital themes concerning PWAP: its importance and its caution. Despite its diminutive size and brief duration, because it came first, PWAP defined the issues and set the precedents of subsequent experiments in federal art patronage. Indeed, conversations on the subject have strayed very little from the course people such as Edward Bruce and Ellsworth Woodward first set them on more than seventy years ago. Because of their influence, the second theme is linked to the first. Woodward and Bruce, each conservative thinkers, worked for what might be regarded as a model of early New Deal hesitation. What began when George Biddle, FDR's Groton classmate, gained the president's ear, ended amidst fears of an unbalanced budget. In the meantime, though they haggled over the details, Bruce and Woodward still agreed on the general course. They would use PWAP to defend a vision of "culture" used to justify the hierarchical social relationships of industrial America. In this sense, each

hoped to make their version of culture popular in ways calculated to resist the values and social relationships expressed and envisioned by modern popular culture. In short, the two attempted to achieve for art what other reformers did for the national financial system, efforts greeted with the same criticisms. Conservatives decried flouted traditions. Liberals derided any attempt to save the system at all. And if other New Dealers soon confronted the unintended consequences of their actions, so, too, did Woodward and Bruce.[40]

These two defenders of traditional artistic craftsmanship nonetheless oversaw the industrialization of American art, helping to sow changes they intended to prevent. For all its caution, PWAP marked not only the first large-scale patronage of art by government in the life of the republic but the adoption of a modern art style intended for mass consumption—all new departures in the way American art was created and disseminated. PWAP artists were drawn from a ready labor market and worked set hours for fixed wages. A central office procured raw materials, set minimum standards of production, enforced working regulations, directed publicity, and oversaw distribution of a product designed for maximum popular appeal. It even provided for destruction of inferior products, those inevitable mistakes made on the assembly line. When the project closed, PWAP officials defended the experiment through the traditional industrial fashion. They loosed a barrage of statistics hoping to prove that the finished item justified the cost of production, a tactic, in the assumption of one observer, designed to underscore the economical production of "art by the yard." Along with other emergency relief measures, the administration of PWAP posed a formidable challenge to traditional balances of political power. Just as the New Deal administered its variety of relief agencies through a complex web of federal-state political relations, PWAP gathered dozens of local art movements into the first national art community dedicated to the depiction of a national art form. In art as in politics these were steps taken tentatively, for the tradition of localism ran deeply through both. Indeed, so strong was the appeal of locality, as a political faith and aesthetic assumption, that the New Deal in general and the PWAP in particular took great pains to pay it lip service. Nevertheless, centralization characterized both, with consequences Ellsworth Woodward rued.[41]

Art's new methods and America's new directions forced Woodward, one last time, to defend old grounds and confront old fears. Mass production, he had always warned, cheapened art's effects, weakening its regenerative strengths. Yet here were PWAP's national managers, justifying their existence through cost-benefit analyses and claims to efficient mass production. Similarly, artists all over the country now painted "the American Scene," manipulating common themes and subjects from coast to coast—a trend emphasizing how attenuated the logic of the genius loci had become. Worst of all,

perhaps, evidence confirming Woodward's fear was not confined to debates with his Washington supervisors. Some of it came from his own backyard.

In Region Six, Woodward's struggle to document the passing of what he hoped to preserve surfaces most visibly in the contrast between paintings done by two of his artists, J. Kelly Fitzpatrick and Josephine Crawford. Fitzpatrick, an Alabamian, earned the director's praise when he recorded several rural scenes, all oils, in a romanticized impressionist style reminiscent of Woodward's own. Two works especially (figs. 2.1 and 2.2) harmonize vernacular architecture and natural setting, matching plain boards and tall pines. A third canvas (fig. 2.3) depicts a local sawmill in tones reminiscent of earlier American attempts to discover and depict a "middle landscape."[42] Precisely what Woodward described as "the dying scenes of the South," Fitzpatrick's oils contrast sharply with work done by Josephine Crawford, a young New Orleans painter. Crawford did a good deal of work in and around the city, painting such landmarks as the monument on the Chalmette battlefield and the old Spanish Arsenal, but she also did an industrial series (figs. 2.4–2.6) including views of the American Sugar Refinery, a cement plant, and an oil refinery in nearby Norco, Louisiana. Her plain, almost severe style won the attention and acclaim of local art critics. Kenneth Knoblock of the *Item*, noting the pale, almost colorless shades of the works, ranked her studies among the finest in the first of Woodward's two major PWAP showings.[43] Unmistakably modern, the style accentuated the linear emphasis and blocklike appearance of the factories, segmenting conflicting spaces Fitzpatrick had worked to harmonize. No rich brushstrokes nor warm tints inform her art, no romantic feel for the region's agrarian past. Instead, tone, style, and content all suggest a clear break with the painterly techniques taught by Woodward and practiced by Fitzpatrick. This was modern art produced in modernized fashion, something Crawford herself clearly grasped. Among her industrial series she included a painting she entitled *Old and New Skyline of New Orleans*—the first of many such artistic renderings of thirties New Orleans (fig. 2.7) In the foreground she depicted two powerful symbols of the past, the facades of the French Quarter and a tugboat, so vital to river commerce. Behind these, in contrasting tones, rise columnar storage tanks, an industrial landscape dominating the foreground. Light informs this canvas, underscoring the tension between looming future and fading past. Yet, Crawford's painting reflects a great deal more. It represents a transitional moment in art and society, not only in her native city but across a nation struggling to reconcile traditional values with contemporary circumstances, a turbulent watershed conveyed succinctly by the name she chose for her tug: *Torrent*.[44]

Six months as a PWAP regional director did little to resolve and much to deepen Ellsworth Woodward's concerns about art and society in Ameri-

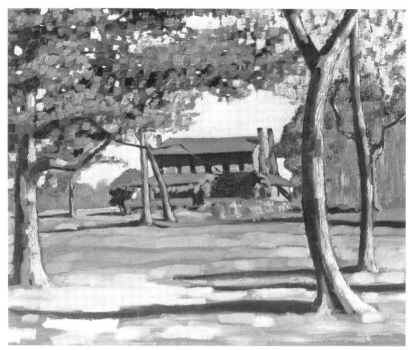

2.1. Untitled by J. Kelly Fitzpatrick, n.d. Oil. (National Archives)

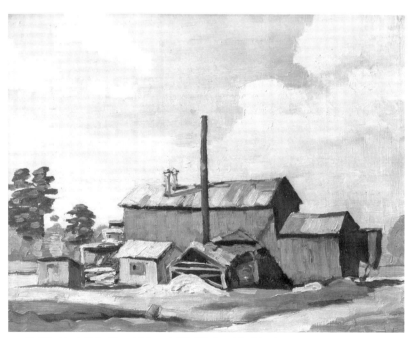

2.2. Untitled by J. Kelly Fitzpatrick, n.d. Oil. (National Archives)

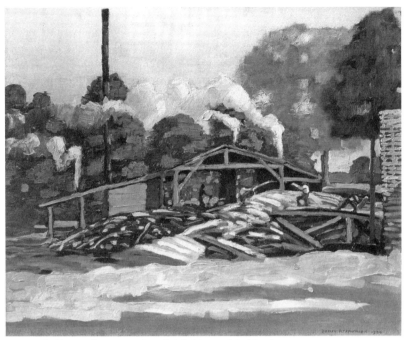

2.3. Untitled by J. Kelly Fitzpatrick, n.d. Oil. (National Archives)

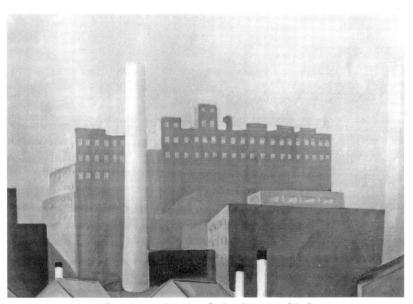

2.4. *American Sugar Refinery* by Josephine Crawford, n.d. (National Archives)

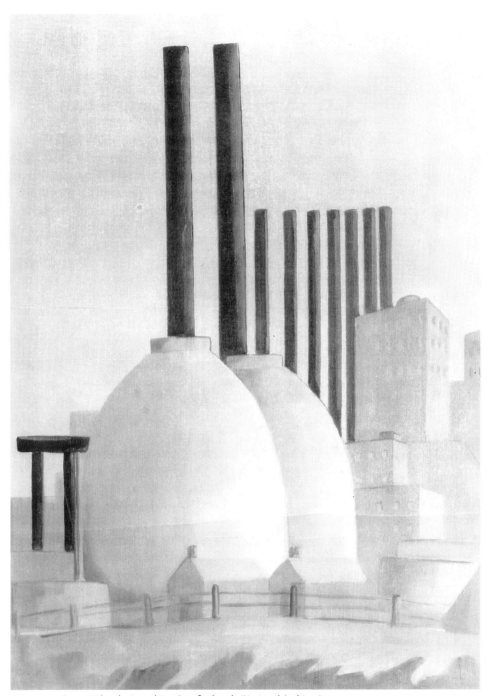

2.5. *Cement Plant* by Josephine Crawford, n.d. (National Archives)

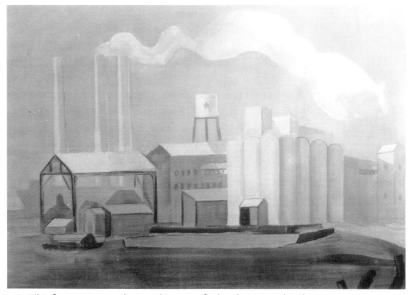

2.6. *Oil Refinery, Norco, La.* by Josephine Crawford, n.d. (National Archives)

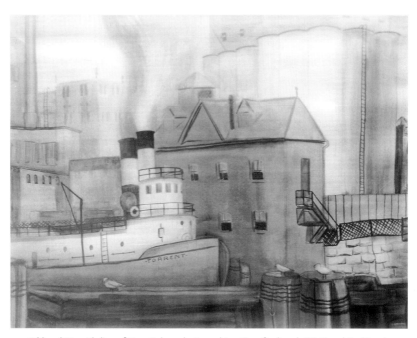

2.7. *Old and New Skyline of New Orleans* by Josephine Crawford, n.d. (National Archives)

ca. If Woodward had become the unwitting manager of an art factory while directing the Newcomb Pottery, his stint as regional director placed him in the vanguard of a movement to modernize American art—no small irony for several reasons. He only haltingly endorsed PWAP's stylistic orthodoxy, hardly surprising given his aesthetic convictions. American Scene painting was unquestionably modern in both appearance and assumption, a contemporary record often focused on subjects Woodward disdained. In other ways, too, the style violated the canons of the genius loci. While American Scene painters rendered specific locales, they never did so in the manner Woodward taught or for the same reasons. This was not a local but a national movement, a visual portrait of America as it appeared at a given movement. As such the style was as elastic as the society it studied, and as dynamic. Woodward had envisioned an art of permanence, simplicity, and dignity, "walls pictured with mystic allegory" designed to lead the mind away from all things sordid and common—the very thing so many American Scene artists were rendering. By focusing on a constructed American landscape, as opposed to pristine nature, and by dwelling on its flaws rather than innate beauty, American Scene painting implicitly acknowledged Woodward's failure at Newcomb Pottery. Clearly, given the disordered state of some American scenes, nature had done very little to reform the American landscape. Additionally, the new style revealed the complexity of modern America and not its simplicity, its myriad facets not always harmonious, its accomplishments and its shortcomings, often as not by depicting the very sordid and common things Woodward believed art should divert American attention from.

How the PWAP created American Scene canvases was equally distressing. Edward Bruce's experiment in federal art patronage not only provided official sanction for a modern style, it modernized its production. Between December 1933 and April 1934, federal managers industrialized American art. They provided raw materials to artists placed on the wage scale in an attempt to rationalize a national art market by regulating production and stimulating consumption. In this regard, the American Scene painting was their product, whose manufacture, distribution, and marketing, as Woodward repeatedly experienced, remained firmly under their control. Bruce might have promised wide latitudes of local autonomy, but in practice the national PWAP office generally viewed regional concerns as provincial impediments to national goals. Such contrasting viewpoints informed Woodward's entire tenure as a PWAP regional director. Ultimately, Washington officials determined who Woodward would hire, and on what kinds of projects they would work. Bruce and Woodward may have shared a common viewpoint on the necessity of hiring artists based on skill and not need, but it was Washington and not New Orleans that determined the ultimate fate of work those artists accomplished.

To Ellsworth Woodward, more than mere public relations demanded that local works by local artists decorate the walls of local institutions. This was his guiding aesthetic philosophy for the previous half-century. But by the spring of 1934, Edward Bruce had other plans.

While Woodward often found himself at loggerheads with national supervisors, it was not the only tension revealed by his PWAP experience. Perhaps the decisive challenge to the genius loci came not from Washington directives but rather the work of his own artists. The "dying scenes of the South," as Woodward phrased them, had an intellectual as well as a physical dimension. They were about more than just soil erosion or agricultural consolidation or urban growth. In an artistic sense, too, new landscapes were displacing older ones, a trend visible in the contrasting styles and subject matter of such artists as J. Kelly Fitzpatrick and Josephine Crawford. If Fitzpatrick's work harkened to Woodward's classroom, Crawford's art was clearly inspired by an evolving city with its segmented spaces and dynamic pace. These were not glimpses of divine beauty, nor loving paeans to Nature serving reform agendas. Neither were they local studies governed by the guidelines of the genius loci. Instead, they turn an unblinking eye on the "American scene," producing landscapes interested not in classical allegory but contemporary life, not social order through aesthetic uplift but all of modernity's conflicts and cross-purposes. Nature, the fount of beauty, Woodward always insisted, would lead artists to Truth, assertions about which modernist artists no longer cared. Their "American Scene" was not the one God had made but rather what Americans had done with it since. In this regard, Crawford was just the beginning of a sustained reinterpretation of the landscape made by American artists during the 1930s.

CHAPTER THREE

The Writing on the Wall

1. *Cotton Time*

Up in Bienville Parish, through piney hills rolling toward the Ozarks, the road winds down a sweeping curve, rises abruptly, and enters Arcadia, Louisiana. Main Street parallels an abandoned railroad track and runs along eighty yards of brick-faced storefronts. The usual concerns flourish: a flower shop, an insurance agency, the pharmacy, and a second-hand furniture store. There is also a Baptist revival hall, but people point it out for another reason. Years before it was a house of the Lord the building was a home for the dead, a funeral parlor, and as such, briefly, the focal point of national attention. That was in 1934 when, shortly after he sprang his trap along the parish line, the sheriff fetched the corpses of Bonnie Parker and Clyde Barrow back to town and leaned them on slabs in the undertaker's window. Tellers of the tale usually smile at the irony, but it is not the only one Arcadians can claim. Across the street and down the block from the morgue cum revival hall stands a United States post office built during the Great Depression. It conforms to the standard floor plan then in vogue, and at one end of the main hall, over the postmaster's door, hangs a mural whose warm pastels convey a soothing subject. The painting depicts an abundant cotton harvest. Black pickers dot the field, sacks filled to bursting. A white driver crests a hill in a wagon brimming over with the yield and descends a road leading toward the mill. Surrounding hills stretch to the horizon (fig. 3.1).

There are people who have lived for a number of years in town but who cannot recall the mural's existence. Others with sharper eyes or clearer memories notice its flawed details. The cotton plants are too small and too green. The pickers' sacks are too short and their movements too relaxed. Picking cotton, these critics assert, is a good deal more strenuous in person than what appears in paint. Still, few who view the mural grasp either its purpose or meaning, and failing this they miss the point of the town's other historical

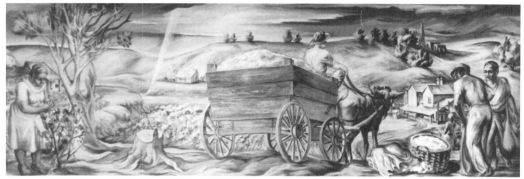

3.1. Completed mural, *Cotton Time* by Allison B. Curry. Arcadia, La., 1942. (National Archives)

irony. The painter's composition reflects the southern society it depicts, a predominantly agricultural world dominated by whites. Blacks who form a statistical majority on the canvas nevertheless occupy an inferior social position. They harvest a crop marketed by the white boss, who presumably will retain the principal share of the profits. But *Cotton Time*, the Arcadia mural, also charts a path toward an idealized vision of the region's future, one bursting with a promise conveyed by the crucial position of the driver. He is the focal point of the work and the key to its interpretation. Symbolic of his own racial superiority, he dominates the pickers, whose placement on the canvas reinforces their marginal position in southern society. The anticipated movement of the wagon suggests the southern future. It and its driver descend out of the agricultural past, sweep sharply downhill and across the entire plane of the canvas along a road disappearing off to the left. A ridgeline parallels the movement, drawing the viewer's eye back across the composition to a second focal point, the oil well located at the distant upper right. Here looms a powerful symbol of industrial might poised on the southern horizon. It reaches for the heavens, dominating the mill below and rivets the driver's gaze, this iron-latticed answer of twentieth-century Americans to the mulberry trees their forbears thrust into mudflats along James River. The road may wind, but the path is clear, and the journey seems easy—as though the process of southern industrialization involved no more than a lazy ride down a country lane leading to easy wealth. Arcadia, it turns out, is home to an arcadian mural.[1]

Cotton Time reflects its historical moment with uncanny accuracy, depicting a corner of Louisiana emerging from the cotton patch and moving toward the oil field with little regard for the journey's consequences. The movement seems so easy, and the landscape so self-contained. Who in the driver's position would be less self-assured? Yet there are hints, in the mural's composition and the story of its creation, of looming transformation. The oil well, it turns

out, key to the artist's design, was no accident. It appeared at the suggestion of Section technical director Edward Rowan, who thought the artist's original composition too stark. "The general scene that you are depicting seems rather dismal," he wrote, "and it might be well for you to give further thought to the landscape in the hope that you will be able to introduce some piece of architecture that has a note of reassurance. Could this not be accomplished on one of the far hills?" It was, and in this fashion, the artist's small addition reflects a major theme of the period. More than art administrators were giving "further thought to the landscape" of thirties America, and before it was over, virtually every detail of the Arcadia mural had been either altered or abolished, especially the social relationships it depicts.

2. "Painting Section"

The story of how art came to a post office in Arcadia, Louisiana, during the 1930s is as compelling as it is complex. Depression mural painting, perhaps the best remembered of all New Deal art forms, is certainly among the least understood. There has been a tendency to associate murals and the thirties with an inseparable closeness, making the terms "depression" and "mural" virtually synonymous, as though the form did not exist either before or after the presidency of Franklin Delano Roosevelt. Confusion also surrounds the New Deal agencies responsible for creating these murals. Since murals were painted under government sponsorship, it is widely thought these must have been commissioned by the WPA, an assumption only partially correct. The Federal Art Project(FAP), an administrative division within the WPA, painted any number of murals nationwide; yet, at one time or another, so did each of the other three New Deal art agencies, especially the Treasury Section of Painting and Sculpture. Later named the Section of Fine Arts and commonly dubbed "The Section," this organization decorated federal buildings raised or renovated, usually post offices and courthouses, with two principal media: sculpture and mural paintings. The Section commissioned works according to its own aesthetic principles and organizational desires, ones quite distinct from the FAP, and commissioned them on a scale large enough to make it and not the WPA the major sponsor of the American mural movement of the 1930s.[2]

The Section was the longest of the New Deal art experiments and Edward Bruce's second stab at federal art administration. PWAP's failure to instigate the sort of revolution in American life Bruce envisioned did nothing to dampen his determination. Instead, he spent a restful summer painting in Vermont, then returned in the fall of 1934 to a new organization whose name had changed but whose goals had not. American society, Bruce still

believed, had arrived at the proper moment of its historical development to commence a fundamental reorganization of its cultural priorities. Heretofore, he explained, American efforts had been consumed by continental expansion and economic growth. Material abundance had followed, but only at the cost of spiritual development. Now that the frontier had closed and with it the "era of easy money," Americans could as a people redress the disparity. Art, like capital, was something unevenly distributed, he asserted, and both inequities demanded adjustment.[3]

Together with his technical advisor, Edward Rowan, Bruce hoped to correct the imbalance by directing American energies toward a new aesthetic frontier. Unlike its predecessor, this effort would not strip the land of hidden riches with no regard to their distribution but tap a virgin reservoir of cultural desire. "Every human being has latent in him the wish to be a writer or painter or musician or a craftsman," Bruce insisted. "I believe that there is innate in the soul of man at all times the wish and longing and the ability to develop the richness of spirit, the beauty of life. Here we have a vast field of new wealth in terms of a true standard of living, in terms of well-being and contentment."[4] He also had people waiting in the wings talented enough to satisfy those desires, artists who would not simply paint pretty pictures or write good stories but provide the cultural foundation of a great civilization. They only lacked patronage. Previously, explained Bruce, American art had been subsidized by its wealthier citizens, people worthy of adulation for their efforts, "their voluntary share the wealth movement," yet people upon whom the nation could no longer rely. Many had lost their fortunes in the depression, others had economized at the expense of art patronage, and all were now participants in a not-so-voluntary share-the-wealth movement otherwise known as the federal income tax and inheritance program. By default then, Bruce reasoned, having appropriated to itself the nation's discretionary income, the federal government had also inherited the responsibility of sustaining the national arts and letters. Recently, it had begun to discharge this duty through establishment of the PWAP, whose most significant achievement in the estimation of its former director was the demonstration of a national thirst for beauty.

Section administrators proposed to slake that thirst by bringing art to places where it was not normally found. Through a series of regional design competitions, they hoped to match local villages with local talents who would render scenes of local interest. Ideally, competition winners would visit the community they had been selected to serve, become familiar with the townspeople, and solicit from them ideas of how they wished to be rendered in paint or sculpture. Once collected, the ideas would be worked into preliminary designs and sent to Washington for Section scrutiny. Thereafter, in routine steps tied to standard reimbursements, artist and supervisor would collaborate to

produce a finished mural, either installed or painted directly on the wall of the recipient community by an artist working in public view. Actual experiences would differ according to local conditions, of course, but in any event there would occur a moment Edward Bruce must have often dreamt about. Once the paint dried, or once the mural had been installed, it would be unveiled to the public when, for at least an instant—Bruce hoped a good deal longer—a piece of artwork, something of beauty crafted according to centuries-old traditions and dispensed by a benevolent patron, the federal government, would become the central focus of communal life. In this sense, at least to Bruce, post office lobbies decorated by his Section became something more than federal buildings in local villages. Rather, each by the physical arrangement of its space became a reflection of the proper ordering of American society. The lobbies, he might have argued, typified the principle of political federalism just as the decoration fulfilled the government's obligation to patronize the arts. The location of murals, distributed as they were across the hinterland in a campaign of cultural parity, reinforced the fundamental social ideal of American democracy. Even the location of the mural itself, elevated above the popular gaze, reflected the position of art and artist envisioned by Bruce. His art, he hoped, would be popular without pandering, reach the folk but always lead them.[5]

In this fashion, the thirties art projects generally but the Treasury Section especially should be seen as the attempt to square what was by then a long-standing American association between refinement and social order with the circumstances of modern industrial society. In his official correspondence Bruce consistently reminded his artists that they were creating art for people unaccustomed to viewing it. Therefore, he warned, the murals must be understandable; they must communicate themes chosen by the townspeople in designs none would confuse. Since the murals would depict scenes of communal harmony and progress, Bruce believed that they would inspire faith in democratic values and ideals. They would also, in the director's opinion, achieve something equally important, something he had come to believe through his own experience. Edward Bruce had a fluttering heart he eventually overtaxed, and there were occasional hints to this effect, such as the heart attack he suffered in 1931. It required a long convalescence but produced a story Bruce told the rest of his life. Laid up in the hospital, he became fascinated with a series of pastoral landscapes hanging on the wall of his room. The paintings projected a tranquillity that produced within him an internal calm crucial to his recovery. It was something he never forgot and, given the opportunity as director of a government art project, an aesthetic shinplaster he hoped to apply to American souls troubled by the Great Depression. Bruce's Section thus communicated on two levels. Viewed from the lobby floor, murals intended

to inspire and uplift. But they also conveyed a message of tranquillity, as conveyed by the artist in his role as articulator of community values and creator of enduring beauty, the vital middleman in a symbiotic relationship between art and citizen.[6]

Various observers have insisted that Bruce's idealism resulted in a good deal of bad art. But bad art can still make good history, especially in this case, where so stark a contrast exists between the ideal and the result. Many things frustrated the Section's desire to make art an everyday American experience. Regional design competitions generated substantial criticism, usually from the losers who complained, sometimes with reason, that judges governing the competitions were naturally predisposed to a small clique of favored painters whose distinctive styles afforded easy recognition. Nor did these competitions regulate the regional distribution of working artists. Quite simply, there were more practicing artists in New York City than in Bunkie, Louisiana, and the ones in New York submitted more and better designs. The preponderance of Section artists thus worked for and in communities with which they were unfamiliar and that many never saw. There also remained the separate concerns of Section officials, artists, and recipient communities. Each mural was something like a chemical experiment dependent on at least three fundamental elements, each of them volatile. Section officials tacked an uneasy case-by-case course between an enforced aesthetic orthodoxy, American Scene painting, and the freedom of artistic license. Artists, of course, were sometimes forced to choose between the integrity of their design and the paycheck it would earn them. The more expedient—some might say cynical—among them learned early what Bruce and his subordinates preferred and developed a specific style they dubbed "painting Section." Then too, the communities themselves, either through active or passive roles in the selection of mural designs, risked creating an unfavorable impression of themselves, either in paint or print, not to mention a loss of local autonomy in exchange for a moment of national celebrity. This capacity for conflict, always potential, was often realized. The Section sometimes badgered, the artists sometimes bucked, and the communities responded with either acclaim or hostility or, more often, indifference. Yet in any case the legacy of these murals, the process of their creation and nature of their reception, provides no mere record of national aesthetic preferences but a valuable glimpse of an anxious society in uneasy transition.[7]

The cumulative effect of Section murals was paradox. Most celebrate traditional values of work, family, and community through a modern cubist style. They were intended to express messages of hope and reassurance, conveying a politically acceptable message through an aesthetically attractive style, yet their very appearance on the walls of county courthouses and village post offices symbolized, and sometimes exacerbated, an immensely controversial

expansion of federal power. The murals were intended to help advance a revolution in art and society, one that would elevate the quality of democratic life by making art an everyday experience in small-town America—sometimes without its consent, more often without its concern. If the form seemed paradoxical, then often so did the content. These messages of hope and optimism were created in the face of unparalleled social upheaval. Amidst widespread poverty murals depicted scenes of abundance. At a moment of massive unemployment they celebrated work as an American ideal and the worker as an ideal American. With the nation's industrial machinery idle, some idealized an Edenic future engineered through technology, while others romanticized an agrarian past, and no few, like *Cotton Time*, struggled to reconcile the two. In an era of intense social and political tension, with a considerable portion of the agricultural population dispossessed from the land and adrift in society, with blacks and union organizers challenging traditional systems of race and labor relations, Treasury Section murals blithely depicted scenes of communal harmony alternately in a romanticized past, an impossible present, or a utopian future.[8]

Such inconsistencies appear throughout the mural landscape of thirties Louisiana, one of the more turbulent places in this volatile period. Sixty years later most remain right where the New Dealers put them, in such places as Jeanerette, Arabi, and DeRidder, among others. Between 1936 and 1942, the Treasury Relief Art Project, which commissioned the first, and the Section, which commissioned the rest, brought twenty-five separate pieces of art to the public buildings of the Pelican State. Four were pieces of sculpture, two were walnut carvings, and the rest, including one fresco, were murals. Their cumulative effect and chief legacy, all efforts to the contrary, was a standardized art achieved through the conscious manipulation of local mural landscapes by administrators anxious to square them with national assumptions. The result moved art in Louisiana even further from the logic of the genius loci, taking it in ways Ellsworth Woodward abhorred toward directions most Louisianans opposed.

3. "Are There No Chickens?"

So much of thirties America, as administrative problem or artistic subject, came down to the land itself. While artists rendered the American Scene, New Deal reformers redesigned the nation to an unprecedented degree. Greenbelt communities and Farm Security Administration cooperatives, Dust Bowl reforestation, western dams, CCC projects, and the Tennessee Valley Authority—all shared the common assumption of recovery through landscape reorganization. And as such enormous regional projects took shape, after 1935

3.2. Preliminary sketch, *Rural Free Delivery* by Conrad Albrizio. DeRidder, La., 1936. (National Archives)

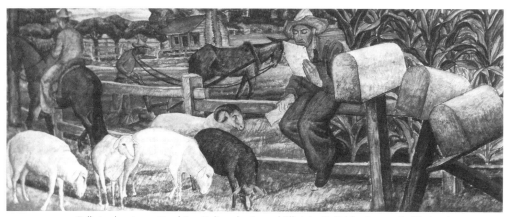

3.3. Full-sized cartoon, *Rural Free Delivery* by Conrad Albrizio. DeRidder, La., 1936. (National Archives)

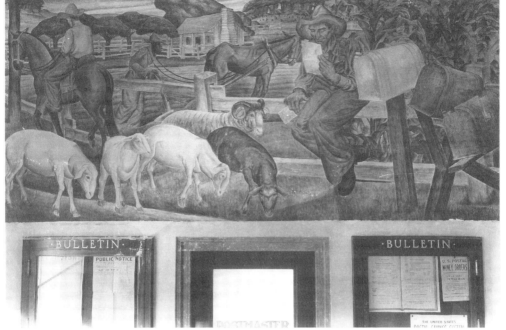

3.4. Completed mural, *Rural Free Delivery* by Conrad Albrizio. DeRidder, La., 1936. (National Archives)

the WPA sponsored thousands of local engineering efforts, supervising the creation of a modern national infrastructure. Meanwhile, artist and social scientist alike were "reading" the land, some hoping to find answers to the riddle of industrial depression, others in search of scapegoats, and not a few for solace and reassurance. As Archibald MacLeish composed *Land of the Free?* and Carey McWilliams published *Ill Fares the Land*, John Steinbeck told his story of a people exiled from their exhausted land to a society busily reshaping nearly every corner of the nation. Small wonder, then, that the men who ran the Section paid such close attention to the mural landscape taking shape across America. In Louisiana, their scrutiny produced numerous changes in the land, some innocuous, others humorous, but all to the same effect. Read collectively, Louisiana's murals mirror through art the physical modernization of thirties America. In art, as in society, the effect was the erosion of the state's physical and cultural isolation.

Rearranging Louisiana began with its very first mural. In 1936, when Conrad Albrizio, a frescoist and art instructor at Louisiana State University, executed a design for the DeRidder post office, Ed Rowan suggested that his scene might convey more hope if the land seemed more bountiful. Albrizio's original design perched a long-faced farmer atop a rail fence waiting glumly

while the postman astride his motorcycle fished for mail in his satchel (see fig. 3.2). In a second draft, however, the postman vanishes and sheep graze placidly in his vacated space (fig. 3.3). This was no accident. DeRidder was one of many Louisiana lumbering towns established in the late nineteenth century whose livelihood had played out by the Depression. Some were simply abandoned while others, like DeRidder, searched for a new economic base. There the people chose diversified farming, a combination of grain and livestock production, and Albrizio's mural, with its fat lambs and lush corn, tidy fences and deep furrows, suggests the wisdom of the choice and the brightness of the future. The farmer still perches atop his fence, only now the mail has come and the news is good. He sits, hat pushed back, reading an opened letter, an earlier frown replaced by a broad grin (fig. 3.4).[9]

In Eunice, Louisiana, the transformation from despair to hope was even more contrived. In 1939, Eunice was a small Acadian town thirteen miles north of Lafayette, Louisiana. Because it sat astride a major east-west highway bisecting the state, Eunice earned mention in the Louisiana Guide. Because the people who wrote the Guide had a good number of larger topics to treat at greater length, they dispatched Eunice with nineteen lines on a single page. But in 1939, Eunice became the focus of national attention when Treasury Section officials determined to commission a mural in each state staged the "48 States Competition." Nearly one thousand artists participated, submitting more than fourteen hundred designs in an attempt, as Edward Bruce explained, to cover the entire nation with murals "which make me feel comfortable about America." Not everyone agreed. Once the contest was over, *Life* magazine devoted three pages to the winners, creating in the process no small confusion. Regional participation in the competition had been, as usual, uneven. Some towns selected for commissions received no entries at all, while others received several. A judicious amount of juggling was required, for artists as well as designs; but no one informed the editors at *Life*. To correct the imbalance, runners-up were awarded commissions for places that had generated no interest. But then residents in several towns learned with varying degrees of bemusement and anger, that the design chosen for their post office had originally been intended for one in a different state or region. Eunice was a case in point. Laura Lewis, a young woman then living in New Orleans, won the commission on the strength of a design she submitted for the post office in Marfa, Texas. Although she was delighted, people in Eunice were considerably less enthusiastic. They had little interest in her design, a study of a deserted Army base in West Texas, and were less amused by Life's glib assertion that the artist's "sketch of a sultry Southern scene will be changed to fit Louisiana's more active life."[10]

Ed Rowan had already taken steps to correct the oversight, and Laura

3.5. Preliminary sketch, *Louisiana Farm* by Laura B. Lewis. Eunice, La., 1941. (National Archives)

3.6. Completed mural, *Louisiana Farm* by Laura B. Lewis. Eunice, La., 1941. (National Archives)

Lewis was nothing if not amenable, as the evolution of her mural design suggests. Though she was happy to have earned a commission, she was also confused by the switch. She wrote to Rowan wondering whether or not she should alter her design. He did not leave the door open for very long. "Since the artists employed under this program are working for the public," he replied, "we have found that art has more meaning to that public when the subject matter is related to or reflective of the locale in which the mural is placed. For this reason I think it is important that you confer with the Postmaster and, if possible . . . make a visit to Eunice to acquaint yourself with the locale." She did. Early in 1940, Lewis drove to Eunice, discussed her project with several of the townsfolk, and met with the Postmaster. An expansive man and "most kind," he spoke at length about various crops grown in the area. His talk and her drive through the surrounding countryside convinced Lewis to illustrate the

typical Eunice farm, one that would convey the "sweep and space and open fields and wide skies of the landscape, its stark beauty."[11]

She succeeded all too well. Her new design revolved around a two-room pine-board farmhouse located as the focal point in the center of the composition. Fences, alternately of wood and wire, ran at right angles enclosing the yard. An empty barn loomed in the upper left, and on the right the solitary figure of a woman leaned against a wire fence, gazing blankly at a field of empty furrows converging on the horizon (fig. 3.5). As a study in rural bleakness, the design rivaled early FSA photography. Rowan was appalled, and his suggestions for improvement typify Treasury Section desires. "It is our feeling that you probably would be able to create a little more interest in your design if you introduced some further elements to relieve the starkness of the barren house," he advised. "Are there no plantings around the house in the way of one or two shrubs? Are there no chickens? It is my frank opinion that the sheer design is not enough to carry the forsaken quality which is all but overstated."[12]

By "interest," Rowan meant acceptance, a point not lost on the artist. Lewis apologized, repeated her enchantment with the "simple forms" of southwestern Louisiana, and promised to soften the starkness of her design. Ultimately, she incorporated each of Rowan's suggestions and added a few touches all her own. In the completed mural, hens and roosters fairly dot the lawn. One kitten paws a crevice in the porch while another laps milk from a dish by the front door. Sunflowers guard a house surrounded by small plants and flowers. The barn appears again at the left but much of the lawn, once empty, is filled by a tractor-pulled disc harrow (fig. 3.6), a crucial addition. In the initial sketch, the empty barn and field suggest an infertile and unyielding land, a barrenness reflected by the woman's pose. She stood in a worried attitude, arms wrapped about her torso as though huddled against the cold landscape. The harrow changed all this. It made a barren land productive, straightened the furrows, deepened and organized them into an orderly procession advancing to a point on a rosy skyline more clearly defined than in the first sketch. Mechanized agriculture, the mural implies, makes for a far brighter future, a conclusion once more sustained by the woman at the fence. Her anxious vigil has ended. The arms have unfolded. One hangs freely at her side while the other leans against the fence, leaving her free to scan the horizon, either greeting a new dawn full of promise or relishing a sunset with the sort of satisfied fatigue derived from productive labor.[13]

Efforts begun by Conrad Albrizio and Laura Lewis were culminated by Xavier Gonzales, whose cycles of hope were a model of Section art. Born in Almeria, Spain, the day the *Maine* exploded in Havana Harbor, Gonzales came to art more by association than choice. His uncle, Jose Arpa, was an artist of national fame, and from him the young Gonzales received his first instruc-

tion. At thirteen, he ended his formal education in order to see the world. Five years later, he was in Revolutionary Mexico planning to become a mechanical engineer in a gold mine. He returned briefly to Europe but in 1921 was off again, this time to the United States. Gonzales settled in Chicago, worked an assortment of odd jobs, and completed his art training by taking classes at the Art Institute. Then he moved south, first to Texas where he taught art in the public schools of San Antonio, and later to New Orleans where he joined the faculty at Newcomb College.[14]

He was seldom idle in any place. Gonzales maintained an exhausting schedule, dividing his time between teaching duties at Newcomb and projects in his own studio. Each summer he abandoned New Orleans for the drier heat of West Texas, frequenting an artists' colony situated near San Marcos and, often as not, teaching summer sessions at various West Texas colleges. In school or in his studio, Gonzales's principal interest was mural painting. At Newcomb, he commandeered the cafeteria walls for his students' use. In New Orleans, his influence permeated the local arts scene. At least two of his students became Treasury Section muralists. One was Laura Lewis, and the other, Ethel Edwards, also earned a Section commission for the post office in Lake Providence, Louisiana, during the "48 States Competition." Like Lewis, Edwards credited her success to her teacher—Gonzales—who, since 1935, was also her husband. By then, Gonzales was himself an established muralist of widening reputation. He had already completed a variety of commissions, public and private, including ones for the Civil Auditorium in San Antonio, Texas, and a more ambitious project at the newly built Shushan Airport on the New Orleans Lakefront. Soon he was among the Section's most prolific muralists, completing no fewer than five commissions, all in the South and two in Louisiana.[15]

Gonzales was not only prolific, he also never forgot for whom he worked. His style was crisp and representative, much in the tradition of the American Scene, and his themes were sure to warm the heart of any New Dealer. His Louisiana work spanned an interval of three years and hung in towns not thirty miles apart. He finished the first in 1936, a design for the post office in Hammond, Louisiana, executed for the diminutive TRAP, a small moon in the Section's orbit. Hammond sat in the heart of the Louisiana strawberry district whose landowners and migrant pickers were both hit hard when the southern agricultural economy collapsed and was a frequent stopover for Farm Security Administration photographers. But where others found heartache and despair, Gonzales depicted a seamless cycle of abundance. Eight canvases depicted the various phases of strawberry cultivation and were hung so that the daily passage of the sun illuminated each in its proper chronological sequence (figs. 3.7–3.10). Gonzales's cycle conveyed to its viewers a sense that

3.7. Mural panel in progress, *Strawberry Farming* by Xavier Gonzales. Hammond, La., 1937. (National Archives)

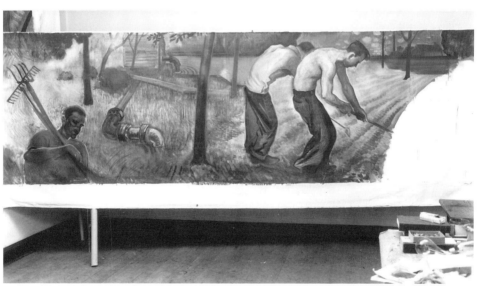

3.8. Mural panel in progress, *Strawberry Farming* by Xavier Gonzales. Hammond, La., 1937. (National Archives)

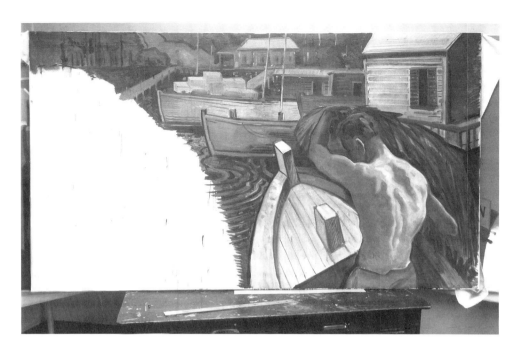

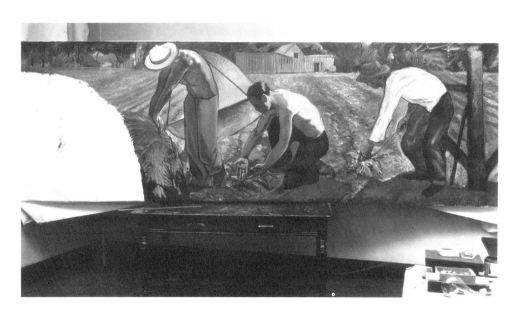

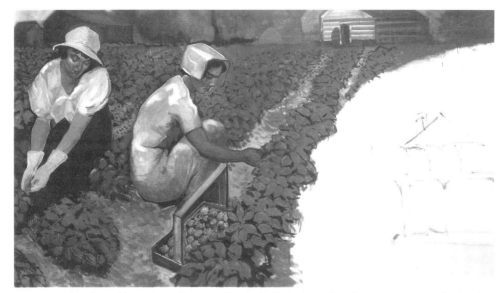

3.9. Mural panel in progress, *Strawberry Farming* by Xavier Gonzales. Hammond La., 1937. (National Archives)

3.10. Mural panel in progress, *Strawberry Farming* by Xavier Gonzales. Hammond La., 1937. (National Archives)

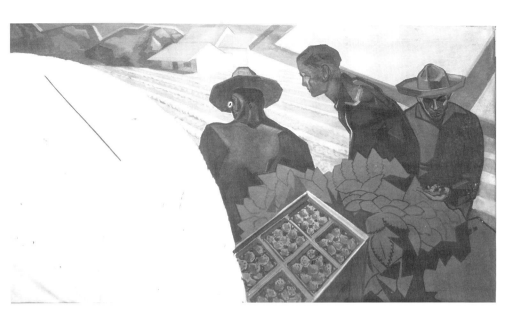

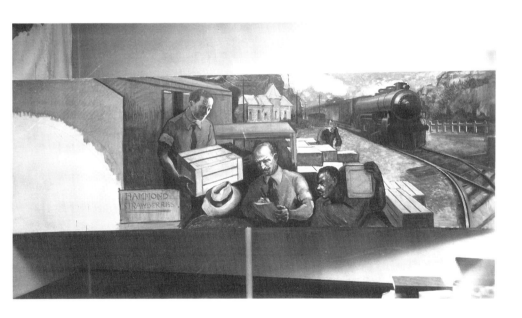

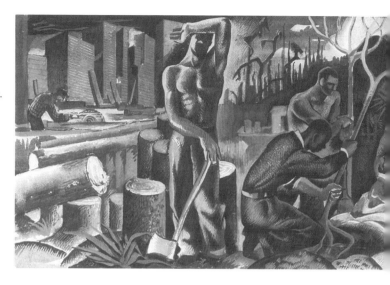

3.11. Completed mural, *Tung Oil Industry* by Xavier Gonzales. Covington, La., 1939. (National Archives)

the cultivation of strawberries, however harsh its labor or unpredictable its market, was nevertheless a part of the natural order of things, timeless, like the sun's daily passing. Repeated each day, the drama of the cycle reached a happy conclusion. Every panel in its turn skirted the myriad hazards of agricultural production. No droughts, no damaging hail, no bank foreclosures, no federal inspectors disturbed the process. Instead day in and day out the right portion of sunshine and rainfall brought forth a bumper crop judged, weighed, crated, and shipped to market—the ideal harvest for the ideal village.[16]

Such abundance, with such certainty, also informed Gonzales's other Louisiana mural, a Section commission completed for the post office in Covington, Louisiana. Covington was just south of Hammond, a small town on the northern rim of Lake Ponchartrain above New Orleans, and a region in transition. Like DeRidder, Covington had been lumbering country until recently, and like DeRidder, too, its mural would ease the economic transition, in this case from timber to the production of tung oil. In addition, the Covington mural offered a quintessential New Deal parable; for in Covington the indiscriminate harvest of timber had nearly ruined the production of oil extracted from the tung nut and put to a variety of uses. Disaster was narrowly avoided, or so it seemed, until Xavier Gonzales came to the rescue with fifty-six square feet of canvas solution devoted to the progressive values of scientific study, rational planning, and resource conservation. The mural itself (fig. 3.11), a single panel, reads from left to right, beginning with standard symbols of deforestation: denuded stumps, a whirling saw, and a woodsman, forearm drawn over his eyes, blind to the consequences of his actions. The

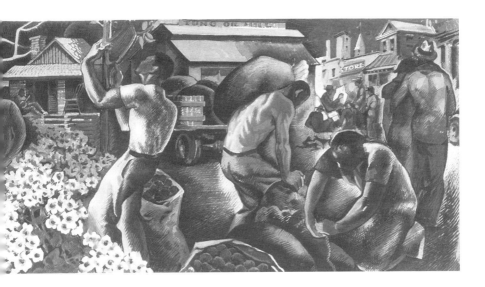

results are inescapable. An ominous landscape looms in the distance, featuring the sawmill and its burner. Reclamation begins in the next section. Here, experimentation seeks to rehabilitate the scarred land. Young trees are rooted and replenished. A man prunes and grafts and, before long, others begin the harvest of tung nuts. These are bagged and shipped to the oil mill in the background right, whose tangible profits, the thriving town, appear in the foreground below.[17]

The Covington mural is the ultimate New Deal fantasy. Here in a simple canvas, Xavier Gonzales replenishes and restores not merely a forest but hope and lasting prosperity to a stricken community founded on thrift, order, and industry. Here, too, through scientific planning and the rational use of natural resources, Gonzales makes a painless transition from agriculture to industry. At center, the billowing tung blossoms and rustic roofs, a banjo picker, and a front porch rocker all spin the traditional myth of rural arcady. This, the artist insists, is the basis of material profit that sustains a civilization whose citizens must guard against a return to the careless practices of the past lest they once more threaten the democratic community and all its attendant values: religion, education, and social harmony. Yet the transition from despair to prosperity was never so easy as it was in DeRidder or Eunice or Hammond or Covington. Inconsistencies and tensions within and among other Louisiana decorations suggest that the cultural transformation of the American nation and the southern region, under way throughout the 1930s, occurred with a good deal more anxiety than ones accomplished with the brushstrokes of Conrad Albrizio, Laura Lewis, or Xavier Gonzales.

4. Southern Pattern

Abundance blessed the mural landscape of thirties Louisiana. Cotton and cane, grain and animal pelts, oil and gas and progressive industry—all came in record numbers and bumper crops to post offices in such places as Abbeville and Haynesville. These were accompanied by local symbols and local heroes, everything from such ubiquitous Louisiana reminders as pelicans, shrimp, and magnolias to palm fronds, Spanish moss, and placid bayous. Even the Seiur de La Salle himself turned up. But as two diametrically opposed views of the Louisiana landscape suggest (figs. 3.12–3.13), one of the salient issues of its day was also present: the debate among thirties Americans over the consequences of modernization. No amount of Treasury Section optimism could conceal completely the kinds of changes represented in the artistic landscapes they shaped. The signal consequence of the modernizing South has been the reorganization of its racial relationships, something hinted at in three Louisiana murals. Meanwhile, two additional murals bear visible witness to other cultural trends of this watershed period, changes that Section art itself helped to sustain.

3.12. Completed mural, *Louisiana Bayou* by Paul Rohland. Ville Platte, La., 1941. (National Archives)

3.13. Completed mural, *Logging in Louisiana Swamps* by Datus Myers. Winnsboro, La., 1939. (National Archives)

One August afternoon in 1941, Hy Knight, the postmaster in Ferriday, Louisiana, rolled a fresh sheet of stationery into his typewriter and in his relaxed grammatical style clacked out a short message to notify the Federal Works Agency that the new mural in his post office had been installed properly and met with his approval. "Mr. Stuart Purser has completed the installation of the mural in this Post Office," he relayed. "It is apparently a high class painting and adds quite a lot to the lobby of the office. I have heard many compliments concerning same." Three sentences later, having completed this bureaucratic chore, the postmaster stuffed it into an envelope, enclosed a short article clipped from the local newspaper describing the mural, and sent it off, without apparent haste, second class.[18]

Knight's letter was the final piece of red tape in a yearlong process begun the day the Section awarded the Ferriday commission to the Louisiana artist Stuart Purser. For Purser, who lived nearby in Pineville, home of a small Baptist college where he worked as the art instructor, the commission capped a summer of uneven fortune. The previous May, on the day his son was born, fire razed the artist's garage studio, burning everything from frames to finished paintings, his supplies, even his car. He and his wife, also an artist, then painted furiously all summer long to complete a joint exhibition in August for the museum of art in Jackson, Mississippi. Amidst this rush Edward Rowan awarded Purser the Ferriday job. He must have been exhausted; still, eager to tackle the design, Purser drove to Ferriday, chatted with Knight and several other townspeople and, within a week, worked up a preliminary design sketch treating a subject dear to local hearts. "It seems that cotton is the only industry of importance," he advised Rowan, "and it is the only subject that was suggested by the individuals in Ferriday with whom I talked."[19]

Cotton it would be. Purser sketched a scene he had witnessed the previous Saturday at Panola Plantation, near Ferriday. It was late afternoon of payday. Black field hands crowded around their white foreman. "Dressed in bright colors," they waited in a nearby wagon for wages that funded the weekly trip to town. In the background, as Purser described, appeared "an old type cotton gin, with a brick stack, that is one of the few remaining gins of that design in the South. To the residents of Ferriday, the gin seems to be one of the outstanding things of interest in that section" (fig. 3.14). Rowan liked the idea and approved the design, but in the interim, while their letters crisscrossed, fresh inspiration struck Purser. He returned to Ferriday, this time to visit the local cotton mill. Taken with the design potential of its interior, Purser forwarded a second sketch Rowan liked even better. Then, some time shortly after the Thanksgiving holiday, Stuart Purser laid aside his original sketch of Panola Plantation with its antiquated cotton gin to concentrate his efforts on the second design, "a modern southern four-stand cotton gin in full operation."

3.14. Preliminary pencil sketch, *Southern Pattern* by Stuart Purser. Ferriday, La., 1941. (National Archives)

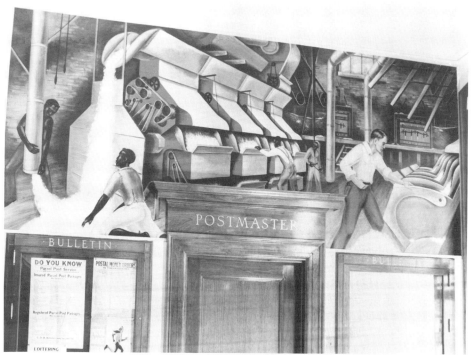

3.15. Completed mural installed, *Southern Pattern* by Stuart Purser. Ferriday, La., 1941. (National Archives)

Despite the necessity of dividing his time between the classroom and the studio, Purser's work progressed swiftly. Section officials approved his full-sized cartoon with minor changes the following summer. Purser finished his mural by mid-July. Two weeks later, it was hanging in Knight's new post office. Two weeks after that, the postmaster crouched behind his Underwood and pecked out his note to the Federal Works Agency, approving the new "high class painting."[20]

The evolution of Purser's sketch from plantation scene to "modern southern four-stand cotton gin" reflected the ongoing transformation of Louisiana society (fig. 3.15). Louisiana's mural landscape, like the physical state it represented, was primarily agricultural, but Purser's interest was the manufacture of the southern staple, particularly the machines themselves. He was clearly fascinated by the power and symmetry of the mill, its neat rows of bins, its ordered pipes, belts, and cogs, each with a specialized function vital to overall production, a symmetry he extended to the mill workers. In his original sketch depicting payday at Panola Plantation, Purser had left little doubt as to the importance of the white foreman. He was sketched at his moment of supreme power, physically elevated above his workers dispensing their means of survival. But the social and racial significance of the old plantation system disappears in Purser's completed mural. Instead, the machine now dominates the mural space. It dwarfs the workers, white and black, reducing the races to roles of approximate importance. Yet, this is not integrationist art. Purser carefully divided his races by emphasizing the vertical thrust of the postmaster's door with the pipe in the middle background. Still, separation is a long way from the racial dominance so overtly suggested in the Panola sketch. Rather, as the machine depends on each of its parts, the manufacturing process also depends upon its specialized laborers, each with an individual function essential to corporate achievement. Industrialism had come to Louisiana, in the mural world and the actual, accompanied by the interdependent emphasis of the manufacturing process itself. The logic of specialized labor and interchangeable parts carried with it a social corollary that threatened to upset the traditional operation of southern caste and class relations, making the title of Purser's mural, *Southern Pattern*, less description than prophecy.[21]

Two other muralists incorporated racial themes into their Louisiana decorations, reaching conclusions similar to Purser's. Painted by Francesca Negueloua, the mural for Tallulah, Louisiana, depicted a scene from the Flood of 1927, an event still fresh in local memory. Negueloa based her painting on the eyewitness account of a local survivor published in the *Atlantic Monthly* whose patronizing tones undermined her praise for black service during the emergency. Indeed, the article matched the spirit of a piece of sculpture raised by the citizens of Natchitoches during the flood year, praising the faithful

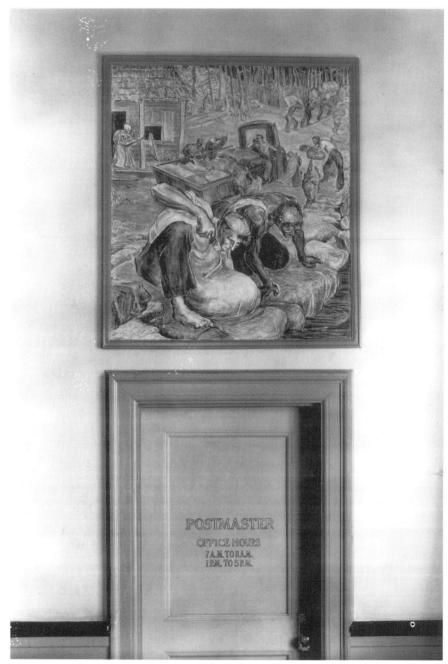

3.16. Completed mural installed, *The River* by Francesca Negueloua. Tallulah, La., 1938. (National Archives)

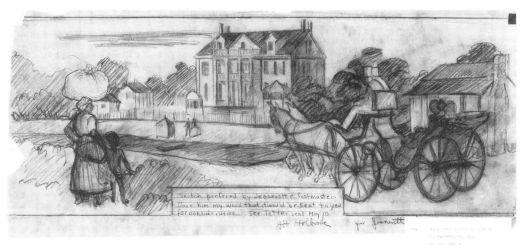

3.17. Untitled pencil sketch approved by postmaster by Hollis Holbrook. Jeanerette, La., 1941. (National Archives)

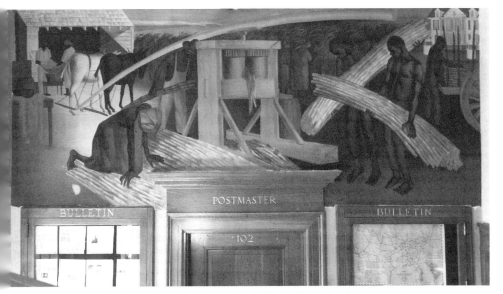

3.18. Completed mural installed, *Sugar Cane Mill* by Hollis Holbrook. Jeanerette, La., 1941. (National Archives)

subservience of "the Good Darky." Ten years later, the painted version of the event provides a more flattering portrait of its black participants in a last-ditch attempt to control raging water. Here, rather than the "shiftless dark-ies" requiring constant supervision found in the published piece, Negeuloa depicts strong, self-directed blacks playing an integral and equal part in the emergency effort (fig. 3.16). Small wonder, then, that the black villagers of Tal-

lulah became enchanted with Francesca Negeuloa's mural, where the forces of nature level with a power equal to Purser's machinery.[22]

African Americans also received sympathetic treatment in the hands of Hollis Holbrook, a Florida artist whose post office commission for Jeanerette, Louisiana, evolved in a fashion similar to Stuart Purser's. Shortly after receiving his commission, the artist contacted the Jeanerette postmaster, who recommended a sketch of an antebellum scene with all the trimmings. Holbrook complied. In his preliminary sketch a mansion modeled on the postmaster's home dominates the scene. A fine carriage enters at right, presumably bearing a couple visiting the owners at center. At the other margin a tignoned mammy balances a bundle of washing on her head (fig. 3.17). But Holbrook grew uneasy with this sentimentalized glimpse into the southern past, so he made a second, starker sketch, paralleling the misery of blacks and mules at the bottom of the region's labor hierarchy. Backs bend pathetically under the strain. In this, the most sympathetic portrait of black life completed in Louisiana, broken cane stalks fall from the grinder in a powerful and unmistakable reflection of workers' lives consumed by demands of the big house (fig. 3.18).[23]

There were, naturally, limits to the work of Purser, Negeuloa, and Holbrook. None did more than hint at things to come, nor advocate change with any degree of openness. Identifying the machine's growing power in southern society and suggesting its influence on the future of southern race relations, or praising black efforts in the face of disaster, or even identifying the harshness of black labor in the South was one thing. Advocating change was quite another, and judging from the reactions of local residents no hint of such was ever discovered. In Ferriday, Hy Knight passed along the favorable comments of other townsfolk and let it go at that. In Tallulah, both the postmaster and the newspaper editor noticed the popularity of the mural among local blacks but reported the circumstance with nothing more than paternal bewilderment. Across the state, in Jeanerette local viewers all but ignored Hollis Holbrook's black workers. They were too busy ogling the mansion, though relegated to the periphery of the final composition, still a piece of local architecture, and as such immensely popular among the villagers. Viewed over the prostrate backs of southern black laborers, it seems, the scene suggested a glimpse of things as they were and should be, inspiring neither remorse nor outrage. Yet clearly, even in a state where white supremacy had been cast in bronze, federal art and grassroots action was already working for change, a rising tide no levee would hold.[24]

While these artists hinted at the social consequences of modernizing Louisiana, Section art made its cultural implications equally visible. Incorporating Louisiana into modern America involved more than eliminating the state's physical isolation. It also meant blending Louisiana's distinctions

into an emerging national culture. By the late 1930s, chain stores, radios, motion pictures, advertising, and mass-circulation magazines had homogenized American culture to unprecedented degrees. Americans transcended their spatial separateness as never before, receiving simultaneously common bits of information, a trend advanced by Section art. In bulletins drafted to announce commission competitions, Ed Rowan and his staff routinely listed such "suggested topics" as "Local History, Past and Present," "Local Industries," and "Local Pursuits." Yet as subsequent observers assert, the same ideas and assumptions expressed through a common style surfaced nationwide. Section art helped to make local color a national craze—the logical result of an organization determined to shape national art tastes through a single aesthetic orthodoxy. The style had once been dubbed "regionalism," but by 1939, as evidenced by the 48-States Competition, the term had reached absurdly shallow proportions. Many of the competitors submitted designs for communities they had never seen, and some of the more enterprising entrants submitted multiple designs for multiple places. As Laura Lewis learned, designs for one place might win commissions in another, a common occurrence. Her fellow artist, Lew Davis, submitted a sketch for the post office in Safford, Arizona, and was awarded the commission for Los Banos, California. But where Lewis created a new design for Eunice, Davis proved less original if more inventive. A few deft brushstrokes transformed mounted Indians in the Arizona desert into mounted caballeros in the California hills.[25]

Not only were Section artists interchangeable, their designs were too, as two other Louisiana murals suggest. Harry Lane was less than thirty years old when he painted his only Section commission, a decoration for the post office in Oakdale, Louisiana. When inquiries to the postmaster and librarian left him with little direction, Lane struck out on his own, in an attempt, he asserted, to "suit any post office." He succeeded admirably, managing an efficiency that appeared not only in his mural but also in the thin folder documenting its creation. Thirteen months separated commission from completed mural whose design the Washington artists altered only slightly. As Lane had hoped, it would have been acceptable to anyone anywhere in the country, and therein lies the point. *Air Express*, whose clean lines and stark contrasts mark it as a streamlined genre piece, depicts the modern and efficient transportation of the U.S. Mail (fig. 3.19). Here is a system where technology abolishes space with as much speed and efficiency possible, a process indifferent to local circumstance. As originally designed, it was even unsullied by people. Only on Rowan's request do the figures appear in the lower left or at the middle distance, anonymous citizens in a society linked by systems of mass communication and mass transportation, reducing its component parts to Anytown, U.S.A.[26]

3.19. Completed mural, *Air Express* by Harry Lane. Oakdale, La., 1939. (National Archives)

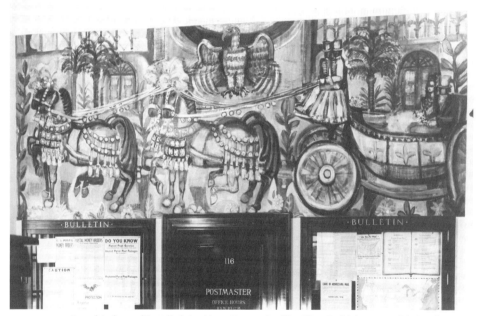

3.20. Completed mural installed, *Louisiana Pageant* by Alice Flint, Arabi, La., 1939. (National Archives)

Alice Flint's mural for the post office in Arabi, Louisiana, was equally prophetic. Flint, a New York artist, won the Arabi commission for designs she submitted in the competition for the Bronx post office. By then, she was also a veteran Section muralist, whose completed mural already hung in the Fairfield, Connecticut, post office. Although she contacted the local postmaster and solicited local ideas for her mural design, she took no relish in the chore. She already had a design in mind, "a mural with horses and carriages, and riders of the aristocratic South of earlier days," and dreaded any interference (fig. 3.20). "I trust he will not suggest any historical episode," Flint wrote, "as

3.21. Completed mural installed, *Tempora Mutantur et Nos Mutamur in Illis* by Alice Flint. Fairfield, Conn. 1938. (National Archives)

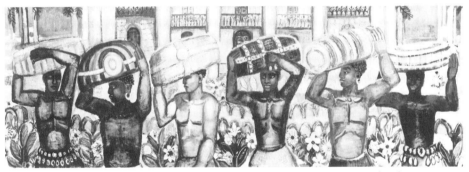

3.22. Completed mural, *Plantation Scene* by Alice Flint. Adel, Ga., 1941. (National Archives)

I detest that type of mural." Nor did she set any stock in the ability of laymen to understand the sophisticated procedures of mural composition. Through his silence the postmaster obliged, much to the artist's relief. Undisturbed, she plunged ahead on *Louisiana Pageant*, a design she completed in orderly fashion save for one minor hitch. Having completed her preliminary sketches, Flint worked up a full-sized cartoon of the decoration. To harmonize with the dimensions of the mural, she purposely elongated the legs of her horses, giving them an extra joint above the fetlock. But such unscheduled departures from representational designs frightened Ed Rowan. "We keenly feel the ne-

cessity of your restudying the legs of the horses," he advised. "The mannerism which you use in drawing the extremities of the legs is one which is frankly disturbing to a number of people." By this Rowan meant prospective viewers, and he offered a little advice. "We feel that since the artists under this program are creating murals for a non-painting public it is essential that the artists avoid those characteristics which might confuse the issue in those minds for whom the work is intended." Flint accepted the criticism graciously, redrew the legs, and finished her mural in the spring of 1939.[27]

The result produced a suggestive blending of artist intent and local perception. *Louisiana Pageant* depicts the passage of a lavishly ornamented carriage driven by black coachmen bearing an aristocratic couple. In fact, Flint decorated her coach so lavishly that local citizens took it for a Mardi Gras float and applauded what they presumed to be national confirmation of their local ritual. None knew, apparently, that the Arabi mural simply repeated the artist's earlier Fairfield decoration (fig. 3.21). Indeed, only the slightest variation separated the two, such as the addition of two horses, the subtraction of three riders, and the inversion of the couple's appearance. Aside from these minor touches the murals are identical. The same coach parades down the same avenue in Connecticut as in Louisiana, and it might have been the same in Adele, Georgia, the site of Flint's final Section commission, had it not been for the insistence by Ed Rowan that another coach scene might smack of the repetitious. Still, Flint was little daunted. In Adele, the parade motif remains intact, expressed this time in the form of several black slaves, all in succession, and each bearing a trunk overhead. If not directly visible, the coach lurks just beyond sight, and its lavish ornamentation is suggested in the splendor of the trunks (fig. 3.22). The murals of Harry Lane and Alice Flint represent the extreme, if logical, implications represented by the growth of national culture during the 1930s. One produced anonymity, the other promoted interchangeability, and both provide a crucial frame of reference without which the meaning of another Louisiana mural might otherwise be lost.[28]

5. Evangeline's Return

In July 1941, the mural version of Evangeline, Henry Wadsworth Longfellow's romantic heroine, arrived back home in St. Martinville, Louisiana, arranged herself beneath her oak along the bayou, and resumed her vigil. White-capped and virginal she waited, the folds of her dress billowing among palm fronds and water hyacinths. A church loomed porcelain just beyond her shoulder. Spanish moss swayed overhead. One hand clutched her prayer book; the other rested demurely at her breast, sitting as she always had, awaiting her lover's return.[29]

In 1940, St. Martinville, Louisiana, was a town of fewer than seven thousand people, two hotels, several boardinghouses, one movie theater, and a stop on the Texas and Pacific Railroad. This was Cajun country along Bayou Teche in the broad triangle of the Atchafalaya Basin west of New Orleans. The Acadians, or Cajuns, were exiles, arriving in St. Martinville after their expulsion from Nova Scotia at the end of the Seven Years' War. They were often characterized as rural peasants living in a small and insular ethnic community, speaking a patois French, assembling at mass each Sunday on the summons of tolling bells, and clinging to an oral tradition of folktales and legends. They believed in the miracles of the saints, in loup garous (werewolves of the bayou), and in the story of Emmeline Labiche, who amidst the exodus had been separated from her lover, Gabriel Arceneaux. After searching the breadth of America, the legend runs, she found him, finally, in St. Martinville, engaged to another woman. Grief-stricken, she lost her reason, weakened, and died. Compelled by her tragedy, the villagers buried her as one their own and perpetuated her memory by repeating her saga. Nathaniel Hawthorne heard it and resolved to write a story from it. Instead, he mentioned it to Henry Wadsworth Longfellow, whose epic poem *Evangeline* is the story of Emmeline Labiche.[30]

By 1940, to the Acadian residents of the region, Evangeline was a powerful symbol of ethnic travail. Cajuns generally led isolated lives as farmers, trappers, and fishermen, consigned to the margins of society. They identified with Evangeline's patient suffering, a myth enduring enough to permit profitable exploitation. Emmeline's grave and the Evangeline Oak, where the first exiles were said to have landed and where Longfellow seated his heroine, were standard stops on the tourist's trail. Calculators of larger stakes also understood her symbolic power and the depth of her appeal. In 1928, as a candidate for governor, Huey Long had stood beneath the oak and transformed the power of her memory into electoral muscle. "Evangeline wept bitter tears in her disappointment," he told them, "but it lasted through only one lifetime. Your tears in this country, around this oak, have lasted for generations. Give me the chance to dry the tears of those who still weep here!" They did. One week later, on Election Day, Long swept the district on his way to the governor's mansion in Baton Rouge, where he did not forget them nor they him. Acadiana received the full benefits of the Long program, remained a solid base of Long's power, and, after the assassination, preserved the Long flame.[31]

Three years after Long's death, St. Martinville received the largesse of an even more powerful patron. In 1938 the WPA remodeled the post office in town, a converted colonial mansion, and a year later the Treasury Section of Fine Arts undertook to decorate it. Harmony governed this project, from start to finish, in a town whose citizens communicated exactly what they wanted to

a federal agency that, in this instance, gave it to them. Local residents seized the initiative, reversing Section procedure. The townspeople of St. Martinville did not wait for a federal artist to turn up, asking questions about their town and how they wanted it represented in paint; it was they who sought the artist. No one knows who first suggested the subject of the St. Martinville mural, but if it was not the postmaster himself, Howard Durand, he was soon its chief promoter. Informed that the Section intended to decorate the renovated building, he busied himself collecting photographs and postcards depicting the town and its surroundings. All were bundled and sent along to the local congressman, Robert L. Mouton, who approached Edward Rowan and relayed the precise nature of what his constituents had in mind. Neither he nor they were vague. By the time Rowan appointed an artist for the job, he already had in hand a set of explicit instructions.

> The scene of Evangeline under the historic oak, Spanish moss swaying lightly in the perfumed breeze, the lilac of the water hyacinths at her feet mingling with the orchid of the evening sky, the toll of vespers suggested by the steeple of the church where now her body lies, give the scene an ineffable note of sadness and yet reflect the nobility of her selfless search . . . something like that is wanted.[32]

It took little more than a year to translate these instructions into paint. Ed Rowan assigned the project to Minetta Good, a lithographer and decorative painter then working in a studio in Freehold, New Jersey. Good was also a veteran Section painter and, as with Harry Lane and Alice Flint before her, the work went smoothly. Shortly before Christmas 1940, Good finished the mural, accompanied it to St. Martinville, supervised its installation, and attended the unveiling. The locals were delighted, chief among them postmaster Durand. "Permit me to commend you on the selection of Miss Good," he beamed, "her paintings are perfect in every respect and have brought word[s] of praise from all who have viewed them." On the day the mural was unveiled, local residents choked the post office lobby, craning their necks and gasping with a general delight broken only once. At some point, a covey of elderly women approached the artist. They huddled only briefly before Minetta Good reached for her brush and called for a ladder, and within moments the scene had recovered its original effervescence. People still crowded the lobby muttering approval, only now these joined the effusive thanks of the elderly ladies, grateful to the artist for honoring their simple request by painting a tiny cross necklace around Evangeline's throat. (See fig. 3.23.)[33]

All were pleased with the St. Martinville project. Minetta Good fully accepted the limits of her artistic license and remained grateful for a chance to

3.23. Completed mural, *Evangeline* by Minetta Good. St. Martinsville, La., 1940. (National Archives)

ply her skills for an adequate paycheck at a time when many of her colleagues could not. She left the experience enriched not simply for this but from her contact with the community she served. Section officials were no less delighted. No private quarrel or public scandal had rocked this project as it had and would others. Instead, they had fulfilled their organizational ideal, bringing art to a place they considered culturally backward and matching an artist with its citizens. The people of St. Martinville were equally pleased. Here, townspeople had seen a familiar and trusted symbol preserved in oil and raised to prominence in a place of public display.[34]

That all were happy is certain, but what this mural signified, what it represented in the eyes of its admirers, and what it means to its subsequent observers is a good deal more elusive. It has been suggested that Evangeline represents an idealized version of southern womanhood, a sort of French-Canadian Melanie Wilkes, frail as ivory and ennobled through long and patient suffering. Certainly such imagery does not contradict either local or regional visions of gender, but the explanation runs more deeply. Evangeline is also an ambiguous ethnic symbol with several plausible explanations. By 1940, the town enjoyed a tourist trade based primarily on her legend. In one sense, a mural depiction of the heroine hung in a public building could be read as commercial promotion, and if so, it would not be the only place in thirties Louisiana packaged for tourist consumption. Ultimately, however, what fascinates the student of Evangeline's return is the larger context of her appearance.[35]

She is distinctly a creature of the 1930s, existing by virtue of a cultural and political compromise that enshrined a local symbol in a federal lobby. Her existence, then, rests on a most fragile foundation, the tacit agreement between a federal agency and a local community that gave one the power to define the nature of fine art and the other a say, not always final, over what that art would depict. Such forces remained in constant tension throughout the 1930s rarely with such balance as in St. Martinville. Yet for all the apparent harmony of this experience, a profound uncertainty permeates that mural. The painting seeks to celebrate one of the central legends of an insular ethnic community at the very moment when modern mass culture exerted unprecedented powers to define and articulate a standardizing vision of American life. Thirties Americans, after all, coined the singular term "The American Way," and the art program helped to clarify and disseminate its basic iconographic vocabulary. That Americans were unsettled by this process has been widely documented even in St. Martinville; for as Minetta Good basked in the glow of local approval, WPA writers and folklorists hurriedly recorded traditional Cajun customs and cultural practices. They had good reason, as Howard Durand surely knew. Already the patois French was passing out of existence, and

the young were moving on, giving up their parents' oral heritage and rural folkways for factory jobs in and around New Orleans. This context gives the Evangeline mural its particular appeal, its holographic quality. Viewed one way, she is the symbol of cultural pride, the long-suffering personification of a long-suffering people, eyes empty from love too long deferred. Look at her again and she has changed. The eyes are still empty and longing, though not through jilted affection, but rather in a parting glance cast at a vanishing way of life. Minetta Good's mural, the people of this place, and the meaning of this period assume their ultimate significance only in relation to the murals of Harry Lane and Alice Flint, especially over time. Now, more than fifty years later, the residents of Oakdale and Arabi still get their mail under the gaze of *Air Express* and *Louisiana Pageant*. But the same is not true in St. Martinville. Some years ago, when the old post office was abandoned, its decorative mural disappeared without a trace and has not been seen since. Raised either in defiance or despair, Evangeline's return, it seems, was all too brief.

In many ways, Treasury Section painting emphasizes how thoroughly local art had slipped from Ellsworth Woodward's grasp. Although the Section hoped to match local painters with nearby surroundings, it honored the ideal more often in the breach. Yet awarding Louisiana commissions entirely to native painters would hardly have produced the indigenous expression Woodward championed. Technical advisors in Washington scrutinized every design, and their guidance, sometimes heavy-handed, produced a common enough set of subjects and styles to afford easy transportation from one community to the next. Section murals, in this regard, should not be confused with turn-of-the-century local color studies. These murals were not excursions into local deviance, or glimpses of exotic others; just the reverse. Section designs almost ubiquitously depicted how local communities experienced national trends, shared national goals, or embodied national values—how each in turn venerated pioneering traditions and disciplined labor, displayed natural and manufactured abundance, and reconciled tradition with innovation. Local symbols abounded, to be sure, but in ways arousing suspicions of too much protest. Instead, through Section auspices, it became possible to depict Louisiana either as an interchangeable node in the transportation system, or through template art, as a generic design easily adjusted to any corner of America.

From Woodward's perspective, the internal evidence was equally disturbing. The mural landscape of thirties Louisiana, like the one emerging all across America, concerned itself not with lofty allegory but with the social, economic, and environmental consequences of modernity. Viewed collectively, machines and modern assumptions dominate this landscape from Abbeville to Ville Platte. Xavier Gonzales's murals for Hammond and Covington

expressly championed modern interdependence. His strawberry sequence climaxed with the arrival of express freights bound for distant markets, just as Covington's future depended on the synthesis of scientific research, rational planning, and forest conservation. Diversified farming, suggested Conrad Albrizio, would guarantee happy news in De Ridder, while Arcadians made the easy transition from cotton patch to oil field. Meanwhile Stuart Purser, Francesca Negueloua, and Hollis Holbrook all suggested the impact modernity might have on the region's race relations in the not-too-distant future. Finally, the story of Evangeline's return suggests a growing concern for the cultural consequences of modernity, specifically its power to alter local circumstance and disrupt traditional custom.

Yet if much else divided them, Section administrators and Ellsworth Woodward had not reached complete loggerheads. Edward Bruce and Edward Rowan, like Woodward before them, refused to patronize needy artists of uncertain skill. Indeed, placing skill above need had been the one point Bruce and Woodward agreed on during their PWAP association. Similarly, Treasury Section art was didactic. It assumed a basic lack of sophistication among its clientele, the American people, to whom it offered inspiration through simple stories in simple styles. It might offer more secular visions of American communities less deeply rooted in locale, but the ultimate aim, a reforming influence achieved through fine art, remained the same. In this regard, too, hierarchy inhered. Section murals might treat subjects too common for Woodward's taste, but the mural program, at least in theory, was a meritocracy. It selected artists who, by virtue of superior skill, became the people's voice, a social rank mirrored by the display of their work in an elevated place within the people's building. Doubtless, the patriarch himself supported such an arrangement, though perhaps not with the same passion he reserved for the final point on which he and the Section agreed. While Ellsworth Woodward struggled to defend his fading localism and Edward Bruce campaigned to establish permanent federal support for the fine arts, a third New Deal art organization threatened to shatter both men's hopes. This was the Federal Art Project, of all the New Deal forays into art patronage during the 1930s, by far the most modernist and the most modernized.

"Art for the Millions"

1. *The Shooting of Huey Long*

Three years after the event it depicted, the editors of *Life* published John McCrady's painting, *The Shooting of Huey Long*. Like his teacher in New York, Thomas Hart Benton, McCrady was a regionalist whose talent made him among the best-known painters in the South. In October 1938, *Life* gave him nationwide exposure, reproducing his version of the Long assassination (fig. 4.1). In the painting, bedlam engulfs Long's new State Capitol moments after the first shot rang out. Onlookers either stand aghast, faces frozen in astonishment, or dash down the hall for cover. Huey's body-guards blaze away with pistol and tommy gun at Long's assassin, Carl Weiss, who slumps to the floor still clutching a small pistol, clothes tattered, blood streaming from his riddled body. The Kingfish, always the focus of attention, occupies center stage. Reeling up the marbled hall, he probes his wound with bloodied and oversized hands, suggesting the ruthless exercise of enormous power. To his left a bust of the Sieur d'Bienville, first governor of Louisiana, glares down across two centuries of state history. On the floor to Long's right, as though placed there to cushion Weiss's fall, sprawls a copy of the *American Progress*, the weekly Longite sheet. Beneath the masthead a suggestive head-line asks "WHAT OF THIS PROMISE TO SHARE OUR WEALTH?" while a cockroach, equally provocative, scurries from beneath the torn front page.[1]

This most celebrated of John McCrady's paintings was also his most con-troversial. *The Shooting of Huey Long* commenced a weekly *Life* feature de-picting critical moments in American history and provoked another round in the continuing quarrel over the Long legacy. His defenders criticized the assassin's Christ-like features. McCrady's Weiss seemed passive, almost sub-missive to the gunfire of his killers. He had the same calm visage and slight build. Bullets crisscrossed his body and opened simultaneous wounds in his side and hand. Other satiric touches, the glowering statue, the bloody hands, the newspaper headline, and especially that cockroach amused anti-Longites nationwide. Such touches presented a less than flattering portrait of the man

4.1. *The Shooting of Huey Long* by John McCrady, 1938. Oil. (Time-Life)

some regarded as hero and savior. But *The Shooting of Huey Long* is suggestive for a deeper, if more obscure, reason. John McCrady finished the painting in his spare time after joining the Federal Art Project in New Orleans. By far the largest New Deal art program, the FAP was also the most controversial, especially in Long's own Louisiana, for reasons the Kingfish himself might well have appreciated.[2]

During his brief and turbulent career Long organized the isolated centers of political power scattered across his state and united them in an alliance of enormous strength. The new organization challenged traditional cliques of political power and social prestige. Long rhetoric promised to redistribute wealth and privilege in his native state, and his actions, though often inconsistent, gave the words a certain credence. His machine swept aside the Bourbon oligarchs, masters of Louisiana since Redemption, and established a massive and unprecedented program of state spending. The Longites built roads, bridged rivers, and brought the rudiments of health care and education to people long accustomed to doing without. Meanwhile, in gestures carefully chosen with an eye for the newsreels, Long flouted tradition and assaulted aristocratic symbols, especially in his running feud with the city of New Orleans, historic bastion of Louisiana social power and political clout. Throughout it all he manipulated traditional images through the new technologies of the mass media, promising to dissolve powerful combinations and protect the liberties they threatened, and to strike the elusive balance between equality and freedom. "Every man would be a king," he had promised since 1928, "but none would wear a crown."[3]

Surely then, it is fitting, that *The Shooting of Huey Long*, a controversial painting depicting the controversial end of a controversial figure, was painted by someone working for a federal agency in Louisiana equally controversial and for all the same reasons. Long's assassination brought the Federal Art Project to life in Louisiana by creating the pretext for a rapprochement between his political heirs and federal relief administrators. By dying when he did Long inadvertently brought to Louisiana a federal art agency cast in his own mold, one determined to establish a powerful cultural alliance fashioned from the isolated art communities of the nation in order to redistribute artistic wealth and power. Styled after Long's own epigram, it was an agency determined to make "every man an artist," something all but guaranteed to cause culturally the same disturbances he had politically.

Organized in 1935, the FAP institutionalized American cultural hierarchy by choosing as its director someone whose background, experience, and understanding of American art and society could not have differed more completely from Edward Bruce's. Holger Cahill was the only son of Icelandic immigrants whose father moved the family to the North Dakota wheat frontier

with disastrous results. Isolation, privation, and failed crops ultimately broke the family, leaving Cahill, then fourteen, to roam the forty-ninth parallel in Jack London fashion. Like Edward Bruce, Cahill, eventually made it to China, though not as a businessman: he stoked coal aboard a tramp steamer. Like Bruce, too, Cahill found art, only from a decidedly different perspective. Cahill reached New York just in time for the Ashcan outburst, where he imbibed the basic values of modern art. Later, he became an art critic, fashioning an anti-industrial critique that blamed the demise of the democratic arts on the rise of machine manufacturing. Cahill insisted that art, rather than being an object of elite possession, belonged to the people and that democratic citizenship alone justified claims to be a democratic artist. Yet despite these differences, Bruce and Cahill devoted their professional lives to the promise of American art, each hoping to make art an everyday experience for millions of Americans. Both struggled to give the American artist his proper role in society, each through opposing methods. Edward Bruce hoped to make art popular while avoiding popular art. Holger Cahill, who believed that the untutored folk were the nation's truest artists, hoped to make popular art the national standard. Both visions worked against values Ellsworth Woodward had worked so long to sustain, but of the two, Cahill's was by far the most threatening.[4]

Cahill's understanding of art and society began with the assumption that "the work of common people with little book learning in art techniques, and no academic training" represented the original and truest American art tradition.[5] Puritans and Quakers began it, he believed, and numerous professional and amateur craftsmen sustained it into the mid-nineteenth century. Between 1820 and 1870, insisted Cahill, American art was less dominated by European tastes, more parochial, and therefore more distinctly American than at any time in the nation's history before or since. The rise of political democracy had fostered a parallel and closely associated cultural democracy maintained by thousands of anonymous craftsmen: "house painters, sign painters, portrait limners, carpenters, cabinet-makers, ship-wrights, wood carvers, stonecutters, metal-workers, blacksmiths, sailors, farmers, weavers, businessmen, housewives, and girls in boarding school." Not only were the arts more readily available to the average American, the American artist reflected and was inspired by the predominant spirit of the day. "If their taste was not [always] the best," he wrote, "it was an honest, genuine reflection of community interests and of community experience."[6]

The coming of the industrial order destroyed the early Republic's political and artistic harmony. Rifts developed between artist, society, and nature, something Cahill attributed to industrialization, mechanization, and the im-

pact of modern science on "romantic conceptions of nature."[7] An avid student of Thorstein Veblen, he regarded the American Civil War as a struggle between incipient industrialism and a dying agrarian order and rued its aesthetic consequences. The war legitimized the machine in American life, he lamented, destroying in the process the social foundation and purpose of the folk art tradition. Antebellum landowners and merchants whose patronage had fostered a vibrant national portrait school were shouldered aside by the new wealth of the industrial age, grubbing parvenu who patronized European art for no better reason than ostentatious display. Worse, handcrafted objects of everyday use were replaced by manufactured items, less handsome but more economical, made and sold cheaply, then distributed widely by the railroad network with far-ranging effects, none of them beneficial. The machine and the rise of manufactures, wrote Cahill, ended the tradition of folk art and effectively closed off the artist from his public for a generation or more. Having rejected the inspiration and comfort their fathers and grandfathers drew from nature, Gilded Age artists either mimicked European styles or worked in solitude. Some, such as James McNeill Whistler, fled the country for the Continent. The rest abandoned their former role as articulators of the values and spirit of the age and retreated within their own "rarefied" styles. "Without society and without nature as its proper foundations," asserted Cahill, "artists turned inward, and conjured all manner of convoluted aesthetics whose value lay principally in their own exoticism and incomprehensibility. The contemporary artist, having lost both nature and man, now seemed determined to lose art itself in the theoretical mass conjured up by his own ingenuity."[8]

This bleak summary of recent American art history was not without its glimmer of hope. While their contemporaries flocked to the continent or shut themselves up in their studios, a small coterie of American painters led by Thomas Eakins and Winslow Homer persisted in the old tradition, using American subjects to reflect upon the nature of American society. Nor had the efforts gone for naught. Eakins and Homer inspired a generation of painters, a recognized school of like-minded artists such as John Sloan, George Bellows, and George Luks, whose work announced a new chapter in American art annals when it debuted at the Armory Show in 1913. "These artists," rejoiced Cahill, "rediscovered the American Scene and brought the gusty vitality of city streets into the staid salons of the genteel tradition," promising to revitalize American art, to make it what it once was and should be, an expression of social meaning. Not even the depression could deny this promise. Certainly, as Cahill conceded, times had toughened for the nation's artists. There had been want and idleness and a resultant loss of skill and spirit. But the industrial calamity had also brought an opportunity seized by the federal government to

re-establish a connection between artist and society severed since Appomattox. Here was a chance to fulfill the promise offered by the return of the artist to the American Scene.[9]

Though Holger Cahill's artistic nationalism echoed the classroom lectures of Ellsworth Woodward, the FAP's egalitarianism, guiding purpose, and organizational structure all challenged the logic of the genius loci. Largest of the New Deal art experiments, the FAP was also the one most determined to make American art a mass experience by creating art through mass production. Moreover, none of the New Deal art projects made so thorough an attempt to nationalize American art by supervising its production, distribution, exhibition, and education at the community level. Ideally, so-called community art centers gathered all FAP functions under a single roof. Artists could develop their skills working in studios accessible to the public. Classroom space would accommodate beginner and more advanced courses in art appreciation and in a range of fine and practical arts tailored to a community's needs. An exhibition gallery would display both local work and FAP shows circulating throughout the country. Meanwhile, not content simply to let the public find a community art center, the FAP sent art and artists to as many public institutions as possible, not only schools but prisons and asylums too. In Florida, classes at the Raiford State Prison led to careers in commercial art for seven inmates. At Bellevue Hospital in New York and in other mental hospitals, art activities sponsored by local FAP affiliates became integral parts of patient care. Edward Bruce might have championed the therapeutic quality of art, but it was Holger Cahill who put the brush in the patient's hand and dared call the results "art." In 1938 Bellevue and the Harlem Community Art Center jointly sponsored a showing of patients' work. Professional psychologists hailed the breakthrough. *Life* responded with urbane condescension. Edward Bruce and Ellsworth Woodward, surely, were appalled.[10]

If Cahill's methods differed from both Woodward and Bruce, then so did his basic form. While Newcomb Pottery reflected Woodward's aesthetic localism and social elitism, and the murals Bruce commissioned expressed his commitment to an art that soothed while it uplifted, then Holger Cahill's form was the print. Bruce always thought that if one masterpiece emerged from either PWAP or the Section, then all his efforts were justified. Cahill disagreed. "Art is not a matter of rare, occasional masterpieces," he asserted. "The emphasis upon masterpieces is a nineteenth-century phenomenon. It is primarily a collector's idea and has little relation to an art movement. When one goes through the galleries of Europe which preserve, in spite of war, fire, flood, and other destructive forces, an amazing quantity of works from the past, one is struck by the extraordinary amount of work which was produced in the great periods."[11] Volume, a synonym for mediocrity to Ellsworth Wood-

ward and Edward Bruce, meant virtue to Holger Cahill, and the print the perfect way to achieve it.

Cahill believed that the print represented the most democratic art form, and championed its recent resurgence. It flourished during the Jackson years, he explained, but fell into disuse after the Industrial Revolution. Throughout the early years of the twentieth century it remained an object of contempt, dismissed as vulgar because of its easy repetition and pedestrian subject matter. Still, despite critical scorn and consumer disinterest, prints began to recover their lost prestige in the mid-twenties with the advent of the American Scene, an occurrence, he observed, of no mere coincidence. The form, he insisted, "is extremely sensitive to the contemporary environment, and is an art rich in social content. It would almost be possible to reconstruct a social history of our period from the prints produced on the Federal Art Project." There were other virtues. Because the print so often depicted contemporary scenes and because it was so easily multiplied, it approximated more closely than any other form the spirit of American democracy. Its subject and message was easily understood by the broad mass of Americans, and its cheap price made it accessible to the average viewer. Through the print, Cahill could reach the masses and demolish barriers between his artists and the society they served. As a result, FAP artists created thousands of monochrome and colored lithographs, wood-block prints, lithotints, aquatints, linoleum cuts, and wood engravings. Some were inspired by the contemporary social scene. Some were informational posters, advertising WPA functions such as plays, gallery showings, or concerts. Others restored the print's lost social role, broadcasting information on behalf of health agencies and other public organizations in the battle against venereal disease, malnutrition, illiteracy, and other social ills.[12]

Though Cahill insisted that both the print and the organization he administered represented attempts to restore lost traditions, not even his powers of persuasion, considerable though they were, could mask the new directions his project implied. The FAP commitment to the print extended beyond mere production to technical innovation. The New York City project, easily the largest in the nation, featured a separate graphic arts division whose workers refined and pioneered such breakthroughs in the print process as color lithography and color wood-blocks. But its greatest achievement and, given Cahill's values, its most fitting legacy was the popularization of the silk screen printing process. Here was popular art in the fullest sense, reproduced easily and distributed widely in a form attributable to no particular place and adjustable to all.

To an unprecedented degree during the 1930s, with Holger Cahill's help, American art became a commodity, something created in bulk and consumed in mass, a trend more conservative minds deplored. Machines and techno-

logical innovation might hasten production, but it also devalued art, these critics charged, undermining its ultimate purpose as a regenerative force in American society. Since the middle of the nineteenth-century, Americans had relied upon art as a way of sorting out the social chaos of a newly emergent industrial order. Art made good people, the logic ran, and was vital to the creation and maintenance of social cohesion. An appreciation for art not only became an important cue to social rank, it also represented a way of ensuring proper values and good behavior among the lower orders. The FAP, of course, threatened all this since it was making the wrong sort of art for the wrong reasons and sharing it with the wrong people. Worse, the subject matter, aesthetic style, and underlying social values all threatened to undermine traditional justifications of local power and prestige. As they appeared on local canvases, industrial subjects reminded viewers of powers beyond their control, as though depression headlines were not reminder enough. Meanwhile, the integrity of local places continued to vanish through artistic interpretations following a national aesthetic whose social assumptions proved equally threatening. Both as the modernizers of American artists and promoters of modern art, the barrier-smashing, egalitarian enthusiasms of FAP organizers touched nerves doubly sensitive in the South. There, either by design or accident, the combination of federal organization and modernist assumption promised to disrupt the region's racial relationships, and in Louisiana not even Huey Long had gone this far.

These were neither values nor endeavors likely to win friends among the New Orleans social elite. The same people who opposed Long also patronized Louisiana art, in a city long regarded as the cultural citadel of the American South. But no sooner had Long's meddling ended when influential Orleanians, specifically art promoters and patrons, found themselves fighting yet another round of the ancient American fight. Long's threat had been internal, an earthquake from the bottom up. He had thundered out of the piney woods, shouting class antagonisms and, especially in his national phase, promising to level society. His true intentions remain conjectural. Given the opportunity New Orleans's old nemesis built a comfortable home as near the Garden District as he could manage. Yet, the message had resonated, both at home and across America. Now in his passing, if unintentionally, he gave rise to an external threat: absorption from above. The new perceptions of art and society adopted and employed by the FAP posed challenges through the arts similar to the ones Long embodied at the polls. Both involved breaking the New Orleans monopoly. And while opposition to the federal art idea in New Orleans was never so embittered as its opposition to Long, it was as deeply entrenched, where local art promoters greeted the FAP with an enmity once reserved for the Kingfish himself.[13]

2. "Mr. Stanton's Attitude"

In 1935, the problem child of American democracy, the segregated South, was also, in the estimation of FAP organizers, the problem child of American art. Holger Cahill and his associates shared with Edward Bruce a gloomy assessment of southern art, and included the region among its principal targets in the campaign to achieve national cultural parity—the aesthetic equivalent of the Agricultural Adjustment Administration (AAA). Strategy dictated the tactics. When he arrived in Washington in August 1935, Cahill enlisted a southerner to attack the southern front. He was Thomas C. Parker, former director of the Richmond Art Institute and an ideal choice. Parker was native to the region, someone who spoke both with a pronounced drawl and a keen understanding of the problems of southern art. He was also a man with whom Cahill was already familiar, having worked with him in 1931 on the project to restore colonial Williamsburg, Virginia. Four years later, as director of the Federal Art Project, through a combination of professional respect and organizational desire, Cahill made Parker his assistant director and never regretted the choice. At heart an educator, Parker was also a scrupulous administrator whose aggressive promotion of the federal art idea won real gains for the movement across the South. Before the close of the federal period in 1939, FAP units were established in all but three states of the former Confederacy: Arkansas, Texas, and Georgia. A southerner pioneered the idea of the community art center, institutional heart of the FAP program, and the first of these was established in the South. Some enjoyed an astonishing success, especially in Florida where a chain of community art centers stretched the length of the peninsula all the way from Pensacola to the Keys. Others dotted the southern interior. In the Mississippi Delta and the North Carolina Piedmont, among the Smoky Mountains, even in the tidewater societies of Richmond and Charleston, Parker and his staff found fertile ground for the federal art seed. Each center opened, each exhibition unveiled, and every art class organized confirmed the success of the effort and quickened the movement's pace. Yet for all the hope and promise, and all the success elsewhere across the South, there was one crucial place where the federal art program met not cooperation but contempt, a cultural citadel whose sustained resistance threatened to wreck the whole campaign.[14]

When it organized their project and began its operations, the national staff of the FAP found New Orleans art in much the same state it had occupied in December 1933. Once PWAP closed the following May, Ellsworth Woodward resumed his myriad other art-related responsibilities while most of his former employees returned to their garrets in the Quarter to support themselves as best they could. Others organized the New Orleans Art Guild

to promote the sale of their work. Little else happened until the fall of 1935, when Holger Cahill wrote to Woodward outlining the organizational structure and aesthetic ambitions of the new Federal Art Project. Word quickly spread among the artists, many of whom cheered not only the prospect of relief but also the project's popular spirit. "I am very anxious to learn more about this very valuable cultural movement," wrote Conrad Albrizio, the fresco painter; "[it] offers such promises not only to the individual artist, but for the South as a whole." Among others, the news stirred even greater rejoicing. Privately and publicly, one New Orleans critic trumpeted the arrival of a new era in American art. "The old art is . . . no tape by which we should measure the power, consistency, and life of our own vitality," announced A. J. Angman. "The tempo of our modern life is full of color inside and out . . . [and] the new . . . patterns are gathering us up in its meshes, weaving a new sky and a new earth. Individuals, groups, and whole nations will change and the new art will epitomize the events in quick strokes and dashing colors." Privately, to Holger Cahill, Angman surmised local conditions and posed the fundamental question. "We need new leaders with courage, new ideas and vision," he wrote the National Director. "In Louisiana . . . anybody can become an art critic. . . . He must have only some money or else pull and society connections. Is that going to be changed?"[15]

Cahill intended to answer in the affirmative. Every tenet of his aesthetic philosophy and social outlook conspired to wring art from the hands of the privileged few and return it to the people. Having set out to bash down the museum walls and to spread art along the city streets and country lanes, he recruited like-minded individuals across the nation to direct the efforts of statewide projects. Generally he was successful, a capable administrator, whose easy affability masked his determination to control his project. By tact and flattery, sometimes with humor and sometimes more bluntly, Cahill assembled a team of state directors more or less sympathetic to the underlying values of his project. Most were solid choices, a handful never worked out, and one in particular, certainly the one he most regretted, was the man Holger Cahill selected to direct the FAP effort in Louisiana. Grandson of Lincoln's secretary of war, Edwin Stanton and namesake of his secretary of the navy, Gideon Welles, Gideon Stanton seemed to combine the finer qualities of neither man and the worst of both. Like his grandfather, the younger Stanton could be vain, petty, and overbearing. With Welles he shared a measure of vindictiveness and the capacity for a poison pen. But unlike the former, Gideon Stanton was not an industrious administrator devoted to his task, and unlike the latter he was unwilling to subdue his private interests in the service of a larger effort. His correspondence conveys a self-righteous tone and an inflated formality smacking of the pompous. As a subordinate he was often petulant,

as an authority frequently imperious, and as director of the Louisiana section of the Federal Art Project he was a man whose career is endlessly revealing.[16]

He came to the post through a circuitous route. Gideon Stanton was born in Morris, Minnesota, sixteen years after his grandfather's death, was graduated from the Rugby Academy, studied art in New York and Baltimore, then joined his father's brokerage firm in New Orleans. He prospered as a businessman, although evidently at some cost to his personal happiness. In midlife Stanton changed professions, quitting the bond market for the art studio, and devoted himself to painting. He preferred oils to other media, employed a conservative representational style, worked diligently, and exhibited regularly. In the meantime, with his friend, Ellsworth Woodward, Stanton assumed several organizational responsibilities on the local art scene. In 1912 he joined the board of directors of the Art Association of New Orleans, becoming its secretary in 1921 and its president six years later. He was also, in 1927, a founding member of the New Orleans Art League. Then the hard times came. Together with other unemployed New Orleans artists, Stanton joined the PWAP where he executed a series of local architectural studies. After the project closed, Ann Craton, a traveling representative from the Federal Emergency Relief Administration (FERA), arrived in New Orleans, urging the artists to organize themselves in order to promote their work locally and plead their cause nationally. They did, forming the New Orleans Art Guild under the leadership of Gideon Stanton, then forty-nine years old, a bespectacled man with a balding head. His efforts on behalf of the guild were minimal, confined chiefly to lobbying for a renewal of the art project, yet visible. In the fall of 1935, probably on the recommendation of Ellsworth Woodward and surely because of his PWAP experience and guild work, Stanton's name came under consideration for the state directorship of the Louisiana project. There seemed no other choice. Parker interviewed him in New Orleans, considered him the best man for the job, and named him to the post in mid-November.[17]

The assistant director regretted the choice almost immediately. Stanton's appointment commenced a three-year brawl between himself and project officials in Washington over every issue of the national effort. The two sides bickered over the nature of the project, its intent and purpose, the extent of Stanton's local authority, the limits of the project's federal structure, the scope and purpose of local projects devised by Stanton, the people he hired and how he supervised them, the work they performed, even the nature of art itself. Three years of this and Stanton finally threw up his hands, a great relief to the national office, but a pyrrhic victory at best. For three critical years Gideon Stanton consistently deflected the efforts of FAP directors to open New Orleans to the federal art idea. At every turn he resisted the egalitarian impulses of the project and frustrated the ambitions of local artists, enthused

with the popular spirit, to organize and to spread "the people's art" along the avenues of the Crescent City. Such stubbornness doomed the federal effort in New Orleans. Despite its prolonged siege the FAP never captured the South's cultural citadel, never made it part of its federal network of community art centers. The efforts did not cease with Stanton's resignation, nor even after the demise of Federal One itself, but they were equally unsuccessful. In retrospect, project officials always counted New Orleans among their most disappointing defeats, a long and costly battle whose opening skirmishes erupted even before the project's first Christmas.[18]

The confrontation began when Stanton appeared to dawdle in hiring artists and deepened when he established the direction their efforts would take. National officials worried that Stanton, who had classified virtually no artists as "professional" in his first three months in office, was sitting on a pool of qualified applicants. He had scanned the relief rolls, he explained in December 1935, but "ha[d] not run across any outstanding material." Throughout Stanton's tenure some of those so judged took exception, and so did the national officers, who continued to receive appeals from qualified New Orleans artists demanding work. One of these came from Eloil Bordelon, together with the suspicion that Stanton had little use for modern art. Bordelon had visited Stanton in his office, showed his portfolio of abstractionist work, and been summarily told that although the director could not "understand" the paintings, he considered them close to forgery and that "there was no room on the project." Worse, Cahill and Parker suspected that the energies of what few artists Stanton did hire were being misspent on a task contradicting the spirit of the national program. Stanton, they learned, had put his people to work not as creative artists on a production unit, or as less skilled trainees on an Index of American Design project, or even as teachers of art or art appreciation. Instead they were working as janitors and librarians, cleaning, cataloguing, arranging, and classifying the collection at the Delgado Museum of Art and indexing the museum's library holdings. They were, in other words, doing exactly what Ellsworth Woodward had wanted his PWAP unit to do, and this was no coincidence.[19]

Gideon Stanton's temperament prevented his ever serving as Ellsworth Woodward's front man. He was no figurehead for a project the other directed behind the scenes. Yet, there is no discounting the patriarch's wide influence. Stanton and Woodward were long-standing friends and associates. Each admired the other's art and respected his efforts to promote art throughout the region. Both were established pillars of the New Orleans art community who shared not only similar artistic preferences but common social convictions. Stanton had been among the first artists Woodward hired when he established his PWAP office in December 1933. Stanton returned the favor two years later,

as newly appointed FAP state director. Instructed to organize a state advisory board affiliated with the local FAP effort, Stanton's first invitation went to Ellsworth Woodward. Like Woodward, Stanton refused to let relief considerations overshadow an artist's skill, adopting Woodward's position that bad artists were bad investments for the taxpayers' money. He, too, showed an early contempt for modern forms, and given the opportunity Stanton set his unit to work on a project dear to Woodward's heart.[20]

The Delgado Art Museum Project also revealed a parochialism similar to Woodward's and alarming to national FAP organizers. In the effort to stimulate art interests in what they considered to be a culturally disadvantaged region, Holger Cahill and Tom Parker developed a standard program they sought to implement at the local level. Their solution contained an implicit judgment that local institutions had either failed to promote the art idea or had done so improperly, adhering to the old values of the privileged academy and exclusive gallery. Not everyone at the local levels agreed, particularly in New Orleans where Ellsworth Woodward and Gideon Stanton had devoted their lives to building the institutions FAP directors now sought to destroy or bypass. A cycle of misunderstanding deepened, revealing the fundamental conflicts of the federal project. Cahill, Parker, Stanton, and Ellsworth all claimed a common interest in art, a dedication to its preservation in the darkest moments of the national emergency, and a commitment to the value of art in a democratic society. All four hoped to make art an everyday American experience and to secure for the artist full membership in the democratic community. But the means were never so mutually agreed upon as the ends, and no means proved more controversial than the federal structure of the FAP. While national directors hoped to fit the program to local needs, they never intended to make it subservient to the local will. Local authorities shared the ambitions of their national administrators and certainly welcomed federal support in the struggle to establish art in the life of the community. But only the finest line separated support from interference. Even under ideal conditions, this traditional pitfall of the federal system left small room for compromise, and in New Orleans neither local director nor national supervisor ever found the common ground. What one side stressed the other side ignored, permitting a mutual suspicion to develop and fester.

It took only a short while before tempers flared. National authorities were ready to intervene within months of the project's establishment. "I am very much disappointed in the progress made on the project in Louisiana," Tom Parker wrote to Gideon Stanton in February 1936. Parker complained specifically that his state director had shown insufficient energy recruiting employees. If, as Stanton had advised, there really were not enough artists on the relief rolls to fill his project quota, Parker replied dryly, then perhaps there

was no need for someone to direct them. The assistant administrator was even more specific with the administrators of the state WPA apparatus. "I am very disappointed in the work of Mr. Stanton," he wrote to Edna Brennan, director of the Louisiana Division of Women's and Professional Projects. "I wanted someone to take over the work to see if we could not have a worthwhile program in Louisiana. Mr. Stanton has not been very active or rather he hasn't the initiative to develop a program. Under the circumstances, I think it best that after due notice you release Mr. Stanton from the payroll." Parker may have confused initiative with interest, but the tone was clear, if not the action. Stanton stayed fired for less than twenty-four hours, in a change of heart Parker neglected to explain. Instead, he rehired his state director, or rather, requested a stay of dismissal. Then, in a final effort to save the Louisiana project, he decided to take matters into his own hands. Parker arrived in New Orleans in mid-February, met with Stanton, supervised the filling of the Louisiana quota, and hammered out a temporary ceasefire with his state director.[21]

There had been a fair trade-off. Stanton kept his job in return for a project functioning more or less according to Parker's directives. It still took several months before Stanton finally turned the Delgado project over to regular WPA workers, freeing his artists for more productive work, but when he did it was to undertake a project that absorbed the state director's interest and won his wholehearted approval. During his visit, Parker discussed with Stanton the Index of American Design, what one scholar considers "the finest legacy of the Federal Art Project." First proposed in 1935, the Index intended to catalog the incredible variety of indigenous American craftsmanship through a "meticulous photographic-cum-archeological type of illustration." New England Shaker crafts, Hispanic ceramics in the Southwest, or ironwork in Maryland, the Index would collect it all, especially objects falling into disuse or disrepair. Though he would come to see the Index as the visual counterpart of the American Guide, organizing so vast an undertaking daunted Holger Cahill, despite his enthusiasm for folk art. But in an illuminating role reversal, Cahill's uncertainty was more than matched by Gideon Stanton's enthusiasm.[22]

Few southerners, Tom Parker included, showed more interest or greater devotion to the Index of American Design than did Gideon Stanton himself. Indeed, no aspect of Stanton's project experience commanded greater personal attention or awarded more satisfaction. In his one major article explaining FAP operations to the local press, the state director devoted three full pages to his Index project and dispatched the rest with a single paragraph. The attraction was both personal and professional. Stanton was the absolute master of this unit, judge and jury, whose approval every plate required before being sent to Washington. It was an ideal role for someone of his temperament, but

the Index, more than any other FAP undertaking, also matched the director's view of art and his understanding of the proper role of the relief artist on his project. In content, execution, and in underlying social and aesthetic philosophy, the Index matched the conservatism of the New Orleans art establishment—at least partially. Ironically, the Index managed to combine the most radical and conventional aspects of Holger Cahill's entire art program. As Cahill himself realized early on, the Index was the one genuinely national project of the FAP, and in the cultural sense one pursued without regard to ethnic hierarchy. With but few exceptions, and those were driven by organizational demands, the Index considered all groups as equal participants in creating indigenous American designs. But there was also enough conservatism to the Index to render Gideon Stanton either blind or indifferent to its farther-ranging social implications. Its subject matter celebrated the craft traditions of the American past, while the methods used to create Index plates harkened to an even earlier age. While other FAP units revolutionized mass-produced art, the Index utilized a guild system already centuries old. Across the country, New Orleans included, older, more experienced artists supervised the Index projects, offering advice and counsel to younger charges. The Index was thus part record and part classroom, a training ground for younger talent, and the FAP project resembling most closely the sort of art activities Ellsworth Woodward himself had organized as a PWAP regional director. The Index conformed to Woodward's artistic environmentalism, prompting local artists to study local subjects. New Orleans Index workers were not some faceless unit churning out oils and watercolors similar in theme and content to dozens of other groups within the federal effort. Rather, as Stanton himself observed, they recorded "the social progress of the American nation, together with [the] local color of a time and place." Here, as in no other aspect of Stanton's FAP service, balance existed between federal supervision and local autonomy.[23]

Still, the balance was easily disturbed. In the spring of 1936 Holger Cahill arrived in New Orleans to direct the establishment of an easel unit within the Louisiana operation, something national officials had urged for months to no avail. Stanton clung to the Woodwardian position that relief artists were, by definition, inferior craftsmen whose works should not be permitted to decorate public institutions. This was the attraction of the Index project, since it demanded skill and craftsmanship in the service of a worthwhile research project whose merits benefited artist and patron alike. The easel project promised none of this. Instead, the specter of relief recipients with little artistic skill and less supervision haunted Gideon Stanton and seemed to him a colossal waste of time, energy, and supplies. He found no sense in a project whose technical competence, so limited from the start, promised to create such a good deal of bad art. None would benefit save the relief worker himself and

only temporarily by extending for another month or two the sad delusion that he was an artist worthy of patronage. Cahill relented and a bargain was struck. He got his production unit, six easelists, who commenced operation in May 1936, and Stanton determined the personnel, six non-relief painters chosen because of skill and not need. The state director also retained dominion over this group. When they started he handed each one a pint of turpentine, a pint of linseed oil, a set of ten colors, seven brushes, stretchers, other supplies, and a memorandum ordering each artist to be at his easel from nine until four every Monday through Thursday, to complete daily time sheets, and to report to the director's office for review at the end of every second week. Standard sizes of canvases were issued, small, medium, and large, each with its own corresponding time limit for completion and explicit instructions concerning content. "The subject matter is to include no nudes, no religious subjects, [and] no propaganda," charged Stanton, and "the subject matter is to be native to or typical of the state." The instructions were terse and overbearing, much in Stanton's character, and never softened despite Tom Parker's repeated entreaties. Nevertheless, after six months, two visits, and a fair number of heated exchanges, the assistant director now had an operational art project in New Orleans.[24]

The ensuing calm did not last long. Eighteen months later, at the end of 1937, Gideon Stanton submitted his annual summary of project activities. His easel unit, the director observed, had maintained a steady level of production, completing an average of thirteen paintings per month. The overall quality of the work had remained, in his judgment, "fairly stable," permitting a number of local allocations and the collection of an exhibition due to open in New Orleans shortly after New Year's. Work also continued apace on the director's pet project, the Index of American Design, where the yield was even richer. Early Index activities had confined themselves almost exclusively to recording the extensive ironwork that latticed New Orleans, especially in the French Quarter. But during 1937 local researches had been widened to include such areas as textiles, furniture, ceramics, and native costumes. The five artists assigned to the Index had worked feverishly and skillfully. Despite personnel changes, including the loss of a supervisor who took a job in the private sector, Stanton's artists finished better than two plates per month with no harm to the quality of their output. "It is a source of gratification," the director observed, "to note that there has been a steady and consistent advance in the technical accomplishment of the artists."[25]

A single cloud hovered over this otherwise rosy horizon. Stanton's glowing summary of project activities coincided with the opening of an exhibition by the local chapter of the American Artists' Congress, featuring works by more than twenty-five artists, some of them FAP employees. Arranged at the

New Orleans Public Library, the show included a number of modern styles and themes, and its own minor scandal. Outraged library officials banned two nudes, one by an Index researcher and another by Eloil Bordelon, the young abstractionist whom Stanton had denied employment. One of the pieces, commented local critic Edith Ballard, "is certainly not the type of thing one might expect to find on a library wall, or for that matter outside a pathological manual. Merely tacking on a title is not enough to 'elevate' such a 'study' to the rank of 'art.'" Nor had she much use for the other piece, Bordelon's "somewhat abstract conception of the essentials of creation," something "good for those who like that sort of thing." Small pruderies aside, the showing no doubt galled Gideon Stanton. It had been organized, according to Myron Lechay, chairman of the committee supervising the exhibition, for reasons dear to national FAP ideals. "These exhibits," he explained, "are part of the campaign begun recently by the group to educate the public in the appreciation of art, and to stimulate public interest toward passage of the pending federal arts bill. This bill, if passed . . . would provide for the establishment of a permanent Federal Bureau of Fine Arts [and] would make the art work now being done under WPA grants a more steady and sure project." "Artists' Congress," "permanence," "federal," and "modern art" were all dirty words in Gideon Stanton's lexicon, terms he associated with a movement he deeply suspected and, when possible, actively thwarted. Worse, they had been uttered by Myron Lechay, a young painter with whom Stanton had recently exchanged sharp words in a confrontation revealing the complex and controversial nature of the Federal Art Project in New Orleans.[26]

By the time of the Artists' Congress showing, these two men had been feuding for almost a year. Little is known about Myron Lechay except that he was a Russian immigrant, had studied under Robert Henri and George Bellows, and that he believed deeply in the promise of the new art movement of the 1930s. He was a modernist in aesthetic practice and social outlook, befriended a local black poet, Marcus Christian, and became a critic of Jim Crow. Ultimately, he left the closed society of New Orleans for the skyscrapers of New York, lingering just long enough to become the major cause célèbre of the Louisiana project. In December 1936, Myron Lechay, president and organizer of the local chapter of the American Artists' Congress, visited the office of Gideon Stanton, state director of the Federal Art Project in Louisiana, requesting on behalf of his organization a full report by the director revealing any future plans to reduce the number of artists enrolled on the project. Stanton would not stand for it. He showed Lechay to the door, reported his actions to the national office, and filed the incident in memory. Six months later, in response to a nationwide WPA quota reduction, the Washington staff ordered Stanton to trim two artists from his rolls. The first choice was easy,

a noncertified painter who did not need the support. Then Gideon Stanton, director of the project, summoned Myron Lechay, FAP easel painter, to his office and fired him, citing a number of reasons. Lechay had been a charter member of the easel unit, had enjoyed its benefits long enough, and had no dependents, explained the director, making him a logical choice. Moreover, said Stanton, Lechay had become a liability to the project, devoting too much time to his "very pronounced activities on behalf of the Artists' Congress" and not enough to his own easel work. Finally, the director questioned Lechay's artistic skill. Since the national office in Washington had recently returned several of Lechay's paintings, having failed to find an interested recipient for the work, Stanton reasoned, little choice remained. As director, he maintained that duty required him to consider other, more skilled artists, first. Closing the issue Stanton gave the knife a twist, suggesting that if Lechay truly needed relief work he should contact one of the WPA labor projects.[27]

Within days an angry letter from Myron Lechay landed on the desk of the national director. Its author minced no words. "In singling me out for dismissal," wrote the artist, "Mr. Stanton . . . expressed his disapproval of my connection with the Artists' Congress. He frequently voiced his resentment to me. He did not like 'his artists' to get mixed up in this." There were also hints that the director doted on a coterie of favored artists. Several of them, explained Lechay, had no need for a relief check. Some owned expensive cars and properties. Many held second jobs. One was not even an American citizen, and others "fresh out of art school" stroked the director's vanity. "I never accepted the suggestions Mr. Stanton made when I brought my paintings into the office," Lechay reported, when "other artists took back their pictures to modify them accordingly; but my failure to do so displeased him." Cahill attempted to minimize the incident by plying a middle course. He advised Lechay to take his case before the local Labor Relations Board and renewed warnings made to Stanton since the original incident, urging the state director to refrain from any disparaging remarks directed toward the Artists' Union, the Artists' Congress, or any similar organization.[28]

Months elapsed before reaching a resolution satisfactory to almost no one. Lechay took Cahill's advice, appealed his case, and lost it. Then he confronted Stanton on the streets of the Quarter, became "rather insulting," in the director's estimation, and followed up this incident with another personal appeal at Stanton's office. The director refused all pleadings. Rather, Stanton warned Cahill that Lechay's return would jeopardize local efforts and was more blunt with the artist himself. "I regret to have to advise you," he informed Lechay, "that I see no prospect of your again being placed on the Federal Art Project here." This closed the matter in Stanton's view, but the tide had al-

ready begun to shift in Lechay's direction. He had done more than simply yell at or plead with Gideon Stanton since his dismissal in June. Throughout the late summer and early autumn of 1937, Myron Lechay spent much of his enforced leisure writing to national WPA officials concerning his case, the operations of the FAP in New Orleans, and the efforts of the local chapter of the American Artists' Congress to spread the federal art idea in a hostile environment. His organization, he informed Ellen Woodward, National Director of the Women's and Professional Projects Division, WPA, not only promoted art locally but advocated the sort of cultural pluralism at the heart of New Deal idealism. "We openly declared that Negro artists and art students should be given equal opportunities," he wrote, but "at present a Negro in New Orleans may not attend an art exhibition without a special note or permit . . . difficult to attain." The local Artists' Congress, he asserted, had also championed the need for a municipal art gallery and for public displays of the project's easel unit. Yet the state director stonewalled every suggestion. "At no time during the entire year was an exhibition of this sort arranged," the artist lamented. "[W]e discovered new painters of distinct promise and since they were poor we urged their enrollment on the project. Mr. Stanton preferred to take on a few of his personal friends who were not in need at all. . . . We tried to expand the project to make it part of the whole life of the community" but succeeded only in angering the state director, who in private conversation repeatedly admonished his rebellious modernist "to mind his own business."[29]

Lechay's pleadings found sympathetic ears in Washington, and with good reason. Tom Parker and Holger Cahill were certainly no champions of Gideon Stanton, with whom they had already been at frequent loggerheads. When Lechay's reports arrived in Washington describing the director's overbearing nature, his favoritism, his sustained indifference to the federal art idea, and abuses and violations in his hiring practices, they reached minds already predisposed to believe them. Besides, reinstating Myron Lechay afforded Cahill and Parker the perfect opportunity to impress upon their reluctant state director the authority of the national office, and in this case what made good organizational policy also made sound political sense. Lechay was the member of a national organization of artists whose support Parker and Cahill could not jeopardize. The American Artists' Congress consistently defended the federal art idea and, at the same time, comprised the largest organized pressure group advocating federal support for the plastic arts. To be sure, the organization could be the FAP's sharpest critic, usually applauding WPA efforts while insisting they be extended. But the support far outweighed the criticism, and the national director knew it. Moreover, he also knew that the national office of the Artists' Congress was well aware of the difficulties their local chairman

had encountered in New Orleans at the hands of someone they considered to be an outdated reactionary—conclusions Cahill and Parker had reached long before.

Organizational needs and political expedience aside, there were always the facts of the matter. In the fall of 1937 Myron Lechay was an artist whose work, if difficult to allocate, bore the unmistakable stamp of professional skill. He was certified on the relief rolls, and a vacancy existed on the project. "Myron Lechay is an artist who has good training, has received considerable recognition for his ability and work, and, regardless of what you or I think of his present work," wrote Tom Parker to Gideon Stanton, "he is still widely recognized as an artist whose training, experience, and ability would qualify him to be employed on the FAP." Under Parker's order Lechay returned to work in November, just one month before the Artists' Congress exhibited. Stanton made no response, nor a single mention of the episode in his annual summary of operations, perhaps as clear an indication as any of the state director's outrage. Stanton's immediate bosses, the state supervisors of the Louisiana WPA, shared the anger if not the silence. James Crutcher, the state WPA director, Maud Barret, his director of the Louisiana Employment Division, and even Leo Spofford, matronly and usually unflappable state director of the Women's and Professional units, all voiced their dissatisfaction. "Since being released from the project," wrote Blanche Ralston, regional director of the Women's and Professional Division to her superior, Ellen Woodward, "Myron Lechay has repeatedly embarrassed the state administration with the pressure he has attempted to organize in promotion of his reassignment to the project." The entire state staff had reviewed the case, she reported, and voted unanimously not to reinstate, but their advice had been ignored. National FAP officials had intervened directly over the state heads "creating a situation deeply deplore[d] in Louisiana." "Such occurrences as these are not appreciated by the State Administrators," warned Ralston, as they "provoke unpleasant situations with reference to the Federal Projects within the states." The protests, duly noted, made their way into the project files in time for a Christmas truce between all parties. Lechay returned to his easel and unveiled the Artists' Congress show. Stanton assembled the facts and figures of the annual report. State supervisors and national administrators focused on more pressing details, and the uneasy alliance between the FAP and its Louisiana project, delicate even under ideal circumstances, held for another two weeks. Then another one of Gideon Stanton's easel painters took an unscheduled Christmas holiday, and the fat went in the fire once again.[30]

When he was a young man growing up in Michigan, Douglas Brown wanted to be an engineer. He took his bachelor of science degree at Harvard and a graduate degree in chemical engineering across town at M.I.T., then

went to work as a lighting expert in the Edison labs in New York. In 1927 the company sent him to New Orleans where he was to supervise the opening of a new facility. Nature decreed otherwise. Brown arrived in New Orleans just days ahead of the great flood, where the rains swept away the plant he was to have opened and redirected his life. Doubtless a professional curiosity drew him to the spot below New Orleans where engineers dynamited the levee to relieve pressure on the city, but the trip had unforeseen consequences. When the levee burst it loosed a flood of passion in Douglas Brown's heart. The rush of water, the roiling colors of tide and earth, what seemed to be the boundless powers of nature overwhelmed him. He resolved on the spot to become a painter and chased the ambition with an engineer's persistence. He spent the next three years under the tutelage of an established local artist, often painting a picture a day, presumably in the hope that energy expended equaled skill accumulated. Meanwhile, Brown immersed himself in the artistic ferment of the Quarter. He mingled with other artists, seeking advice and criticism. He helped to organize the "Provincial Group," a short-lived collection of artists and writers who operated their own gallery and published their own journal, the *Quarter*. Brown left New Orleans in 1930, returned to New York for two years, then traveled the Caribbean, drawn as always to the power of nature. In Haiti, stricken with dysentery, he watched a hurricane drive hundreds of frightened natives before its fury, an experience so galvanizing that he rose from his sickbed, seized his brush, and worked at his easel uninterrupted for days. In Guatemala, he painted an erupting volcano, and in Mexico, he succumbed easily to the human tumult of the revolution. There he met the three luminaries of the Mexican art movement, Rivera, Orozco, and Siqueros, absorbed their aesthetic fervor, and earned their attention and praise. Rivera broke a long-standing habit and bought one of Brown's paintings. Government commissions followed. Later, the former engineer became the first American in six years invited to exhibit at the Mexican Government Art Gallery. But a brief stint with the Mexican Department of Education ended abruptly when Brown was fired in retaliation for the dismissal of several Mexican nationals from the New Mexico FAP unit.[31]

With no immediate prospects, the artist drifted back across the border. In November 1936, almost destitute, Brown returned to New Orleans looking for work and using as references Stefan Hirsch, Diego Rivera, and his former French Quarter teacher, Myron Lechay. Master and pupil visited Gideon Stanton, who liked Brown's work and appointed the painter to the FAP easel unit in the spring of 1937. He may have been the only thing Myron Lechay and Gideon Stanton ever agreed upon, but in aesthetic preference and social outlook Douglas Brown was much closer to the former than the latter. Like Lechay, Brown advocated the popular tenets of the new art and had the

pedigree to show for it. By the time Stanton handed him his colors, brushes, and admonitions against nudes and propaganda, Douglas Brown was already a member of the Mexican Association of Artists, the League of Revolutionary Artists and Writers, and, of course, the American Artists' Congress. Titles of his FAP works such as *American Orphanage, Boom in Steel*, and *The Four Stations of the Day* reflect his commitment to pedestrian scenes and subjects. But another project responsibility Brown assumed in the fall of 1937 indicated his dedication to carrying art directly to the people. While the squabble widened between Stanton and Lechay, a three-cornered correspondence developed between the embattled director, project officials in Washington, and William Stuart Nelson, president of Dillard University, a historically black college in New Orleans. Nelson wanted art classes and an exhibition gallery established at the school under project supervision but lacked funding for the entire endeavor. Tom Parker, who had the eye for it, spotted an opportunity for a catchall compromise. He approved organization of the art class, then advised Stanton to have Myron Lechay teach it. Nelson would get his class; Lechay could work at something worthwhile according to his own aesthetic and social creed at a place far from Stanton's sight. It might have worked had not Lechay and Stanton bumped into each other on Royal Street and gotten into a shouting match. Instead, the compromise dissolved, the controversy grew more acrimonious, and Douglas Brown, not Myron Lechay, wound up teaching the class at Dillard.[32]

Brown could not have been more pleased, either with the work or the results. The combined responsibility of his easel work and teaching load required his keeping hours well beyond the maximum permitted on the project, but at the director's request Brown refused to claim any overtime. Instead, he continued to make the trek to Dillard, and so did his students. Many, lacking bus or streetcar fare, walked all the way from Louisiana Avenue, a distance measured not in blocks but miles. Their desire also surfaced in their work, and, perhaps a little too much, Brown wished to share this with the public. On Christmas Day 1937, he boarded a bus for Washington, hoping to secure an exhibition of his students' work at Howard University. During the visit, Brown met with Tom Parker twice in two weeks, interviews granted on Brown's "urgent request." But sometime in between chats he ran out of money, and there the trouble began. Brown wrote to Stanton requesting the director to forward his check, the first notice Stanton had that Brown was out of town. Worse, before leaving, Brown had neglected to fill out his time sheet and had left a note for a fellow employee asking her to complete the chore, crediting him with the time spent in Washington. Stanton responded with predictable rage. He refused to forward the check, invalidated the time sheet, and sent Brown's file to the regional WPA office for investigation.[33]

In the meantime, no doubt sensing Stanton's ire, Brown took steps to cover his tracks. He wrote Stanton once more, stating that Parker himself had permitted him to use the overtime hours accumulated on the Dillard project to cover hours lost on the trip to Washington. Then he grew bolder, stating, allegedly under Parker's advice, that easel painters were entitled to vacations of up to two weeks provided they made up the time, and that the Dillard hours were applicable. This did nothing to soothe the state director's temper. Instead, in an angry letter, Stanton advised Leo Spofford that this second instance of federal meddling, right on the heels of the Lechay fracas, established a clear and intolerable pattern of national indifference to local sensibilities. Spofford and the other supervisors of the state WPA operation agreed. Other projects were administered through her office, she complained to State Supervisor James Crutcher, but not the Art Project, whose national administrators not only intervened over her head but did not even bother to direct correspondence through her office. For her part, and for Stanton's too, she had had enough and recommended terminating the project in Louisiana. Crutcher, who agreed, warned Ellen Woodward in Washington that unless future actions and correspondence were routed through proper channels, or the project was administered exclusively from Washington, his people were prepared to scrap the entire program. Once again, only eleventh-hour intervention saved the project. Tom Parker disavowed most of what Douglas Brown had said and left the affair completely in local hands. With the approval of the Louisiana WPA office, Stanton invalidated the time sheets, docked Brown's hours from the date of his last completed painting, sometime before Thanksgiving, and fired the painter. This action, if not Lechay's reinstatement, received space in Stanton's annual report, and when it did no one in Washington raised a whisper of protest. By then, another temporary peace had been established, more fragile than the others and shorter in duration, for it had come at greater expense. Years of quibbling and months of quarreling had worked to the advantage of neither and the dissatisfaction of both. Tempers and time were growing short.[34]

By the spring of 1938 national project directors had promoted the idea of establishing a community art center in New Orleans for more than two years. Gideon Stanton rebuffed every entreaty. Instead, the activities of the Louisiana project, for the first two years of its existence, represented a tacit compromise struck between mutually suspicious parties. Project directors in Washington, anxious to establish themselves in the cultural capital of the South, had bankrolled a limited version of the national plan. In New Orleans they had established a production unit similar to those operating throughout an expanding federal art network and a research project, the Index of American Design, one close to the aesthetic and social ideals of the local art

establishment. The compromise favored the locals. Despite the existence of the easel unit, evidence suggested that it was not being used according to national intentions, and additional efforts to establish federal art instruction in the city also met frustration. By 1938, then, project officials in Washington might rightly have begun to question the worth of their efforts. Indeed, some account must have been taken, for within a year of the Lechay and Brown affairs, federal supervisors resumed their aggressive promotion of the community art center. This time, however, they appeared ready to force the issue, touching off one last confrontation with Gideon Stanton.

Local opposition to the center had not been universal. Certainly it enjoyed the support of Myron Lechay and his fellow members of the American Artists' Congress, as well as numerous other New Orleans artists. Then, too, articles on the community art center published in the local press excited public interest. National administrators led by Robert Armstrong Andrews, a regional FAP director, resolved to tap what they considered to be a gathering well of underground support. When Stanton forwarded an article he had released for local publication describing the nature and purpose of FAP efforts in New Orleans, Andrews took the state director to task for a missed opportunity. The article had not so much as mentioned "the broad national program of the community art centers," an inexcusable lapse, lamented Andrews, who suggested that any future writings the director intended to publish be cleared through the national office. Next day the regional director wrote to Leo Spofford with a public relations ploy calculated to build popular support for the center. Andrews enclosed a *Reader's Digest* synopsis of an article on FAP activities published in *Time*, suggested that the condensation was of ideal newspaper length, and requested that Spofford secure its publication beneath a headline questioning why New Orleans had not joined the federal network. He then resumed pressure on the state director, offering general guidelines for organizing community support for the center, various fund-raising strategies, tips for securing the cooperation of the business community, and one clear warning: "You have a good opportunity in New Orleans and I don't want you to overlook it. It is essential that the development of the community art center begin now and it is your responsibility as State Director to do so. For more than two years you have been receiving from this office information and instructions regarding the Community Art Centers and nothing whatever has been done in New Orleans to cooperate with the National Program in this respect."[35]

Stanton rose to the challenge with a characteristic response. "I am duly in receipt of your rather tart and uncalled for letter," he replied, "impl[ying] remissness on my part for not having taken action in the past two years towards

establishing here a Community Art Center." His wounded pride demanded justice. Stanton insisted that he had acted with complete fidelity to national directives at every turn and that his only sin, if any, lay in his failure to carry out an order never issued. Although he was aware of the national effort to establish community art centers throughout the country, he explained, "at no time have I received direct instructions from Washington to proceed in the matter." Rather, any offense had been directed the other way. "Not once has my opinion as to the necessity for a Community Art Center in New Orleans been asked for," complained the director, "in spite of the fact that for the past thirty years I have been in close contact with the Art interests of the community." He then questioned both the purpose a center might serve in New Orleans as well as the ultimate ambitions of the national administrators. "In following through any set [FAP] course," Stanton observed, " . . . you may find that art activities are already adequately provided for amongst the pupils, some of whom are doubtless underprivileged, of the city public schools. I suggest to you that you have a survey made fully to ascertain to what extent, in face of existing facilities, a Community Art Center is necessary and vital to New Orleans, unless, of course, the permanency of the Federal Art Project in the community is the only issue and is to be forwarded regardless of existing art facilities, or anything else."[36]

The issue could not have been made more clear. "Mr. Stanton's attitude is somewhat provincial," commented Douglas Bear to Holger Cahill, who suggested that time was running out for the new art in New Orleans. The viability of the FAP depended ultimately upon local goodwill, both Bear and Cahill knew, something nonexistent in the city by the fall of 1938. By then national administrators were both exasperated and determined to force the issue. Meanwhile Stanton considered himself under attack from all sides, harassed from below by the Lechay crowd, harried from above by Cahill's administrators. National supervisors continued to press for a community art center, less with carrots than sticks. Stanton began to receive critical reviews of his Index plates. He took it personally and responded resentfully. The tones grew increasingly bitter once national authorities began, in addition, to question the quality of the easel efforts. Finally, in November, Stanton requested a vacation. Project officials, perhaps suspecting the response, turned him down. There was no going on. The director's resignation became effective shortly after the first of the year. Three years it had gone on like this, a long deadlock finally broken. Now, despite the fatigue and frustration, FAP administrators looked with hope to what might happen in the new year.[37]

3. "Mrs. Durieux's Enthusiasm"

Gideon Stanton never recorded his reaction to leaving the FAP. Given the changes soon to recast the project, he may have regretted not holding his post just a few months longer. Given the controversies he experienced and criticisms he encountered, he may have regretted taking the position at all. Perhaps he relished the opportunity to resume paintings interrupted by his unhappy tenure as a federal bureaucrat. It is certain, however, that just weeks after he cleared out his desk, Stanton's thoughts were not about any of that. They turned instead to the death of Ellsworth Woodward, the old defender of the genius loci who passed from the scene just as the federal art idea began to catch hold in New Orleans.[38]

Woodward had been no friend of the Federal Art Project. Though he accepted Stanton's invitation to serve on the statewide board of advisors, in thought and action he opposed at every turn the project's egalitarian ideals, its experiments in mass-produced art, and the insistence of its directors that relief considerations took precedence over the quality of artwork produced. Like Gideon Stanton, Woodward applauded the Delgado Museum Project and supported its extension. Like Stanton, too, he cheered the Index of American Design. "I realized from the first announcement the practical value of such a compilation of historic examples of design," he commented to Holger Cahill, "but now that you have a glimpse to show of how impressive the work is and will be in completion, one is doubly impressed." Beyond these, the most localized and conservative FAP activities, Woodward remained either aloof or openly hostile. He passed no judgment on the skills and production of Stanton's easel unit or the community art center idea, although his devotion to artistic craftsmanship as PWAP director and his lifelong commitment to local art institutions suggest his opposition.

The depth of Woodward's concerns surfaced when he took sides in the debate over establishing permanent federal patronage. Permanency had been Edward Bruce's intention all along, a cause pursued until his own death in 1943. The effort, ultimately in vain, reached highwater mark in the spring of 1938, when Congress debated and denied the so-called "Coffee-Pepper Bill." Woodward opposed it down the line, echoing conservative criticisms that permanent federal supervision would sponsor the creation of bad art by patronizing a select group of favored stylists and sap the initiative of American artists through a dole system rewarding indolence. As president of the Delgado Museum writing on behalf of the Southern States Art League, Woodward aired his views in a public letter opposing the bill, a ringing defense of local institutions and local ideals in one of his very last pronouncements on American art. He turned seventy-seven in 1938 and lived for another seven months.

Toward the end of February 1939, his enormous energy finally gave out. He contracted a cold he never shook. Two weeks later, pneumonia stilled hands that for fifty years had known no rest, flashing before classrooms and across countless canvases, shaping a vision of American art and society as alluring as any Newcomb ware, and as fragile. Now two of his former pupils would direct the new art in New Orleans.[39]

Three weeks after Gideon Stanton resigned, Robert Andrews picked his successor, a bright and witty art teacher at Newcomb College named Caroline Wogan Durieux. One month short of her forty-third birthday, Durieux was a small woman with dark hair drawn back and wound into a tight bun. Andrews liked her from the start. She is "splendidly equipped to serve the Project as State Director," he reported, a skilled craftsman and experienced teacher, who had traveled widely, developed a cosmopolitan character, and had all the right ideas, meaning she shared an interest in the federal art initiative, especially the community art center. Her work possessed "vitality and humor." She showed promise as an administrator, and best of all, perhaps, she was no Gideon Stanton. "Her personality is cooperative and she is well-liked by many different groups in the city and state," wrote Andrews. "Most important, I feel she has the imagination and initiative to carry through a strong program and that she can secure support from the general public." Durieux was also a native Orleanian. She had been born into a Creole family and grew up, as she later recalled, in "the old Wogan house on Prieur Street where multiple cousins and aunts and various 'kinnery' . . . would gather. And the chatter of French would only be silenced when grown-ups and children collected in an Aunt's room who led them in prayers as she knelt in her long-flanneled night-gown with her hair braided in long 'pigtails' for bedtime."[40]

Such formative experiences shaped her career. Durieux always credited her Creole upbringing for instilling within her a sense of satire, an ability to see through artifice and pretense. Even the sturdiest facades crumbled before her pen and brush. Her art mocked the self-important, deflated the smug and arrogant. It lcvclcd, in the political and social sense, although she never invoked the stridency of the social realists. "No one better than she knows how to depict the intellectual abdication of our own smug classes of second rate conformers," wrote one observer. "She tilts at a world she has always known, moved in, and rebelled against." Durieux was only four when she resolved to become an artist, and her training commenced formally in Ellsworth Woodward's classroom at Newcomb where she was graduated in 1917. She won the New Orleans Art Association scholarship that year and used it to continue her studies at the Pennsylvania Academy of Fine Arts, where she received her first exposure to the modern art movement. In 1920 she married Pierre Durieux, a Creole export merchant, and over the next fifteen years followed her husband

as his business interests drew the family to a variety of Caribbean posts. There were stops in Cuba and South America, and another lasting seven years in Mexico, where Caroline met Diego Rivera and where her art matured. She became a lithographer, softening the points of her satirical barbs and establishing her own social vision. Critical acclaim followed. Rivera painted her portrait and wrote lavish tributes of her work. Others agreed. "Her work is her own, original, personal, without outside influence," wrote the critic Carl Zigrosser. "She belongs to the groups of social commentators, satiric, witty, keen, and amusing in her observation of the foibles of humanity. She creates types and endows them with the truth of life and the enduring memorability of art." This quality of her work and outlook also interested the writer Carleton Beales. "So capable is the technique, the color and composition of the work . . . so satisfying and unobtrusive her aesthetic," he wrote, "that the observer is drawn at once to the subject matter: a whimsical yet realistic portrayal of very definitive types."[41]

All of this Durieux brought with her when Pierre fell ill in Mexico and the family returned to New Orleans in 1936. They took a flat in the Quarter on Chartres, where Carrie went looking for work with her characteristic directness. "I need a job," she wrote her friend, Lyle Saxon. "Pierre is broke and I must help. At the end of the month I will be home and fall on you like a ton of bricks." It worked. Saxon found Durieux a spot in the office of his Louisiana Writers' Project, making illustrations for the *New Orleans Guide*, then nearing completion. From there she had taken a position on the Newcomb faculty where Robert Andrews found her just before Christmas 1938.[42]

Durieux started on the first of February and spent her spring unfolding an ambitious program to spread the federal art idea across Louisiana. She arranged for exhibitions of project work at the Newcomb art school, in the gallery of the Louisiana State Art Commission at the Old State Capitol in Baton Rouge, in small towns in between such as Reserve and Edgard and Covington, even in the Jim Crow branch of the New Orleans Public Library on Dryades Street. When she established art classes for children and adults in Baton Rouge more than seventy people applied the first day. Nor was she through. Additional classes were organized in Boothville, a tiny town near the mouth of the Gulf, and at the People's Community Center, a black church in New Orleans. Sculptors went to work, designing decorations for the Audubon Zoo and more practical objects such as benches, drinking fountains, and wading pools for the Magnolia Street Housing Project. Durieux submitted proposals to reestablish a ceramics unit on the Newcomb campus, and to give her project a genuine statewide character by using project vacancies to hire needy artists from across Louisiana and not just, as had been the practice,

in New Orleans. She lobbied New Orleans mayor Robert Maestri and came away with a monthly commitment of fifteen hundred dollars. In the meantime, the requests of potential sponsors piled the director's desk. The city of Shreveport solicited art classes similar to those established in Baton Rouge. Dean Hard at Dillard still hoped for an FAP allocation gallery. Among others, representatives of the Canal Street Branch of the New Orleans Public Library, the Lafayette City Hall, and the Iberia Parish Courthouse all requested murals of various sizes and themes.[43]

Each exhibition, each class, each parish or state art organization brought into the network represented one more coup scored by the new director. Her national supervisors delighted in the efforts and the enthusiasm, especially Robert Andrews, whose May 1939 visit to the project convinced him that Louisiana finally had a state director "who [could] carry through the program . . . [with] the support of both the progressive and reactionary groups in the City." But Andrews was hopeful for other reasons. While in Louisiana he tightened the organization's structure and give its administrators a crash course in public relations. In addition, Andrews met with local powers in New Orleans and in Baton Rouge, wooing their support. He also hired an administrative assistant for Durieux, enabling the state director to spread the art idea across Louisiana while someone else did the paperwork. He was Arthur MacArthur, an aspiring novelist, whom Andrews hoped to make the project publicist. Since its inception, Andrews instructed MacArthur, the local project had suffered from a bad press. "In Louisiana," he wrote, "the public has not learned to respect the Project as a technical and cultural agency. About six months ago, I recall very well the prevailing attitude which was that any paintings allocated were a 'taking-off-our-hands' of material for which no one had any use." In the future, he advised, care must be taken to present the Project as a contributing member of the community deserving respect and support.[44]

The visit and the instructions also anticipated the culmination of hopes long deferred. While in New Orleans, Andrews and Durieux thrashed out the idea of establishing a community art center in the city, and within weeks the new state director submitted a formal proposal for the projected Orleans Parish Art Center Association, a nonprofit public corporation, whose FAP assistance depended on the adherence of the center to federal guidelines. The center would maintain a continuously changing exhibition gallery, featuring two shows running concurrently, one of art collected across the country, the other, chosen by the art center director, to represent local efforts. Both showings could include industrial, commercial, and home arts, as well as painting and sculpture. The community art center would also furnish gallery talks and other educational opportunities for the general public, including studio in-

struction in as many fields of art as possible. Finally, the center would house the production units of the local project, whose efforts it would display and promote throughout the community.[45]

But just as art on the federal plan seemed certain in New Orleans, the roof fell in again. The Orleans Parish Art Center Association never advanced beyond the drawing board. Instead, two decisions, one national and one local, combined once more to frustrate all efforts to establish the federal art idea in Louisiana. The first, made by Congress, ended the federal organization of the arts projects, limiting them to the states. The second, a technical ruling by Alma Hammond, in effect proscribed the local unit to the limits of Orleans Parish. The congressional stipulations atomized Federal One, demolished the Federal Theater Project outright, and left the other three art projects to scrounge for state and local sponsorship in order to continue operation. Although the Washington office continued to function, the congressional decision effectively severed it from the local projects it formerly administered. Cahill, Parker, and the national administrators retained their offices in Washington but were powerless before local authorities free to ignore or accept their advice. They could plead, they could suggest, they could counsel, but they could not coerce. Worse, from an organizational perspective, an "eighteen-month ruling," written into the Emergency Relief Act, prohibited any WPA worker from receiving more than eighteen consecutive monthly relief checks. The rider triggered massive layoffs among the veterans of all the arts projects, precisely those least expendable in the transition from federal to local sponsorship. Employment quotas dropped in some areas. The number of community art centers plummeted everywhere. And new channels of communications, even more arcane and less flexible than their predecessors, reflected the national shakeup. At the state and local level, too, people lacking technical expertise in the arts made vital decisions affecting the operations of the art projects.[46]

In New Orleans, the project reeled under a combination of new burdens shared by all of the projects as well as crises all its own. While Congress demolished the federal structure of the FAP, Alma Hammond, regional supervisor of the Women's and Professional Projects, now the State Service Projects, forbade the Louisiana project, sponsored by the city of New Orleans, to operate beyond the city limits. In effect, said Hammond, no statewide program existed since, technically, the New Orleans-based project had no state sponsor. The effect dashed most of Durieux's hopes. Until sponsorship could be found, months later, the Baton Rouge art classes ceased along with every other plan to expand art activities across the state. Even after the Louisiana Art Commission assumed the responsibility of state sponsorship, circumstances frustrated the long-awaited expansion. As the art commission arrived on the scene, Rob-

ert Andrews, who had been in ill health for several months, left it, taking with him a solid reputation and ending the fine working relationship he and Carrie Durieux had established. Worse news followed in a ruling handed down from the new Federal Works Agency (FWA), effectively ending any further attempt to create a statewide art program. Since she had assumed the state directorship, Carrie Durieux and Robert Andrews had labored toward this end and had begun to make real strides before the organizational reconstruction of 1939. Durieux persevered in Andrews's absence, huddling with state WPA directors to establish an interlocking system of state and local sponsorship capable of sustaining a grassroots art movement across Louisiana. The plan called for the Louisiana Art Commission to act as the state sponsor and coordinator of local efforts to establish whatever art activities each community desired. Ultimately, the director hoped, six community art centers could be assembled into a statewide art chain. The New Orleans project, administrative and technical headquarters of the network, would provide the manpower, sending artists as needed to points in the hinterland for the same wages their colleagues made in the City, but therein lay the rub. The WPA wage scale differed according to region and community, and national director of the Community Services Projects, C. E. Triggs, refused to bend the rules.[47]

The ruling dashed any hope of a statewide program. Through some artifice the Baton Rouge art classes resumed in September 1940, but that was the extent of it. No community art centers were established in Louisiana. Neither Lafayette nor Iberia Parish got its federal muralists, and a ceramics unit, though much discussed, never returned to the Newcomb Art School. Dean Hard never got his allocation gallery, though Myron Lechay and two of his confederates continued to offer lessons at Dillard. Instead, the federal structure of the FAP destroyed, the Louisiana project confined to New Orleans, a city hostile from the start to any white-collar WPA project and especially this one, the former national supervisors and the present state director contented themselves in the fall of 1940 with a victory more symbolic than real. In September, they dedicated an exhibition center in a building on Toulouse Street in the Quarter donated by a wealthy local art patron. The federal incubus had not only been tamed but quarantined.[48]

4. "American Art for every American Home"

The demise of Federal One and the failure of statewide expansion coincided with the formation of "A New Southern Group," an ad hoc and short-lived association of Louisiana artists who briefly bore the federal art torch. With one rule-proving exception, a seventy-year-old physician and self-taught amateur, it was a remarkably homogenous collection, sixteen painters, sculptors, and

printmaker with a common artistic background and outlook. They were almost all university-trained professional artists with a common demographic and aesthetic profile. Of the sixteen, only five were alive at the turn of the century. One was thirty; the other four were toddlers. The rest, born after 1900, shared an average age of thirty-one. They were also all modernists, committed to the social values of the new art. Two were Newcomb alums trained by Woodward, who then pursued additional studies, respectively, in Philadelphia and Paris. Five attended the Art Institute in Chicago. Another studied at the Rhode Island School of Design and two more in New York at the Arts Students' League. Most were also university affiliated. Three taught at Newcomb, two ran one-man departments at small private colleges in Louisiana, and two others, including its director, Paul Ninas, supervised classes in New Orleans at the Arts and Crafts Club. Four more belonged to the art department at LSU, sponsoring agent of the group's second and final traveling exhibition. Finally, a collective resumé covered all of the federal art bases. Three were FAP artists, including Caroline Durieux and her eventual successor as state director, the former PWAP sculptor Angela Gregory. Six others had earned Treasury Section commissions, among them Xavier Gonzales, the prolific muralist and veteran of the diminutive Treasury Relief Art Project.[49]

The New Southern Group toed the federal line, sharing the regionalist principles of American Scene painting and the egalitarian social ideals of the government programs. Some, it seemed, had little choice. Among these sixteen artists, one had studied with John Sloan and another with George Luks. Two, including John McCrady, studied with Thomas Hart Benton. "The aim of the society," the group announced at its inception, "is to exhibit our work and by thus acquainting the people of our region with what we are doing, to become recognized as an integral part of the cultural structure of the New South." They hoped, in short, to become the artistic voice of the region, communicating southern values through a distinctly southern visual language. "Louisiana's cultural and natural advantages," proclaimed Conrad Albrizio, a transplanted New Yorker and group member, "should enable the state to play a leading role in the evolution of a distinct and interpretive southern art." Yet neither Albrizio nor his colleagues were advocating the art of the genius loci. The group rejected the ethereal themes and classical allusions for the vernacular subjects of the American Scene. Sometimes, they explored irrational themes abhorrent to the tastes of their genteel predecessors, and often they painted with an emotionalism expressed through studies of black culture.[50]

Black life fascinated these artists. Though "nigger tales," a longstanding subgenre of southern art and fiction, became a minor growth industry among Louisiana writers during the 1930s, the painters and sculptors of the New Southern Group rejected their conventional stereotypes. Instead, like

their modernist colleagues elsewhere, through black portraiture and especially studies of black religion, these artists explored the irrational dimensions of human emotion through canvases calculated to subvert the genteel tradition. "Art is not the copying of nature," asserted Angela Gregory, who as group president in 1939, used tones that would have mortified her former teacher, Ellsworth Woodward. "It is, rather, the artist's job to translate what he sees and feels," she insisted. "Consciously or unconsciously he translates the life about him and becomes truly the greatest historian of his environment and civilization." Gregory's commitment to an emotional interpretation of her environment made her sensitive to the role of blacks in southern society. "I appreciate more each day the rich, artistic back-ground of the South, and the important part the Negro has had in its history," she reflected in 1938. "I spent a good portion of my summer . . . sketching negro characters." She was not alone. At one time or another, McCrady, Durieux, Albrizio, and most of her colleagues in the group made intensive studies of black life and culture.[51]

They did so for additional reasons as well. If studies of southern blacks offered a means of confronting the values of the genteel order, they also reflected a commitment to the principles of the new art. The painters and sculptors in this group were among the first generation born, reared, and come to maturity in industrial America, and their art tastes and social values reflected this condition. As children of the industrial order Gregory and her colleagues developed a certain cost/benefit dimension to their aesthetic speculations. They yearned for a utilitarian art whose value justified energies expended in its creation. The artists conceived of art as a service rendered on behalf of the community and the nation, a positive force enriching the lives of all Americans. The art of the New Southern Group served a purpose, the members asserted, and because it served a purpose it was good. It ministered to the needs of an industrial society conceived of in industrial terms. Members of the group, together with hundreds of their colleagues in the thirties, a group not limited to the plastic arts, conceived of American society as a machine composed of many different yet interdependent groups or parts, all of them of approximate value since the absence of one necessarily disturbed the operation of the rest. Such a relativist conception leveled society by diminishing the room between the classes and the races. In the South, black people, the stage props of the white social world in popular art, letters, and films, now became a valuable tool of social analysis. Since they were a part of Angela Gregory's social world, and since her self-proclaimed role as artist in society required a critical interpretation of her environment, black people could no longer be trivialized as apes, buffoons, and barbarians. Instead, studying black life now became a necessary and useful means of achieving social self-awareness.

The utilitarian conception of art deepened the egalitarian spirit of its champions. Like so many of their colleagues throughout the country, the group's members thought themselves to be participants in a broad democratic movement destined to breach walls of elite privilege. "I visited practically all the museums in New York, Philadelphia, and Boston," reflected Julius Struppeck, a young Louisiana sculptor, after touring the East Coast in the fall of 1940, "but I found more inspiration in Times Square and Rockefeller Center. Museums are so dead and stuffy." For Struppeck and others, the new art preserved and extended the democratic tradition, giving its practitioners a sense of national comradery. Edward Bruce, to whom Struppeck addressed his remarks, spoke for them all when, in one of the many section bulletins he drafted, he insisted that "we shall become aware increasingly that as artists we are working not only as individuals, but as indispensable parts of a great nation-wide cooperative plan. . . . We artists shall realize that, while one group is creating works of art for one city or town, other groups equally intent, are working for other parts of the country." But national solidarity involved its own set of local consequences.[52]

The New Southern Group sowed the seeds of its own destruction. Having adopted the values of the new art, it sought to express a modern, critical interpretation of society articulated in a distinctly regional visual language understood by all—impossibly conflicting ambitions with predictable results. It debuted with high hopes in the exhibition season of 1939, fittingly the year Ellsworth Woodward died. The group remained active for two years, then vanished altogether. During its brief existence it impressed critics and won praise from both Carrie Durieux and Robert Andrews for playing a pivotal role, together with the FAP, in establishing an artistic renaissance in Louisiana. Yet, both their modernized methods of production and their modernist aesthetic distanced their work from the region whose uniqueness they strove to express. They worked now not as a distinctly southern group but merely as a unit in the "broad nation-wide movement" which happened to operate in the South, employing forms and techniques and espousing ideals common among affiliated units all across the country—a trend similar to the FAP effort in Louisiana during its final months of operation.[53]

New initiatives and new personnel directed the program in its final phase. With war raging in Europe and across the Pacific, the FAP focused its attention on national defense. Art became the shield of the republic, as national advisors hoping to dissuade sympathy for the fascist aggressors organized a series of cultural exchanges between the United States and Latin America. Caroline Durieux, whose extensive knowledge of the area and fluency in the language made her a prime candidate for the job, agreed to conduct a showing of "democratic art" on behalf of the New York Museum of Modern Art.

She left New Orleans in June 1941, giving way to the last of the Louisiana state directors, Angela Gregory. Gregory was thirty-eight when she took her post, a diminutive woman, barely five feet tall, and an impressive sculptor. She was the daughter of a distinguished professor of engineering at Tulane, and as a young girl she frequently accompanied her mother, a Newcomb alumna and pupil of Ellsworth Woodward, on sketching trips to Audubon Park. Angela, too, attended Newcomb also under Woodward's tutelage, then studied sculpture in Europe. She exhibited her work widely during the twenties and was among the first artists Woodward hired when he opened his PWAP office in December 1933. Thereafter, she supported the government art movement, especially after Durieux's appointment as FAP state director. The two were friends and colleagues, and Gregory was Durieux's logical successor, someone whose tenure marked the emergence of mass art in Louisiana. Gregory supervised the project's conversion to defense work and presided over local efforts organized in conjunction with two massive national art promotions, the "Art Weeks" of 1940 and 1941.[54]

Two weeks after Gregory's appointment, when the *Times-Picayune* featured a story on the New Orleans art unit, reporter Arthur Haliburton found many changes from the efforts first established under Gideon Stanton's supervision. By then the Delgado Museum Project was a distant memory. New Orleans artists no longer cleaned, cataloged, or organized exhibitions of local works for the local institution. The easel unit had also ceased operations, having completed the last of its several hundred views of the American Scene. Instead, local and regional perspectives had given way to a national defense effort communicating patriotic ideals and values to a mass audience. "At 716 Dauphine Street," the project's work studio, reported Haliburton, "artists are preparing posters to promote Army and Navy recruiting, to stir interest in air raid precautions, and other civilian defense activities, to combat disease, and to accomplish other objectives. They design and execute these posters and reproduce them in quantity by the silk screen process." Less than one year later, in the estimation of Alma Hammond, the project had become "truly a war production center." By then, the New Orleans project had created ten thousand posters, twenty times the artistic output of the previous six years. It increased this figure tenfold in its final year of existence, producing a total of more than one hundred thousand silk screen posters, advocating conformity to a variety of acceptable forms of behavior—everything from good nutrition, proper dental hygiene, and precautions against venereal disease to the purchase of war bonds, use of blackout curtains, and silence about defense work. New Orleans artists, in messages easily understood and quickly repeated, now spoke to the masses through a form disconnected from any given place.[55]

The creation of the poster unit coincided, not accidentally, with two efforts intended to promote art on an unprecedented scale. Dubbed "Art Week" by its originators, the promotion, first organized in 1940, hoped to place as many pieces of art in as many American homes as possible. "Our country today is turning towards the arts as at no time in the history of the Republic," proclaimed the movement's publicists. "There are strong currents toward an art of native character and native meaning, which shall express with clarity and power the interests, the ideals, and the experience of the American people." Never before, continued the appeal, had so much art reached so many people. "Popular magazines, reaching millions of persons every week[,] feature reproductions of works of art in color. In 1939, 250 books devoted to the arts were published and many of these made their way into the best seller class." Then there was the work of the government art projects, reaching more than two million people alone in exhibitions opened at the New York World's Fair. FAP art centers boasted an aggregate monthly attendance of more than three hundred thousand citizens, and there could be no counting the numbers who came into daily contact with federally created art in post offices, courthouses, or playgrounds. In all forms, in all media, in all places, art now hung in the public view. Yet, "very few of our artists, craftsmen, and designers are able to support themselves by the sale of their work, and very few dealers in art are able to show a profit at the end of the year."[56]

This was a major confession. Federal art administrators had often predicted that the productivity of their units would stimulate a nationwide interest in art capable of sustaining artists above the subsistence level. Art Week implicitly acknowledged failure. "A broad foundation for a potential public art market has been laid during the past few years," lamented the promotion's organizers, "but so far no coordinated effort has been made on a national scale to put into motion the forces that will bring the work of our artists and craftsmen directly to the American home, the church, the business office, [and] the club, thus opening up [the] broad potentialities of the American art market." The problem of American art, then, was no longer the estrangement of the artist from society, or the cultural isolation of regions such as the South and West, or the concentration of artists in the urban centers of the Northeast. Rather, like the rest of industrial America, the problem of American art was underconsumption, and the organizers of Art Week posed a solution. By coordinating a nationwide sales promotion uniting the productive skills of the American artist with the business savvy of the national corporate community, the organizers hoped to accomplish in seven days what federal art administrators had failed to do in seven years.[57]

The plan was simple. A National Art Week Committee supervised subordinate state and local committees responsible for collecting works from any

artist using any media, arranging the pieces into "Sales-Exhibitions," promoting the event in the local media, and fulfilling the most critical ambition of the entire effort. "The primary purpose of ART WEEK is to stimulate the sale of American Arts and American Crafts," asserted the organizers. "The real success of each Sales-Exhibition will be measured by its actual sales results. The development of an aggressive, comprehensive *sales* program for every Sales-Exhibition is a task of major importance." To emphasize the point, the National Art Week Committee drafted a special series of "Service Help Bulletins" offering all manner of marketing tips. Local committees were encouraged to secure the cooperation of the business community, identified as people experienced in sales, merchandising, and sales promotion work, managers of large retail establishments or manufacturing concerns, real estate, insurance or automobile agency managers, or promotion managers of hotels and newspapers. The bulletins encouraged aggressive tactics with all the trimmings. "Sales-Exhibitions should be set up in a manner which will clearly portray that their primary purpose is to *promote the sale of art and craft items*," the instructions advised. "Sales slogans, price tickets, [and] appealing merchandising displays are silent sales devices that should be utilized generously."[58]

Preparations continued through the fall of 1940 and climaxed at the end of November with the first "National Art Week." When it commenced on November 25, 1940, Art Week was precisely what its organizers had envisioned, the most massive art promotion in American history. Nearly 6,000 organizations participated in the preparation of 1,400 "sales-exhibitions" whose total of nearly 125,000 pieces represented the work of 28,000 artists. State and local committees established in each of the forty-eight states, in the District of Columbia, and the Territory of Hawaii, advanced the cause in any way possible. Sound trucks patrolled urban areas, announcing the festivities. Radio stations broadcast the times and location sites of exhibition centers. Art projects working overtime papered the countryside with promotional posters. Other efforts were more innovative. In some states touring exhibitions loaded onto trucks roved across isolated rural areas. A dairy company in Nebraska distributed Art Week notices with its milk deliveries. In Connecticut Art Week flyers accompanied the monthly billing statements of local department stores.[59]

The effort yielded large returns and an even larger campaign the following year. In a seven-day span, reported Francis Henry Taylor, director of the Museum of Modern Art and National Chairman of National Art Week, Americans bought more than fifteen thousand original works of art, a gross profit exceeding one hundred thousand dollars. The figure delighted Art Week organizers and encouraged plans for a second annual promotion, scheduled like its predecessor for the beginning of the Christmas rush. Taylor gave way as chairman to Thomas J. Watson, president of IBM, and this was no coin-

cidence. "Although Mr. Watson has long been known as an art patron and friend of the artist," explained the release announcing his appointment, "it is rather as a business man that he was chosen by the President to give constructive leadership to this nation-wide program." Under Watson's supervision, not surprisingly, Art Week assumed a more tightly organized, corporate character. He began by pledging nearly fifty thousand dollars of personal income for the purchase of works from every state, then marshaled the resources of the corporation he managed. Each office in the IBM system donated time, organizational skills, and promotional space, encouraging other corporate sponsors to follow its lead. Most did, and once again, seven days of selling netted more than one hundred thousand dollars. True to their word, the promoters of the two Art Weeks had demonstrated the viability of art as a product for mass consumption.[60]

The National Art Weeks of 1940 and 1941 also provided federal art administrators and the New Orleans art establishment a common ground they had not found in five years. Angela Gregory supervised the state committee for Louisiana in 1940, and although activities were confined primarily to New Orleans and Baton Rouge, the future state director saw room for optimism. "We have at least planted a seed," she observed, "for I am delighted to say that already there has come the splendid request for a permanent organization of the combined interests of business men and artists to meet immediately upon completion of Art Week and actually coordinate for the years to come the principles for which Art Week stands." Her sentiments did not go unfulfilled. State relief officials had originally greeted the promotion with suspicion, but the first Art Week preparations had unified the disparate elements of the New Orleans art scene and organized them into a cohesive movement. Every local art organization, radical and conservative alike, backed the event, and although sales had been modest they promised brighter things.[61]

Louisiana's second Art Week was larger, broader, and more tightly organized than its predecessor. Ethel Crumb Brett, a local clubwoman educated at Newcomb and well connected in the community, headed the state committee. Art director of Le Petit Theater in the Vieux Carre, Brett was also an energetic promoter and organizer under whose supervision preparations for Art Week 1941 unfolded across the state. She organized local committees in each major city and many small towns, drafted the speakers of service clubs and civic organizations to publicize her plans, arranged for press and radio coverage, and coordinated the efforts of university and college art departments eager to assist. Nearly two dozen events were staged throughout the state, uniting private and public art organizations of every size and sort. Sales-exhibitions dotted the map, in Shreveport, Alexandria, Baton Rouge, Lafayette, Lake Charles, Monroe, Natchitoches, New Iberia, Ruston, even in such tiny towns

as Thibodeaux, down near the Gulf, and Houma, where the local Art Week chairman sold three of her own watercolors for a total of twenty-one dollars. Preparations were more grandiose, of course, in New Orleans. Brett secured the ballroom on the twelfth floor of the Roosevelt Hotel for her central exhibition hall and supervised its conversion into small sections, "much in the manner of a Paris Salon des Tuileriers." Local firms donated decorative materials, the National Youth Administration (NYA) loaned a battery of typists, and Angela Gregory's unit fulfilled other clerical duties, printed two thousand posters advertising the event, helped to hang the central exhibition, and supervised its dismantling after Art Week.[62]

Art Week 1941, the largest art promotion in Louisiana history, was also the last event of its kind the New Dealers sponsored. When hostilities erupted with the Japanese fewer than two weeks later, the relief projects converted to war work, and what remained of the art program was dismantled in 1943. Though lost in the sensation that followed Pearl Harbor, the Art Weeks are still a cogent reflection, perhaps the logical fulfillment, of the course American art and society followed during the early decades of the twentieth century. They illustrate the growing organization of American life and the emergence of a national consumer culture, something paralleled by the direction of the FAP since 1935. Sprung from what was to have been a temporary relief unit intended to last no more than six months, Holger Cahill's organization evolved into the largest art factory in American history, disrupting long-standing traditions of art production and local patronage. The FAP industrialized American art, placing artists on the wage scale, procuring raw materials, maintaining production quotas, overseeing product distribution and public relations, coordinating the far-flung operations of a vast national effort, even supervising the destruction of inferior materials, the inevitable piece ruined on the assembly line.

The project's industrial character and popular idealism challenged powers previously exercised by local elites. In their struggle to achieve cultural parity throughout the nation, Holger Cahill and his colleagues regarded the American people in whatever locale or region as fundamentally equal and, to a large degree, interchangeable. Assuming this basic equality, the FAP directors concocted a federal art plan organized around an institutional hub, the community art center, with a program of education, exhibition, and production they could implement anywhere in America. Some concessions were made to local circumstances, of course, but never to the extent of compromising the overall federal structure. Instead, when local challenges arose, such as those aired by Gideon Stanton, project administrators defined them as provincial and dismissed them as an unfortunate brake on the national movement.

The collision between the FAP and pockets of parochial resistance was es-

4.2. *Oil Derricks, Bayou LaFourche* by George Ivolsky, n.d. Oil. (National Archives)

4.3. *Ice House Stack* by Edward Schoenberger, n.d. Oil. (Louisiana State Archives)

pecially acute in Louisiana. Three years after organizing the art project in New Orleans, national FAP officials were still engaged in a smoldering feud with their state director, a stubborn localist determined to blunt federal intrusion into his backyard. Neither side emerged victorious in a struggle that typified the basic tensions of the day. The effort to establish the federal art idea in New Orleans pitted strong personalities against one another, but the confrontation that ensued transcended the men and women involved. Instead, it represented the collision of rival sets of political and cultural values. One, rooted in the genteel past, defended a series of hierarchical social relationships defined, in part, through art and devoted to locale. The other, more modern view, reflected a half-century of American social development. It championed a modernized view of American society, national in scope, mass in appeal, and industrial in thought and composition.

The modernization of American art produced mixed results in Louisiana. Trends begun by PWAP, sustained by Section murals, and culminated by the FAP in New Orleans do not reveal the consistent usurpation of a specific locale by a national organization. Similarly, they do not demonstrate the clear success of local resistance. The result, much in the American tradition, was amalgamation, a natural development, it seems, for this most amalgamated place. Local elites retained their grip on art in New Orleans during the Great Depression. But the kind of art they continued to supervise was unquestionably transformed, and in ways that suggest the continued assimilation of New Orleans and Louisiana into a modern national culture, something visible in the visual record of social transformation recorded in a sampling of FAP canvases. Louisiana easel art during the 1930s retained a certain parochial conservatism. For the most part, the art remained more representational and less abstract than in such centers of avant-garde expression as New York.

Still, the paintings document both modernization and modernity. Vertical thrust and structural uniformity inform George Izvolsky's *Oil Derricks, Bayou LaFourche* (fig. 4.2), just as the factory and the web of mass communication unites objects and connects them to things beyond its margins (see fig. 4.3). Clarence Millet's *New Federal Building* suggests the rise of the modern state and the foothold it has gained in Louisiana (fig. 4.4). Two additional New Orleans scenes, Edward Schoenberger's *Ice House Stack* and Alice Fowler's *Garages,* show cubist influence (figs. 4.3 and 4.5), evidence of modern trends also visible across rural Louisiana. What unites and defines the composition of *Ice House Stack* reappears in the segmented spaces of Herbert Frere's *Corner of Street* (fig. 4.6). Even in rural scenes the factory dominates the landscape, as suggested in ways where both rural place and rural people rendered appropriately enough in water color hover alike on the brink of abstraction (see figs. 4.7–4.9). Meanwhile, several Louisiana artists explored the vitality of

4.4. *New Federal Building* by Clarence Millet, n.d. Oil. (Louisiana State Archives)

4.5. *Garages* by Alice Fowler, n.d. Oil. (Louisiana State Archives)

4.6. *Corner of Street* by Herbert Frere, n.d. Oil. (Louisiana State Archives)

4.7. *Misty Morning* by Charles Reinike, n.d. Watercolor. (Louisiana State Archives)

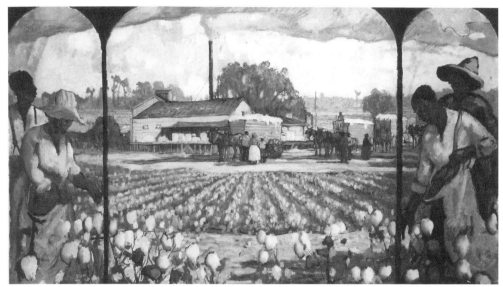

4.8. *The Cotton Industry* by Knute Heldner, n.d. Oil. (National Archives)

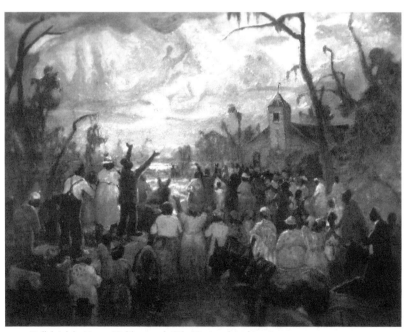

4.10. *Hallelujah* by Knute Heldner, n.d. Oil. (National Archives)

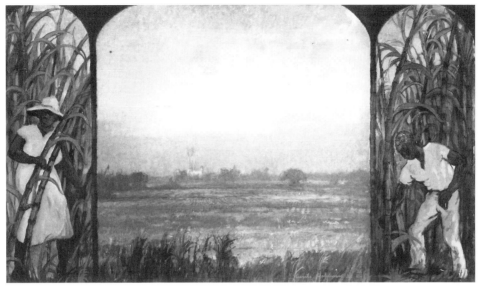

4.9. *The Sugar Industry* by Knute Heldner, n.d. Oil. (National Archives)

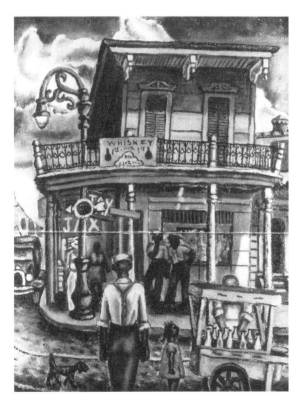

4.11. *Corner of Dauphine and St. Phillip Sts., N.O.* by Jane Ninas, n.d. Oil (National Archives)

4.12. Untitled by Harold K. Pierce, n.d. Oil. Displayed at Prominent Negro Artists Exhibit in Harlem Community Art Center as "An Oil Painting by Harold K. Pierce of N.O." (National Archives)

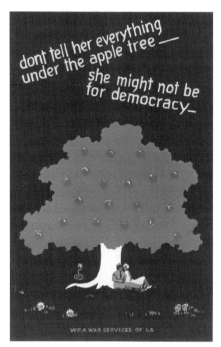

4.13. *Don't Tell Her Everything Under the Apple Tree* by Anon., WPA War Services of Louisiana, 1941–43. Silkscreen. (The Historic New Orleans Collection)

4.14. *Every Bond You Buy Is Mud in His Eyes* by L. Wheelahan, WPA War Services of Louisiana, 1941–43. Silkscreen. (The Historic New Orleans Collection)

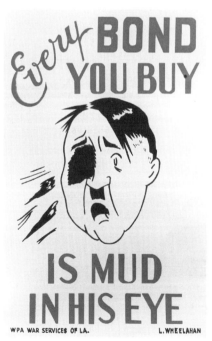

both rural and urban African American life. Knute Helner's *Hallelujah* (fig. 4.10) depicts a rural black congregation, while Jane Ninas studied the urban corner of Dauphin and Phillip Street (fig. 4.11), rich in its opportunities for conversation and consumer enticement. Moreover, modernist explorations of black life in Louisiana were part of a national artistic exchange. Harold K. Pierce's untitled study of an African American man (fig. 4.12) was included in an exhibition at the Harlem Community Art Center while New Orleans hosted a show that included the work of "six well-known out-of-town Negro artists." Finally, two posters made by the Louisiana Art Project suggest a new art for modern America, easily reproduced and able to transcend space altogether (figs. 4.13 and 4.14).

The enormous gulf separating FAP canvases from Newcomb pottery reflects the scale of early-twentieth-century transformations experienced by people throughout Louisiana and across America. Newcomb's arts and crafts experiment hoped simultaneously to refine society through handmade objets d'art while finding an acceptable professional role for a female artist in modern society, aims linked by Ellsworth Woodward's association of beauty with nature. Conceived in the feminine, nature was to direct the entire process, guiding artists by inspiring their designs and uplifting the pottery's patrons by enriching their domestic environments. The pottery thus provided an institutional response to nineteenth-century preoccupations with gendered space, middle class respectability, and antimodernism, making it part, that is, of the "feminization of American culture" so much the focus of contemporary debate then and scholarly analysis since. By the 1930s this focus had shifted. New concerns demanded new solutions, though clearly, as the New Deal cultural experiments suggest, art was still to play a role in building citizenship and creating the good society. Only now modernist assumptions transformed the definition of those terms, undermining nineteenth-century social hierarchies, and modernized methods broadcast this new, more inclusive vision of who Americans were and what America ought to be. In the process, art ceased to be a local concern limited to a specific social class. Instead, FAP administrators were determined to make art a mass experience through mass production, stripping the terms "art" and "artist" of their nineteenth-century class privileges and ethnic biases and making art part of the new consumer vision of America.

Though it had eroded steadily during the last decades of his life, aesthetic localism in New Orleans did not die with Ellsworth Woodward. Others, too, it turns out, shared his concerns if little else, especially a local writer of national stature different from Woodward in every way but one. He had eschewed Garden District respectability for French Quarter bohemianism, high art for popular fiction. He did not build institutions so much as ridicule them, defend

authority so much as flout it. He usually linked refinement with repression, and even if he collected Victorian furniture, very little in his art and experience defended genteel assumptions. Still, at the time of Woodward's death he was conducting his own struggle with modernism and modernity as director of the Federal Writers' Project in Louisiana.

CHAPTER FIVE

Louisiana Guide

1. The Width of a Carnival Mask

W hile American Scene painters and Treasury Section muralists manipulated the aesthetic spaces of thirties America, it would be difficult to overstate the degree to which other Americans trans-formed their physical surroundings. Highways, bridges, parks, and stadia, courthouses and college campuses, Americans either built or refurbished them all, and much more. And when not repeating such projects in impressive numbers, they initiated others on astonishing scale. They wrestled rivers, re-configured urban space, planned suburbs, consolidated farmlands, and reor-ganized the physical display of their past, though never in a cultural vacuum. Instead, their efforts initiated a sustained debate over profit and loss, what was being sacrificed for what was being gained, something reflected in much of the period's considerable artistic ferment. While the American Scene domi-nated the painted canvas it also overwhelmed the printed page as numerous writers, some on their own hook, others at public expense, focused on the American landscape, seeking clues about where the country had been and where it might be headed. In this way, all places were made to say something about America, and in this more relativistic cultural moment, any place was as good as another: Harlan, Kentucky, or colonial Williamsburg; Cimarron County, Oklahoma, or Greenfield Village; uptown Manhattan, Mt. Rushmore, or Pie Town, New Mexico. The logic even applied to the back end of the Loui-siana bayou, where the same issues that shaped Ellsworth Woodward's career and the development of the arts projects in Louisiana determined the efforts and expression of the man who was then Louisiana's most popular author.

By 1930, Lyle Saxon was the recognized literary voice of Louisiana, some-one, he once quipped, "internationally known locally."[1] Four volumes pro-duced annually since 1927—three confections of travelogue and popular his-tory and a biography of Jean Lafite—all enjoyed critical and popular acclaim, making Saxon the recognized authority on New Orleans and Louisiana. He often dismissed these as the "Eatin' books," but they had established him as

heir to a New Orleans literary tradition stretching back through Grace King and Lafcadio Hearn to George Washington Cable, and had led at least one reviewer to hail him as "the new voice of the Old South." Yet, over the course of the 1930s two things undermined what had once seemed so promising a future. The first was Saxon's struggle with his only novel, *Children of Strangers*, a wracking experience marked by years of obscurity and gin-soaked torpor. The other was the cultural ferment of the1930s, and the two were not unlinked.[2]

In 1935, the same shot that killed Huey Long gave Lyle Saxon his second chance. Less than one month after Long's funeral Saxon became the first and only director of the Louisiana Writers' Program. Though his friends would always lament the decision, he jumped at the opportunity, happy, he wrote, "to see the very end of the red plush era in my life!" It was a job, after all, meaning a badly needed measure of financial security. More than that, Saxon found fresh inspiration and renewed determination. As he later confided to one interviewer, the desperate stories told by applicants to his new project finally stiffened his resolve to finish his novel. It went to press eighteen months after he took the job. Most important, the project promised to restore his national reputation by reclaiming his title to local ground, and herein lay the issue. During the 1930s, New Orleans and Louisiana, previously the subject of local art, became part of a national debate over the meaning of American place, forcing Saxon to confront with words the very same issues Ellsworth Woodward and Gideon Stanton had faced with clay and brushes. Only for Saxon, far more so than either Woodward or Stanton, the stakes were greater, more personal. In his case, two specific places in Louisiana were not merely the inspiration for his art or the sources of his literary celebrity. Instead, they lay at the core of an identity he had worked hard to construct and maintain. Through his WPA work, he resisted the modernization of either place while struggling to preserve whatever he could of each. Saving them, he might save himself. But in the end, his participation in the American Guide Program only hastened changes he hoped to avoid, something of tremendous consequence in a life and labor deeply connected to the central issues of thirties America.[3]

When he died in the spring of 1946, Lyle Saxon had two funerals. Bultman's on St. Charles Avenue in New Orleans prepared the body, dressed it, brushed the coat, folded the hands, and powdered the face. Friends and admirers and mere acquaintances attended a service held at the funeral home. Later the closest mourners accompanied the body to Baton Rouge, Saxon's boyhood home, where a second service convened at St. James Episcopal Church, the Reverend Phillip Werlein presiding. Two blocks away, in Magnolia Cemetery, six men muscled the casket to the grave. The Reverend intoned a final prayer. The gathering dissolved. Once the last mourners had drifted away, black men shovelled dirt clods onto the lowered coffin.[4]

By then, friends and editors were already busy recounting the life of Louisiana's most celebrated contemporary author. Most recalled a man of imposing physical and creative stature. He was fully six feet tall and weighed over two hundred pounds. Heads turned when he loped along Canal Street. At Antoine's knowing patrons nodded toward his table. Tourists sought him out for autographs; the bolder among them requested private tours or his company for cocktails or both. Louisianians in general, Orleanians in particular, hailed him as the chronicler of their world. Since the late twenties, they reflected, his short stories and travel writings earned him a national literary reputation. DeMille bought the screen rights to his biography of Jean Lafite. His only novel, *Children of Strangers*, enjoyed brief popular and critical acclaim. More recently, Saxon had served eight years as the state director of the Louisiana Writers' Program, the white-collar relief unit funded out of the sprawling WPA. Saxon's group had been a model of bureaucratic efficiency, perhaps the most successful of its kind, completing three full-length volumes while serving as an editorial clearinghouse for affiliated projects throughout the Southeast. Yet the effort, wrote many, had left a divided legacy. The work reaffirmed the director's reputation as chief guide to New Orleans and Louisiana, but only at prohibitive cost. Long years on the federal treadmill sapped the author's creative vitality. Then his health broke under the pressure of deadlines. Gradually, red tape and triplicate reports silenced Louisiana's clearest voice.[5]

Most observers supplemented the resumé of Saxon's literary career with reflections on a kind and gentle man. Despite his size and celebrity, wrote his friend Judith Hyams Douglas, Lyle Saxon loved all Louisianians great and small. His heart, she assured, matched his frame, a point others echoed. Some remembered how the author's genteel poverty never kept him from being among the softest touches around. Another recalled the tenderness of his handshake. "He had a rare, leaping sympathy which enabled him at will to see with the eyes of another," wrote one interviewer, "[he was] a sensitive, large-souled, and intensely human being."[6] The New Orleans black community applauded his defiance of Jim Crow and counted him among its truest friends. So did men such as Robert Tallant, one among a covey of aspiring young writers who had flocked to Saxon for support and encouragement and gathered under his protective wing. Those nestled closest called him "Papa." Most meant it. Still others remembered Saxon's wit and conviviality. They celebrated the author's air of cultured urbanity, his cosmopolitan éclat. He was, they boasted, the archetypal Orleanian, easy with a laugh and quick with a drink, someone who knew the value of good food and fine conversation. Raconteur whose bar-to-bar tours of the Quarter became legend, keeper of New Orleans's most bohemian salon, "artist with a jigger of absinthe . . . relic of the past harried into an uncomfortable present," lazy man and spirited Carnival

reveler, he was no mere guide to New Orleans but the physical embodiment of all those values the city cherished in itself, as much a part of the cultural landscape, insisted one admirer, "as Audubon Park, . . . or Congo Square, or the Napoleon House."[7]

While some proclaimed him the representative of the city, others made him a symbol of the state. Born to a fine old family on a plantation just north of Baton Rouge, they said, he was a man of aristocratic temperament, charming and graceful, someone who "liked beautiful things" almost as much as he cherished Louisiana's golden age of steamboat days before the War.[8] "In 10,000 libraries his name is linked with the glory that was Louisiana," gushed one admirer. "In his native state he has become a figure almost legendary."[9] Even Lucius Beebe, usually a less charitable if more polished observer, was equally enthusiastic. He dubbed Saxon "the official historian of Louisiana, and New Orleans' most hospitable showpiece . . . a recognized authority on local antiquities and institutions, . . . [whose] progress through the streets and saloons is accompanied to such saluting and adulation as hasn't been seen since the late Huey Long." "He was himself something of the spirit of the town," Beebe later observed in a memorial tribute, "a survivor of the Creole legends of yesterday, an institution . . . [f]or Saxon was a part of the New Orleans and Louisiana of which he wrote so warmly, a conscious holdover of southern chivalry, a courtly and articulate representative of the aspects of the old Louisiana civilization which has not quite disappeared. He was born in dancing pumps and he wore them all his life while being an historian . . . whose books . . . were handbooks to the way of life alike in Rampart Street . . . and the mystery-haunted bayous of the back-country Mississippi."[10]

The life others commemorated, the one Beebe celebrated, was Lyle Saxon's greatest artistic achievement. There were two sides to Saxon's character never separated by more than the width of the Carnival mask he loved to don. He was at once a reluctant modernist and determined antimodernizer, someone caught between the two and beset by either extreme. Born in 1894, he joined the modernist assault on Victorian convention and rejected its abiding faiths in the power of Reason, the assurance of Progress, and the certitude of Knowledge. Likewise, he resisted the immutability of character types and the binary oppositions of Victorian logic: civilized and savage, male and female, black and white. Indeed, Saxon's art and folklore interests reveal someone happily collecting evidence to the contrary. Like most modernists, Saxon believed that only the thinnest veneer of civilization covered the animal passions and baser instincts of the human condition. Like them, too, he believed the inner world of chaotic experience invited exploration and artistic expression. Moreover, he experienced firsthand the modernist enthusiasms of twenties Manhattan. He moved there in 1926 and imbibed the modern temper, accepted many of

its beliefs, and adopted most of its behaviors. Given the choice between black and white, Saxon always chose gray. He shared as well the modernist preoccupation with the animal within, an interest in African American life and expression, a sense of theatricality, and a penchant for alcohol. Yet, if opposing Victorianism was one thing, embracing modernism's fuller implications was quite another.[11]

For Lyle Saxon, some of modernism's "honesty" proved too "terrible" for telling. Unlike most white, male modernists, he never married and died childless. And while Saxon happily staged versions of self for public display, there were limits to the role, restrictions on the truths he told about himself. A man of troubled identity emerges from the work of his biographers, someone of obscure roots and ambiguous sexuality, struggling through adulthood to reconcile his divided character. Though he often regaled acquaintances and interviewers with tales of his plantation youth, in truth he had been born, possibly out of wedlock, in Bellingham, Washington. It is certain, however, that before her son's first birthday Saxon's mother returned to Baton Rouge where, with family help, she raised a child who never saw his father again. Similar uncertainties shroud other aspects of the author's social world. Saxon, likely, was homosexual, although others suggest his bisexuality. Sufficient evidence sustains either possibility; however, the salient point is neither the activity nor the uncertainty but rather the consequence of this ambiguity. Against a mood of truthful exposure, at least on this issue, Saxon remained carefully closeted. While more radical modernist colleagues attacked any social facade as fraud and hypocrisy, Saxon hedged. Victorian convention stifled, to be sure, and he freely rebelled against it. But he never damned facades outright, especially the one of his own construction: his public image as a leisured man of southern letters, the bohemian aesthete of the Louisiana bayou.[12]

Saxon's life, art, and public persona focused on two specific places in Louisiana: the French Quarter in New Orleans and the Cane River country near Natchitoches. These were not simply places where he lived and worked. They were the sources for his stories, the focus of his art, and the foundation of his celebrity. If part of Saxon's reputation linked him to Congo Square and the Napoleon House, the rest was made in North Louisiana, along Cane River. He had first visited the region as a young reporter in the spring of 1923 to write a story about a local artist's colony at Melrose Plantation near Natchitoches. Melrose was owned by John H. Henry and his energetic wife, Cammie, to whom Saxon was drawn immediately. "[She] is one of the most charming persons you have ever seen," he wrote of their first meeting, "[a]nd she is overflowing with love for her fellow man. Her manner is cordial, and her handshake is firm. She wins her to you at once."[13] In "Aunt Cammie," as she was ubiquitously known, Saxon found a kindred spirit and lifelong friend,

and through her he commenced a lasting relationship with the place and its people. He lived there intermittently between 1927 and 1935. Thereafter, he spelled bouts of WPA work with holiday and weekend visits, and when the Writers' Project finally closed in 1943, he planned to retire there, a dream never realized. Three years later, dying of cancer, he was en route to Melrose for a final visit when a hemorrhage forced his return to the hospital bed he died in. Mutual friends sent Cammie Henry sympathy cards.

A common physical and cultural insularity connected these two places. For the most part, when Lyle Saxon wrote "New Orleans," he meant the French Quarter, the original twelve-by-six-block grid platted in 1718. From an early point in its history, the Quarter had been known not so much as a distinct architectural section as its own social world. More recently, however, it had fallen on hard times, and its future seemed uncertain. When the heyday of Storyville ended with the vice crackdown inspired by World War I, the Quarter tottered on the brink of destruction, a marginal space filled with marginal people. City fathers anxious about their civic reputation hoped to raze the Quarter and extend the Central Business District across Canal Street to the river. Instead, during the twenties, in a movement Saxon spearheaded, the Quarter became an arts colony, a southern Greenwich Village, infused with the spirit of bohemian revolt and just as self-consciously opposed to urban boosters as previous French Quarter tenants. Indeed, such different worlds inhered on either side of Canal Street that prolonged absences from desks in the city's financial center were explained as having "gone Quarter." The same kind of isolation characterized the Cane River country, and Saxon invested it with all the familiar virtues of plantation idealists. "Melrose Plantation lies within a bend of the Cane River," he once wrote, "[and] is almost surrounded by this quiet stream. It is comprised of one thousand or more acres, planted for the greatest part in cotton, and it is a little world all by itself. . . . A great many of the Negroes who live at Melrose have never been away from the plantation more than once or twice in their lives. It is that feeling of permanence that makes plantation life so charming."[14]

Not merely insular worlds, these were places populated by people of marginal status. If the Quarter was inhabited by poets and petty criminals—two groups often confused for one another, and neither one welcome on the far side of Canal—Melrose, too, was a place apart, where rural folk lived more closely to the nineteenth than the twentieth century. Some, like Saxon and Cammie Henry, did so as a matter of choice, proclaiming their love for manor as a means of expressing their contempt for modernity. Others were born there as black field hands and sharecroppers or into the mulatto community situated nearby at Isle Brevelle. None was a part of the modern American mainstream, and as such, all attracted Saxon's attention. He spent his adult

life preoccupied with marginal places and marginal peoples, probing and exploring the relative power and powerlessness of the privileged and disadvantaged.[15]

Always at the core of his artistic expression, the margin was Saxon's passion and preoccupation, a focus unifying what might otherwise appear as *ad hoc* efforts, ambitions, and activities. At various times and in varying combinations, he was a newspaperman and editor, a travel writer, folklorist, and biographer, a novelist and a bureaucrat, a bohemian, an art patron, and what now might be labeled a historic preservationist. Nevertheless, a clear pattern and a series of common concerns mark a whole, if complicated, consciousness. As a cub reporter in New Orleans, Saxon slummed the Quarter for a living, relaying the lives and times of drifters and dope peddlers, prostitutes, pimps, and pickpockets. The same theme with only slight variation links his other efforts. Even before the vogue of the 1930s, his travel writings insisted that only by leaving the highway and exploring the byway would someone find the "real Louisiana," and, by inference, the "real" America. A similar perspective even informed his sense of the past. History, Saxon once insisted, was in the footnotes and fragments excluded from the official records and narratives. So, too, were his subjects real and imagined. His fullest literary portraits depicted the lives of women, blacks, and mulattos, by no accident the three central characters of his only novel. The one biography he wrote detailed the life of a pirate, Jean Lafite. The folklore studies for which he became renowned often focused on what Saxon surely recognized as Lafite's black female counterpart: the voodoo priestess Marie Laveau.[16]

Saxon not only identified with the marginal folk he wrote about but numbered himself among them. As a young writer, he made self-reference to a "poor but honest nigger."[17] Later, as an established author frequently interviewed, he voiced consistent laments over having been "born too late." Though he managed to maintain a reputation for unceasing patience among his public, his letters and diaries smolder with resentment at afternoons wasted with social boors and society doyens. No doubt with them in mind, he once sketched a young woman gazing vacantly into a mirror, captioning the image with the phrase: "Society: Why I Don't."[18] His alienation from social convention manifested itself in other ways as well. Throughout his adult life, Saxon collected tales of shocking crimes and the supernatural and other bits of exotica with an enthusiasm bordering on the relentless. Some were clipped from newspapers and carefully preserved; others were relayed or retold by various correspondents. Even as an impoverished writer, struggling with a novel in the early 1930s, Saxon continued to build his library of the grisly and ghostly. Later in the decade, he turned his WPA fieldworkers loose on the state with instructions to add to the collection, and when they did, he treated the

results as personal property. When he closed his WPA office in 1943, Saxon combed through eight years of accumulated New Deal onion skin, carefully separating office record from arcane tale, sending the records to Washington and keeping the stories for himself. Indeed, his final WPA volume, *Gumbo Ya-Ya*, wedges tales of ax-murderers, voodoo priestesses, and body snatchers, between chapters on "Creoles," "Cajuns," and various other ethnicities in and around New Orleans.[19]

The evidence Saxon collected on the subjects he pursued served a double purpose. In one respect, it exposed the hypocrisy of Victorian assumptions about gender and race. His fictional women were neither shrinking violets nor paragons of virtue. They were heroines, sometimes earthy, but always figures of strength and power such as Famie Vidal and Adelaide Randolph in *Children of Strangers*, or Kate Dangerfield in his short story "The Gay Dangerfields." Saxon's folklore collections also featured strong women. He was drawn not only to Marie Laveau but also to a host of charismatic black women, many of them like Mother Catherine, Mother Shannon, or Sister Haycock, who attracted large cult followings through varying combinations of religious zeal, voodoo charm, and faith healing. Nor were such women merely the products of Saxon's imagination; they were also among his closest friends. His own grandmother had been a suffragette and leader of the women's movement in Louisiana; his mother was a journalist; and Cammie Henry, perhaps the most intimate friendship of his adult life, was a robust woman of boundless energy and enthusiasm. Even more casual friendships with artists Caroline Durieux and Alberta Kinsey, the naturalist Caroline Dormon, and Judith Hyams Douglas, the New Orleans attorney and activist, fit this pattern.[20]

If Saxon refused the convention of "the fairer sex," he also resisted the orthodoxy of the dominant race. Here, too, in person and print, he strained against the prevailing currents. At his death, black Orleanians eulogized Saxon as a friend to the race, someone who had contributed to black charities and encouraged the development of black artists, especially the poet Marcus Christian. As a WPA administrator, they recalled, Saxon had established the all-black Dillard History Project—one of only two such adjuncts to the American Guide Program in the South. This had been a Jim Crow unit, to be sure, but one that compiled a record of achievements by black Louisianians in slavery and in freedom, while bringing its members into contact with the national leadership working for racial justice. Surely, such observers predicted, the combination of race pride and organizational opportunity facilitated by Saxon's direction boded well for the African American future. Similarly, race figured as largely as gender in Saxon's literary imagination and folklore collection, and for the same reasons. At its heart, *Children of Strangers* not only depicted with great care the complexity of racial relationships among whites,

blacks, and mulattos along Cane River, it was an impassioned plea for racial tolerance climaxed with an interracial marriage. Likewise, the folklore files are filled with studies, stories, and legends of black life, not only in New Orleans but throughout the state.[21]

To strong women and sympathetic blacks, Saxon added the power of the supernatural in his quarrel with convention. Ghost stories and cemetery tales were standard features of the Gothic South long before Lyle Saxon found them. Still, few people collected the stories in greater volume or told them with more enthusiasm. Each of his published works paused at least once, to relay tales of shocking violence or include a voice from beyond the grave. He interrupted his narrative of the 1927 Flood, for example, to relate the tale of "Molly Glass, the Murderess," "a free quadroon . . . hanged in the public square . . . for a murder so atrocious that it puts to shame the crimes in the Newgate Calendar."[22] The *New Orleans City Guide* devotes an entire chapter to the city's fabled cemeteries. *Gumbo Ya-Ya*, especially, brimmed with tales of heinous crimes and haunted houses.[23]

Through criminal stories and supernatural tales, Saxon linked the power of the antisocial and the extraworldly to the resistance of his marginalized Others. Typically, the protagonists of these stories were women and various peoples of color, all of them joined by their opposition, often violent, to custom, law, or social more. *Old Louisiana* includes detailed accounts of Temba, "a slave who murdered his master";[24] the Fort Rosalie Massacre of 1729, when Natchez Indians killed nearly 250 French settlers; and a pirate attack on a ship carrying Ursuline nuns to New Orleans. Ghost tales rounded out this imagery, not merely extending the resistance but usually intent on punishing arbitrary power and vindicating powerless victims. "The Christmas Tree" in Pontcha-toula, Louisiana, was named by local whites "because once four Negroes hung there during a lynching," Saxon explained. But black Pontchatoulans "always avoided the tree," because "a hanged Negro will invariably haunt the spot near where he is hanged."[25] Tales set in the Carrollton Jail depicted the wrath of spirits outraged by innumerable miscarriages of justice. "New Orleans has more ghosts than there are wrought-iron balconies in the Vieux Carre," Saxon insisted, and these too fit the model.[26] One story told of a young woman whose sweetheart had been killed in the Great War. Unsure about marrying another man, she sought the dead lover's guidance, sitting all night beside his tomb. "At last she heard a noise," Saxon relayed, "and glancing upward saw an old owl . . . overhead." At every pass, the owl dropped a rose in her lap, circling until the woman held fourteen red and thirteen white flowers. These she recognized as symbols for the thirteenth and fourteenth letters of the alphabet. "N" and "O," and "[a]s soon as she awakened to this fact, the roses withered and died." "Later," the story concludes, "she learned that the man she nearly

married was a criminal and had swindled numerous women by pretending to marry them."[27]

If the tales themselves enabled Saxon to distance himself from Victorian convention, the method of their telling strengthened the role through which he blunted the harsher implications of modernist assumption. The ghost stories and other tales of scandal, vice, and violence all share the common voice of the southern paternalist. By affecting the bemused tolerance of "knowing" authority confronting the peculiarities of different, meaning inferior, peoples, Saxon appropriated the latitude such power afforded. In short, he "passed" by speaking through a carefully constructed narrative voice developed early in his career and maintained thereafter. He confided with his readers, implying shared values and common sensibilities, even affording an opportunity for vicarious participation in what the author often depicted as the trial of civilization. Many of the tales unfolded as courtroom dramas, no simple fictional ploy. The court tales created an illusion of clarity, depicting the stark confrontation of order and authority with chaos and anarchy. Essentially studies of deviance, such stories had the ability simultaneously to shock and assure, a profoundly popular and, from Saxon's perspective, useful combination. Through them, he defined the bizarre and established the accepted in ways that both deepened the trust between author and audience and reaffirmed their dominant social position. The stories flattered, telling readers how normal they were by parading the strangeness of others. Moreover, they rarely ended without restoring authority, punishing the antisocial, and returning society to its accustomed courses.

Yet the stories were never so clear as all that. Affecting the narrative voice gave Saxon the opportunity, literally, to open the books on the long history of those defying the power of conventional authority. Soothsayers and conjurers, common criminals and voodoo queens, rebellious slaves, wrathful Indians, tramps, and other drifters, Saxon brought them all before the bar, sometimes in ways making it difficult to distinguish between the accused and their accusers. Close readings of many of these tales reveal authority figures acting as savagely as those brought to "justice." Judges and prosecutors extract confessions through torture. The perjured testimony of a planter's wife convicts an innocent man. Capital criminals have their heads severed and rammed on pikes or their bodies broken on the wheel and placed on public display.[28] Nor was he through. By appropriating the patrician's voice, Saxon not only gained an aura of unimpeachable authority, he obtained an effective means of undermining that very authority, acquiring a liberty he often used to explore the narrowness of the margin separating acceptance from abhorrence. These were, ultimately, cautionary tales serving as pointed reminders about lines easily crossed and often smudged. What made the stories "bizarre" in the

first place was the sudden disintegration of order and the abrupt collapse of appearances. Without warning, the rational went insane. Docile slaves turned violent. A man whom others had shot at and certainly hit reappeared the next day "unharmed." A chapter in *Gumbo Ya-Ya* likens a series of ax murders in New Orleans to "a modern 'Dr. Jekyll and Mr. Hyde.'"[29] Eventually, order returns, though usually accompanied by warnings of how near a thing this had been, and no telling when it might happen again.

These many-layered messages revealed the essence of the author's life and art. Like the figures in his stories and the people of his tales, Lyle Saxon was a protean man of many masks whose characterization of Jean Lafite applied equally to himself. Writing Lafite's biography, he asserted, "was rather like trying to put together a jigsaw puzzle . . . which had been cut into a thousand fragments, and further complicated because upon the reverse side was another picture."[30] The complaint is frequent enough among biographers, only with Saxon the distortion was usually his own handiwork. He surrounded himself with nymphs and satyrs and other symbolist trappings, both in prose and at home. He invented identities and romantic pasts not only for himself but also for people he met in the Quarter—a habit formed as a child, maintained as an adult, and continued after death. As a boyhood prank, he and a friend once posed to a "Matrimonial bureau" as an eligible woman seeking a husband. Responses poured in from across the country, but one suitor, a man from New York determined to plead his cause in person was stopped only after he had reached New Orleans by a telegram explaining that the object of his ardor had lost both legs in a car wreck. This ended the engagement, but the larger charade had only begun. As an adult, Saxon's guided tours through the Quarter often included a formal bow before the invisible if "dashing equipage of the Baron Carondelet."[31] More typically, however, it was in cocktail party conversation, the performance art of modernist discourse, where Saxon displayed his greatest artifice. His former WPA protégé, Edward Dreyer, recalled Saxon's ability to muster the exact facial expression demanded by any conversational twist, an act often practiced whose skill lay in the inverse relationship between Saxon's response and Saxon's disinterest. Appropriately enough, the author's multiple poses continued to appear even after his death. His posthumous memoir, *The Friends of Joe Gilmore*, relayed "semi-autobiographical" stories sometimes from the perspective of his butler, "The Black Saxon."[32]

Indeed, "masking" was the central motif of Saxon's life, something that made Mardi Gras more than the annual pre-Lenten festival, even for this devoted Orleanian. Carnival provided not only the opening scene but the controlling metaphor of *Fabulous New Orleans*, each of whose chapters Saxon likened to "a decorated car which tells a story."[33] But more than that, Mardi Gras displayed in person the world Saxon depicted in print. Every year, just

before Lent, society appeared to turn upside down. Ghosts shrieked and goblins wailed; Indians paraded down Magazine Street, King Zulu reigned, and "nuns danced with devils." Private inhibitions and public barriers all seemed to collapse, much to Saxon's delight. He was himself a spirited Carnival reveler whose devotion to masking surfaced alike in private act and public pronouncement. For several years while he lived there, Saxon and his friend Judith Hyams Douglas rented the Grand Ballroom of the St. Charles Hotel, where they cohosted an annual "all-day Shrove Tuesday gala." It was "a highly informal party," Saxon recalled, whose "only stipulations were that each guest should be in costume and masked."[34]

Saxon's Carnival revelry fit the broader patterns of his life and art. In a very real sense, Lyle Saxon led not one but two double lives. One struggled to reject Victorian convention, while the other sought to avoid modernist exposure. Both utilized a self-constructed persona, a literary and social mask, whose success depended ultimately on Saxon's mastery of places beset alike by modernization and modernism. Across Canal Street urban boosters plotted the Quarter's demise. Extending the business district, they reasoned, would not only expand profits but diminish the kinds of lawlessness threatening the city's image. While modernization threatened cultural assimilation, modernist thought challenged the provincial and the concreteness of place. Saxon feared each and resisted both in more than just literary form. Throughout his adulthood, both in the Quarter and along Cane River, Saxon struggled to preserve the physical vestiges of the "Old Louisiana" that leant the mask credence. In both places he worked to shore up in paint and plaster what he proclaimed in print. Beginning in the 1920s, he moved there and restored two homes to the period of the 1830s, what he always hailed as the city's "Golden Age." Meanwhile, he toured the plantation countryside with Cammie Henry, commiserating with her over mansions gone to ruin, then returned to Melrose to redouble the effort to save it from time and modern trend. He restored the oil portrait of Augustin Metoyer, the mulatto patriarch of Isle Brevelle. Later, he refurbished the old slave hospital at Melrose, converting it to a writing space. There he struggled to record the unique social character of Cane River before it became too late. "Ten years ago this community was far from a highway or a railroad," he once observed. "Today, a highway passes through this community and the old customs are disappearing. The young mulattos, like young people everywhere, are adapting themselves to the modern standards of living." Later, following the publication of *Children of Strangers*, an interviewer asked why he had chosen so obscure a people in so remote a place for the subject of his fiction. "[B]ecause," he explained, "the country is very dear to me, and I wanted to see it put down upon paper before it lost its qual-

ity and became standardized"—a central concern making coherent what others have seen as his inconsistent activities during the 1930s.[35]

2. Papa Saxon's Literary Plantation

The same burdens and concerns that befell Ellsworth Woodward beset Lyle Saxon when he organized his Writers' Project office on the second floor of the Canal Bank Building in New Orleans. Nothing in his modest budget provided for office supplies and equipment, leaving him to beg or borrow everything he needed from affiliated WPA offices equally strapped. In the meantime, he began interviewing prospective staff workers, a host of unemployed hopefuls, among them teachers, newspapermen, aspiring novelists, pulp writers, and the opportunistic. A month spent poring over the maze of bureaucratic regulations required by the WPA, sifting through the operating procedures of the massive and always changing American Guide manual, and wheedling paper clips and typewriters left Saxon "nearer the asylum than I've *ever* been in my life."[36] And the principal strain, as for Woodward before him, stemmed from the constant parade of people desperate for work. Most brought a tale of woe, others an intention "to grab any government money they can—and not work for it." Some were friends, such as Caroline Dorman. Others were complete strangers. Asked for references, twenty-four-year-old J. M. Rowe of Shreveport, produced a wad of rejection slips from the *American Mercury*, the *Atlantic Monthly*, and *Esquire*. An ex-reporter from Alexandria claimed that the son he had lost in the European war more than entitled him to a share of "made work." A man in Baton Rouge, veteran of a different war, argued for work based on his opposition "to the odious dictatorship set up in this state by the present nefarious state political machine." The otherwise scarcely literate application of a black woman concluded: "I have a desire to become a famous writer so help me if you please."[37]

If Saxon's first month on the job produced a reaction similar to Ellsworth Woodward's, it also provided a windfall crucial to the project's future. At one point, Saxon relayed, he was too "nervous and 'all in'" to hold a pen, and at another he simply fled the office, vowing to return to Melrose "with my tail between my legs." There, at least, he was not required to "sit in an office and dictate form letters to poor devils who want work." "If only I had the power to just hire people and then put them to work," he lamented, "but all I say now is 'come back Thursday' . . . and it always tears me up to refuse people who need work so badly."[38] Yet for all his distraction and uncertainty by early November he had hired some thirty people, a mixed group of authors, critics, reporters, and editors, a librarian, a lawyer, and a draughtsman, along with Edward

Dreyer, whom Saxon chose to manage his office. Dreyer, a young man still in his twenties, had earned his B.A. and M.A. in English at Tulane, then gone to Duke, where he completed all the Ph.D. requirements except his thesis. He returned to New Orleans in 1935 and landed a clerkship in the Social Service Division of the local FERA office where Saxon found him. The director thrived on the company of keen young men, often aspirant writers, who made up a disproportionate share of his retinue, but among them all Saxon developed an especial affection for "Eddie" Dreyer.

Dreyer combined wit, enthusiasm, and efficiency in ways that made him indispensable to Saxon, both professionally and personally. When a mutual friend on the project celebrated a birthday, Dreyer telegraphed "congratulations on attaining our mental age, signed the Dionne quintuplets." He quoted Shakespeare to his typists and engineered office pranks, including an impromptu minstrel song performed by a secretary in light mulatto makeup announcing the publication of *Children of Strangers*. He had an incisive mind and the audacity to say so. "The trouble with us is that we are too clever for words," he once confessed, "especially me," something Saxon cherished over the six years they worked together. Dreyer ultimately became the project's assistant state supervisor then assistant regional supervisor, each time as Saxon's right-hand man. After Pearl Harbor, when Dreyer enlisted, Saxon brought all the influence he could muster to keep him stateside and out of harm's way. The next year, a WPA travel assignment provided an opportunity for a brief reunion in Chicago, where Dreyer was training. "Little did I think I'd be spending the afternoon of *Father's Day* with the Ensign!" Saxon exclaimed, reflecting, perhaps, a lingering glow. Eddie Dreyer had bought the childless author a card.[39]

Through their complementary roles, Dreyer and Saxon maintained the project's internal stability, literary quality, and the smooth relations it enjoyed with local and state politicians and national project directors. In Eddie Dreyer, Saxon found someone on whom he could depend for emotional and professional support, not only a confidant to brighten his salon but a capable administrator who whipped the New Orleans office into shape. Dreyer showed an easy grasp of guidelines handed down from the national office and adjusted handily to sudden and frequent shifts in policy and procedure. Later, once district offices had been established throughout Louisiana, he coordinated their activities, oversaw their correspondence, and chided them for their literary style, imploring them not to "use two adverbs where only one will do." Dreyer shielded Saxon from the sort of burdens and imbroglios that produced the high rate of turnover among FWP directors in other states. Instead, Saxon devoted his energies to a careful shaping of guide copy, his first interest, and to cultivating smooth public relations, his last. While Dreyer de-

ciphered procedure and hunted adverbs, Saxon hit the luncheon circuit, addressing local civic leaders and literary clubs, a chore he always despised, yet one accomplished with characteristic charm.[40]

Though he always professed contempt for politics and politicians, Saxon accomplished no mean statecraft by expanding his project statewide amidst the brawl over Huey Long's succession. He had barely opened his office before Long's heirs converted an upcoming gubernatorial election into a popular crusade, lambasting the opposition as the "Assassination Ticket," and accusing its candidate, Cleveland Dear, of collaborating with New Dealers to buy the election with WPA jobs. National FWP supervisors watched the contest warily. "[S]hould the Long crowd get control of the WPA," warned Darel McConkey to FWP national director Henry Alsberg, "there will probably be some tough sledding for the writer's projects." Yet despite a Longite victory, Saxon managed to establish a district office in Shreveport, right in the machine's backyard. More or less in opposite corners of the state, Shreveport and New Orleans were long-standing political and cultural rivals. Viewed either as an extension of the New Orleans social elite or as a New Deal pawn, Saxon's district office was bound to cause suspicion, and Shreveport opponents wasted no time raising complaints against it. Project workers were noticed sipping coffee for long hours at a downtown hotel. Others evidently preferred livelier refreshments and more creative diversions. Project trash cans contained more empty whiskey bottles than waste paper, critics charged, and several drunken writers routinely disrupted affiliated offices nearby, especially the local sewing project. "You are no doubt aware of the feeling of animosity toward the project that exists in almost every parish in the state," wrote Henry Spiva, Saxon's Shreveport supervisor, "every possible attempt to cast suspicion of almost any conceivable misdemeanor—from drinking to illicit relations—has been made toward the employees on this project." Nevertheless, despite lingering criticism, the office continued operations, while Saxon pressed his expansion into the spring of 1936.[41]

Saxon spent the next eighteen months dodging the Long controversy and overcoming local resistance to his state effort. Ultimately, he established district offices in all seven Louisiana congressional districts, even in Baton Rouge, an accomplishment "doubly important," he believed, since it secured the cooperation of state university administrators. "As you know," he wrote Henry Alsberg, "this was Mr. Huey Long's greatest stronghold, and there had been some friction in that quarter until very recently." Across the river from Baton Rouge, in Lafayette, Louisiana, Saxon's problem was not Long's legacy but local supervisor Mary Jane Sweeney, who resisted Eddie Dreyer's attempts to tame her rhetoric and curb her boosterism. Because she was well connected locally, she reminded Dreyer, she had an obligation to see her community

represented as favorably as possible, and "[i]n many instances, I added only a short phrase to soften cruel and untrue words, but . . . these were eliminated." Eventually, a stalemate developed, broken only when Saxon displayed the physical power of his office. When he finally assented to Sweeney's entreaties for closer supervision from the New Orleans office, she took this as a signal of Saxon's imminent arrival and arranged several luncheons and teas in his honor. What showed up, however, was not the director but two assistants checking tour miles on a tight budget in a battered car. They kept Mary Jane Sweeney in the field twelve hours a day for a solid week, where they "hunted the end of so many dirt roads" filled with ruts, holes, and other obstacles that two weeks after their departure Sweeney was still under an osteopath's care.[42]

Between February 1936 and July 1937, amidst adverse conditions and local suspicions, the district offices maintained a gypsy-like existence typified by Blanche Oliver. She had been a freelance writer and the author of a book of black verse, *Cawn Pone and Pot Licker*, before Saxon appointed her, in March 1936, to run the Monroe office in northeast Louisiana. This made her and four coworkers responsible for reporting on the fourteen surrounding parishes with no fiscal provision for travel. When she finally obtained the use of a government car, she found them all "in about the same condition as the United States was during the administration of the past President, Herbert Hoover." Six months later, after much haggling, many supplications, and a hands and knees estimate of her total floor space, she installed her first telephone in her third new office. Originally her tiny project had been settled with other WPA offices in downtown Monroe, but when district supervisors consolidated all FERA and WPA relief activities under the same roof, they evicted her to convert her space to file storage. Local authorities grateful for expanded WPA efforts secured for her a free office on the fourth floor of the Central Bank Building, where the elevator was shut off, requiring Oliver and her staff to navigate three flights of stairs in the summer heat. She never complained, although she knew exactly how many steps there were between the street and her desk. Clearly, this situation could not last, or so her WPA supervisors said after they discovered that Oliver had neglected to secure the mandatory three bids required to authorize a lease agreement with a private organization. She took this second eviction with considerable aplomb and, presumably, great relief. Her new office, at least, was a whole floor nearer the ground. There Oliver assembled her researches and rechecked her work in a hectic trip to Baton Rouge, where she spent twelve-hour days in the LSU library. When it was all over and Saxon had been forced to close her office, she packed off nineteen thick envelopes of material, including suggested tours through her district, histories of each parish, monthly reports, business correspondence, folklore researches, write-ups of every town and village in her region, excerpts from

significant documents and diaries, human interest stories, interviews with local residents, and one poem—"Swan Song of the Fifth Louisiana District Federal Writers' Project":

> There ain't no nothin' much no more
> An' nothin' ain't no use to we,
> In vain we'll wish that we could write
> More stories for the likes of thee.
>
> We seen a letter in our box, with
> "Confidential" writ thereon,
> We haven't did a thing but weep,
> At what was wrote inside upon.
>
> So fare thee well, a fond farewell,
> Ah, woe is us—alas! alack!
> We done our job so doggone well,
> You'll never more recall us back.[43]

In this fashion, Saxon stitched Louisiana into an effective organization, systematizing the manufacture of words used to weave village and city, state and region into a national literary portrait. A common production system used in all forty-eight states harvested raw material, refined it, then distributed it to middle-class America. Every state project completed essays on a common set of topics, each based on information collected, more or less, in standard fashion. In Louisiana, as elsewhere, it began in the field at the local level, where district project employees gathered facts, figures, and stories. National Youth Administration (NYA) workers joined the harvest. Mostly kids just out of high school or working their way through college, they ransacked parish libraries and courthouse files, and interviewed local citizens, usually elderly, and sometimes former slaves. District writers transformed notes jotted at the scene on scraps of paper or index cards into preliminary field essays referred to as "field continuity." These were reviewed by field editors, either district workers or volunteer experts in specialized fields, a process that yielded "field editorial copy." The state office reedited "field editorial copy" into "state editorial copy" shipped to Washington. At each point quality control checks condensed essays, blue-lined booster rhetoric, and purged phrases likely to stir controversy. All along the line, the smooth flow of production copy remained the overriding concern. National officials constantly implored state directors to provide regular shipments of state copy, who in turn assigned minimum quotas of weekly field continuities. Monthly reports focused on a cost-benefit

analysis of man-hours worked versus works produced, either written or edited—a modernized system justified through modern accounting, and one as applicable to Maine as Montana.[44]

Saxon's organization not only covered every parish and congressional district in Louisiana, in one of only two instances among the southern Writers' Projects, it even crossed the color line. Not long after work commenced on his project, Saxon approached Marcus Christian with the idea of organizing a separate unit to collect material on the history of black Louisianians. Christian was a poet by choice and, until recently, the operator of a modest dry-cleaning business by necessity. His grandfather had been a slave, his twin sister had died when she was seven, and Christian himself was orphaned before his fifteenth birthday. But race-consciousness and not family tragedy drove his thoughts and inspired both the rage and remorse in his writing. When the strain of Jim Crow life drove a friend to a nervous breakdown, Christian yearned for the chance "to curse everything in the South . . . to blow it to smithereens." More common occurrences, such as the sight of cotton bales stacked along Canal Street, stirred equally anguished responses. "I was thinking how many hopes and disappointments of a black man had gone into those bales," he reflected. "How many drops of actual blood had gone into their making? How many outraged cry of an oppressed people were muffled when the huge press had descended upon the soft fleecy cotton? How many lynchings—how many underfed black children—how many moans of raped black women—how many cries of help from the black manhood of the South have been called in vain because of . . . cotton bales that drip with the blood of black people."[45] For Marcus Christian, this was the opportunity of a lifetime and the beginning of a long and complex relationship with Saxon.

What was known officially as the Dillard History Project began informally for Christian the night Lyle Saxon knocked on his door. Years later he still recalled it "as if it were only yesterday when I welcomed [him] into my little shot-gun cottage." Saxon brought the bottle, Christian furnished the mixers, and Saxon broke the ice by admiring his host's books and brass candlesticks. They chatted long into the evening, mostly about how Saxon's project functioned, but also about Christian's own literary aspirations. Finally, Saxon offered Christian a job and then his hand, "a gesture of genuine friendship," Christian would always remember along with the manner of Saxon's departure. On his way to the door, Saxon stopped to wrestle with Christian's dog, covering himself "with a fine layer of dog hair." When Christian began to brush the hair from Saxon's coat, he admonished his guest that "you're the only white man I've ever done this for." Saxon chuckled and offered in smiling reply, "Oh I'd do that much for you."[46]

The Dillard Project began in January 1936 and continued operation until

1942. At its height it employed ten writers, among them Octave Lily, previously a high school teacher; Eugene William, a Dillard graduate; Homer McEwen, an unemployed social worker, and Clarence Laws, whose college funds had run out. Later they were joined by James B. Lafourche, formerly a reporter for the *Louisiana Weekly*, the state's most prominent black newspaper; Alice Ward Smith, a young novelist and former history teacher; and Christian himself, once Saxon secured special dispensation for the poet, who refused to be certified for poor relief. "They were as fine a group . . . as I have ever had the pleasure of associating with," insisted Albert J. Bloom, another Dillard writer, "and the memory of them and the project will always be a bright light of experience for which I would trade nothing."[47]

The unit functioned exactly as its parent organization and concentrated its efforts on researching the history of black life in Louisiana since the colonial period. Each Dillard writer pursued assigned topics in local libraries, newspaper archives, and government repositories. Marcus Christian and Lawrence Reddick, a member of the Dillard history department, reviewed completed essays, and although scant evidence documents the reception of Dillard writers in New Orleans public institutions, there is little missing the significance of their assumptions and efforts. "We began to take an attitude which was consistently critical of most histories," Christian later noted, "particularly those written from the typical southern viewpoint." Instead, he continued, "we began to suspect that there was an important Negro or person of Negro descent in nearly every historical woodpile and worked accordingly. To say that we were not disappointed is to make an understatement," something confirmed by the twelve-hundred-page Dillard history of "The Negro in Louisiana."[48]

The manuscript chronicled the many-faceted experiences of black Louisianians from 1719, when the first slaves arrived, to 1942, the year the Dillard project closed. Several chapters focused on the energy, versatility, and skill of black labor. Others emphasized the complex and conflicting demands of plantation life and work, underscoring the ability of Louisiana's slave population to withstand the rigors of bondage and retain a measure of cultural power. Black Louisianians had shaped their society in numerous ways, the Dillard writers found, through dancing and language, in dress, diet, agricultural practice, speech pattern, religious belief, and through folk custom, especially voodoo. Imported by slaves from the West Indies, they asserted, voodoo was no quaint practice easily satirized by white sophisticates. It was a form of black resistance, "the earliest and most frequently used power by the black community to resist the power of the white." Still other chapters detailed the harshness of slave life, undermining more conventional images of antebellum New Orleans. Rather than gay balls, sharp wits, and steamboat opulence, the

Dillard historians described "the brutality of the sale . . . of a dark consumptive woman dragged to the block" amidst "the resounding chants of auctioneers."[49]

Though it was never published, "The Negro in Louisiana" said as much about the American future as it did the state's past. As Adam Fairclough writes, the manuscript coincided with a liberalization of racial ideas in New Orleans and renewed calls for organized opposition to Jim Crow. Indeed, the manuscript's themes and the related activities of its authors all confirm significant developments locally and nationally. It had been created by a unit whose existence owed more to black assertion than white patronage. Ultimately, what brought Lyle Saxon to Marcus Christian's door was the refusal of James B. Lafourche to accept anything less than his due. In addition to his nine years with the *Louisiana Weekly*, Lafourche was a college graduate; yet when he applied for work on a white-collar project, local relief authorities handed him a shovel. Lafourche, always something of an operator, was also persistent. He took his case to John W. Davis, who headed an organization to promote black interests among New Deal relief administrators, and before long Harry Hopkins, Henry Alsberg, and Jacob Baker had all heard of James B. Lafourche. Washington officials then found a local institution, Dillard University, willing to sponsor a black writers' project and, presumably, Lafourche, whose digging found new directions in 1936.[50]

Once created, the unit's organizational connections linked its members to other like-minded individuals in New Orleans and across the nation. Not only John Davis but Sterling Young visited the Dillard Project, together with such prominent black artists as Richard Wright and Jacob Lawrence. Meanwhile, a handful of local writers joined the national effort to assert a modern critique of American society, anticipating professional historical scholarship by celebrating social diversity and emphasizing the multifaceted achievements of black Americans. Nor were their efforts confined to the past as at least three Dillard writers, Octave Lily, James Lafourche, and Clarence Laws, all joined organized efforts determined to achieve racial justice in the immediate future.[51]

During his eight years with the Federal Writers' Project, Lyle Saxon achieved an extraordinary measure of organizational success, but only at tremendous expense. In the eighteen months following his appointment, despite an especially volatile political climate and the restrictions of Jim Crow custom, he managed to forge a biracial statewide literary effort. Unlike the Federal Art Project in Louisiana, Saxon's writers worked in every parish and covered each of the state's major regions. National officials not only recognized his skills but utilized them whenever possible, both personally and professionally. During its existence, New Orleans became something of an FWP haven for har-

ried national administrators. Meanwhile, when the guide programs bogged down in Mississippi and Arkansas, the national office deputized Saxon a "regional supervisor" and dispatched him to reenergize the efforts in Jackson and Little Rock. Then, when he finally closed his New Orleans office in 1943, Saxon accepted an invitation to Washington, where he helped draft the final WPA Report. It was a fair record for someone "known internationally locally," but it did not come without its cost. As Saxon's friends suspected, his success as an administrator conflicted with his artistic sensibilities, though not in ways they assumed. Lyle Saxon did not spend eight years counting paper clips and shuffling WPA triplicates indifferent to his art. Instead, he used the job to advance an art increasingly attenuated by the very organization he so skillfully administered. Because the art depended on Saxon's mastery of two isolated places, he himself had done what he most feared, connecting them to a national literary evaluation of modern American society, the modernist portrait of modernized America. His original impulse had been preservation. His ultimate result was the very transformation he struggled to avoid.

Saxon's protracted struggle between means and ends and unintended results produced a division within him visible to Marcus Christian. One night not long after the project closed, it was Christian's turn to call on Saxon, and the two spent the evening working on the Dillard manuscript. By then they had forged a relationship close enough, from Christian's perspective, to regard himself as Saxon's "black son." But that night, when they parted, the author called the poet "boy." Saxon's tone suggested a term of endearment, but Christian's pride wondered. "What had happened to Saxon," the poet ruminated, "where along the line did he get the seeds of a tragic melancholy and frustration which will sooner or later tear wide the bonds of his existence? Where came that love of the underdog and hatred of the overlords, of which he himself is one and even likes it sometimes? Were the black blood connections in the ascending or descending scheme of things? Or was it love?"[52] In truth, it was neither. Saxon was no more a prisoner of mixed blood than of blind devotion. He was someone alienated from the social mainstream treading a path between private impulse and public acceptance, like the southern blacks with whom he empathized. But by 1943, he was also someone whose WPA experience undermined the public persona he had maintained to such advantage since the 1920s. He had been a bohemian and an aesthete, an artist of growing renown equally comfortable mixing cocktails in the Quarter or sipping dripped coffee on the Melrose gallery. But after fifteen years, with no job and in declining health, he faced an uncertain future. He had once been the master of two local places, but as the WPA experience suggests, and as the three volumes his project published reveal, the struggle to retain his grasp on New Orleans and Louisiana during the 1930s had gone for naught.

3. "New Orleans—Old and New"

Late one Friday afternoon in the summer of 1937, after another trying week, Henry Alsberg sat nursing a headache in his office, bracing to fight cross-town traffic for a New York train. He may even have already reached for the bottle of bisodol he kept locked in his office safe just for such moments, but Alsberg would not need it for long. As he gathered his things, the director's secretary, Dora Thea Hettwer, delivered a package just arrived from New Orleans. Alsberg summoned other project officials into his office and, accompanied by "oh's and ah's from them all," opened the bundle. Inside, he found the rough draft, a working dummy, of the New Orleans guide compiled by Lyle Saxon and his staff. Alsberg rocked back in his chair, browsing through a collection of photographic illustrations. A smile creased his lips then broadened into a grin. The headache vanished. New York could wait. He tucked the package under his arm, trundled it home, and spent the entire weekend poring over Saxon's manuscript. Work on the New Orleans guide had began almost as soon as the project opened. Despite repeated entreaties from Washington to concentrate efforts at the state level, Saxon's priorities never wavered. Almost as soon as he hired them, his Orleans staff began accumulating the raw data that after two years filled 208 separate essays, more than 3,200 pages of material, on the history, culture, society, and current shape of New Orleans. Months of cutting and rewriting by Saxon, Dreyer, and the editorial staff reduced the manuscript by four-fifths. Local artists then trimmed it and packed the bundle off for Washington where it not only cured Henry Alsberg's headache but became, perhaps, the FWP's greatest achievement—this for several reasons.[53]

The Idaho guide may have been the first, and the Washington, D.C., guide the thickest, but the *New Orleans City Guide* established the precedent followed by each succeeding FWP publication. Six months prior to completing the dummy, Saxon and his staff began to speculate on how best to get their work published. Robert Maestri, a former furniture salesman turned Longite politician, had just taken office as mayor of New Orleans, and Saxon seized the chance to cross several "t's" with a single stroke. He approached state WPA supervisor James Crutcher with a plan to secure the mayor's good graces by inviting his office to publish the manuscript. This would not only "cement a friendship between the WPA and present leaders of the state," as Saxon advised. It would also ensure the manuscript's publication, redounding to the credit of all. Maestri would appear as a patron of the arts, something clearly more statesmanlike than used furniture, and Saxon and state WPA officials could silence persistent accusations of boondoggling. Alsberg liked the idea, too, but Saxon was not through. Determined to equal the quality of his earlier works and distrusting both local publishers and the Government Printing Of-

fice, Saxon advanced a second idea, the brainchild of Clark Solomon, a member of his state advisory staff. He suggested that in Maestri's name the manuscript could be offered to one of the larger New York firms, Harper's, perhaps, or Scribner's. If accepted, the firm could publish the manuscript exactly as if it had been their own from the start, affording the project all the benefits of a major publishing venture with national distribution and marketing systems. This would guarantee a vastly larger press run than any local firm could offer with all royalties accruing to the public beneficiary of choice, in this case, the New Orleans Department of Public Welfare. Here was a major FWP turning point, the chance to reach an audience commensurate with the undertaking, but what thrilled Henry Alsberg even more was the spirit and content of the volume itself.[54]

Saxon's guide made New Orleans the embodiment of modernist America, a multifaceted place of sensual delight since its colonial establishment. "Early in its history," he asserted, "the town took on a gay and light-hearted appearance," becoming "a Babylon where Creoles, English, Spanish, French, Germans, Italians, and Americans did little else than dance, drink, and gamble," and where the principal forms of entertainment included everything "from bear and bull-baiting to Voodoo rites conducted by Negroes in Congo Square."[55] Not even the puritanical influences the Americans brought with them could dampen a social life modeled after the spirit of Versailles, he insisted, a *joie de vivre* impervious to whatever flag flew over the Place d'Armes. Instead, long after 1803 New Orleans remained a scene of revelry and romantic desire, the cornerstone of Burr's conspiracy and the place where a handful of pirates, prisoners, and plain-shirted frontiersmen, "as strange a force as ever served under one flag," defeated an army of British regulars down on the mudflats east of town.[56] Such episodes merely prefigured the city's golden age, Saxon insisted, the steamboat days of antebellum America, when opera flourished, literature blossomed, and European theater stars crowded New Orleans. "Gambling, horse-racing, dueling, steamboat racing, and cock- and dog-fighting in addition to Mardi-Gras," all "made New Orleans . . . a gay metropolis," then and still.[57]

If New Orleans was a place of exotic sight and sound, the guide insisted, it was also something less to understand than experience. Borrowing a device he often used, one popular throughout thirties literature, Saxon introduced his readers to Crescent City social life by making them participants in the story itself. The essay on "Folkways," for instance, begins in the Quarter amidst the sights and shouts of crowded streets in ways calculated to jar, confuse, and excite its readers. The language is foreign, the people strange, and the ambiance mysterious as the reader struggles out of slumber for understanding: "Sleepily you get up, and pulling something around you [and] step on the

balcony of your . . . studio. . . . You rub your eyes and stare at the extraordinary creature who is emitting . . . blood-curdling noises." Sight and sound whirl, jumbling together thick accents, foreign phrases, and flashes of high society and low: "Across the little iron guard-rail that separates your gallery from the one next door, a pleasant-looking chap wearing a white linen suit puffs a pipe with a philosophic air and surveys the scene below him as if it all belonged to him. You crane your neck over the balcony to get a good look at the overflowing bundle of wash which a Negro woman balances on her head.[58] The pipe smoker, it turns out, is a native Creole who befriends the reader, then guides him through the Quarter. He deciphers the cries of street vendors, translates snatches of patois French, expounds on the mysteries of New Orleans coffee, and indulges his guest's desire to visit the city's more prominent Voodoo shrines. Together they tour Marie Laveau's grave and browse through a Voodoo drugstore whose wares and prices appear as both text and pretext to additional essays explaining "spasm bands," Congo Square, Creole myths and legends, "Negro Cults," Carnival traditions, and the graveyards of New Orleans, its celebrated "cities of the dead."[59]

The guide not only reflected Lyle Saxon's own artistic sensibilities; its tone and assumptions matched FWP values. Henry Alsberg and his staff actively promoted the American Guide Series as proof of the cosmopolitan character of America. Similar to Holger Cahill, who saw in the Index of American Design a tangible record of the nation's artistic diversity, Alsberg regarded the collection of state and local guides as a chronicle of American ethnic and cultural variety. The series celebrated the heterogeneity of the landscape and its people, though not simply in support of New Deal political objectives, as critics often charged. FWP guides helped popularize modernist thought, rejecting the fixed for the fluid and exchanging hierarchy and "100 percent Americanism" for simultaneity and variety, a point made explicitly on Saxon's first page:

> Have you ever been to New Orleans? If not you'd better go.
> It's a nation of a queer place; day and night a show!
> Frenchmen, Spaniards, West Indians, Creoles, Mustees,
> Yankees, Kentuckians, Tennesseeans, Lawyers and Trustees,
>
> Negroes in purple and fine linen, and slaves in rags and chains.
> Ships, arks, steamboats, robbers, pirates, alligators,
> Assassins, gamblers, drunkards, and cotton speculators;
> Sailors, soldiers, pretty girls, and ugly fortune tellers;
> Pimps, imps, shrimps, and all sorts of dirty fellows;

...
A progeny of all colors—an infernal motley crew . . .[60]

The heterogeneous city stood for modernity itself, a place equally devoted to amalgamation and absurdity. "The melting pot has been simmering in New Orleans for over two centuries," the guide asserted, "and the present-day Orleanian is a composite of many different racial elements. Intermarriage has broken down distinctions and destroyed the boundaries of racial sections. With a few minor exceptions there are no longer any districts occupied exclusively by one group."[61] Such variety, it asserted, accounted not only for the city's longstanding tolerance one for another but its collective indifference to adversity or consistency. Weathering disaster was commonplace in a city that only made sense by not making sense; for who but Orleanians placed ads to favorite saints in the local newspaper, and where in America, on the last day before Lent, were things more topsy-turvy than among a populace "governed" by Rex, the Lord of Misrule?[62]

While Saxon's guide advanced modernist assumptions, it also took pains to assuage fears of overmodernization. Though the steamboats disappeared and the quadroon balls diminished once railroads and Union regiments arrived, Saxon underscored the city's ability to resist modernization by emphasizing its unique architectural heritage. After all, he noted, New Orleans was composed of many sections notable for "the tenacity with which they clung to older forms . . . in the face of changing modes and modern standardization."[63] It was also home to the Vieux Carre, one of the most distinctive architectural sections in the entire country and the physical embodiment of the town's spirit. Here two-story edifices stood nearly flush to the narrow streets decorated with intricate iron grillwork, a hint of the inner beauties arrayed behind simple plain-board or brick facades:

> To enter the courtyard house one passed through massive portals into a high-arched flagstone alleyway which, wide enough to admit a carriage, led from the banquette to an inner courtyard garden, surrounded by high walls that provided an abundance of shade throughout the day. Life in such habitations as these possessed a distinctly European flavor; for the inhabitants, seated on their cool patios or on the verandas that surrounded them, enjoyed absolute freedom from the hot, dusty streets.[64]

Assertions drawn from surveys of local architecture and extended to its populace served a double purpose. Successive waves of construction innovations and stylistic fads from Greek Revival to Steamboat Gothic charted the city's cultural and social development, sustaining Saxon's belief that it had

escaped the influence of modern styles. Indeed, against the advice of his own advisory committee and of the national editorial staff, Saxon dispatched the subject of modern architecture with three sentences, one of them an assertion that there was very little of it in the city. But if the old facades provided haven from modern trends, they also suggested the consequences of their future neglect. Ruing the loss of its older structures, the author warned his readers against the two greatest perils threatening local architecture and all it embodied. "The loss of the St. Louis Hotel . . . has been termed an architectural calamity," he wrote, but "a still greater calamity is in store . . . for unless the famous old buildings are carefully and properly preserved against the corrosive effects of time and modern standardization, the city will eventually lose its most distinctive claim to fame—a native architecture that flourished a century ago and has never been equaled since."[65] The same logic applied to the city populace, in Saxon's estimation, an entire social world nearing oblivion. When the drowsy outsider steps onto his balcony at the beginning of the "Folkways" essay, he encounters a chimney sweep. "Look at him closely," the author insists, announcing a theme sustained throughout the guide. "Here stands the last of a dying breed, the symbol of a fading past heated by coal and threatened with extinction by the modern conversion to natural gas."[66]

Modernist without being modernized, or so it asserted, the guide looked both ways at once, celebrating new directions while mourning those abandoned. Saxon's essay on "Gay Times in Old New Orleans," for example, rejects Victorian morality even as it rues the destruction of its double standard. The piece combines tales of various reform movements never taken seriously either by the local populace or the author with a wry survey of the tenderloin districts, including Storyville, whose demise he mourns and whose roiling humanity he misses. Before the European war, he memorializes, thieves connived, drunks reeled, lovers shouted, and working girls beckoned, but now all has vanished forever:

> for where can one find the equals of former celebrated procuresses? Countess Willie Piaza, under whose roof a Central-American revolution was hatched, is dead. She is dead and her gilded mirrors and green plush chairs and white piano sold at auction; the piano, badly in need of tuning, going for $1.25. Josie Arlington was buried in and later removed from Metairie Cemetery, but a bronze maiden, representative of the virgins whom Josie never allowed in her house, still knocks in vain on the door of her tomb; and a legend which tells of a red light mysteriously issuing from the grave is current.[67]

Saxon's New Orleans did more than delight Henry Alsberg and his staff. When it debuted just in time for the 1938 Carnival season, the guide played to

rave reviews. Later, Edna Ferber called it "my Bible," the basis for the opening chapters of her novel, *Saratoga Trunk*.[68] The public response was more immediate and equally enthusiastic. "It gives the spirit as well as the substance of America's gayest, most romantic and best fed city," wrote Jean West Murray for the *Washington Post*. "And if you are one who has never walked along the levee top and smelled that rich mixture of crushed oyster shells, ripe bananas, green coffee and raw sugar which is the waterfront's distinct aroma, never lingered under the heavily fragrant magnolias by moonlight; never seen the old Dueling Oaks in City Park, or sipped cafe au lait at dawn in the French Market, this book will present to your five senses something of what you will see, hear, taste, smell, and feel when you go for a real visit to New Orleans."[69] Others echoed Murray's sentiments, applauding the guide's sensory richness and praising its lavish illustration. It not only narrated stories of Carnival pageantry, they insisted, but presented itself with the same elaborate ornamentation. Photographs studded the work. Pen and ink sketches appeared at the head and tail of essays and tours, and a series of original Caroline Durieux prints complemented the text. Recipes for cocktails and favorite local dishes garnished the essays on night life and cuisine. Yet even more, what had originally delighted Alsberg and his staff was echoed by the critics. Readers of the volume, assured one reviewer, were certain "to retain a general impression [of New Orleans] compounded of mirth, sobriety, frivolity, asceticism, and above all tolerance."[70] "Not the least value of these volumes," wrote the sociologist Howard Odum, describing both the specific guide and the general series, "will be their use as a source book and as a guide for further research and study into what many have called the `Pluralism of America.'"[71]

Saxon's *New Orleans City Guide* accomplished one of the more successful "balancing acts" of thirties America. The guide titillated while it assured, providing both structure and subversion. Here was a place "seething with sin and hot jazz," with all the modern conveniences. Modernist revelry ruled the day, liquor flowed, and gambling flourished, but the airport was new, the hotels were air-conditioned, and the railroads ran on time. New Orleans was the bohemian Quarter *and* the staid Garden District, Mardi Gras *and* Ash Wednesday, the Cabildo *and* the new Huey P. Long Bridge, providing a highway connection between the city and its surrounding region. The city was both serious and frivolous, old and new, ideas repeated throughout the guide and announced by its dust cover illustration. A cartoon representation of the equestrian statue on Jackson Square featured the general astride a horse with snorting nostrils and a pink ribbon tied to its tail.[72]

Yet the New Orleans guide also underscored just how precarious the balance was, and how easily it might be disrupted. Though Lyle Saxon did not invent the idea of New Orleans as American exotic or found the city's modern

tourist trade, he helped to establish what remains one of the standard stops for middle-class automotive Americans off to see the country. What predecessors began, then, Saxon extended, helping to commodify the city as a packaged item of mass consumption and advancing the kind of cultural standardization he always opposed and proclaimed New Orleans as haven from. There was an FWP counterpart to the American Art Week campaigns of 1940 and 1941, associated promotions designed to stimulate American Guide sales and encourage tourism across the country. This is how a photograph made it into Saxon's project files depicting a series of FWP guides arrayed in the display window of a downtown department store. The New Orleans guide was given central prominence, of course, yet surrounded by guides from other states and cities, all of approximate size and cost, and each produced from the same template. The evidence undermined Saxon's determination to preserve New Orleans from modern standardization, and confirmed a trend begun when national editors expressed concern over some of the guide's more vivid passages.[73]

To make the guide more palatable to its audience, Washington editors cleansed the original manuscript, quite literally, of its more colorful touches. Working within a specific genre, in this case FWP guidebooks, did not *per se* standardize Saxon's material. But while he worked creatively within the form, his national editors did have a consumer target in mind, middle class, automobile tourists, and their comments did aim at producing an evenness of treatment across the country, both in terms of guidebook material and tourist experience. On Henry Alsberg's suggestion, for instance, warnings against the illicit nature of gambling activity wherever conducted accompanied all references to the numerous gaming opportunities available in New Orleans. The director also scrapped "The Red Light District," the original title of an article devoted to the history of local prostitution, once again requesting the same admonition that the institution was no longer recognized by law. Similarly, Alsberg blue-lined a survey of the city's infamous female impersonator clubs, while his editors excised a line from "New Orleans Old and New." The poem advanced Saxon's assertion that Orleanians were the product of many social, ethnic, religious, and cultural influences, united in mutual disrespect for the sort of puritanical conventions that prevailed throughout the remainder of the nation. "A progeny of all colors—an infernal motley crew," it asserted, New Orleans was a place of "White men with black wives, and vice versa too." "No Southern State will admit in print that a black man could ever have a white wife, as the *vice-versa* implies," warned one of the copy editors. "If this poem is the opinion of the essayist, I can suggest the substitution of one word (tan) to make the line read as follows: 'Tan men with black wives, and vice-versa too.'" Saxon's response went unrecorded, but the published poem version retained neither its original nor its suggested coloring.[74]

Yet not even this threat to southern racial sensibilities matched the furor raised by Saxon's essay on "Gay Times in Old New Orleans," an examination of the city's sexual openness. The original piece was both longer and livelier than what ultimately appeared in the guide, not only more explicit in detail but more insistent of its theme: that New Orleans had always paced the country when it came to enjoying pleasures of the flesh and that modern American prudery had unfortunately curtailed much of the former ribaldry. "There is a flavor of decadence about this article," wrote Charles Wood, one of Henry Alsberg's editors. "No objection is made to the frank statement of the merchandising processes of prostitution but it is the evident delight in recounting them and the nostalgia for the past glamour of the district that might better be toned down." Wood also took exception with Lyle Saxon's suggestive explanation for the divergence of attitudes and behaviors. The rest of the country, Saxon observed, had been "too busy expanding to pay attention to such things," a point Wood grasped immediately. "[T]here is a suggestion of reproach here," he observed, an insinuation on Saxon's part that Orleanian dalliances represented both the more natural inclination and a lesser vice than American expansion.

Given his contempt for modernization, it is hardly surprising that Lyle Saxon linked deviance with Manifest Destiny; but this was hardly something Henry Alsberg could let stand. Although Alsberg valued Saxon's contribution to the Project the essay had become something of a cause célèbre among not only project supervisors but other, more prominent administration members. Considering the sensitivity of either group to adverse publicity, the ultimate fate of "Gay Times in Old New Orleans" was almost certain from the start. After two paragraphs praising Saxon's efforts, Alsberg suggested that the essay needed considerable toning down. "The consensus of opinions among the people in my office in the Administration," he advised, "is that the article as it now stands would get us into trouble and therefore I have to ask you to do something about it." "I do not think that there is any point in our trying to make minor changes and deletions," Alsberg continued. "My conviction is that it should be rewritten altogether in considerably shortened, and generalized form, that its tone should be somewhat different, more objective. . . . What I mean is that the article should, perhaps, be less outspoken in its details and not make the subject as attractive as it is made."[75]

The incident caused neither rupture nor recrimination between the national director and his state supervisor. Saxon rewrote the piece, content, perhaps, that the incident itself simply confirmed conclusions drawn by the original. "It seems entirely innocuous to me now," he wrote Alsberg when he returned the revised piece, "and I do not see how anyone—even the most squeamish—could disapprove of it." Yet, the editorial cleansing reflected a trend continued for the duration of Saxon's project work. What began in 1935

as an experiment in American letters became ultimately an exercise in literary manufactures often eschewing local color for the sake of national clarity. Linking New Orleans to the American Guide Series meant altering it however subtly in ways Saxon opposed but could not avoid. Writing to preserve, he was, nonetheless, helping to transform, a dilemma with both a personal and professional dimension played out in his subsequent WPA endeavors.

4. "God What a Nuisance!"

In the spring of 1936, after a month working late nights and long weekends, Lyle Saxon and his staff had nearly finished the rough draft of their guide to Louisiana. "I've got reams of papers to read and correct," he wrote Cammie Henry, "my eyes hurt and I'm hot and cross and don't like this guidebook business no how, nowhere, no time . . . God what a nuisance!"[76] The exhaustion and frustration were understandable. In less than eight months Saxon had established project offices in New Orleans and Shreveport, supervised the collection of research materials, weathered all manner of bureaucratic emergencies, completed reports, budgeted resources, survived a political attack by a Longite faction determined to drive the WPA out of Louisiana, and assembled an enormous dummy for the proposed Louisiana guide. The manuscript sent to Washington covered the state in three volumes totaling nearly one quarter of a million words. "We were rather surprised ourselves when we saw the complete dummy," Saxon wrote to Henry Alsberg. "It had grown to such preposterous proportions, but I thought it wiser to have too much than too little."[77] Yet, despite periodic notices announcing the guide's imminent release, nearly five years separated rough draft from published work, and therein lies the tale. By then personal and organizational changes had made both the state director and his project something different from what each had previously been.

So often delayed, so much the product of organizational and personal turmoil, the Louisiana guide typifies Saxon's later years with the WPA. Increasing age and declining health hampered his ability to adjust to workloads, organizational shake-ups, and key changes of project personnel in Washington and New Orleans. They were also years spent working on a topic peripheral to Saxon's interest amidst material confirming his fears. Following the cues of the New Orleans guide, Saxon insisted that Louisiana remained "a section of the United States which is different from the other states," unmodernized and more colorful than the duller stretches of homogenized America. In truth, however, the state was not the city, and no amount of editorial improvement could make it so. Compiling and editing the state guide forced Saxon to treat subjects of either passing interest or positive aversion. There

were large stretches of the state neither witty nor gay, ones the spirits of the past seldom frequented, if at all. Other evidence attested to how enthusiastically some Louisianians had embraced the modern agenda, eschewing lichened pillars for belching smokestacks. Given Lyle Saxon's preferences and his later WPA experiences, it was no accident that he completed the guide to New Orleans with twice the enthusiasm in half the time.[78]

Although Henry Alsberg received the Louisiana dummy with his characteristic excitement, there were hints of future trouble from the very start. We have "your amazing three-volume guide of Louisiana," he wrote Saxon. "You have done a marvelous job."[79] Alsberg, in fact, considered it the best received to date, but his editors took immediate and specific exception. While most praised Saxon's prose, many questioned his focus, expressing uniform dissatisfaction with the essay detailing the state's history. "State history is not adequately carried through to the present," commented one editor. "The later history from 1861 to the present is especially bad." The editors considered "tactful" Saxon's essay on contemporary Louisiana politics, especially his treatment of Huey Long's contributions, but in most other instances they condemned his cursory treatments of modern industry and society. Nearly fifty pages discussed art and literature in Louisiana, one observed, while only six pages treated agriculture, its principal economic base. "The history and development of the cities are very well covered, but we find the copy somewhat deficient in contemporary scene description," wrote another reader. "This is particularly true of Abbeville, Alexandria-Pineville, Gretna, Lafayette, Natchitoches, New Iberia, Opelousas, Ruston, St. Martinville, and Winnfield," in short, true of virtually everywhere beyond New Orleans[80]

Like the guide to New Orleans, the Louisiana dummy eschewed the modern for the antiquated and relied on architecture to convey its basic theme. Saxon used the unique structures of insular places and isolated peoples, always at the core of his writings, once again to express what he considered the state's uniqueness. Where the New Orleans guide began with a stroll through the French Quarter, linking its courtyards and culture, the state guide evoked its mood through moldering plantations. "In my childhood, thirty years ago, I remember perhaps fifty plantations which were in operation," reflected the author. "Now, three decades later, I do not know more than five of these families that are still living on their plantations. There is a sadness in all the old houses nowadays, for their day is done. To one who remembers the life and gaiety in these old dwellings, a tour through the plantation country is heartbreaking. . . . [E]ach year [one] finds fewer and fewer of the old houses. Fire and flood have taken their toll, and many have crumbled into the Mississippi. In twenty years they will all be gone, all, that is, except those few which have been restored and cared for. And the restorations have been few indeed."[81]

While the past crumbled the future loomed, the pace of modernization told succinctly in Saxon's tale of two capitols. Then and since, Baton Rouge was the home of two very different state capitols, and there was no mistaking the side Saxon chose. One, an impressive display of "Steamboat Gothic," had stood for decades impervious to time, tides, and the satirical wit of Mark Twain. The other, a modern structure built by Huey Long, was not only the most tangible symbol of his regime but also his gravesite. "Compared with the old statehouse, nearly a mile to the south," wrote Saxon, "the new capitol of Louisiana is a significant monument to the increasingly important place of the State in the life of the nation since the early years of the twentieth century. The graceful but outmoded structure that stands among old oaks and magnolias and crowns a bluff of the Mississippi River has for its successor a towering display . . . on an open sweep of land back from the river."[82] To Saxon, the structures represented rival ways of life. "As the old building was typical of more reposeful trends in the past century," he asserted, "the new one is the embodiment of industry, efficiency, and large movements in the present age. In contrast with its placid surroundings it is startling and somewhat incongruous in appearance, bold reminder of the State's new objectives, and a rather violent departure from the things belonging to the old life of Louisiana."[83] Physically and symbolically, Long's new capitol soared above the great homes up and down the river, a modern usurper disrupting the integrity of the surrounding plantation district often featured in Saxon's writings.

North of Baton Rouge, there were other glimpses of the gathering threat, though none more ominous than the content of the original guide completed on Saxon's project. While writers in the district offices submitted guide copy marveling at the progressive character of the small towns and cities beyond New Orleans, none proved more determined to challenge the city's hegemony than the compilers of a guide to Shreveport, whose booster rhetoric ridiculed the faded charms of Creole grandeur and championed instead a bright industrial future. "The dominant theme of the book," announced its district supervisor in 1937, "is that although Shreveport may lack the glamour of the deep South, it is steeped in an atmosphere of progress. That Shreveport is a city with more of a future than a past, that it is a city going forward instead of backward, are points [to be] stressed. . . . [A]lthough the city has a log cabin background," she concluded, "it has a skyscraper future."[84] Small wonder Saxon buried such disturbing commentary, ensuring that the guide was never published, and dismissing modern architectural forms in Louisiana with a single sentence he surely relished: "Modern architecture of the new international style is excellently represented by the Municipal Incinerator in Shreveport."[85]

If the state guide's content irritated the artist's sensibilities, crucial chang-

es of structure and personnel disrupted the project that created it. The chief disturbances occurred in the spring and summer of 1939, when the demolition of Federal One, what dashed Caroline Durieux's plan to carry the federal art idea across Louisiana, forced her friend Lyle Saxon to reorganize his own operation. The timing could not have been worse. Saxon was barely out of a hospital bed, following stomach surgery, when many favored staffers were forced off the project by the so-called "eighteen-month ruling," dismissing WPA employees carried on relief projects for eighteen consecutive months. Both events devastated Saxon. Once broken, his health never fully recovered. Key office workers, many of them friends and trusted colleagues, departed precisely when he needed them most. Frustrations large and small further delayed the guide's completion. Maps were mislaid, and other items went astray in the mail. Saxon struggled to find adequate illustration for the volume and had an even worse time searching for a publisher. Most were reluctant, owing to the immense popularity of *A Guide to New Orleans* and the fear that it had already stolen any thunder the Louisiana guide might contain. When Hastings House published it in 1941, making *Louisiana: A Guide to the State* among the last in the series, it appeared in an edition four times smaller than its celebrated predecessor. More important, Saxon struggled to finish the guide at a crucial juncture in FWP history.[86]

He had nearly completed the finished manuscript when John Newsom replaced Henry Alsberg as national director of the newly titled Writers' Program, a change tantamount to the completion of the new capitol in Baton Rouge. Saxon and Alsberg had much in common, chief among them a certain discomfort in the bureaucratic world of federal cultural production, and over the years they had established a warm correspondence and comfortable working relationship. Alsberg relished Saxon's wit and easily fell under the author's charm, but there were professional attractions as well. The Louisiana office functioned smoothly almost from the moment it commenced operation, and it turned out precisely the kind of copy Alsberg was looking for—crisp, witty, and urbane, a style well suited to the middle-class tourists marked as the consuming audience of FWP guidebooks. Likewise, Saxon's image of New Orleans as model of cosmopolitan tolerance fit the New Deal political message. The result, in both administration and content, left Saxon and his office a good measure of local autonomy, something that ended when Alsberg left Washington.[87]

Neither Alsberg nor Saxon had much in common with the new director, and neither his arrival nor the state guide's completion provided Saxon much satisfaction, if any. John Newsom, an experienced administrator and former newspaperman, most recently the director of the Michigan Writers' Project, lacked the artistic sensibilities that had cemented the rapport between Saxon

and Alsberg. "This is a production unit, and it's work that counts," observed the new director. "I've never been for art for art's sake alone," an assertion bound to irritate Saxon, who resented his frequent urgings to finish the guide. Indeed, to expedite its publication Newsom himself arrived in New Orleans, an experience from Saxon's perspective almost as exasperating as its net result. Once again, the volume's release coincided with Mardi Gras in order to boost sales, and though critical applause followed, it never reached the level of the New Orleans guide, either as a sales item or a literary achievement. Instead, *Louisiana: A Guide to the State* paled before its predecessor and within four years disappeared from print. The effort also took its toll on the state director, who vented his frustration to Cammie Henry. "The Guide is out, as you know," he wrote, "but we have not received a single copy for ourselves, nor have the newspapers been sent review copies. I'm in a rage about it but what can I do? It certainly was a sad day for the Writers' Project when they got rid of Henry Alsberg and substituted this Newsom creature who manages to get everything mixed up."[88]

Earlier Lyle Saxon had made arty wisecracks about service for a government writers' program, but by spring 1941 his reserves of patience and humor were running thin. Deadlines and supervisory pressure shattered his nerves and left him exhausted. His drinking did not help. He was thinner since leaving the hospital in 1939, more drawn and noticeably grayer, an aging man conscious of it. "[N]ever ruin your middle age in order to make things easier when you are old," he warned a young correspondent in 1942. "I've completely ruined five years, and I'm not sure the game is worth the candle . . . I'm rapidly turning into an old man, very white as to hair, and sort of on the haggard side. . . ."[89] Indeed, by then the candle was burning low and the game playing out.

The Louisiana guide was the last major publication Saxon's unit completed, though not the director's last book. Though his work on the Writers' Program had redeemed his reputation, by his own estimation the personal toll had been prohibitive. The theme proclaimed and celebrated in the New Orleans guide had been challenged by events ever since within and without Saxon's organization, and much evidence suggested that the pace of modernization had overwhelmed his every effort at resistance and restoration. Work on the Louisiana guide forced him to view a less palatable landscape beyond the Vieux Carre, dotted by fewer great houses along the river and more such eyesores as Huey Long's capitol and the new incinerator in Shreveport. The material only reemphasized events within the reorganized FWA structure, one now supervised not by an artist but by a bureaucrat. The Louisiana project was still a vital link in the national effort, but it existed on a shorter leash in firmer hands, the context framing Saxon's final literary effort. During the

troubled creation of the Louisiana guide, he began gathering a folklore collection, material he grew to consider the essence of Louisiana, the last major project of his life, one pursued long after his project closed and completed only shortly before he died.

5. "The Real Under-the-Crust Louisiana"

Like so much of Lyle Saxon's WPA experience, the seeds of his last book were sown in 1936, during the effort to establish his district projects. In March he left New Orleans and headed west through the Acadian parishes to Lake Charles, near the Texas border, where he oversaw the usual round of details. He explained his project to local relief administrators and civic groups, clarified procedures to local workers, and drafted an article for the hometown newspaper. Though he found such work tedious, the trip produced an unexpected windfall, or *langiappe* as Saxon himself might have called it, he explained in the press release. The guide project, he asserted, represented a chance for Louisianians to discover their own heritage, one whose breadth few understood and fewer appreciated. Seldom, if ever, Saxon explained, did he go anywhere in Louisiana without uncovering some new fact of the state's story or facet of its culture, and the trip to Lake Charles made a case in point. Along the way Saxon had run across an unfamiliar phrase used by the Acadian women of Opelousas. Their weekly talk fests, something akin to a sewing circle or a quilting bee, they called "gumbo ya-ya," or "everybody talks at once."[90]

Saxon spent his adulthood panning for such serendipitous glimmers, and first conceived of a book on folk sayings, superstitions, and supernatural tales even before joining the Writers' Project. "I could write another non-fiction book on 'Curiosities of the Deep South,'" he wrote in 1933, using "strange old stories, true ones, of old Creole days in New Orleans and in the country of Louisiana. Or I could do a book about the Acadians and Southwest Louisiana. Or maybe something else entirely, but a non-fiction book with this background. I've gone into the folklore a good deal in the last four years and have encountered both mermaids and werewolves."[91] Nor did he ever abandon this idea. Instead, Saxon incorporated these suggestions into a single volume whose construction, intent, and meaning to its principal compiler encapsulates much of his life and career.

Fortune provided an intersection for private interest and public service when folklore collection became an early FWP priority. Saxon delighted in the opportunity to use his organization on a project so dear to previous interests, and by 1936 his energies had already netted substantial results. "We have a vast quantity of folklore collected," he explained to Henry Alsberg, "and we anticipate doing something rather good with it."[92] Though such hopes went

unrealized for nearly ten years, between 1936 and 1942 Louisiana project writers fanned out across the state, finding enough in the collective memory of its citizens to fill whole filing cabinets with legends and tales, social customs and superstitions, the reminiscences of former slaves, home remedies, folk sayings, cultural rituals, and religious practices culled from various ethnic groups and three different races. Yet while project workers conducted interviews and checked facts, and Saxon roughed out chapters, others redefined the concept of folklore in such a way as to make the Louisiana volume obsolete even before it was published.

In 1937, Benjamin A. Botkin replaced John Lomax as director of the FWP Folklore Unit and over the next two years redirected its focus and methods. Botkin, who specialized in folklore at the University of Oklahoma, eschewed "nostalgia for the old, the odd and the picturesque," for what he styled "living lore."[93] "Upon us devolves the tremendous responsibility of studying folklore as a living culture," he asserted, "and understanding its meaning and function not only in its immediate setting but in progressive and democratic society as a whole." Rather than ghost stories and folk remedies, Botkin encouraged project writers to collect materials on the common lives of ordinary Americans struggling to make sense of their contemporary world. Such materials, he insisted, revealed "the process of cultural conflict, change, and adaptation," a subject best relayed through the closest adherence possible to the original speech patterns of subjects interviewed. "The folk movement must come from below upward rather than above downward," Botkin insisted. "Otherwise it may be dismissed as a patronizing gesture, a nostalgic wish, an elegiac complaint, a sporadic and abortive revival on the part of aristocrats going slumming, dilettantish provincials going native, defeated sectionalists going back to the soil, and anybody and everybody who cares to go collecting." Rather than interpretation or embellishment, then, Botkin encouraged objectivity among his writers while also broadening the focus of their exertions. By gathering material on ethnic groups and urban workers instead of concentrating solely on rural peoples in remote places, Botkin hoped to make folklore the cultural sinews of the pluralist society, the abiding tie between place and people, locale and nation.[94]

In short, Ben Botkin modernized folklore collection in much the same way and for many of the same reasons as Holger Cahill modernized art production. Botkin's folklore, like Cahill's art, acquired a more egalitarian and utilitarian emphasis, developing along lines similar to American Scene painting. Early FWP folklore efforts, including Saxon's own, share much in common with the romantic nostalgia of some regionalist painting, while Botkin's folklore mirrors the social realists. But in a larger sense, the new art and folklore trace the growth of a more inclusive and organized society, stressing the

national over the local and embracing the values of cultural relativism. For as Holger Cahill proposed to systematize national art production and make everyman an artist, Ben Botkin proposed to systematize national folklore collection and make everyman his own biographer.[95]

While Botkin articulated his vision of the new folklore, William T. Couch, the director of the University of North Carolina Press, applied Botkin's principles to the American South. Couch accepted Henry Alsberg's invitation to coordinate FWP efforts throughout the region on a project designed to gather southern living lore. A thoroughgoing modernist, Couch planned an unvarnished look at the lowest rungs of southern society, and though he failed for a variety of reasons to achieve his original ambitions, the results published in 1939 under the title *These Are Our Lives* depict a South unlike anything Saxon ever wrote about. Couch's book, a collection of "life histories," gathered by FWP workers in North Carolina, Georgia, and Tennessee, told stories of hard work and hard luck. Its documentary tone contained none of the romantic flavor, folk remedies, or spirited revelries of Saxon's travel tales or guide copy. Instead, here was the South of sharecroppers and mill workers, struggling for survival, compiled by someone who, clearly, could not be charmed with a cocktail and a ghost story. In New Orleans, the new folklore arrived to about as much local enthusiasm as greeted the new art.[96]

Lyle Saxon showed little appreciation for either Botkin's innovations or Couch's invitations to assist the southern folklore project. Though both men pled their case in person, neither seems to have made much headway. When Botkin arrived in New Orleans just after Thanksgiving 1938, he encouraged Saxon and his staff to collect "local stories of real life rather than what we call supernatural." "We are interested in contemporary American life and want realistic material," he explained, something that "will have some value of American life through the story teller." Yet, while Saxon listened patiently and played his usual role as charming host, *Gumbo Ya-Ya* contained nothing like the "living lore" Botkin envisioned. Meanwhile, if anything, Couch fared even worse when he visited the New Orleans office in May 1939. Although he left hopeful about "the excellent material" the Louisiana writers would soon furnish, of the more than one thousand life histories collected by FWP, only two were contributed by Saxon's staff. Saxon kept the rest of the material to himself, treating his project's collection as personal property he took with him when he closed the project in 1942.[97]

While Botkin and Couch redirected folklore studies, Lyle Saxon clung to old conceptions through another three years of delay and distraction before completing *Gumbo Ya-Ya*. Though editing began in earnest in the summer of 1941, rapid turnovers in office personnel slowed its progress. After Pearl Harbor, when some staff members enlisted, some were drafted, and others

took higher paying jobs in defense plants, two of the losses were especially critical. Eddie Dreyer and Joe Treadwell, an office manager of longstanding, both joined the Navy, leaving Saxon virtually alone. According to Saxon, Treadway had worked on the project since 1935 and had "literally grown up in [the] office" where the director admired his sharp mind and even temper, his "tact, wit, charm, efficiency, conscientiousness, punctuality, dependability, affability, and trustworthiness." "You'll never know how helpless I was with that miserable project after Dreyer and Joe Treadway left me," he wrote to Judith Hyams Douglas. "I look back on those last few months of last year and on the first sixth months of this year as a bad dream and I'm glad that they are over." There were other delays as well. The following year, 1943, having closed the Louisiana office, Saxon did a stint in Washington, one that he claimed nearly killed him, compiling the final record of the WPA. "This job is playing out," he wrote one friend, "and the quality of work has fallen off. . . . A year ago I had gotten all fixed up in fine shape, as National Consultant for all publications, and that let me travel around . . . but Congress fixed all that by wiping out the Regional Staff, so now I'm like a Minister Without Portfolio, I'm grounded. As a matter of fact, I'm right back where I started from six and a half years ago . . . and all I've got to show for those years is the sad fact that I'm much older, and my eyes are bad now, and I've published some guidebooks. . . . And what the hell?"[98]

Having finished the WPA report, his last government project, Saxon returned to Melrose, rested briefly, then devoted himself full-time to the volume he came to regard as his masterwork. He was joined by Robert Tallant, Saxon's last protégé, and, no doubt, someone who filled the void left by Dreyer's departure. Using project files, the two condensed, rewrote, and edited the manuscript while Saxon fished for a publisher without mincing words. "Although I directed this work for a period of seven years, I was really astonished to see how much material was still available for publication," he wrote his agent at Houghton-Mifflin. "It seems too bad that this material be wasted or . . . fall into inexperienced or careless hands. The whole thing is nearly my life work . . . a popular history of Louisiana, for which there is a crying need in the Public Schools." It was the only public statement Lyle Saxon ever made on the subject of education in Louisiana, but there were even more urgent protestations to the work's value. "Let me say here—and I will say it again in the introduction—that this book constitutes a sort of cross section of Louisiana," he asserted. "I've put a good deal of myself into this book and it is my pet. I mean that I consider it more important, in its way, than the Guide books, for it is the under-the-crust world of Louisiana that nobody has written before."[99]

While Saxon was the volume's chief backer, he was also its most spirited defender. With the Writers' Project, he had been an editor's dream, an author

of unusual malleability who not only accepted suggestions from Washington but incorporated many verbatim into the final text. Not so with *Gumbo Ya-Ya*, where Saxon stiffened, especially when it came to the title itself. His agent at Houghton, Paul Brooks, wrote in the spring of 1943, updating Saxon on the project's progress. Final contractual wrinkles had all been ironed out, Brooks reported, and the editorial staff considered the manuscript "a combination of scholarship and *joie de vivre* equaled by few." Only one small problem remained. Brooks and others at Houghton feared that the title might injure sales by scaring off potential customers who might feel silly asking for it by name. Saxon held firm. "We insist that the title 'Gumbo Ya-Ya' be retained," he responded. "We submitted it to some one hundred people and of those more than 80% have approved it; these were not Cajuns or Creoles, but ordinary readers. . . . You may remember that the appellation 'Shangri-La' has been incorporated into the American language. We believe that the title 'Gumbo Ya-Ya' is good enough perhaps for national adaptation."[100]

Released just after the war ended, in November 1945, *Gumbo Ya-Ya* fairly burst with all the romantic symbols and rare characters dear to Saxon's heart. Echoing the "Eatin' books" and the New Orleans guide, it appealed to all the senses. Street vendors cried by day and ghosts wailed in the night. In Perdido Street in New Orleans, "every night is like Saturday night . . . wild and fast and hot with sin."[101] Some chapters swayed to the rhythms of black spirituals. Others delighted in the smells of cast-iron skillets simmering in Creole kitchens. Forty photographs illustrated the text, supplemented by reproductions of paintings by John McCrady and Edward Schoenberger and eight Caroline Durieux lithographs. Another former FAP artist, Roland Duvernet, designed the frontispiece, the "Ghost Map of Louisiana," a cartographic survey of the state's macabre past with all the trimmings: buried treasure, severed hands, leering skeletons, haunted steamboats, deserted mansions, and an inset of the French Quarter bearing the legend, "The United States of Vieux Carre." It was colorful; it was entertaining, and as Saxon continued to insist, it revealed a self-contained place whose unconventionality defied modern norms and rejected modern forms. Still, for all its enthusiasm and excesses, though its first edition of ten thousand copies sold out within a week, *Gumbo Ya-Ya* disappeared long before its incorporation into the national dialogue.[102]

Part of the problem was its content. The shifting definition folklore underwent during the 1930s, its transition from collecting local arcania to probing the national character through living lore, left Saxon's material beached by an abandoned tide. Rather than real words revealing real lives, *Gumbo Ya-Ya* revisited old curiosities and retold old conventions. Despite opposing Jim Crow in his personal life, his folklore collection repeated stereotypical images of licentious blacks. Along Perdido Street, rife with the aromas of "stale

wine and beer, whiskey, urine, perfume, [and] sweating armpits," black men "sagged over the bars, their eyelids heavy from liquor and reefers."[103] Flashy colors, swaying hips, and casual violence, all characterized the "Kings, Baby Dolls, Zulus, and Queens" of Saxon's first chapter, while subsequent chapters styled other ethnic groups in equally familiar tones. Residents of "The Irish Channel" on Adele Street drank and brawled, sometimes while keening widows waked their dead and sometimes not. Germans were a "frugal" lot, often to a fault, who preferred beer to water. But the chapters on two local ethnicities, Creoles and Cajuns, revealed just how committed to stereotype Lyle Saxon remained.

Depicted in chapters placed back to back, the material on Creoles and Cajuns described one by using the other as foil. Creoles, Saxon asserted, lived a separate existence detached from modern society and unsullied by commerce. All were "gay and festive," each "refused to learn English," and none "ever had colored blood." Creole women "always enjoyed a reputation for great beauty," the Creole father was "absolute head of his household and his word was final in all matters," and all Creole children "received a French education."[104] Meanwhile, Louisiana Cajuns played rural rube to urban Creole aristocrats, or as Saxon explained through the constructed dialect of Theophile Polite Narrows, whose "dark eyes . . . glitter hotly in the Louisiana sun, 'we Cajun are damn fool, us.'"[105] While Saxon's Creoles eschewed acquisition for aesthetics, his Cajuns remained isolated rural peasants. One group spoke fluent French, the other a semi-intelligible patois in a dialect thick as gumbo. "Many [Cajuns] still live in rude shacks, weave their own cloth, [and] continue to cling to a chronic aversion to wearing shoes," *Gumbo Ya-Ya* explained.[106] Most were poor and few were literate in either French or English. They observed ancient customs and practiced strange folk beliefs described at length. All Cajun men, more or less, conformed to the assertion set near chapter's end: "A Cajun is proud of his race, his family, his strength, his prowess as a hunter, fisherman, fighter, or lover, and he boasts of all of these with a childish lack of restraint."[107]

In this fashion, Lyle Saxon's final publication reveals the paradoxes at the core of his existence and his conflicts, never resolved, with modernity. Though modernist enough not only to grasp but to celebrate the uncertainty of individual existence and the simultaneous varieties of American experiences, he never stood apart from this material, isolated and exposed, never examined either it or himself with the kind of clinical detachment other modernist contemporaries did. Instead, Saxon's reluctant modernism sought to conceal what others aimed to reveal. As Terry Cooney suggests, modernism gave its southern converts a way of subverting tradition, exploring the many Souths they found with all their varieties, extremes, and inconsistencies. But studying

the South was never Saxon's aim, nor using the universality of the modernist South as a way of defining America. What made the Quarter and Cane River unique and therefore attractive was its isolation from and indifference toward modern America, not the way it could be made an encapsulation of it. The real riddle of remaining "internationally known locally" was how to achieve the former without losing the latter, and Lyle Saxon never solved it. Instead, he struggled to reconcile opposing directions down to the very end.[108]

In retrospect, Lyle Saxon's life and art seem an especially cogent reflection of their time and place. His first book, *Father Mississippi*, linked natural disaster and cultural change in the story of a regional calamity that anticipated the national collapse of the Great Depression. The combination of eyewitness reportage and nostalgic reminiscence foretold both the style and substance of early thirties expression. Even his assertion that, because it transcended the states and the region, managing the Mississippi River was a federal responsibility, looked to the immediate future. But if the book foreshadowed early reactions to industrial crisis, its author never kept pace with the ensuing intellectual currents, largely for personal reasons. *Father Mississippi* gave Lyle Saxon an identity he was still defending in *Gumbo Ya-Ya*, long after the artistic ferment of the Great Depression had taken the country in such different directions. He spent the balance of his life in the guise of a southern anachronism, masking as urban aesthete and plantation scion and mastering a kind of literary paternalism whose tales of isolated peoples and insular ways became the basis for his national celebrity. In this sense, Saxon's greatest fortune was also his cruelest fate.[109]

When the interest in local place he helped to sow blossomed into national rage, it compromised Saxon's art and identity. Though it was intended for a national audience, his material was supposed to remain inaccessible to all others but himself. This way Saxon the author remained the exclusive voice of those places. But two things happened during the 1930s to break his grip on them. First, the relativist emphasis of modernist assumption disrupted the hierarchy of American places. Where it had once been not just possible but popular to dismiss the place near Dayton, Tennessee, "where the road made off for the hills," this was no longer the case. Now, because each place in America had something to say to all Americans, few writers traveling alone or at federal expense risked missing the story they now knew each place must have. Time and again, when various Writers' Projects informed their national supervisors that local quirks and eccentricities did not exist, they were assured by Alsberg's staff that of course they did and ordered to go find them. The results, FWP guides revealed, made such places as Cane River and the Quarter no longer the odd exception but the American rule. All over the country, private and public writers now discovered diverse peoples and disparate cultures,

all of them contributing vital clues to the ongoing effort not to preserve local integrity but to define national identity. And as the new folklorists asserted, what went for place applied for people too. If the story of inaccessible places now mattered, so did the voices of their peoples; indeed, mattered so much that the story was best told in their own words and not filtered through an authorial consciousness who, despite good intentions, was apt to condescend. What had once been "under the crust," was now in plain sight as the margin, Saxon's lifelong concern, became mainstream.[110]

If modernist assumption undermined Saxon's art, then so did the pace of American modernization. Though the WPA distinguished between its white- and blue-collar projects, in both culture and construction, similar results occurred. In either case, the politics of localism inhered, especially after Congress atomized the national arts program in 1939. But if local authorities supervised their own sites, the work in progress there was completed, most often, according to federal guidelines being enforced on the same kinds of projects all over the country—a trend equally true for physical construction and artistic expression, and sometimes both at once. The post offices Section artists decorated were built according to one of a small number of standardized floor plans. Then, too, if the same kinds of structures were appearing in communities all over the country, New Dealers also oversaw their physical and artistic connection. While WPA laborers paved streets and poured concrete highways, FWP scribes matched this work with words. The tour sections of state guides connected each state with its neighbors, making it possible, as the national administrators had intended, to navigate the country according to a common set of directions, assumptions, and accommodations—a trend only hastened after Pearl Harbor.

The new connections made through physical construction, artistic expression, mass media exposure, and wartime mobilization required new adjustments of people and places alike—ones Saxon never made. Though the early thirties leant credence to his stories of faded grandeur told with southern accents, the balance of his life revealed the limits of his art. Mourning what was lost, it turns out, was only half the story, and Saxon never mentioned what might be gained in the process. This task he left for others who had by depression's end transformed what once seemed like a calamitous break with American history into another of the long series of triumphs over adversity that defined the American experience. Told from modernist assumptions, disseminated through modernized methods, this latest version of the oldest theme missed Lyle Saxon completely. Instead, he redoubled his efforts to preserve what had not already disappeared, acts of intense urgency almost certain to fail. So much depended on keeping the insular isolated, for it meant concealing things he did not want exposed.

Yet preservation had its own transforming effects, however unintentional, as Saxon himself learned in his final Carnival season. He had done so much to popularize Mardi Gras, to celebrate its masked saturnalia. But in doing so, he had made New Orleans accessible to anyone with an automobile, a guide, and an urge to join the fun. Such openness, Saxon learned, undermined the strategies of concealment at the heart of his literary art and folklore collection. Instead, it made Mardi Gras a modern mass experience, hastening the collapse of old traditions he himself had worked so hard to save. The Carnival season of 1946 exposed the future and prompted from Saxon a characteristic, if poignant, response. Over the years he had often contributed pieces to local newspapers, celebrating old customs and spreading Carnival spirit. It was the country's first Mardi Gras since the war ended and Lyle Saxon's last. Over the radio, in the final public statements of his life, he urged his audience to save Carnival from modern trend by reviving the flagging custom of general masking on Mardi Gras day.[111]

Two months later, dying of stomach cancer, Saxon set off for one last visit to Melrose. But in Baton Rouge, on the trip north, his stomach hemorrhaged, forcing his return. Surgeons operated, but complications developed and then pneumonia. Though he labored for breath, to Robert Tallant sitting bedside he whispered assurances that there were no regrets, that he had had "a wonderful time." Next day, Saxon lapsed unconscious, his breathing harsh and struggling. In the last hours it softened and grew more intermittent. Finally, on the morning of April 9, 1946, it stopped altogether. Two days and two funerals later, friends buried Lyle Saxon just a few blocks from Huey Long's new state capitol.[112]

CHAPTER SIX

"The Grandest Picture"

1. "The Central Instrument of Our Time."

Lyle Saxon's only novel, *Children of Strangers*, closes with scenes central to his life, art, and quarrel with modern America. The climax begins when Famie Vidal, a mulatto woman and the novel's tragic heroine, agrees to accompany Henry Tyler, a black sharecropper, to celebrate Easter Sunday with his all-black congregation. "Their appearance together," Saxon relates, "would serve as an announcement that their future lives would be spent together" and everyone would know that "she had left her own people and had gone to his."[1] It seems she had little choice. As an unwed teenager, Famie bears the posthumous son of a white man. She devotes her life to the boy and continues to support him even after he has grown and moved to Chicago by selling her land, labor, and possessions. Gradually, she withdraws from the mulatto community to which she had once been so deeply connected and gravitates toward her fellow black workers at Yucca plantation. They share meals and conversation. She even adopts their folk remedies. Finally, to satisfy her son's persistent demands for money, she spurns her family's offer to make gradual payments on her last parcel of land. Instead, desperate for ready cash, she sells the tract at well below its market value to Guy Randolph, Yucca's owner. The transaction provokes a swift climax. Shocked by her drift toward the black community and outraged by the sale, her family disowns Famie. Then her son returns, remaining only long enough to collect the sale's proceeds and tell his mother a final goodbye. He is leaving for California, he tells her, where he hopes to pass for white, and she will never hear from him again.

Two scenes on Easter Sunday close the tragedy. On her way home from service with Henry, Famie notices the approach of her mulatto neighbor, driving her great aunt and her former mother-in-law to church.

> John Javillee looked at Henry on his mule, and recognized Famie riding behind him. His face hardened as he flicked the reins on the back of the roan horse. He looked full in Famie's face, then spat over the wheel [while the women] looked straight ahead. None of them spoke to her.[2]

The encounter reduces Famie to tears she can neither restrain nor hide from Henry, but a final indignity awaits. In the novel's last scene, the two are stopped by Harry and Flossie Smith, friends of the Randolphs who have driven up from New Orleans for the holiday. Flossie, descends from the car, camera in hand.

> "Oh, Harry, just look at the couple on that white mule! Aren't they wonderful? I must take their picture . . . "
>
> "Oh, come on, Flossie, it's just some niggers on their way home from church."
>
> But Flossie was signaling Henry Tyler to stop: "Oh, please wait. I want to take your picture. Yes, turn the mule around a little and ask your wife to look at me . . . What's the matter is she shy? Lift up your head, I can't see your face for that sunbonnet . . . Well, never mind, you'll look coy with your head down. Maybe it will be better that way, more natural. Now boy you smile. Don't look so solemn. Harry, give him a dime, won't you? There, I've got it. But I never did see the woman's face."
>
> "Come on, Flossie, put the camera away and let's go in."
>
> "Well, of course I'm going in. You didn't think I was going to stay out here in the road all day. Harry, I'll bet I've got the grandest picture. They were so typical. You know, Harry, I always say that niggers are the happiest people. Not a care in the world."[3]

What closed *Children of Strangers* deepens the irony of Saxon's last years, and in this sense, the novel's end could not have been more prophetic. The story of its creation reveals its author's reluctant modernism, just as its text displays his contempt for modernity. Mostly, however, read in relation to Saxon's later activities, the story's end captures him once more in his divided role. Determined to preserve what he could of "Fabulous New Orleans" or "Old Louisiana," he only hurried their transformation, not only through guidework, it turns out, but also by his cooperation with the documentary photography project conducted by the Farm Security Administration (FSA). Saxon accompanied at least one FSA photographer into the field, and to several others he suggested stories or subjects they might pursue. Where he went and what he proposed clearly revealed his intentions. Saxon hoped to collect visual evidence confirming the Louisiana he wrote about. But why these photographs were being taken, the audience for whom they were intended, and the stories they would ultimately tell all undermined the author's effort. Hoping to resist the opening of Louisiana, he only abetted it, an irony climaxed the July afternoon in 1940 when, on Saxon's own insistence and after his arrangement, a young woman stepped from a car to photograph Melrose.

It is a familiar story often told. Between 1935 and 1943, in three separate

institutional incarnations, a dozen or so photographers, in various combinations and for differing lengths of service, took pictures for Roy Stryker, head of the Historical Section in the Information Division of the Farm Security Administration. The perspectives differed, the styles varied, the assignments changed, the personalities clashed, and the net result has left historians of modern America with one of their richest sources of research, speculation, and debate. During its eight-year existence, Stryker's photographers created the most extensive visual portrait of America in its history. But if this accomplishment is immutable, the meaning of those photographs and of the effort that produced them is something altogether different.

The organization itself, its photographic style, and the record of American life it completed have become the object of an expanding body of scholarly literature. Studies have concentrated on the photographers themselves, individually and severally, on collections and interpretations of their work, on Stryker's leadership and influence over the effort, on the project's ultimate aims and ambitions, its treatment of race, even on the content of selected regional photographs analyzed in the light of organizational needs and purposes. Still, scholars have failed to achieve anything approaching consensus with regard to the effort's ultimate meaning. Earlier observers discerned three separate phases of what is generally referred to as the Farm Security Administration file. These researchers suggest that early FSA efforts, principally the work of Walker Evans, Dorothea Lange, Ben Shahn, Carl Mydans, and Arthur Rothstein created what has become the enduring pictorial image of the Great Depression. The photography, often outraged, depicted scenes of widespread deprivation, the physical and spiritual toll of "hard times" made visible in washed-out gullies and empty faces and squalid living conditions. Beyond expressions of anger, such photographs served another purpose. They were intended to crystalize support for New Deal agricultural policies, or, as one observer has explained, the photographs documented the plight of rural America to urban America in order "to preserve the tenuous coalition which had brought the New Deal to power."[4] By 1938, this interpretation holds, the effort had succeeded so well that Roy Stryker asked his photographers to emphasize the happier aspects of American life. They did. Images of grimy children and tattered shacks gave way to photographs celebrating the sturdiness of American faces, the durability of American values, the strength of the American character, and the pastoral beauty of the American landscape. A final period, almost a regrettable coda, began when the FSA unit was transferred to the Office of War Information (OWI). Here, until its demise in 1943, Stryker's staff produced propaganda photos glorifying the American war effort.[5]

The final two chapters of the FSA story have traditionally commanded less attention and considerably less enthusiasm. Most observers share the view

of John Vachon, one of the photographers, who lamented that the heady days of passion and commitment reflected in the socially conscious work of the earlier period gave way to a standardized, cookie-cutter vision of the American scene. "What was left of Stryker's outfit," rued Vachon, "was turned into a branch of the OWI to photograph defense plants and shipyards and 'God Bless America.' Then the whole thing fell apart. That is it stopped."[6] More recently, however, some historians have reviewed the FSA oevure in its entirety, emphasizing the continuity between the earlier period and the later ones and studying the photographs not solely for their content but also for the way they were created, collected, and disseminated. These researches have been especially rewarding, providing significant parallels between FSA photography and the larger concerns of artists and writers and other creative people during the depression decade.[7]

FSA photography shared much in common with the artistic expression of thirties America. Most veterans of the project came to photography with backgrounds in the other arts. Ben Shahn and Russell Lee, for example, were painters. Walker Evans aspired originally to write fiction. John Collier, a former muralist, once studied with Maynard Dixon, Dorothea Lange's first husband. Jack Delano attended art classes in Philadelphia until his funds ran out in the early months of the depression. Marion Post studied dance. But whatever their backgrounds, the photographers' documentary style fit within the American Scene movement. Social realism informed both Ben Shahn's painting and his photographs, while a case can be made for the regionalism of many other file photographs, especially Marion Post's landscapes. The two forms shared both style and subject, and each, an innovative aesthetic departure in the early thirties, became an aesthetic orthodoxy once raised to power and prominence by a federal patron whose political authority it supported and whose social values it reflected.

FSA photographers also present a demographic profile and social outlook consistent with other thirties artists. Most came from urban, middle-class environments. Lange and Post were reared in the Northeast, near New York City, Shahn's home after his family emigrated from Lithuania in 1906. Evans, born in St. Louis and raised in Chicago, experienced his greatest moments of artistic stimulation in Paris and New York. Lange, Post, and Lee all came from broken homes, though like the rest of the group, none lacked for material comfort. Instead, with the exception of Russell Lee, who as a small boy saw his mother struck and killed by a car, the photographers were little prepared for the trauma they encountered in the field. Some were shocked by what they found, others outraged, and most used print and photograph to demand redress for such appalling conditions. The photographers accepted the assertion made by their colleagues in other media that art was something

more than what their fathers and grandfathers had believed, that it was not the passive creation of rarefied beauty; instead, properly used, art was a vehicle of social protest and a catalyst for social change.[8]

The photographic activism of Stryker's team also paralleled the ideals and goals of other federally sponsored cultural projects. It relied for the source of its idealism on a basic faith in the American people, specifically their ability to weather adverse conditions not of their own creation. It also implored the necessity of change, the government-sponsored improvement of conditions deemed intolerable. With brush, pen, and now camera, thirties artists demanded a redistribution of wealth and power, the restructuring of society in order to provide traditionally disadvantaged groups with jobs, houses, improved literacy rates, and increased health care. Yet, like their colleagues in other arts on other projects, the photographers accompanied their demands for change with a simultaneous lament for what was being changed. While federal artists explored new forms and experimented with new systems of patronage and production, and while federal writers assembled the new guide to the American nation, their efforts were accompanied by a palpable nostalgia, a romanticizing of things its very existence had rendered obsolete. FSA photographers followed suit. If many of the more memorable photographs created by Stryker's team protested the status quo and agitated for its overthrow, others sought to reinvigorate some of the heartier American myths challenged by the depression. Together with American Guides, Section murals, and FAP easel work, FSA photography reveals the struggle by thirties Americans to reconcile traditional values with contemporary innovations, an attempt, steeped in paradox, to square past ideals with contemporary scenes, a simultaneous determination to effect change and deny it.[9]

Not only in art or outlook, organizationally, too, here was a first cousin, if not a full sibling, in the New Deal art family. Like the other organizations, the FSA effort quickly transcended its original scope. An emergency six-month experiment to aid starving artists became a sprawling attempt to redefine art and regulate its production and consumption. A proposal to write five regional guidebooks grew into a grassroots survey of American life spanning eighty feet of library shelf. The same transition from ad hoc experiment to mass production characterized Stryker's unit, whose effort widened from recording desks and offices to national photographic inventory. Then, too, while federal writers maintained copy flow through weekly word and page quotas, and federal easelists completed paintings according to time schedules determined by the size of their canvases, Roy Stryker maintained production as a preeminent organizational priority, and for the same reason. Production justified expense, and distribution culminated production. From the very beginning the Unit evolved into an organization of mass communication. FSA photo-

graphic exhibitions prepared by Edwin Rosskam, a full-time staff member hired exclusively for the purpose, crisscrossed the country. FSA photographs illustrated all the newly established mass-circulation magazines, among them *Life, Look,* and *Survey Graphic.* The photographs also appeared throughout the spate of documentary books published during the thirties, and this was no accident. Early on, Roy Stryker built a distributive network, ensuring the mass dissemination of his unit's photographs. In August 1939, his office even began formulating lists of proposed stories and subjects for interested publishers, operating as an information agency sensitive to the needs of its parent administration.[10]

The FSA thus shared with the other arts projects a common set of philosophical ambitions, organizational needs, and stresses between the two. Roy Stryker experienced the same tension between content and production that plagued the administrators of the other cultural programs. His controversies with Walker Evans over the paucity of Evans's productivity and with Dorothea Lange over the control of her negatives are well documented and highly instructive. So, too, is the manner in which such disputes were resolved. Three major artists—Evans, Lange, and Ben Shahn—set the technical standards and social outlook of subsequent FSA work, and then left the organization on the outs with its director. When Evans repeatedly ignored Stryker's appeals to increase his output, Stryker fired him. Shahn quit, horrified to learn that Stryker sometimes "killed" negatives he deemed unfit for the file, punching holes through what Shahn considered works of art. Dorothea Lange, a zealous guardian of her photographic art, became estranged from the unit at the same time, although she took longer formally to sever her tie with it. Evans, Shahn, and Lange were replaced by such artists in their own right as Russell Lee, Marion Post, and John Vachon, but as others have observed, they were a younger, more malleable set of photographers more committed to augmenting the file than defending their aesthetic values. Relatively early in its administrative existence, then, production gained ascendancy over artistic innovation, a condition never altered and a context crucial to any understanding of the photographic portrait of America recorded by the FSA.[11]

During its eight-year existence the organization amassed a photographic file whose contents reflect the growth of both modernization and modernist assumptions. In its most basic context, the file documents the physical and cultural destruction of rural America—land erosion and human exodus. Stryker's photographers recorded the westward flight of Arkies and Okies, the migration of field hands and sharecroppers to urban manufacturing centers, and the concentration of small-scale farmers onto larger FSA-sponsored agricultural cooperatives where various specialists instructed client families in the rudiments of middle-class existence. In the American South, the de-

mographic consequences of agricultural consolidation represent a decisive moment in the region's history, a "draining of the fens," foreshadowing its industrialization during World War II. But the FSA file also reveals the influence of modernist assumptions on American photography. FSA photographs departed from the gauzy, highly romanticized photography in vogue during the 1920s. The documentary style, as it came to be known, demanded stark images in sharp focus, what many of its practitioners claimed as an unblinking eye on "reality." Its compositions often jumbled conflicting objects for discordant effects, a method mastered by Walker Evans who used photography as his idol James Joyce used language. Evans accumulated the infinite minutiae of daily life, a vast array of objects however absurd their association might be within the same frame. Meanwhile, other FSA photographs probed the inner tensions of modern life, contrasting the ideal and the actual and exposing the gulf between the two. The results, usually ironic, often juxtaposed the fantasies of Hollywood directors or Madison Avenue executives with scenes whose "reality" undermined illusion. Calculated to stir emotion rather than appeal to reason, the effect mirrored the general modernist assault on Victorian facades easily pierced, they asserted, by concrete experience.[12]

FSA photographers thus helped advance a modernist portrait of modernized America, synthesizing the two in the narrative structure of the photo essay. Here in this format, these two things achieved a complementarity vital to the future of both. Modernists were rarely modernizers; indeed, many were openly hostile to the modern system. Likewise, modernizers usually resisted modernism, a trend not solely attributable to the traditional separation of thinkers and doers. Modernizers and modernists tacked in opposite directions, modernizers toward systemic connection, modernists toward internal abstraction. Unchecked, each moved toward a logical extreme the other abhorred—routinization or disintegration. Modernist thought leaves people teetering on bridges amidst the crumbling structure of scattered thoughts. Modernizers, meanwhile, created robots, one of thirties America's other basic fears. But the photo essay balanced these two, lending structure without uniformity and diversion without disintegration. Individual photographs might convey the essential randomness of modernist experience, but their inclusion in a organizing narrative moderated their ultimate effect. Similarly, the modernist quirk provided an essential check against modernized overregulation. Roy Stryker sent his photographers across American looking for stories, not individual photographs, whose sum total became a new kind of American storytelling.

How the FSA file grew and how its photographs were organized suggests a new conception of America. The file evolved as negatives accumulated from the field. Initially, prints developed in the central office in Washington

were captioned, then arranged by state according to subject. This practice was abandoned in 1942 when Paul Vanderbilt, previously a librarian at the Philadelphia Museum of Art, reordered the collection along two separate filing systems. One preserved the original order in which negatives were exposed and submitted from the field, grouping separate photo series into self-contained stories or "lots." The other, dubbed the "Classified File," arranged these same prints into groups according to six geographical regions across the country. The prints for a given region were then sorted topically under any one of nine general headings and within each general heading under one of thirteen hundred subheadings. This was no simple change. As Alan Trachtenberg has observed, Vanderbilt created a dynamic system of filing images deliberately conceived to accommodate future, presumably different, conceptions of American society. The system was devised specifically to be fluid, to accept the relativity of ideas and images. It was, in short, modernist at the same time it was modernized. Devised according to guidelines suggested by the sociologist Robert Lynd, the Classified File mirrored the machine culture in which it was conceived and intended to serve. It sorts the American nation into pigeonholes, envisions the country as a coherent and logically organized construct, a rational corporate entity. The file sees America as the sum of its separate parts, making Vanderbilt's system the visual analog of the printer's box where photographic images replace bits of type as the basic building blocks of communication. Vanderbilt himself asserted that the file represented "a stock-room of parts" to "the assembled useful machine," a mechanistic image shared by Trachtenberg. "Rather than predetermine combinations that constitute a finished whole," he writes, "the file traffics in component parts." Visual instead of verbal, fluid instead of static, here was a dramatic break with the past.[13]

Documentary photographs sorted into the Classified File posed a fundamental challenge to such aesthetic localists as Ellsworth Woodward and Lyle Saxon. Woodward had little use for the photograph either as an art form or an educational tool. Cameras were not art; they were mechanics. They did not render Nature; they merely recorded it. Relying on them, Woodward believed, would not only make poor art but lazy artists. The essence of artistic expression, he believed, came only from direct contact with the subject, something he once explained to Angela Gregory while admonishing her never to work from a photograph. Nor could Woodward abide the use of photographs or motion pictures to supplement his classroom lectures unless they were followed by immediate studio experience. Photographic images were fleeting and impermanent, he argued. Only knowledge gained through experience endured, requiring hours of study and reflection and, in the case of the aspiring artist, practice.

To Woodward, photography in general, especially the documentary sort,

represented all that was wrong with American art. Photographs violated the methodological dicta spelled out in Woodward's classrooms. These were stark scenes stripped of all painterly technique. The subjects were squalid, and in the case of the new 35mm cameras, the negatives themselves were often grainy. Photographs of this sort not only focused on ugly things; they were themselves ugly. Here encapsulated was the whole threat of industrial manufactures. The photographic negative was reproduced easily and disseminated rapidly, a cheap form requiring no artistic training, and as a vehicle for the rapid broadcast of repulsive things, almost unrivaled in its potential for cultural damage. Nor could a form seem better calculated to disrupt Woodward's localized sensibilities. FSA photographers were not local craftsmen depicting local scenes. They crisscrossed the country, snapping photographs not to interpret local beauty but to build national stories. Here was the form to undo fifty years of teaching and creation.[14]

Lyle Saxon's connection to FSA photography was less dismissive and more complicated. As a young boy, he developed an interest in photography and as an older man explored its various uses. Saxon not only displayed his constructed self before the camera, he understood photography's potential to abet his preservationist impulses. Film could preserve things rapidly disappearing from view, and in 1931, beginning a trend he continued for the rest of his life, he chaperoned the photographer Doris Ullman to Melrose and along Cane River. Such activities only increased after he joined the WPA. Before long, Saxon was a man of some stature within the relief administration, an important southern contact beyond the immediate circle of the Writers' Project. He already had the respect and admiration of the documentary filmmaker Pare Lorentz, who cited *Father Mississippi* as the guiding spirit of *The River*. Indeed, it may have been through Lorentz that Roy Stryker first contacted the Louisiana director. What is more certain, however, is that Saxon became a trusted connection. Pressed to find a new supervisor for the FSA region of which Louisiana was a part, the Washington administrators not only solicited Saxon's advice but appointed his man. Moreover, he became the mandatory first stop for any of Stryker's photographers traveling through Louisiana and, as such, someone in position to influence the Louisiana file. Sometimes he merely suggested subjects and locations. On at least one occasion, after arranging for him to travel downriver below New Orleans, he even assumed his familiar role as tour guide and accompanied Russell Lee into the Cajun country. Later, after repeated entreaties from Saxon, Marion Post reprised Doris Ullman's travels through the Cane River country.

Ultimately, Saxon's experience with FSA photography patterned after his WPA work. Hoping to preserve Louisiana as a colorful place of exotic peoples, he watched instead as FSA photographers universalized the state, displaying

its places and peoples at least in part according to Benjamin Botkin's folklore assumptions. While the file began with the land, specifically soil erosion, it made an early and decisive focal shift. "Look Roy," Ben Shahn told Stryker, "You're not going to move anybody with this eroded soil—but the effect this eroded soil has on a kid who looks starved, this is going to move people." Stryker agreed, altering the direction file photography took, not only emphasizing people over place, but concentrating—as Botkin had urged his folklorists—on the daily struggle of ordinary people negotiating the essential conflicts of modern life. Differences might emerge in the exact coping strategies, but only ones of degree and not kind. In this sense, the file linked the variety of American folk customs, ethnic practices, and religious rituals into a common theme, one that made the peculiar commonplace and whose cumulative effect eschewed both the ethereal and the exotic for the ordinary and everyday. Before it was over, then, Lyle Saxon's romantic Louisiana became something altogether different, especially the two places he held most dear.

2. New Orleans and Vicinity, 1935–36

Between 1890 and 1935, Louisiana photography remained largely a localized affair with a handful of photographers working in specific places. As Frank deCaro notes, the Swiss immigrant George Francois Mugnier, worked the New Orleans vicinity, while Arch Lee Bush photographed backwoods life and labor in the Florida parishes above Lake Ponchartrain. Andrew Lytle, "renowned as a Confederate Civil War photographer," maintained a studio in Baton Rouge. Across the Mississippi River Joseph Barthet, Olide Schexnayder, and Eli Barnett worked respectively out of the small south Louisiana communities of Thibodaux, Egdard, and Crowley. Subjects and styles varied to be sure, but early-twentieth-century Louisiana photography was as localized as its art and politics, a pattern followed in the next generation with one crucial difference. Charles L. Franck, Elmore Morgan Sr., Fonville Winans, and Clarence John Laughlin can all be associated with a specific region. Franck was a commercial photographer in New Orleans. Morgan photographed the lumber districts of north Louisiana. Winans is often associated with southwestern bayou water culture, and Laughlin explored the plantation district above New Orleans. But this younger group also enjoyed the greater mobility of more portable equipment and the Long road-building program. In the 1930s, then, Louisiana became more accessible not only to local photographers roaming within the state but to national photographers roving across it.[15]

All of Roy Stryker's original photographers reached Louisiana between 1935 and 1937. Carl Mydans and Arthur Rothstein both worked in New Orleans and below the city in Plaquemines Parish. Meanwhile, Dorothea Lange

crossed north Louisiana, recording cotton cultivators and the remains of Lumberton, a logging center turned ghost town. Here Lange collected local evidence sustaining the national indictment she and husband Paul Taylor advanced in *American Exodus*. Lumberton's deserted shops and abandoned bank testified both to the economic collapse and to unrestrained acquisitiveness as its cause. There had been a brief moment of success in Lumberton, but when the timber played out, the profit seekers moved on, leaving only stumps, empty streets, and a few idle stragglers to sift among the ruins. But even before Lange and Taylor incorporated Lumberton into their record of American failure, two other early FSA photographers did even more to universalize Louisiana, to draw it out of local context and into the modernist portrait of modernized America.[16]

Walker Evans and Ben Shahn were not only modernist artists, they were former roommates whose work in Louisiana was part of the first immediate contact either man ever had with the American South. Evans had aspired originally to fiction but had returned from Paris unable to match, or even to meet, his idol James Joyce. He turned to photography instead and by 1935 stood on the brink of establishing his mastery of form and modernist perspective. By then a renowned painter, Ben Shahn took up the camera on a bet, then badgered Evans for lessons. Now both came to Louisiana with a common purpose, if divergent methods. Evans mastered the 8 x 10 studio view, a camera suited to his deliberate style. Shahn used a Leica, one of the new 35mm cameras mass-produced for easy use and maneuverability but often branded a "toy camera" by purists such as Evans. While Evans worked alone, frequently dropping out of sight for long stretches, Shahn traveled with his wife, Bernarda, who sometimes held the wheel while her husband leaned out the window snapping pictures. Usually, too, their different cameras were pointed at differing subjects. While Evans often let structures speak for the society he saw, Shahn concentrated on people, conversing at length with the vagrants he encountered or following migrant pickers home from the field. Yet for all their differences, it was Evans himself who noticed their similar photographic perspective, not one to provide much comfort for aesthetic localists.[17]

In a memorable series shot among moldering plantations on either side of the river, Evans recorded visual proof of Saxon's chief lament through a medium Woodward dismissed. Above New Orleans and below Baton Rouge, Evans confronted ruins Saxon could not arrest, suggesting "truths" Saxon would rather avoid. Because Saxon's romance depended on mansions in perpetual decay, the trick was to keep them from disappearing altogether, an eclipse whose certainty Evans captured. At Belle Grove plantation, he made several 8 x 10 exposures, at least two of them interior scenes. One concentrated on a cracked pedestal. The other was exposed in a room facing west. Grimy walls

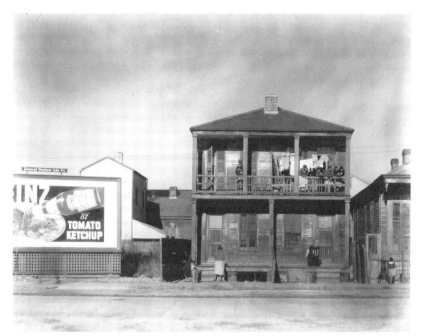

6.1. Walker Evans, "A Negro House in the Greek Revival Style" (Library of Congress, Prints and Photographs Division, FSA-OWI Collection, lc-usf-342-1284)

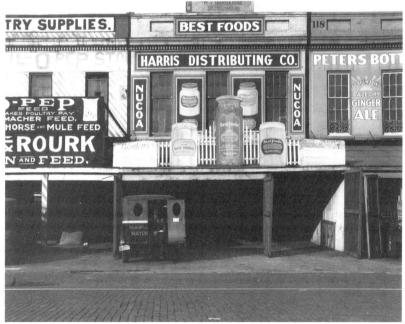

6.2. Walker Evans, "Waterfront Houses in Louisiana" (Library of Congress, Prints and Photographs Division, FSA-OWI Collection, lc-usf-8121-c)

6.3. Walker Evans, "A Small Town Shop Front in Louisiana" (Library of Congress, Prints and Photographs Division, FSA-OWI Collection, lc-usf-8108-c)

6.4. Walker Evans, "The Outskirts of the Factory District" (Library of Congress, Prints and Photographs Division, FSA-OWI Collection, lc-usf-1297-a)

bore graffiti traces, plaster chunks carpeted the floor, and at the center of the frame, in the heart of a small anteroom, a cross of light filtered through closed shutters. Perhaps the most powerful image of the sequence, Belle Grove's interior belongs more to Rosa Coldfield than Kate Dangerfield.

Had he seen it, Ellsworth Woodward would have been equally disturbed by the art of Walker Evans. Studying his "vulgar" subjects through his "vulgar" form, Evans assaulted Woodward's genteel ideals. Where Woodward spent a lifetime advocating moral order through art, in the space of "one-twentieth of a second," Evans exposed the shallow depth of such faiths. Woodward's hope had rested on pleasing architecture and tasteful decor. Evans's camera focused on cracked columns, sagging eaves, and broken bits of china strewn on rotting floors. Masters and servants have vanished, and the balance of Evans's Louisiana work suggests what took their place. Photographs recorded in and around New Orleans contrast the waning influence of artisanal crafts with the waxing power of national industrial culture. "A Negro house in the Greek Revival style," for example, juxtaposes nineteenth-century architectural forms with twentieth-century commercial messages, contrasting the plainboard living quarters on the right with the Heinz advertisement at left (fig. 6.1). Nearly as tall as the house and easily as broad, the billboard commands a proportionate share of the visual space, a stature in American society commensurate with the home. Evans expands this message in "Waterfront warehouses in Louisiana" (fig. 6.2) and again in "A small town shop front in Louisiana," where Evans abandoned his typical frontal camera angle to reveal the store's false front (fig. 6.3). Yet this temple of commerce now wears the mantle of the ancients once claimed by antebellum planters. Over the door a peaked arch enshrines the proprietor's name in cast cement letters below frieze work flanked by urns. One final photograph, "The outskirts of the factory district," suggests Evans's own reaction to modernized American growth (fig. 6.4).

While Walker Evans probed the facades in and around New Orleans, Ben Shahn studied people in the same places. Though he did shoot a series of passersby in Jackson Square and another in Plaquemines Parish, Shahn captured his most evocative negatives in and around Hammond, Louisiana. Above New Orleans, U.S. 51 ran due north across a twenty-mile stretch of swamp and marsh separating Lake Maurepas from Lake Ponchartrain. Once it cleared the lakes, the highway entered a pine district of thick woods and deep wells stretching toward the Mississippi line. The road paralleled the main line of the Illinois Central, whose directors established the town at the turn of the century and planted several dozen northern families picked by management for their "industriousness." Proximity to the railroad provided the settlers with their chief means of livelihood, for this was strawberry country. Centered around Hammond, seat of Tangipahoa Parish, the region pro-

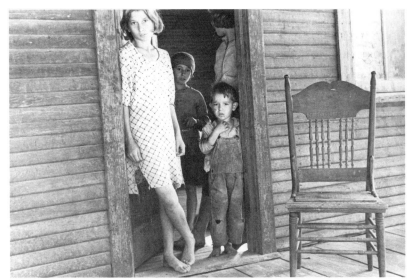

6.5. Ben Shahn, "Children of the Fortuna Family, a Family of Strawberry Pickers" (Library of Congress, Prints and Photographs Division, FSA-OWI Collection, lc-usf-33-6174-m4)

6.6. Ben Shahn, "A Child of the Fortuna Family, a Family of Strawberry Pickers" (Library of Congress, Prints and Photographs Division, FSA-OWI Collection, lc-usf-33-6174-m3)

6.7. Ben Shahn, "A Stove in the Home of a Strawberry Picker" (Library of Congress, Prints and Photographs Division, FSA-OWI Collection, lc-usf-33-6179-m3)

6.8. Ben Shahn, "The Interior of a Strawberry Grower's House" (Library of Congress, Prints and Photographs Division, FSA-OWI Collection, lc-usf-33-6176-m3)

duced nearly 90 percent of the national strawberry crop, harvested each year during a frantic, two-month period between March and May. A ripened crop required immediate harvest. Picking continued virtually around the clock, demanding large pools of migrant laborers, chronically poor, politically unorganized, easily exploited and, together with the southern sharecropper, a common symbol of national inequity throughout the 1930s.

This was fertile ground for Ben Shahn. He arrived in the strawberry districts in October 1935, well after the harvest, and befriended a family of berry pickers. Undoubtedly Shahn realized the implications of a migrant family whose name, "Fortuna," belied their fate. In framing "Children of the Fortuna family," Shahn linked three barefooted children to their stark surroundings and a vulnerability suggested by an empty chair and averted eyes (fig. 6.5). A second exposure made the suffering timeless and the Fortunas not simply migrants but universal symbols. Here the eldest daughter appeared with the same distant gaze, only this time arrayed beneath a portrait of the Virgin Mary and her child cradled in her arms (fig. 6.6).

Other photographs recorded around Hammond reversed conventional associations of elite order and popular disorder. In the photographic still life "A stove in the home of a strawberry picker," Shahn ennobles the simplicity of migrant life, incorporating the Fortunas and their neighbors into a peasant tradition centuries old (fig. 6.7). But "The interior of a strawberry grower's house," contrasts plain board floors and barefoot children with mass-produced commercial appeals. The tension between the two makes the interior not only unreal but surreal. False promises jumble together creating illusions Shahn punctured with the composition itself. Just to the left of the smiling couple he captured the double entendre of a beer ad, using the familiar labor slogan, "In union there is strength," to undermine glib assurances of low prices and guaranteed satisfaction (fig. 6.8). Finally, Shahn borrowed a favorite Evans motif, using a photograph of a billboard north of Hammond, in Amite, Louisiana, this one advertising the new George Raft picture *Stolen Harmony*, to provide the theme of his series.

Just months apart, Shahn and Evans drew similar conclusions from what they saw in Louisiana. Evans's scenes of plantation wreckage spoke alike to brittle facades and abandoned craft skills. The literal props of elite power had all crumbled, while others appropriated their emblems. The hand-carved urns of the previous century were now available in cast cement, and no amount of gauzy romance would reverse the process. Ever the modernist, Evans himself confronted truths he found unpleasant. He was not alone, of course, in invoking the ruined mansion as a symbol of social collapse just as he was not the only American photographer suggesting that machines and modernization

had gone terribly wrong. Ben Shahn, among others, agreed down the line, using the lives of Hammond's poor to depict the human consequences. There, with irony and in one instance surreality, he exposed the ad-man's false promises, using specific misfortune to sustain artistic outrage and advance general social indictment. Like Evans, Shahn universalized Louisiana, made his photographs speak about bigger issues to larger audiences, connecting them to ancient traditions and national conditions in ways capable of wresting the ground right out from under Lyle Saxon's feet.

3. Crowley and Vicinity, 1938

What helped cement Walker Evans's artistic reputation also got him fired. Years of experiment and innovation may have produced a new understanding of the photograph and a different way of looking at America, but disappearing for weeks on end was no way to complete schedules and maintain production. Evans might have produced photographs of unsurpassed quality, but he did so in insufficient quantity. Told to increase his output or suffer the consequences, he took his tools and skills elsewhere, refusing, he insisted, to work in a photographic factory. Ben Shahn followed quickly, and into the vacancy created by the former roommates stepped a younger group of photographers, including Russell Lee.

It almost seems as though photography was invented for someone like Lee, a trained engineer whose first wife was an artist. The only surprise is that it took until 1935, when Lee was thirty-two, before he found his medium by synthesizing the two. Tutored by his friend, Konrad Cramer, a veteran of the Bauhaus movement, Lee quickly mastered the technology of shutter speeds, F-stops, and chemical developers. Meanwhile, the deepening depression provided both subjects and perspective. Lee began to attend farm auctions, first observing and later photographing debt-ridden people forced off the land. "I was developing a social consciousness," Lee observed, "because people were so damn poor." And much like other documentary colleagues, he resolved to put his art to social purpose. Encouraged by his friend, the Missouri artist Joe Jones, Lee traveled to Washington and renewed an old acquaintance with Ben Shahn. Shahn then introduced Lee to Roy Stryker, beginning their long association and lasting friendship. Lee, who had no father, went to work for Stryker, who had no son, and each helped to fill the other's void. Stryker nurtured, taught, chided, praised, and encouraged with folksy chatter well-suited for the role. "Boy, your batting average is certainly up," he wrote Lee in 1939. "The way you hit everything on the head astounds me some days. Keep it up." Lee returned the affection with hard work and fond letters. He became

Stryker's most prolific photographer, perhaps the archetypal FSA field hand, and one of his very first excursions, on Stryker's arrangement, brought Russell Lee into Lyle Saxon's orbit.[18]

Both Saxon and Louisiana made big impressions on Lee, whose schedule forced him to leave long before he was ready. "I arrived in New Orleans on Saturday and have been in contact with Lyle Saxon ever since," he informed Stryker's secretary. "I am getting fine cooperation from Mr. Saxon and expect that the surface will be barely scratched in six weeks, so don't be surprised if I happen to get lost in Louisiana."[19] Getting lost in Louisiana was exactly what Saxon had in mind. He peppered Lee with ideas for a photographic "survey of the state." Lee was charmed. He considered Saxon "a swell guy with a real appreciation for documentation" and was only too eager to begin what became the widest tour through Louisiana of any FSA photographer. Lee took hundreds of pictures in dozens of locations, and though he never made it to Melrose, as he and Saxon planned, Lee visited several of the author's other haunts. He wandered the streets of New Orleans, particularly the Vieux Carre, where the bars and saloons along Decatur Street attracted his eye. At Saxon's arrangement, he also spent two days aboard the *El Rito*, a packet steamer bound for the Gulf, photographing the crew and the fishing villages hugging the river below New Orleans. Once he returned, Saxon and Lee toured the mansions along River Road as far north as New Roads, above Baton Rouge, making alternate studies of plantations and storefronts much in the style of Walker Evans.[20]

Yet Lee did more than merely retrace the steps of his FSA predecessors. He spent the bulk of his time and the majority of his film in Acadiana, stopping in such towns as St. Martinville and Abbeville and Opelousas. At Delcambre and in Jeanerette he studied the increasing mechanization of the sugar cane harvest. He visited the salt plant on Jefferson Island, the shrimpers in Morgan City, and the sugar mill at Breaux Bridge. He took an extensive series of photographs at the home of an FSA client in Morganza and made additional stops in New Iberia, Raceland, Houma, Lafayette, and Erath, among others, even one in tiny Scott, Louisiana, the self-proclaimed "Gateway to the West." More specifically, however, Lee went to Acadiana, escorted by Saxon, to see the National Rice Festival in Crowley, where he recorded more than one hundred photographs of a small community at work and play.[21]

The Crowley series typifies Lee's photographic methodology and principal thematic concerns. Among FSA photographers, he is, perhaps, the easiest to study in series because he worked that way, a typical engineer, systematically assembling stories one photograph at a time. With good reason Roy Stryker called him "a taxonomist with a camera," and the principal focus of study, throughout his FSA tenure, was the small town. Nothing loomed so

large in Lee's photography or inspired greater attention or more determined effort. His biographer suggests that Lee's rootless youth left him with a heightened attachment to place and determination to belong. If so, he was someone uniquely suited to his times. As Lee joined the FSA, the air fairly crackled with concern for the community. Artists, documentarians, urban planners, New Deal administrators, Hollywood filmmakers—all took up the issue of the American community from one perspective or another, including the person with the greatest influence over Russell Lee's photographic work. In an oft-quoted interview he granted later in life, Roy Stryker recalled his response to a photograph made by Walker Evans.

> I remember [his] picture of the train tracks in a small town. . . . The empty station platform, the station thermometer, the idle baggage carts, the quiet stores, the people talking together, and beyond them the weather-beaten houses where they lived, all this reminded me of the town where I had grown up [Montrose, Colorado]. I would look at pictures like that and long for a time when the world was safer and more peaceful. I'd think back to the days before radio and television when all there was to do was go down to the tracks and watch the flyer go through.[22]

Troubled by the collapse of modern America, nostalgic for a "safer and more peaceful" time, like so many of his contemporaries Stryker allayed concerns raised by the former by documenting the persistence of the latter. As long as the village endured, so did its values, linking past and future, a point Stryker emphasized and Lee pursued. He became Roy Stryker's small town specialist who, shooting script in hand, provided visual proof that despite half a century of industrial growth, urban expansion, demographic transformation, and cultural confrontation, the old verities—individualism, democracy, and community—remained intact and in balance in their traditional residence. Lee roamed the continent from New Jersey to New Mexico, creating a string of small-town portraits, each a visual reassurance that even in the new world the old gravity inhered.[23]

While Lee's most celebrated community portraits were done in San Augustine, Texas, and Pie Town, New Mexico, his series shot in and around Crowley, Louisiana, clearly anticipates these later studies. In 1938, Crowley, the seat of Acadia Parish, straddled two worlds. It was an urban area but only by a strict interpretation of the Census Bureau definition. Fewer than ten thousand people lived there, by the state's standards a medium population center. Crowley also sat at the crossroads of agriculture and industry. The principal livelihood was rice, either its cultivation or its processing. Rice fields surrounded the town, stretching across alluvial plains beyond the parish lim-

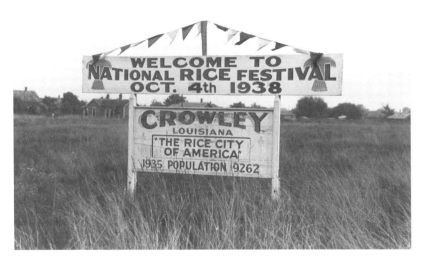

6.9. Russell Lee, "A Sign of Welcome—in the Outskirts" (Library of Congress, Prints and Photographs Division, FSA-OWI Collection, lc-usf-33-11721-m2)
6.10. Russell Lee, "Rice" (Library of Congress, Prints and Photographs Division, FSA-OWI Collection, lc-usf-34-31389-d)

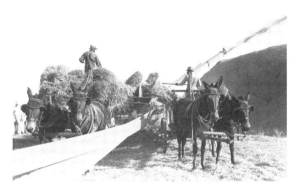

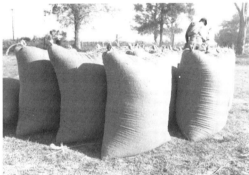

6.11. Russell Lee, "Threshing Rice in Louisiana" (Library of Congress, Prints and Photographs Division, FSA-OWI Collection, lc-usf-33-11629-m2)

6.12. Russell Lee, "Bags of Rice Fresh from the Thresher" (Library of Congress, Prints and Photographs Division, FSA-OWI Collection, lc-usf-33-11626-m1)

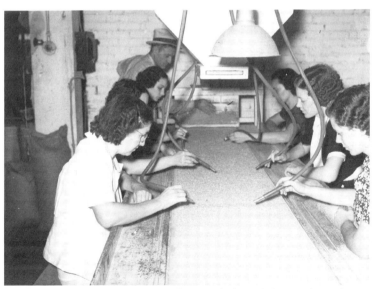

6.13. Russell Lee, "Removing Impurities from Rice before Polishing" (Library of Congress, Prints and Photographs Division, FSA-OWI Collection, lc-usf-34-31442-d)

6.14. Russell Lee, "Polishing Rice at the State Rice Mill" (Library of Congress, Prints and Photographs Division, FSA-OWI Collection, lc-usf-34-31376-d)

6.15. Russell Lee, "The Compressor Gas Treatment of Rice" (Library of Congress, Prints and Photographs Division, FSA-OWI Collection, lc-usf-34-31446-d)

6.16. Russell Lee, "Filling Packages with Rice at the State Rice Mill" (Library of Congress, Prints and Photographs Division, FSA-OWI Collection, lc-usf-33-11658-m2)

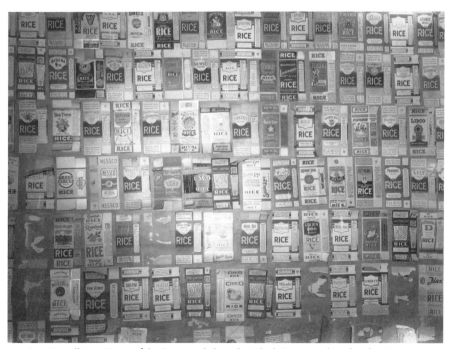

6.17. Russell Lee, "Some of the Private Labels under Which Rice is packaged at the State Rice Mill" (Library of Congress, Prints and Photographs Division, FSA-OWI Collection, lc-usf-34-31437-d)

its. Within the town, a rice mill employed one-tenth of the local population. Crowley was thus an ideal synthesis of tradition and innovation, a place of horse-drawn wagons and mechanized threshers, of work habits rooted in the soil yet firmly tied to expanding market opportunities. The people of Crowley could rightfully claim allegiance to the land, even as Lyle Saxon's scribes called it "a progressive little town" and the rival of nearby Lake Charles as "Rice Capital of the World."[24]

Better still, the town represented one of the more colorful tiles in the American mosaic. Like St. Martinville, home of the Evangeline mural, Crowley was French-Catholic, settled and inhabited by the Acadian exiles of eighteenth-century Nova Scotia. They deviated substantially from the American norm, speaking a patois French with a heavy dialect, and attending mass, not meeting. Acadians possessed a distinctive lore and practiced unique customs. Here was a town to allay all concerns. For those fearful of the small town's future, Lee depicted a place knit closely by the ties of family, culture, religion, labor, leisure, and celebration. Anyone concerned with the growth of a standardized culture could take renewed confidence in a place such as Crowley, of distinctive cuisine, music, dance, and dialect. Given Stryker's instructions and, no doubt, Saxon's more specific enthusiasms, Lee was excited about Crowley before he even saw it. "I have been able to line up a great deal in the last few days," he wrote his boss in Washington. "One of the most important things . . . is the National Rice Festival [in Crowley]. . . . This really sounds like something: Cajun dances, Cajun bands, balls, and all sorts of ceremonies, big parades, and floats. Please do not commit me for any work . . . because I certainly want to attend this."[25]

With that, Lee cleared his schedule, finished projects for local health authorities in New Orleans and, accompanied by Lyle Saxon, drove to Acadiana. The rice harvest was still in full swing, so in typical fashion Lee photographed every step in the process. The Crowley series includes scenes of mature rice standing in the field and the harvest itself, the cutting, threshing, bagging, and hauling of rice to the mill (figs. 6.9–6.12). With the same meticulous precision, Lee photographed the full range of mill operations, both in Crowley and in nearby Abbeville, Louisiana. Separate photographs documented the grading, polishing, and packaging processes, completing an exhaustive study of rice production from field to market (figs. 6.13–6.17). Then Lee went into the streets of Crowley to watch the harvest celebration. He photographed bands and crowds and floats, storefronts decorated for the festival, the Rice Queen and her court, children eating ice cream, crowded streets full of parade watchers, isolated farmers stretched out on the grass, mothers and fathers, young men staring hard into the camera, a rice eating contest, and "the Cajun dances and Cajun bands" that had first excited his interest. It was a rich portrait of

village work and play, of toil and reward in a town poised on the brink of the future. For every snap of Lee's shutter further removed Crowley from its locale, drawing it into the new vision of America crafted by writers and painters and photographers such as himself.

Together with FAP easels, FWP guidebooks, and Treasury Section mural work, Lee's Crowley series reveals the cross-purposes of thirties art. Though Russell Lee photographed a particular locale at a particular time, his pictures were designed for a larger purpose and intended for a broader audience. In the process, they became less concrete things and more abstract symbols, sought out and preserved not so much for what they were but rather the things they might be made to represent. Paradox resulted. Here were more than one hundred photographs designed to allay American anxieties by reaffirming shaken faiths in old values challenged by new circumstances. The complexities of modern life, the dangers of machine culture, and the oppressive collectivism of mass society might have produced ominous situations in other parts of the world. Elsewhere, European fascists, Russian Communists, and Japanese warlords might be creating mindless automotons devoid of individual liberties marching in lockstep, but not in America. Freedom, cohesion, and diversity all flourished in such places as Crowley, a small town managing to reconcile the conflicting demands of agriculture and industry, tradition and modernization, autonomy and community. Yet the photographs themselves were made by a modern information agency utilizing an innovative form to create idealized portraits of modern life, icons of Anytown, U.S.A., whose place never mattered so much as the message they served. A fine line visible in the Crowley series ran between what America celebrated and feared most about itself, where images of small-town America, like the rice on which it depended, were harvested, packaged, and marketed for national consumption.

While Lee's photographs connected Crowley to the larger themes and issues they served, their internal evidence reveals what Lyle Saxon refused to see. The people Lee found in Crowley were nothing like the quaint rural foils of urban Creoles Saxon believed them to be. Nor were they, for that matter, the living link between a mythologized past and an uncertain future so many intellectuals needed them to be. What Russell Lee photographed in Crowley, Louisiana, was "living lore" as conceived by Ben Botkin—the continuous mixing of values, beliefs, and behaviors inherited as tradition and their adjustment to new influence and contemporary circumstance. His photographs should not be read as tales of despoilation, the intrusion of machines into a pristine folk world. Nor are they glimpses of some exotic "other," people invested as they were by another of Saxon's writers with all the classic attributes: swarthy skin, impulsive temperaments, and venal tendencies. Instead, these are studies in adaptation—how modern mass forms and habits were

6.18. Russell Lee, "Pulling Down Rice from the Decorated Concession Stand at the National Rice Festival" (Library of Congress, Prints and Photographs Division, FSA-OWI Collection, lc-usf-34-31461-d)

received, adapted to, and modified to suit prevailing needs. The process might produce reconciliation, the ability to square old values with new departures, or resistance and resentment—a refusal to adjust or a determination to reject one side or the other—exactly what was happening in the Acadian world Lee photographed.[26]

Six years before it was even published, Russell Lee's photography documents the obsolescence of the world described in *Gumbo Ya-Ya*. Modernization might have transformed harvest methods and influenced festival rituals, but it had not atomized the community, shattered its basic beliefs, or abolished its essential social patterns. Men still harvested the crop, sometimes with machines, sometimes with mules, and sometimes with both. In the mills, traditional gender patterns prevailed. Women performed custodial labor under male supervision, inspecting and cleaning while other men tended heavy machinery. And though electrified and adjusted to include such mainstream American elements as a festival beauty queen, music, dancing, and cuisine retained their familiar tang. To be sure, all might be adjusted for wider exportation, but not necessarily to Acadian disadvantage. As a final Crowley photograph attests, the bottlers of Coca-Cola were not the only people to grasp the significance of increased consumption, and any group so closely attuned to the essential modern message bore little resemblance to "a simple, uneducated, uncultured, yet intrinsically genuine and loveable people"[27] (fig. 6.18).

Instead, what Russell Lee captured in Crowley was just another step in Acadian creolization, something Cajuns had been doing ever since their arrival, and something Americans were not only beginning to understand and accept but experience themselves. This was, after all, the "National Rice Festival."

4. Melrose and New Orleans, 1940–41

Eighteen months after Russell Lee left Crowley, Marion Post completed one of the trips Lee had not found time for. Post was another of the younger, second generation of Stryker's photographers who, with Lee, exposed the overwhelming majority of FSA negatives made in Louisiana. Post traveled widely in Louisiana, recording fur trappers below New Orleans, architectural studies in the Quarter, and two of Louisiana's cooperative farming projects, all-white "Terrebonne" in Schriever, and LaDelta, its black counterpart near Lake Providence. But between these stories, in the summer of 1940, she obliged Lyle Saxon's long-standing request. Documenting Melrose had been one of Saxon's pet projects for some time, and he paid special attention to its details, not only arranging for Post's visit but providing her with a local guide. He was Saxon's friend, Francois Mignon, a French businessman who extended his six-week tour of Louisiana into a thirty-year residence once he happened upon Melrose. Among other things, Mignon kept a diary whose pages confirm the context of Post's visit. Earlier in the year, doubtless on Saxon's initiative, field workers from the Historic American Buildings Survey had combed the plantation, taking photographs and measuring its principal buildings. They showed "particular interest," Mignon noted, in "the mulatto pictures in Lyle's cabin, and . . . the big oil of Pere Augustin."[28] Post's arrival some months later struck Mignon as the simple and logical extension of this earlier activity. "A staff photographer from Washington D.C," he assumed, "has been sent up from New Orleans to round the collection of photographs of historic edifices here." Mignon was eager to assist the effort whose results he believed would be "incorporated into the files of the Historic Buildings Section of the Information Bureau of the Department of Agriculture in Washington."[29]

Garbled titles aside, Saxon's intent was clear, and the shoot was on. Five days later, when the weather cleared sufficiently, Mignon accompanied Post along Cane River "to point out places . . . to photograph for the Federal files." Despite intermittent showers and bogged roads, between July 9 and 12, 1940, the Melrose series took shape. Tuesday afternoon, July 9, Post shot the interiors of several Melrose cabins and "exterior photographs of the mud construction on Lyle's shaded gallery in front."[30] Mignon and Post then divided the rest of the afternoon between additional architectural studies and a series of "family groups and portraits" of various Melrose hands all posed in front of "the

stationary blinds at Lyle's." Later Post and Mignon visited the home of Zeline and Joseph Rocque, an elderly mulatto couple on whom Saxon had modeled characters in his novel. Here Post took interior and exterior photographs of the Rocques and their home, then called it a day. Wednesday morning Post worked alone along Cane River before joining Mignon that afternoon to do additional work at the plantation and to caption photographs from the previous day. Finally, two days later, Post took her last photographs in the area, depicting "Henry," one of the mulatto field hands, at work and at home. There at the Henry cabin Post also took close-ups of "Henry and his little boy Joseph," whose results Mignon eagerly anticipated. "I suppose that not the least interesting feature for me," he observed, "will be to note if the difference in skin coloring as between father and son will be manifest in these photographs, particularly as Henry is so light he seems almost white, while Joseph is so dark he is almost dark chocolate."[31] In the end, the FSA file never included the racial complexities that Mignon anticipated, but his disappointment would be nothing like what his friend Lyle Saxon was in for.

That Saxon's own intentions might produce unwanted results surfaced immediately in the contrasting versions of Post's visit recorded by the photographer and her guide. They parted late on the afternoon of July 12. "With the photographs of Cane River finished," Mignon recalled that evening, "we drove over to the saloon [where, k]nowing we should not see each other again very

6.19. Marion Post Wolcott, "A Cross-Roads Store, Bar, 'Juke Joint,' and Gas Station in the Cotton Plantation Area" (Library of Congress, Prints and Photographs Division, FSA-OWI Collection, lc-usf-34-54355-d)

6.20. Marion Post Wolcott, "An Old School on the John Henry Cotton Plantation" (Library of Congress, Prints and Photographs Division, FSA-OWI Collection, lc-usf-34-54652-d)

6.21. Marion Post Wolcott, "A Bedroom with Religious Pictures on the Mud Walls of an Old Hut" (Library of Congress, Prints and Photographs Division, FSA-OWI Collection, lc-usf-34-54676-d)

6.22. Russell Lee, "A Fireplace and Mantel in an Old Plantation House" (Library of Congress, Prints and Photographs Division, FSA-OWI Collection, lc-usf-34-31355-d)

6.23. Marion Post Wolcott, "An Old House with Mud Walls Which Was Built by Mulattoes, Now a Part of the John Henry Plantation" (Library of Congress, Prints and Photographs Division, FSA-OWI Collection, lc-usf-34-54684-d)

6.24. Marion Post Wolcott, "An Old House with Mud Walls Which Was Built by Mulattoes, Now a Part of the John Henry Plantation" (Library of Congress, Prints and Photographs Division, FSA-OWI Collection, lc-usf-34-54834-d)

soon, we sat for half an hour, sipping a cold drink and musing about Cane River as we contemplated the deep blue reflection of the sky on the placid surface of the water."³² Mignon had liked "Miss Post," a "young lady" whom he found both "attractive and intelligent." She was blessed with "a certain appreciation of fundamentals in her concept of humanities," he believed, something he found "uniquely refreshing."³³ He had also enjoyed her company, was sorry to say good-bye, and even after watching her drive off had "lingered for a few moments on the gallery" chatting with one of the plantation hands, a grown woman who, prior to Post's arrival, had never had her picture taken. Meanwhile, "Miss Post" headed for her next assignment in Louisville, Kentucky, with nothing like the twilight reverie Francois Mignon read into their brief collaboration. Instead, following the long drive from north Louisiana to the banks of the Ohio she informed her boss, somewhat bluntly, that she had "spent the day with Lyle Saxon's pansy friend, taking pictures along Cane River."³⁴

The separate stories anticipate the divided results of the Melrose series itself. Like so much thirties art and so many other FSA stories, Post's Melrose photographs juxtaposed the rural isolation of a receding past against the growing consolidation of a modern future. There are, for example, the requisite contrasts of billboard advertising and plain board architecture (figs. 6.19 and 6.20). An interior shot pits the disorderly emotionalism of the rural poor against the balanced order of refined space photographed by Russell Lee in a plantation home near New Orleans (figs. 6.21 and 6.22). Then, too, no fewer than seven times Post emphasized the contrast between mud and chink walls and the electrical wiring of Saxon's own cabin (figs. 6.23 and 6.24). Not that Saxon could have protested. After all, his own art throve on this tension just as his laments for plantation days gone by derived credence from the reality of lichened pillars and crumbling gables. Similarly, the New Orleans guide establishes the same tension on page one, where a pen-and-ink illustration of a modern skyline glimpsed through the grill of a Quarter balcony enforces the introductory title: "New Orleans—Old and New." The real problem, then, was not so much the internal evidence collected within Post's frames but the ultimate purpose and distribution of her photographs.³⁵

Fittingly, the issue was organization. In 1942, when Paul Vanderbilt reorganized the FSA file, he transformed the collection from the two-hundred-some-odd localized "stories" or "lots" it once was into a single photographic narrative of the American people. This was no small transition. The separate images of a given place in a given time became larger, iconographic expressions, a series of types incorporated into a larger story with its own set of themes and values. The cumulative effect, writes Alan Trachtenberg, "drains the image[s] of exactly what gives [them their] photographic power: particu-

6.25. Marion Post Wolcott, "Three Members of the Rocque Family, Which Ranks among the Oldest Families of the French-Mulatto Colony in the Cotton Plantation Region" (Library of Congress, Prints and Photographs Division, FSA-OWI Collection, lc-usf-34-54564-e)

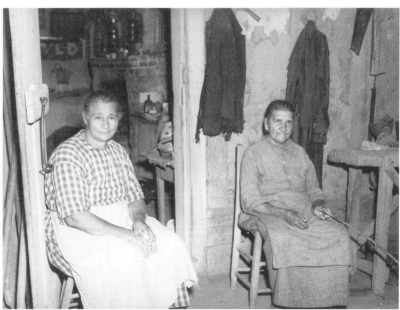

6.26. Marion Post Wolcott, "Two Women of the French-Mulatto Colony near the John Henry Plantation" (Library of Congress, Prints and Photographs Division, FSA-OWI Collection, lc-usf-34-54681-d)

6.27. Marion Post Wolcott, "A Member of the Rocque Family, Which Belongs to the Old French-Mulatto Colony near the John Henry Plantation" (Library of Congress, Prints and Photographs Division, FSA-OWI Collection, lc-usf-34-54561-e)

6.28. Marion Post Wolcott, "Uncle Joe Rocque" (Library of Congress, Prints and Photographs Division, FSA-OWI Collection, lc-usf-34-54685-d)

6.29. Marion Post Wolcott, "Sunday Afternoon" (Library of Congress, Prints and Photographs Division, FSA-OWI Collection, lc-usf-33-31194-m1)

6.30. Marion Post Wolcott, "Sunday Afternoon" (Library of Congress, Prints and Photographs Division, FSA-OWI Collection, lc-usf-33-31193-m4)

larities of place and person, costume and texture, hour and minute of day and night."[36] In this fashion, the photographs of the Melrose "lot," the place and people Saxon knew and Post recorded, were separated for distribution among the numerous subheadings of the Central File where they could be reclaimed only as such archetypes as "Old Man," or "Rural homes." Post's photographs of the Rocque family, for example, were dispersed among four separate subheadings (figs. 6.25–6.28). A similar process atomized the rest of the Melrose community, in the process either fracturing its delicate web of human relationships or eliminating them altogether. Whether they failed of development or were "killed" by Roy Stryker, the photographs of a light-skinned father and his "almost chocolate son," the ones Francois Mingon expressed such interest in, the focus of Saxon's novel, and the issue closest to the character of this mulatto colony, never made it into the FSA file. Given the middle-class American he knew to be his constituency, it is highly doubtful that Roy Stryker would have permitted the wide circulation of such photographs, thereby avoiding the issue of miscegenation, the heart of Cane River's racial complexity.[37]

Four months later, what occurred at Melrose happened again when Marion Post returned to Louisiana near Christmas 1940. Given the larger implications of her assignment and the kinds of photographs she took, perhaps this last FSA work she did there was also her most fitting. She had returned to photograph neither a new FSA experiment nor an old plantation. Instead, she had come to Alexandria, a small community in central Louisiana, where the construction of a newly established military camp had attracted waves of job seekers. They had come from all over the South, Post found, not only draining the immediate hinterland but attracting people from as far away as the Carolinas. Their sudden arrival had overwhelmed local resources and accommodations, as it would time and again in the wartime South, and Post made the same adjustment. Now instead of scarcity and want, she recorded the temporary camps and crowded conditions of a boom town. But in addition to this assignment, Post made one last tour through the French Quarter. Rich alike in human and architectural variety, the Quarter had attracted the interest of several FSA predecessors and colleagues. Perhaps she intended to expand the growing file of New Orleans photographs. Perhaps, too, she returned wishing to complement a series of photographs she had done there earlier that summer. Whatever the motivation, what strikes the observer is the difference between her Quarter and Lyle Saxon's.[38]

Saxon had spent his adult life retelling the Quarter's intrigues, reliving its past, and reanimating its spirits. What made this space so central to his life and art, what consumed his energies and shaped his interests, what even determined his residence, was the degree to which it stood apart from the rest of the city and the rest of America. But for Marion Post, the Quarter was just the

reverse. In January 1941, its vernacular possibilities attracted her more than its distinctive balconies or bohemian flavor. Through the Quarter she wandered, snapping photographs whose titles emphasize their common urban forms: "Old buildings" (the caption of at least seven photographs in the series) or the slightly longer, if equally generalized "Old buildings in the French Quarter" and "Old Buildings in the *Vieux Carre*." Additional photographs of the Quarter's inhabitants extended this basic logic. While Saxon had reveled in their exoticism, collecting the quirky and the unconventional like so many jewels in a crown, Post captured the Quarter's "everydayness," its common scenes of common people doing common things. Old men played checkers. Women sunned on stoops. Neighbors knotted in conversation. Post found no ghosts or aristocrats or gamblers, not a single conjurer or criminal, and no Baron Carondelet anywhere in sight. Instead, the scenes were so unremarkable that Post linked the twenty-four separate images under a common, generic title: "Sunday afternoon" (figs. 6.29 and 6.30).

The contrast suggests the broader implications of thirties America and the specific complications of Saxon's life and art. Similar to such other well-known forms of thirties expression as the American Guides and Treasury Section murals, the photographs advance a modernist vision of modernized American life. All were pieced together with easily recognizable and infinitely manipulable symbols arranged in cubist fashion. Their effect simultaneously blends and abstracts. Sometimes, as in the "Sunday Afternoon" series, a handful of national types were clothed in a variety of local costumes. Other times, as at Melrose, the simplicity of national type required the sacrifice of local complexity. In either case, these were currents Saxon had struggled against since early adulthood. Their cumulative effect undermined both the author's art and his identity, something foreshadowed in the concluding scenes of *Children of Strangers*, whose climax began, appropriately enough, with the physical transformation of Cane River, uniting the twin fears of Lyle Saxon's life. If one of the novel's themes concerns the human consequences of uncertain identity, another makes explicit warnings about the perils of modernization. Throughout the novel, Saxon depicts modern times in familiar images with predictable results. Machines run amok with disastrous effects. Modernity disrupts lives, corrupts values, and undermines the integrity of this previously insular community. In this sense, Famie Vidal's decline symbolizes the collapse of an entire way of life, an assertion rendered nowhere more clearly, or autobiographically, than in a scene toward the novel's close. Explosions shatter the quiet of a plantation morning, scaring dogs and scattering birds. "It's de road-builders," Henry Tyler explains to a puzzled Famie. The modern world has bridged Cane River, with implications fully realized by Adelaide Randolph, Yucca's mistress. Saxon modeled his character on Cammie Henry

6.31. John Vachon, "Numbering Steel Plates Ready for Installation into Hulls of Ships at the Higgins Shipyards" (Library of Congress, Prints and Photographs Division, FSA-OWI Collection, lc-usw-3-34457-d)

6.32. John Vachon, "Ramp Boats under Construction at the Higgins Shipyards" (Library of Congress, Prints and Photographs Division, FSA-OWI Collection, lc-usw-3-34411-d)

and not surprisingly entrusts her with a benediction for the fictional Melrose. "I'm almost sorry to see the new road come to Yucca and Isle Brevelle," she tells her husband. "Things will never be the same with a highway before our door. Years ago I used to long for such a road, but now I'm afraid of it, someway. Everything will change."[39] This was Saxon's point precisely, and one he made persistently, if vainly, right up until his final trip to Melrose, the one he never finished.

In June 1943, John Vachon arrived in New Orleans, the last FSA photographer to visit Louisiana. By then Allied strategists were completing plans to invade Sicily, bomb Hamburg, and overrun Tarrawa. The Writers' and Artists' Projects had both closed in Louisiana. Interviews, parish write-ups, life histories, folklore tales, tour reports, time sheets, and other onion-skinned detritus had been boxed up and shipped away. Hundreds of unallocated paintings sat in the Rosedale warehouse awaiting destruction. Lyle Saxon was in Washington, finishing the final WPA report on the FWP. Treasury Section painters had completed their last mural, and the FSA Historical Unit, now part of the Office of War Information, was in its final weeks of existence. Roy Stryker was preparing to resign. Russell Lee was in the service, working with Pare Lorentz on a photographic mission for the Army Air Force. Marion Post had left in 1942, packed her cameras away, and married Lee Wolcott.

Vachon passed through wartime New Orleans following a long swing through the Great Plains. He photographed ration lines along Canal Street and the sulphur industry below the city, but Vachon's most extensive efforts occurred in the Higgins Shipyard, where he recorded photographs he often disparaged as "'God Bless America' work." Still, given the larger implications of the arts projects and FSA survey, these final images seem less departure than logical fulfillment. Throughout the 1930s, Louisiana had been opened both as physical place and artistic opportunity. Bridges, roads, and airports, paintings, guidebooks, and photographs—all had made Louisiana accessible to Americans as never before. As Marion Post witnessed at Alexandria, the world was rushing in, making Louisiana part of a national defense system, transforming space and accelerating social change. But as the world rushed in, Louisiana rushed out too, a reciprocal movement John Vachon captured in the Higgins shipyard series. At Higgins, in precisely the same fashion that guidebooks had assembled America for middle-class motorists, local workers constructed one of the crucial means to American victory overseas. By piecing together numbered parts, they built the landing craft so decisive to amphibious operations in the Pacific and the cross-channel invasion in Europe, a collaborative effort transcending specific place or person and symbolized by the ubiquitous gesture of common cause (figs. 6.31–6.33). What had once been an

6.33. John Vachon, "Higgins Shipyard Workers Leaving at 4 PM" (Library of Congress, Prints and Photographs Division, FSA-OWI Collection, lc-usw-3-34456-d)

insular world of localized peoples had become part of modernity, something accomplished by artists and engineers alike.

During the 1930s, while Louisiana modernized, it also became part of a new modernist definition of America. If the previous generation had idealized the nation as a series of fixed, hierarchical relationships governed by reason, inclined toward order and "one hundred per cent Americanism," modernists disagreed. Depicted in their art during the 1930s America became instead more fluid than fixed, more relative than hierarchical, and vastly more cosmopolitan. Pluralism, once conceived as the country's gravest weakness, became instead its saving grace and amalgamation, not separation, its guiding intellectual faith. The new America was also more dynamic, a protean thing composed of many elements always changing—in an image frequently invoked: a kaleidoscope. Modernist America was many things simultaneously, a montage of fragmented spaces and discordant sights and sounds often juxtaposed for various emotional effects, all of them, it seems, calculated to disrupt genteel faiths in order, reason, progress, and stability. Instead, modernist America defied rational explanation, accepting uncertainty and constant adjustment as the necessary condition and essential coping mechanism of modern life—a

redefinition powerful enough to transform Louisiana from American exception to American microcosm. Because of its European tang and its polyglot culture, Louisiana had always been marginalized, an object lesson, to many, confirming the necessity of hierarchy and assimilation. Modernist artists reversed the thinking. To some, Louisiana became part of a larger American story. To others it became a microcosm, with its mixed demography and composite culture so rich in glaring contrasts.

Modernized methods broadcast this modernist portrait. Radio, advertising, mass-circulation magazines, and newsreel footage carried the message across the country—together with circulating exhibitions of federal art and FSA photographs. Regardless of form, all shared a common method and effect. Whether radio script or photo-essay, like guidebooks and Higgins boats, each was mass-produced and created for the express purpose of abolishing space, of covering the most distance in the least time. Here was a means of national cultural expression noteworthy alike for the volume and velocity of its production, the scale of its distribution, and for such people as Ellsworth Woodward and Lyle Saxon, its indifference to locale.

Appropriately, no one with the FSA understood this implication more clearly than the thoroughgoing modernist who came of age as artist and individual within the organization. As a young college student, John Vachon had been attracted to such modernist writers as Joyce, Faulkner, and James T. Farrell, and was enough of a jazz enthusiast to pray once for a world without Guy Lombardo. In 1936, following dismissal from the graduate program at Catholic University for yet another modernist predilection, alcoholic overindulgence, Vachon took a job in Roy Stryker's office captioning the backs of FSA photographs. Eventually, tutored by the older hands, he learned photography well enough for field assignment, embarking on what became a distinguished career in photojournalism. When Vachon left he took with him the most intimate knowledge of the file's nature and content, something he conceived of in expressly modernist terms. For him, the file was always more than the sum of its separate images, a vast montage of America captured at a specific yet fleeting point. Because America was so dynamic, accumulating its contemporary record made time precious and distance an obstacle. Documenting the moment demanded photography in perpetual motion, a camera literally rootless, even if it meant as it often did for Vachon moments of profound isolation and uncertainty. Such were the demands of modernist expression, its rigor and reward, fittingly enough rooted in a paradoxical relationship no modernist could fail to appreciate. If his travels across America heightened Vachon's sense of alienation, they also affirmed the endeavor's worth. Recording America at a specific moment meant accumulating something of inestimable value because the moment was bound to change, a permanent record

of an impermanent thing. Like sand castles in a tidal trough the moment was doomed, leaving only the photographs, themselves subject to the changing perceptions of future generations. With his camera, the photographer stood adrift in time and space, recording scenes that could not last, whose meaning must always change. "I didn't know it at the time," Vachon recalled thirty years later, "but I was having a last look at America as it used to be," an assertion he associated with his first trip across the Continental Divide.[40]

What John Vachon accepted, Ellsworth Woodward and Lyle Saxon resisted in different ways with equal futility. Modernity and modernist assumption undermined Woodward's aesthetic localism. Woodward had aspired to permanence and progress like so many of his genteel generation, seeing in art a way of achieving reforms nineteenth-century Americans had long envisioned. Art rooted to place would lead, uplift, and ennoble, inspiring the best in craftsman and consumer alike. Newcomb Pottery would help make this possible by diminishing the harm of industrial manufactures and establishing craft goods as a refining influence in private homes. But experience inverted the ideal. The industrial model shaped the pottery far more than Woodward ever cared to admit and certainly not, as he had hoped, the reverse. Instead, Newcomb's silent halls, its hushed reverence for beauty in process, somehow deafened Woodward to the future audible so clearly in jazz joints so close at hand. Not high art handmade but popular culture mass-produced became the decisive influence of twentieth-century American life. Broadcast across the airwaves, it transformed not only the nation but the world as well. In the end, the machines had moved too fast and changed too much, and the ideas they inspired about self, society, and experience made of the genius loci and "the most perfect expression of locality" its logic inspired quite literally a museum piece.

For Lyle Saxon the consequences were far more personal. Born a generation later, Saxon had little use for the aims or methods of Woodward's reform idealism. Notions of public order and projects in social uplift usually aroused his contempt and never inspired his concern. Thus, while Woodward built institutions grounded largely on antimodern beliefs, Saxon, with a modernist's sense of theater, struck poses flouting those institutions in largely antimodern surroundings. The gesture, the witty remark, the cocktail artfully poured or gratefully received, these were his master performances and the Quarter and Melrose his stage. But whether as personal style or fictional art, Saxon's modernism had its limits. Like many of his contemporaries, he contested genteel faiths in reason, order, and progress, and set out instead to probe the "real," the animal, the exotic under-the-crust. But where more committed modernists rushed to probe the self, Saxon hesitated, concealing what others

exposed. His stage, then, was also his screen, not the vital self laid bare but the stuff from which he crafted a public persona to mask private truths. Yet the persona was always divided, revealing Saxon's own ambiguous relationship with modernism and modernity. Through this persona, Saxon's tenuous modernism inverted late-nineteenth-century assumptions of the "exotic" and "picturesque." His fascination with traditionally marginalized characters stemmed not from his intention to affirm genteel hierarchies of power but to expose their hypocrisy. Yet the challenge always came from someone standing in the very guise of those he challenged—the southern paternalist whose intimate knowledge of the "quaint" customs and curious beliefs of Cajuns and blacks made him the knowing chaperon of the uninitiated, master of the local scene. By the 1930s, this was already a well-established figure, one visible since northerners first began touring the Reconstruction South. Now, nearly seventy years later, amidst another moment of regional upheaval, sufficient evidence of dislocation and transformation existed to sustain either laments about standardization and homogenization or elegies to the way things were. Only now modernists wanted the "real" thing, the "straight" story of plain people—not exotic folk—in their own words or depicted through their own art. By 1945 both the intellectual currents and the way they were disseminated had changed in ways that challenged if not usurped the authority of local voice. The modernist agenda had been broadcast that far that fast, making of Lyle Saxon both participant and victim.

They led such remarkable lives, these two men, in ways that say so much about their time and place. Together they spanned the American experience from the beginning of the Civil War to the end of World War II. Though born on opposite coasts in different generations, they found their way to the same city where they lived in the separate social worlds of the great southern metropolis. They were artists, both of them, and though of vastly different stripe Ellsworth Woodward and Lyle Saxon found unacknowledged common cause struggling to defend localized visions of self and society against the transforming power of modernity and modernism. Between 1890 and 1945 the very ground beneath their feet seemed to break loose as new landscapes, both real and aesthetic, undermined the foundations of their institutions and identity. For all of his tireless energy, Woodward failed to transform America through localized art, a dream, it now seems, every bit as doomed as Saxon's attempts at literary preservation. Still, in their separate struggles and similar fate their lives provide access not just to the particulars of their historical moment and geographical place but also to themes and subjects more transcendent. Through them we glimpse the myriad aspects of the modern American story, and through them, too, we confront anew the essential complexity

of American life before and since, its dynamic character, its protean nature, and the infinite demands it places on its citizens and students alike. In this way, though their moment has faded, the uptown patriarch and the French Quarter bohemian linger in memory like Carnival throws hanging in the trees above St. Charles Avenue long after the floats have passed.

Epilogue

Do You Know What It Means?

Nearly sixty years after his death in 1946, Lyle Saxon's worst fears were realized in the aftermath of a hurricane whose name connoted "torture" to some Ancient Greeks and "pure" among the Romans. Doubtless had he experienced it, even while he mourned the loss, Saxon would have relished irony so perverse, just as other observers in a later day might perceive larger meaning in the tale of two floods eighty years apart. Indeed, the disasters frame a completed tale, the rise and fall of New Deal America, with beginning, middle, and end. One details the collapse of a highly privatized social world, whose very eclipse helped to legitimize its replacement by a waxing set of more liberal values in politics, art, and society. The other suggests how completely a slim majority of contemporary Americans has rejected those values. And the story of the two disasters together, their deeply interrelated causes and consequences, reveals succinctly the cultural fault lines that have divided this country in the past and continue to divide it still. In short, they bookend a remarkable twentieth-century story at whose heart lies the very meaning of modern America, a story begun with heavy rains falling in a rising river near the close of the nineteen-twenties.

When the swelling tide of the river surged south, crumbled levees, crippled the delta, and raced for New Orleans in April 1927, Lyle Saxon, then a young reporter and aspiring artiste, found his moment and made the most of it. Threatened with the imposing doom of his cherished city, core source of his own identity, he seized the story, as journalist and popular historian. *Father Mississippi*, first of the "eatin' books," marked Saxon's emergence as the popular literary voice of Louisiana and, especially, New Orleans. It made him "internationally known locally," a regional voice in the national limelight, guide to the mysteries and charms of bayou and back alley alike. One part reportage and two parts romance, *Father Mississippi* interspersed chapters detailing the river's discovery, exploration, and nineteenth-century development

with firsthand accounts of the flood. Throughout, Saxon deftly juxtaposed past achievement with present threat, building an exquisite tension unbroken until the very moment of the city's reprieve by Dame Fortune and well-placed dynamite. The book limned his future, shaped his career, and commenced what became a life's work, one whose ultimate achievement occurred when the Writers' Project he administered published the *New Orleans City Guide*.

Yet, when the river flooded, it did more than simply focus Lyle Saxon's creative energies. It transformed America, too. In many ways, the flood anticipated the Great Depression, provoked debate about the meaning of America, and facilitated subsequent cultural and political change. Frustrated by Herbert Hoover, who was alternately indifferent to their concerns or duplicitous in his relations, black political and community leaders gravitated in increasing numbers toward the Democratic Party. In the flood's aftermath, embittered by the cruel treatment of local planters, black laborers streamed out of the Delta. Soon, in depression America, their testimony about a virtual fiefdom of class privilege and racial exploitation found parallels across the nation: in the factory districts of the urban Northeast and Midwest, along the Southern Great Plains, and amidst the leafy plenty of the California valleys. Then, too, the disaster facilitated the expansion of federal authority, transforming its role in the power relationships of modern America and in the daily lives of ordinary men and women. Less than a year after the flood, Congressional legislation established *the* crucial precedent for the kind of expanded role of federal power in everything from regional management to local economy, public construction to art patronage—what became then and remains still, the preeminent political issue of modern America.

Thus, the creative ferment of the 1930s grew along lines first glimpsed even before the flood waters had begun to recede. In this sense, the *New Orleans City Guide* culminated new trends in American society, politics, and art. Quoting rhymed impressions of the city already a century old, Saxon opened the volume by asking then asserting,

> Have you ever been to New Orleans? If not you'd better go.
> It's a nation of a queer place; day and night a show.

Then and since, he insisted, New Orleans represented "a progeny of all colors—an infernal motley crew," the Modernist Mecca of the American South, an exotic, cross-pollinated culture almost impossibly co-mingled: peoples, continents, and cuisines, race, music, and language. It was

> Negroes in purple and fine linen, and slaves in rags and chains.
> Ships, arks, steamboats, robbers, pirates, alligators,

Assassins, gamblers, drunkards, and cotton speculators;
Sailors, soldiers, pretty girls, and ugly fortune-tellers;
Pimps, imps, shrimps, and all sorts of dirty fellows.

New Orleans was elite and popular, white, black, and mulatto; it was Creole and Anglo and Cajun, Irish, German, and Italian, Catholic, Protestant, and Jew; it was at once provincial and cosmopolitan, accessible and insular, uptown and downtown, Garden District and Vieux Carre. New Orleans was North American and Caribbean. It was jazz and gumbo and voodoo, a social world of blend and pastiche, an urban center after the very heart of modern consumer culture. The entire city, it seemed, existed for the sole purpose of pleasure, satisfaction, and sensuous self-indulgence, the one that "Care Forgot." Until August 2005, that is, when atmospheric disturbance, reckless development, environmental destruction, cultural division, and political malfeasance of epic dimension, especially at the federal level, all converged on the city with catastrophic results.

When the levees broke on August 29, 2005, it was almost as if, even as the water rushed in, time raced out, compressing two disasters into a single story shaped by several shared contexts. Both floods occurred not merely in a deeply divided America, but an America divided deeply over the very same issues. Nativism, Fundamentalism, and Prohibition, core issues then are core issues still: immigration reform, the Christian coalition, and the "War on Drugs." Teaching evolution at public expense, what provoked the "trial of the century" in Dayton, Tennessee, remains an open question hotly debated in state legislatures and among local school boards. Popular culture generally, Hollywood especially, remains the target of choice among socially conservative cultural critics determined to preserve the sanctity of the American family. While "Islamo-fascists" may have replaced "Anarcho-syndicalists," both cause and consequence remain the same. A sinister force of foreign origin lingers among us, a threat to American liberty so ominous that it must be opposed even at the risk of abridging those very same liberties. Yet, ultimately, the fundamental issue in either event was race, and there the paths diverge in ways that raise the relationship between these catastrophes beyond casual chance or sheer coincidence to the level of American metaphor.

The story of Katrina, its causes, events, consequences, and continuing development, stands in stark opposition to a version of America, created in the flood's aftermath, that flourished throughout the ensuing decade. The three calamities bunched so closely around 1930, flood, depression, and dust bowl, catalyzed new definitions of American self and society, rejecting previous assertions of "100 percent Americanism." Instead, during the 1930s, American artists not only discovered diversity but celebrated it. With pen,

brush, and camera as in numerous other forms, they reveled in the essential, if complicated, variety of America. This had been in large part a public effort, funded by taxpayers, one whose basic assumptions and guiding values pointed, however tentatively, toward a fundamental redefinition of the very term itself. Mandated by the court at the close of the previous century, "public" had meant white entitlement, the central organizing principle of American social thought, the determining influence of its social and spatial relationships. But the modernists thought otherwise, even Lyle Saxon in his own tortured way in his own segregated city, and if the trend reached a zenith of sorts in its modernist conception of modernized New Orleans, it was in no way an isolated incident casually dismissed.

In our own time this tide has reversed its course all but completely. The federal response to Katrina, delayed, misdirected, and determined to privatize clean-up and reconstruction efforts, represents the ultimate repudiation of the creative expression, cultural mood, and political innovations of the 1930s. Since August 2005, to a significant degree, the city has been sacrificed to the dominant political and cultural trend of contemporary American society. Privatization, whose interrelated and driving concerns are capitalist growth and cultural resentment, has not only polarized wealth and poverty to an unprecedented degree in the American experience. It also represents a reaction against the civil rights advances of early postwar society, the wholesale abandonment of public commitments and public spaces, a word now pejorative code for racial other. Thus, the distinctive landscape structures of the contemporary American built environment: gated communities and decayed ghettoes. And in New Orleans, privatizers found an especially soft target. There, concentrated racial majorities have elected successive black mayors from wards either beyond Republican electoral calculus or indifferent to party appeal. The city's single-industry economy, its shrinking tax base, chronic unemployment, soaring crime rates, and decaying infrastructure, its penchant for corruption and the often Byzantine twists of local and state politics make it a virtual poster child for critics of urban dysfunction and the free market apostles of private sector panacea. Then, too, what attracts the tourists, Bourbon Street and the "Big Easy," offends the evangelical base of contemporary conservative politics. Indeed, the city's essential Creole nature, celebrated by some, vilified by others, has become in recent times the very source of its own undoing. Rapid wetlands development below New Orleans, one avenue of local white flight, destabilized the natural defense that may otherwise have softened Katrina's impact. Meanwhile, stringent federal budgets passed by successive administrations determined to curry political favor through reduced public spending weakened the city's levee system, its man-made protection. So that when the levees broke, the heaviest blow fell on the

very people least able to absorb it, the ones not only living at the city's lowest elevations, quite literally people at the bottom of the heap, but also those farthest from federal concern. What hostility enabled, indifference has sustained, something manifested in the prolonged agony of the city's lower districts.

Down in the Ninth Ward, nearly two years after the fact, the physical destruction and cultural erosion remain plainly visible. Chest-deep weeds crowd devastated structures or overwhelm the spaces where they once stood. Some have vanished entirely, wrenched from slabs by the water's surge, or damaged sufficiently for the bulldozer and the wrecker's ball. Several lean at precarious angles. Others have been abandoned or share cramped space beside "emergency" trailers. All bear the storm's distinctive stigmata: the alpha-numeric symbols in the four wedges created by the letter "X," lingering vestige of the grim, door-to-door accounting conducted in the ensuing weeks and months among this shattered community of broken lives and blue canvas roofs. Only the barest rudiments of community and public cohesion exist. Stubborn homeowners determined to stay have spray painted messages reading "Do Not Demolish" down the sides of their houses. Fire hydrants stand askew on former corners. Hand-lettered boards nailed to telephone poles pass for street signs and even the basics, electricity and ice, are hit and miss propositions. Meanwhile, victims and observers alike search for understanding and answers to the abiding question: what, ultimately, does this story tells us about ourselves and our society, the meaning of modern America, past, present, and future.

In 1947, twelve months precisely after Lyle Saxon died, Louis Armstrong and Billie Holiday appeared together in a highly fanciful film depiction detailing the birth of jazz. Directed by Arthur Lubin, *New Orleans*, is something of a cult classic among jazz enthusiasts, who enjoy an ensemble cast that includes Russell Moore, Charlie Beal, Zutty Singleton, Lucky Thompson, Barney Bigard, and Woody Herman and His Orchestra. Others may enjoy the plot, though only as a wonderful example of just how bad it can get. Critic Alan Venneman insists that the project began in the febrile imagination of Orson Welles, "a true jazz aficionado," who envisioned an epic depiction of the form as a black creation in a film built loosely around Armstrong's life. Yet, though he hired Duke Ellington as a consultant and Elliott Paul as his screenwriter, the project went no further. Ultimately, Lubin directed Paul's script, but the final result, shot through with stilted dialogue and plot twists implausible even by Hollywood standards, is anything other than what Welles had in mind. In the finished piece, jazz ceases to be a black creation and becomes instead a white problem. Script revisions reduced Armstrong and Holiday to bit players, the latter, in her only feature film appearance, as a maid. Instead, the story revolves around the relationship between Nick Duquesne, a white club owner

and "King of Basin Street" and Miralee Smith, high-society daughter and opera singer whose parents resent her growing interest in the music and musicians on the wrong side of Canal. The ending could not be more contrived, nor could it come quickly enough, save for its interspersed musical performances, including several pieces of vintage Armstrong and three full numbers by Holiday: "Farewell to Storyville," "The Blues Are Brewing," (backed by Armstrong), and "Do You Know What It Means to Miss New Orleans?"

Sixty years later, while almost no one has ever seen *New Orleans*, nearly everyone knows that song. The short list of performers who have covered it includes such diverse names as Fats Domino, Ricky Nelson, and Allison Krauss, although to most listeners the standard version still belongs to Louis Armstrong. Written the year the film debuted, a Louis Alter/Eddie DeLange collaboration, it tells a wistful, slow-paced tale of sentimental reverie, connecting an absent love to a distant place. Given the themes, love and loss, and its enduring popularity, to no surprise "Do You Know What It Means to Miss New Orleans," both tune and title, has resurfaced repeatedly in the editorial and essay response to Hurricane Katrina. Only now it has acquired a radically altered significance. Stripped by the storm of its original sentimentality, the question demands far more serious consideration of vastly more complicated issues. Already in decline long before the storm, and given the magnitude of the demographic and economic devastation, some observers doubt the city's ability to survive, much less rebound. Others envision a "newer, better" New Orleans, detailed in plans to redline the city back to the future, a Disneyfied version of its former self, its familiar facades free of their former "problems." But if the city's future remains uncertain, there is no missing the meaning of its past. Throughout the twentieth century, New Orleans had been one of those signature spaces where Americans have alternately staged their loftiest hopes and harbored their darkest fears. It has served both masters of modern America's warring selves, either as the blended city of tolerance, excess, and exuberance or a cautionary tale of crime, violence, poverty, and racism. In truth, it is wholly neither and much of both, an American dilemma whose resolution we can no longer defer. As the privatizing influences that contributed so decisively to the city's demise and continued suffering restore conditions not just in New Orleans but throughout America to something resembling the Mississippi Delta before the rains fell all those years ago, answering the old question, with its newer context and deeper meaning, has also acquired renewed urgency.

Do you know what it means to miss New Orleans
And miss it each night and day?

Notes

Introduction

1. Cronon, *Nature's Metropolis*.

2. Dorothy Ross, "Introduction: Modernism Reconsidered," in Ross, *Modernist Impulses in the Human Sciences*, 1–25; Hollinger, "The Knower and the Artificer"; Berman, *Preface to Modernism*; Huyssen, *After the Great Divide*.

3. Eysteinsson, *Concept of Modernism*.

4. Ross, *Modernist Impulses in the Human Sciences*, 24.

5. Ibid., 1–14; Eysteinsson, *Concept of Modernism*, 1–102; Cantor, *American Century*, 1–166; Tichi, *Shifting Gears*; Scott, *Women of 1928*, xxiii, xxv.

6. Gorman, "American Modernism as a Culture."

7. Ibid.

8. Daniel Singal, "Towards a Redefinition of American Modernism," in Singal, *Modernist Culture in America*, 1–27; Douglas, *Terrible Honesty*, 54; Cantor, *American Century*, 62–63, 67.

9. Gorman, "American Modernism as a Culture."

10. Banta, *Taylored Lives*; Keller, *Regulating a New Society*.

11. Smith, *Making the Modern*, 6.

12. Ohmann, *Selling Culture*; Marchand, *Advertising the American Dream*; Strasser, McGovern, and Judt, *Getting and Spending*.

13. Levine, *Unpredictable Past*, 206–30.

14. Cantor, *The American Century*, 49.

15. Keller, *Regulating a New Society*, 4.

16. Bender, *Community and Social Change in America*.

17. The phrase is borrowed from the title of Martin Berman's superb study of modernism and modernization, *All That Is Solid Melts into Air: The Experience of Modernity*.

18. See *Making Whiteness*, especially 121–98.

19. Jordan and deCaro, "'In This Folklore Land.'"

Chapter 1

1. Goins and Caldwell, *Historical Atlas of Louisiana.*

2. Both quotes are from Hair, *Kingfish and His Realm*, 59–60. Additional material on Louisiana lumbering is available in Burns, "Gulf Lumber Company, Fullerton"; and Curtis, "Early Development and Operations of the Great Southern Lumber Company." For an account of race, labor, and unionism during the period see Norwood, "Bogalusa Burning."

3. For an account of the establishment of Hammond, Louisiana, see Romero, *Louisiana Strawberry Story.* The development of late-nineteenth-century southwestern Louisiana is discussed in Millet's "Southwest Louisiana Enters the Railroad Age" and "Town Development in Southwest Louisiana." Studies of the petroleum industry in early-twentieth-century Louisiana include Loos, *Oil on Stream*, and Banta, "Regulation and Conservation of Petroleum Resources in Louisiana."

4. Rabinowitz, *Race Relations in the Urban South*, and *Race, Ethnicity, and Urbanization: Selected Essays.* An indispensable series of essays on race and New Orleans can be found in Hirsch and Logsdon, *Creole New Orleans.* Segregation in Reconstruction Louisiana is discussed in Somers, "Black and White in New Orleans," and Dethloff and Jones, "Race Relations in Louisiana." Conclusions different from those of Somers and Dethloff and Jones are presented in Fischer, "Racial Segregation in Ante Bellum New Orleans," and *Segregation Struggle in Louisiana.* For accounts of the three New Orleans race riots of the period see Vandal, *New Orleans Race Riot of 1866*; Taylor, *Louisiana Reconstructed*, 103–13; 291–96; and Hair, *Carnival of Fury.* Accounts of the New Orleans African American community include Blassingame, *Black New Orleans*; Rankin, "Impact of the Civil War on the Freed Colored Community of New Orleans"; Rankin, "Origins of Black Leadership in New Orleans During Reconstruction"; and Vandal, "Black Utopia in Early Reconstruction New Orleans." The African American influence on Louisiana is discussed in MacDonald, Kemp, and Haas, *Louisiana's Black Heritage.* The most comprehensive study of twentieth-century Louisiana race relations is Fairclough, *Race and Democracy.*

5. Hair, *Bourbonism and Agrarian Protest.*

6. The best single-volume study of late-nineteenth-century New Orleans remains Jackson, *New Orleans in the Gilded Age.* See also Everard, "Bourbon City." Specific studies of New Orleans politics include Haas, *Political Leadership in a Southern City*; Haas, "John Fitzpatrick and Political Continuity in New Orleans"; and Ettinger, "John Fitzpatrick and the Limits of Working-Class Politics in New Orleans." Ethnic and immigration studies of New Orleans include Niehaus, *Irish in New Orleans*; Irvin, "Impact of German Immigration on New Orleans Architecture"; and Shanabruch, "Louisiana Immigration Movement." The most celebrated incident of ethnic violence in New Orleans occurred in 1891, when eleven Sicilians, all of them accused mafiosi implicated in the murder of the city's police chief, David Hennessy, were dragged from

custody and either shot or hanged. Accounts of this incident may be found in Coxe, "New Orleans Mafia Incident"; Botein, "Hennessy Case"; and Baiamonte, "'Who Killa de Chief' Revisited." New Orleans labor studies during the period include Arnesen, *Waterfront Workers of New Orleans*, and Rosenberg, *New Orleans Dockworkers*. Radical influences in the city and the state proper are treated in Green, *Grass-Roots Socialism*, and McWhiney, "Louisiana Socialists in the Early Twentieth Century." Public management in New Orleans is the subject of Fairclough, "Public Utilities Industry in New Orleans." William Ivy Hair discusses the impact of white supremacy on social relationships, especially marriage, in *The Kingfish and His Realm*. See also, Anthony, "'Lost Boundaries.'"

7. The best single-volume study of the modernizing New Orleans landscape is Lewis, *New Orleans*. Other considerations of the city landscape include Mitchell, *Classic New Orleans*; Starr, *Southern Comfort*; and Kingsley, "Designing for Women." The history of Storyville can be found in Rose, *Storyville, New Orleans*, and Foster, "Tarnished Angels." Dale A. Somers studies the city's sporting life in *Rise of Sports in New Orleans*. Mitchell, *All on Mardi Gras Day*, 60. For Mitchell's full discussion of Rex, Comus, and the "Americanization" of Mardi Gras, see especially 51–112.

8. Quoted in Ostransky, *Jazz City*, 57–58.

9. The definitive study of jazz's formative period is Schuller, *Early Jazz*. Alan Lomax treats the Orleanian most commonly associated with the beginning of jazz in *Mister Jelly Roll*.

10. Grantham, *Southern Progressivism*.

11. As yet Woodward has no scholarly biographer, though he is the subject of numerous articles and theses. See Barkmeyer, "Ellsworth Woodward and His Work," and Boyer, "Etchings of Ellsworth Woodward." See also, "Ellsworth Woodward," Artists' Files, Department of Curatorials, The Historic New Orleans Collection, New Orleans, Louisiana (hereinafter cited by artist's name, Artists' Files, THNOC). This is a thick file full of assorted bits of biographical materials such as chronologies, capsule biographies, exhibition catalogues, and photocopied newspaper articles. See also, Cline, "Contemporary Arts and Artists of New Orleans and Their World"; Mount, *Some Notables of New Orleans*, 159–60; Norvell, "Ellsworth Woodward", Ford, "Artist in Stone"; Looney, "Historical Sketch of Art in Louisiana"; Radcliffe, "Some Artists of Louisiana"; Ethel Hutson to S. A. Trufaut, May 15, 1934, Ellsworth Woodward Papers, Department of Archives and Manuscripts, Howard-Tilton Memorial Library, Tulane University, New Orleans, Louisiana Box 1, (hereinafter cited as Woodward Papers, TU); Untitled biographical sketch, Woodward Papers, Box 4, TU; Bentley Nicholson, "Ellsworth Woodward and His Work," in "Newcomb Pottery," Department of the Registrar, New Orleans Museum of Art (hereinafter cited as "Newcomb Pottery," NOMA).

12. "Ellsworth Woodward," Artists' Files, THNOC; Woodward Papers, Box 1, TU; Untitled biographical sketch in ibid., Box 4, TU; "The Man Who Molded Newcomb Pottery," *Times-Picayune*, (New Orleans), Mar. 27, 1987; *Item*, (New Orleans), Feb. 28,

Mar. 1, Mar. 2, 1939; *Tribune*, (New Orleans), Mar. 1, 1939; *States*, (New Orleans), Feb. 28, Mar. 1, Mar. 2, 1939; *Times-Picayune*, Mar. 1, 1939.

13. Ellsworth Woodward to Edwin L. Stephens, Apr. 1, 1912, Edwin L. Stephens Papers, Department of Archives and Manuscripts, Tulane University, New Orleans, Louisiana, Box 1 (hereinafter cited as Stephens Papers, TU). "Ellsworth Woodward," Artists' Files, THNOC; *Item*, Feb. 28, 1939; *Item-Tribune* (New Orleans), June 5, 1913; *Times-Picayune*, June 29, 1913.

14. Cullison, *Two Southern Impressionists*, ix-xi; Boyer, "Etchings of Ellsworth Woodward."

15. Untitled biographical sketch, Woodward Papers, Box 4, TU; "What Has Art to Do with Practical Things," Woodward Speeches, TU.

16. Thompson, *William Morris*, esp. 32–40 and 88–107; Stansky, *William Morris*, 60–73. Woodward followed Ruskin and Morris so closely that he often addressed his close friend and long correspondent, E. L. Stephens as "Ruskin" while signing his letters, "E. W. Turner." "Everyday Art," Woodward Speeches, TU.

17. "The Lesser Arts," "Art in Education," Woodward Speeches, TU.

18. "What Has Art to Do with Practical Things," "Art in Education," "The Lesser Arts," Woodward Speeches, TU.

19. "What Has Art to Do with Practical Things," Woodward Speeches, TU.

20. "Everyday Art," "The Genius Loci," Woodward Speeches, TU; Lee, *Genius Loci*, 6. Woodward once joked about his intense devotion to the southern countryside by recalling the bitter cold of his boyhood winters. "No one forced by the rigors of the New England climate to pour a kettle of boiling water over the kitchen pump as the first move toward the family breakfast can look upon a palm tree unmoved," he explained. Quoted in "The Man Who Molded Newcomb Pottery," *Times-Picayune*, Mar. 27, 1987.

21. "Art in Colleges," Woodward Speeches, TU.

22. "What Has Art to Do with Practical Things," "The Lesser Arts," Woodward Speeches, TU. Woodward repeatedly emphasized what a long evolutionary process lay ahead of the country in the struggle to raise art standards. See for example an untitled manuscript Woodward drafted in response to a letter requesting a summary of his aesthetic beliefs in the Woodward Papers, Box 2, TU. Archie Palmer to Ellsworth Woodward, Nov. 21, 1933, Woodward Papers, Box 1, TU. For a broader discussion of artistic nationalism during the period see Alexander, *Here the Country Lies*, 7–27.

23. "Art in the South," Woodward Speeches, TU.

24. Kaplan, *Art That Is Life*, 77–100, 207–22; Anscombe, *Arts and Crafts in Britain and America*, 63–83, 168–88; Lears, *No Place of Grace*, 60–96. For a bibliographic treatment of the movement see Vance, *Arts and Crafts Movement*; and *The Craftsmen*, 1–39 (Oct. 1901–Dec. 1916). "Everyday Art," Woodward Speeches, TU, Box 1; Woodward to Stephens, Apr. 2, 1909, Stephens Papers, Box 1, TU.

25. "Ellsworth Woodward," Artists' Files, THNOC; *Item*, June 7, 1931; Ormond and Irvine, *Louisiana's Art Nouveau*, 3–14; Poesch, *Newcomb Pottery*, 9–16; Mitchell,

"Analysis of the Decorative Styles of Newcomb Art Pottery"; "Newcomb Art School"; Callen, *Women Artists of the Arts and Crafts Movement*, 88–89; Kaplan, *Art That Is Life*, 324–25; Anscombe, *Arts and Crafts in Britain and America*, 153.

26. "Newcomb Pottery: It Is Acquiring a Wide and Useful Fame," in "Newcomb Pottery," NOMA. Woodward quoted in Freeman and Douglas, "Newcomb Pottery."

27. Blasberg, "Newcomb Pottery"; Sheerer, "Newcomb Pottery Workers: An Appreciation," in "Newcomb Pottery," NOMA.

28. Smith, "Origin, Development, and Present Status of Newcomb Pottery"; Ellsworth Woodward to Edwin L. Stephens, May 18, 1902, Stephens Papers, TU.

29. Blasberg, "Newcomb Pottery"; Cox, "Potteries of the Gulf Coast" (Apr.).

30. Cox, "Potteries of the Gulf Coast" (Apr.), 18–19; Blasberg, "Newcomb Pottery," 73–74.

31. Cox, "Potteries of the Gulf Coast" (May).

32. Blasberg, "Newcomb Pottery," 75; Smith, "Origin, Development, and Present Status of Newcomb Pottery," 4.

33. Poesch, *Newcomb Pottery*, 17–32; 45–49.

34. Quoted in ibid., 52.

35. Antippas, "Newcomb Pot Revolution of 1887"; Poesch, *Newcomb Pottery*, 47–56.

36. Antippas, "Newcomb Pot Revolution," 102.

37. For a discussion of political reform in turn-of-the-century New Orleans, see Taylor, *Citizen's League*.

38. Poesch, *Newcomb Pottery*, 61–69; Ellsworth Woodward to E. L. Stephens, Dec. 29, 1907, Stephens Papers, TU.

39. Quoted in Poesch, *Newcomb Pottery*, 69.

40. Ibid., 61–85; Cox, "Newcomb Pottery Active in New Orleans"; "Newcomb Potteries." For a more general discussion of the commercialization of the Arts and Crafts movement, see Anscombe, *Arts and Crafts in Britain and America*, 189–207.

41. Poesch, *Newcomb Pottery*, 75ff.

42. Quoted in ibid., 82; *Item*, June 7, 1931.

Chapter 2

1. Ellsworth Woodward to Edward Bruce, Record Group 121, Records of the Public Buildings Commission, National Archives, Washington, D.C., Entry 124, Correspondence of Edward Bruce, 1934–43, Box 7 (hereinafter cited as RG 121/Entry 124, Box #, NA).

2. Civil Works Administration Bulletin, no. 464, Entry 105, "Central File of the Advisory Committee and the Project, 1933–34," Box 2, NA (hereinafter cited as "CWA Bulletin, 464, RG 121/105, NA). For Edward Bruce's background and career, see Contreras, *Tradition and Innovation in New Deal Art*, 31–37, and McKinzie, *New Deal for Art-*

ists, 7–8. The plight of American artists in the early depression is discussed in McDonald, *Federal Relief Administration and the Arts*, 341–76, esp. 345–48; and Vitz, "Struggle and Response." Discussion of early New Deal art initiatives include Biddle, *American Artist's Story*, 259–73; Brown, "New Deal Arts Projects," 84; McDonald, *Federal Relief Administration*, 357–61; Contreras, *Tradition and Innovation*, 29–31; and McKinzie, *New Deal for Artists*: 1–10.

3. Dows, "New Deal's Treasury Art Program," 55. Discussions of the PWAP organizational meeting include Rubenstein, "Government Art in the Roosevelt Era," 2; Contreras, *Tradition and Innovation*, 40–41; and McKinzie, *New Deal for Artists*, 10. Tugwell and St. Gaudens are quoted in CWA Bulletin, 464, RG 121/105, NA, pp. 4,7.

4. Watson, "Public Works of Art Project," 7.

5. Discussions of PWAP's organizational structure, goals, and administrative personnel include Edward Bruce, "Implications of the Public Works of Art Project," RG 121, Entry 106, Central Office Correspondence and Related Records, 1933–34, Box 4, NA, (hereinafter cited as RG 121/106, NA). (Bruce's article was later published in the Mar. 1934 issue of the *American Magazine of Art*.) Bernstein, "Artist and the Government," 73; McCoy, "Poverty, Politics, and Artists"; Contreras, *Tradition and Innovation*, 41–49; and McKinzie, *New Deal for Artists*, 9–13.

6. Bruce, "Implications of the Public Works of Art Project"; Forbes Watson, "The Artist Becomes a Citizen"; Watson, "Public Works of Art Project," 8; Watson, "A Steady Job," 169–70; all in RG 121/106, NA. Rowan, "Will Plumber's Wages Turn the Trick?"; Contreras, *Tradition and Innovation*, 42–43; Dows, "The New Deal's Treasure Art Programs," 56; Rubenstein, "Government Art in the Roosevelt Era," 5.

7. CWA Bulletin, 464, RG 121/105, NA.

8. Bruce's views on art are discussed in Contreras, *Tradition and Innovation*, 35–36. His defense of American Scene painting and his description of it as "a native product" are in Bruce, "Implications of the Public Works of Art Project," RG 121/106, NA. For a discussion of the origins and ideals of American Scene painters, see Baigell, *American Scene*, 13–41.

9. Paul Honore to Edward Bruce, Dec. 15, 1933, RG 121/105, Box 2, NA.

10. Bruce, "Implications of the Public Works of Art Project," RG 121/106, NA; Watson, "The Affiliated Plum Pickers Attack the Public Works of Art Project, RG 121/108, NA.

11. Gustave Courbet quoted in Nochlin, "Invention of the Avant-Garde," 12.

12. "Untitled biographical sketch," Woodward Papers, Box 4, TU; Boyer, "Etchings of Ellsworth Woodward," ix; "Ellsworth Woodward," Artists' Files, THNOC; C. C. Zatzinger to Edward Bruce, Nov. 17, 1933, RG 121/106, Box 4, NA.

13. "Art in the South," Woodward Speeches, TU.

14. "Art in Louisiana," Woodward Speeches, TU; Edward Bruce to Ellsworth Woodward, Mar. 22, 1934; Bruce to Woodward, Dec. 10, 1933, RG 121, Entry 108, Central Office Correspondence with the Regions, 1933–34, Box 3, NA, (hereinafter cited as RG

121/108, NA); "PWAP Report of Art Project," Report of the Assistant Secretary of the Treasury to the Federal Relief Administrator, Dec. 8, 1933–June 30, 1934, RG 121, Entry 115, PWAP Reports, Box 1, NA, (hereinafter cited as "Final PWAP Report," RG 121/115, NA).

15. *Times-Picayune*, Dec. 17, 1933; *Item*, Dec. 18, 1933; CWA Bulletin, 464, RG 121/105, NA.

16. Edward Bruce to Ellsworth Woodward, Dec. 10, 1933; RG 121/108, NA.

17. Ellsworth Woodward to Forbes Watson, Dec. 10, 1933, 121/108, Box 3 NA.

18. Woodward to Watson, Dec. 13, 1933; Ellsworth Woodward to Edward Bruce, Aug. 18, 1934; both in RG 121/108, Box 3, NA.

19. Ellsworth Woodward to Forbes Watson, Dec. 19, 1933; Watson to Pierce Butler, Dec. 22, 1933, RG 121/108, Box 3, NA. Woodward later moved his office downtown into the French Quarter at the Natural History Building, 715 Chartres. Ellsworth Woodward, "Public Works of Art," unpublished mss. (hereinafter cited as "Woodward Circular," RG 121/106, NA); "Region no. 6, List of Names and Addresses"; "List of Artists Employed Between Tuesday December 12 and Monday December 18, 1933," Box 5; all in RG 121/106, NA.

20. Ellsworth Woodward to Edward Bruce, Dec. 16, 1933; Woodward to Bruce, Dec. 21, 1933, RG 121/108, NA.

21. Edward Bruce to Ellsworth Woodward, Dec. 15, 1933; Woodward to Bruce, Dec. 30, 1933, RG 121/108, NA. For discussions of the tension between relief and skill see Contreras, *Tradition and Innovation*, 43; McKinzie, *New Deal for Artists*, 13ff.

22. Ellsworth Woodward to Edward Bruce, Jan. 23, 1934, RG 121/108, NA.

23. Ellsworth Woodward to Edward Bruce, Mar. 14, 1934, RG 121/108, NA.

24. Edward Bruce to Ellsworth Woodward, Jan. 27, 1934, RG 121/108, NA.

25. Edward Bruce to Ellsworth Woodward, Jan. 2, 1934; Woodward to Bruce, Jan. 17, 1934; RG 121/108, NA.

26. "Washington Office, Administrative Payroll," RG 121/105, NA; Ellsworth Woodward to Forbes Watson, Dec. 23, 1933, RG 121, Entry 108A, Central Office Correspondence with Regions, 1933–34, Box 3, NA, (hereinafter cited as RG 121/108A, NA); Edward Bruce to Ellsworth Woodward, Dec. 21, 1933; Bruce to Woodward, Dec. 22, 1933; Woodward to Bruce, Dec. 30, 1933; Bruce to Woodward, Jan. 2, 1934, ibid.

27. McCoy, "Poverty, Politics, and Artists," 93; "Program of Public Works of Art Project in Region #6," RG 121/108A, NA.

28. "Woodward Circular," RG 121/108A, NA. Ellsworth Woodward to Edward Bruce, Dec. 14, 1933; Woodward to Bruce, Dec. 16, 1933; Woodward to Bruce, Dec. 26, 1933, RG 121/108A, NA.

29. Untitled speech in Woodward Papers, TU; Ellsworth Woodward to Edward Bruce, Dec. 19, 1933, RG 121/108A, NA.

30. "Minutes of the Meeting of Regional Chairmen of the Public Works of Art Project on Monday, February 20, 1934 in Room 68 of the Treasury," RG 121/106, NA,

(hereinafter cited as "Regional Directors' Meeting, February 20, 1934," RG 121/106, NA); Ellsworth Woodward to Edward Bruce, Mar. 21, 1934, RG 121/108A, NA; Woodward to Bruce, Dec. 16, 1933; Woodward to Bruce, Dec. 19, 1933, ibid.; *Times-Picayune*, Jan. 6, 1934; "List of Pictures: PWAP, Region #6," RG 121/106, Box 5, NA; Alberta Kinsey to Edward Bruce, July 22, 1934, RG 121, File 108, Central Office Correspondence with Artists, 1933–34, Box 2, NA, (hereinafter cited as RG 121/108, NA).

31. "List of Artists Employed," RG 121/106, Box 5, NA; Ellsworth Woodward to Edward Bruce, Dec. 16, 1933; Forbes Watson to Ellsworth Woodward, Dec. 20, 1933; Woodward to Watson, Dec. 19, 1933; Woodward to Watson, Dec. 23, 1933; all in RG 121/108A, NA.

32. Forbes Watson to Ellsworth Woodward, Dec. 20, 1933; Edward Rowan to Ellsworth Woodward, Dec. 27, 1933, RG 121/108A, NA.

33. "Regional Directors Meeting, Feb. 20, 1934," RG 121/106, NA; Ellsworth Woodward to Edward Bruce, Apr. 9, 1934; Bruce to Woodward, Mar. 22, 1934, RG 121/108A, NA.

34. Ellsworth Woodward to Edward Bruce, Jan. 26, 1934, RG 121/108A, NA; Bruce to Woodward, Apr. 26, 1934, RG 121/105, NA; Woodward to Bruce, Mar. 16, 1934, ibid.; Woodward to Bruce, Apr. 3, 1934, RG 121/108A, NA; Bruce to Woodward, Mar. 7, 1934, ibid.; Woodward to Bruce, Mar. 8, 1934, ibid.; Woodward to Bruce, Apr. 14, 1934, ibid.; Woodward to Bruce, Mar. 21, 1934, ibid.

35. "Public Works of Art Project," RG 121, Entry 110, "Publicity File," Box 1, NA, (hereinafter cited as "PWAP," RG 121/110, NA); Ellsworth Woodward to Edward Bruce, May 17, 1934, RG 121/108A, NA; "Uncompleted Projects Estimates by Regional Committees," RG 121/105, Box 5, NA; "Work of Artists Employed in Emergency Conservation Work Camps," RG 121/106, Box 4, NA; PWAP Bulletins, nos. 1 and 2, ibid.; William J. Johnstone to Ellsworth Woodward, Jan. 26, 1934; Woodward to Johnstone, Feb. 7, 1934, ibid., Box 1; Jack Edwards to Edward Rowan, Apr. 3, 1934; Edwards to Ellsworth Woodward, Mar. 22, 1934; Robert Fuchs to Rowan, Mar. 14, 1934, all in RG 121, Entry 107, "Correspondence and Other Personal Files of Ed Rowan," Box 1, NA, (hereinafter cited as RG 121/107, NA); *Times-Picayune*, Mar. 23, 1934. "PWAP," RG 121/110, NA; "PWAP Report Concerning Its Activities and Liquidation," RG 121/106, NA.

36. Forbes Watson to Edward Bruce, June 3, 1934, RG 121/106, Box 4, NA; Untitled manuscript dated May 11, 1934, RG 121/105, Box 5, NA; "Final PWAP Report, RG 121/115, NA.

37. "Final PWAP Report, RG 121/115, NA; Catherine Howell to Edward Bruce, n.d.; Gideon Stanton to Bruce, Jan. 17, 1934, RG 121/108, NA.

38. Angela Gregory to Edward Bruce, Jan. 28, 1934; Gardner Reed to Bruce, Jan. 28, 1934, RG 121/108A, NA. For additional comments made by the artists of Region Six, see Harry Coughlin to Bruce, Jan. 30, 1934; J. H. Coughlin to Bruce, Jan. 31, 1934; Werner Hoehn to Bruce, May 4, 1934; Nell O'Brien to Bruce, n.d.; Randall Davey to Bruce, n.d.,

ibid.; Alvin Sharpe to Ellsworth Woodward, Mar. 4, 1934; Woodward to Bruce, Mar. 16, 1934, RG 121/105, Box 4, NA.

39. Ellsworth Woodward to Edward Bruce, Jan. 26, 1934, RG 121/108A; Elizabeth Lawes to Bruce, Mar. 21, 1934; Joe Greenburg to Woodward, Mar. 30, 1934, RG 121/107; *Item*, Feb. 22, 1934. No exact allocation records survive for Region Six. Some references to this topic are available, however, in "PWAP Report Concerning Its Activities and Liquidation," RG 121/106, NA; "Artwork Returned to the Regions," RG 121, Entry 109, Miscellaneous Central Office Files, Box 1, NA; Cecil Jones to Anne Craton, Mar. 30, 1934, RG 121/106, Box 2, NA; Edwin L. Stephens to Edward Bruce, May 3, 1934, RG 121/105, Box 1, NA; "Requests For Pictures," ibid.; Robert Maestri to Edward Rowan, July 23, 1934; Sen. John Overton to Edward Bruce, May 29, 1934, ibid.; "Exhibition of Water Colors Loaned to Army Camps by the Section of Fine Arts," ibid., Box 5; "Congressional Correspondence-List of Artwork Allocated to Senators and Congressmen," ibid.

40. Scholarly assessments of PWAP include Contreras, *Tradition and Innovation*, 67–101, and McKinzie, *New Deal for Artists*, 21–33. On the unforeseen consequences of New Deal agencies see Badger, *New Deal*, 299–312. The competing versions of "culture" in late-nineteenth- and early-twentieth-century America is most cogently expressed in Levine, *Highbrow/Lowbrow*. Levine's ideas are further refined and amplified in several essays included in *Unpredictable Past*.

41. Localism and New Deal politics is discussed in Karl, *Uneasy State*, esp. 80–181.

42. Ellsworth Woodward to Edward Bruce, Mar. 27, 1934, RG 121/108A, NA; National Archives Still Pictures Branch, RG 121-PWAP, Records of the Public Buildings Service, "Prints, Public Works of Art Project, 1933–34," Box 2 (hereinafter cited as "PWAP Prints," Still Pictures Branch, NA). Thomas Bender treats the "middle landscape," a major concern of mid-nineteenth-century American artists and social thinkers in Bender, *Toward an Urban Vision*, esp. 74–80.

43. *Item*, Feb. 22, 1934.

44. PWAP Prints, Still Pictures Branch, NA.

Chapter 3

1. The pertinent correspondence documenting the assignment, supervision, and completion of Treasury Section commissions is kept in Entry 133, the so-called "Embellishment Files" of Record Group 121, Records of the Public Buildings Service, National Archives, Washington, D.C. Hereinafter, citation to specific mural decorations will be by "File," RG 121, Entry number and description, Box #, NA. Edward Rowan to Allison B. Curry, Sept. 5, 1939, "Arcadia P.O.," RG 121, Entry 133, "Embellishment Files," Box 37, NA. A succinct overview of each mural or sculpture decoration for every Section commission completed, including an explanation of the work and a capsule

biography of the artist, is available in RG 121, Entry 135, "Letters Received and Other Records," NA.

2. Overviews of the Section appear in Contreras, *Tradition and Innovation*, 51–56, 61–64, 101–31, and McKinzie, *New Deal for Artists*, 35–73. The best survey of Section artwork appears in Marling, *Wall-To-Wall America*. See also Park and Markowitz, *Democratic Vistas*. For an interpretation of southern post office murals, see Sue Bidwell Beckham, *A Gentle Reconstruction*. More recently, Barbara Melosh examined gender values in Section Art and Federal Theater productions in *Engendering Culture*. The best contemporary source for Section artwork appears in Bruce and Watson, *Art in Federal Buildings*. For accounts tracing the Mexican Mural movement, its popularization of the form, and influence on American mural painting during the 1930s, see Biddle, *American Artist's Story*; Brenner, *Idols Behind Altars*; Orozco, *Jose Clemente Orozco*; Myers, *Mexican Mural Painting in Our Time*. An illuminating comparison of the American and Mexican mural movements appears in McDonald, *Federal Relief Administration*, 354–57.

3. "Government Patronage of the Arts," RG 121, Entry 118, General Administrative and Reference File of the Chief, 1935–37, Box 1, NA.; "Bulletin, Section of Painting and Sculpture," no. 1, Mar. 1, 1935, RG 121, Entry 130, Bulletins of the Section of Painting and Sculpture, 1935–41, Box 42, NA; "Section of Fine Arts" (speech delivered at a session of the American Artists' Congress, June 8, 1941, by Robert Cornbach), RG 121, Entry 122, General Correspondence File, Box 165/24, NA.

4. "Bulletin, Section of Painting and Sculpture," no. 1, Mar. 1, 1935, RG 121, Entry 130, Bulletins of the Section of Painting and Sculpture, 1935–41, Box 42, NA.

5. Edward Rowan to Edward Bruce, Jan. 6, 1935, RG 121, Entry 122, General Correspondence File, Box 33/174, NA; "Exhibition of Preliminary Sketches for Murals, Section of Fine Arts," Entry 135, Box 203, NA; Marling, *Wall-to-Wall America*, 3–27.

6. Bruce, "Government Patronage of the Arts," RG 121, Entry 118, Box 1, NA; Edward Bruce to Josephine Roche, Oct. 18, 1940, ibid., Entry 124, Box 10, NA. Bruce's health problems are discussed in both Contreras, *Tradition and Innovation*, and McKinzie, *New Deal for Artists*. In 1935, what Contreras calls "a massive stroke" and McKinzie labels a heart attack left Bruce paralyzed on his left side. Briefly he resigned as the Section's director but reversed himself, saying that he preferred to devote whatever time and energy he had remaining to, as McKinzie quotes, "my big dream of my life." Thereafter, though Bruce was the Section's "chief," he was frequently away from the office and entrusted its day-to-day operation to Rowan. Several thick files illuminate the relationship between these two men in RG 121, Entry 124, Correspondence of Edward Bruce, Box 10, NA; "Government Patronage of the Arts," RG 121, Entry 118, General Administrative and Reference File of the Chief, 1935–37, Box 1, NA.

7. Marling, *Wall-to-Wall America*, 3–71.

8. Gelber, "Working to Prosperity."

9. "DeRidder, P.O.," ibid., Entry 133, Box 39, NA.

10. Marling, *Wall-to-Wall America*, 81–89; Edward Rowan to Laura B. Lewis, Oct. 16, 1939, "Eunice P.O.," RG 121, Entry 133, Box 39, NA; Saxon, *Louisiana*, 453.

11. Lewis to Rowan, Jan. 16, 1940; Rowan to Lewis, Jan. 19, 1940; Lewis to Rowan, Apr. 28, 1940, ibid.

12. Rowan to Lewis, May 28, 1940, RG 121, Entry 133, Box 39, NA.

13. Ibid.

14. "Xavier Gonzales," Artists' Files, THNOC.

15. Ibid., *Morning Star-Telegram* (Fort Worth), in RG 121, Entry 124, Box 2, NA. Aside from his two Louisiana commissions, Gonzales completed at least three others, one for the courthouse in Huntsville, Alabama, one for the post office in Alpine, Texas, and another for the post office in Amarillo, Texas.

16. For an overview of the TRAP see, "Final Report Treasury Relief Art Project," RG 121, Entry 119, Box 1, NA. A valuable summary of TRAP aspirations and operations written by its director is Dows, "New Deal Treasury Art Programs. "Hammond P.O., Gonzales," RG 121, Entry 119, Box 12.

17. "Covington P.O.," RG 121, Entry 133, Box 39, NA.

18. Hy Knight to Federal Works Agency, Aug. 22, 1941, "Ferriday P.O.," RG 121, Entry 133, Box 40, NA.

19. Rowan to Purser, July 9, 1940; Purser to Rowan, Aug. 12, 1940; Purser to Rowan, Sept. 10, 1940, ibid.

20. Rowan to Purser, Aug. 19, 1940; Purser to Rowan, Nov. 28, 1940; Rowan to Purser, Dec. 9, 1940, ibid.

21. Rowan to Purser, July 5, 1941; Purser to Rowan, Aug. 5, 1941; Rowan to Purser, Aug. 13, 1941, ibid.

22. "Tallulah, P.O.," RG 121, Entry 133, Box 41, NA; Murphy, "Overflow Notes."

23. "Jeanerette, P.O.," RG 121, Entry 133, Box 40, NA. R. M. Almond to Treasury Department, Procurement Division, Aug. 2, 1938, "Tallulah, P.O.," Box 41, NA; *Times-Picayune*, Sept. 8, 1941.

24. Adam Fairclough discusses the incipient Civil Rights movement in thirties Louisiana in *Race and Democracy*, 21–73.

25. "Bulletin, Section of Painting and Sculpture, no. 1," Mar. 1, 1935, RG 121, Entry 130, Box 42, NA. Baigell, *American Scene*; Marling, *Wall-to-Wall America*, 81–89. For discussions of various aspects of regionalism in thirties America, see Aaron, "Approach to the Thirties," Jordy, "Four Approaches to Regionalism in the Visual Arts of the 1930s," and Wertheim, "Constance Rourke and the Discovery of American Culture in the 1930s." A valuable survey of artistic expression in the thirties South is Noggle, "With Pen and Camera." Robert Dormon studies the regionalist movement in *Revolt of the Provinces*.

26. "Oakdale, P.O.," RG 121, Entry 133, Box 40, NA.

27. Rowan to Alice Flint, Aug. 5, 1938; Flint to Rowan, Aug. 22, 1938; Rowan to Flint, Aug. 29, 1938; Flint to Rowan, Sept. 2, 1938; Flint to Rowan, Sept. 30, 1938; Flint to

Rowan, Nov. 4, 1938; Rowan to Flint, Nov. 19, 1938; Rowan to Flint, Dec. 21, 1938, "Arabi P.O.," RG 121, Entry 133, Box 37, NA.

28. Flint to Rowan, Dec. 27, 1938; "Fairfield P.O.," RG 121, Entry 133, Box 12, NA; Flint to Rowan, Apr. 6, 1939, "Adele P.O., RG 121, Entry 133, Box 24, NA.

29. "St. Martinville P.O.," RG 121, Entry 133, Box 39, NA.

30. Saxon, *Louisiana*, 353–59.

31. Williams, *Huey Long*, 289.

32. Howard Durand to Hon. Robert L. Mouton, Aug. 1, 1939; Commissioner of Public Buildings to Robert L. Mouton, Aug. 11, 1939; Minetta Good to Ed Rowan, Sept. 15, 1939; Rowan to Good, Sept. 20, 1939; and Rowan to Minetta Good, Oct. 12, 1939, all in "St. Martinville P.O.," RG 121, Entry 133, "Embellishment Files," Box 39, NA.

33. Robert L. Mouton to Ed Rowan, Jan. 23, 1940; Ed Rowan to Minetta Good, Jan. 30, 1940; Good to Rowan, Feb. 12, 1940; Rowan to Good, Mar. 13, 1940; Mouton to Rowan, May 1, 1940; Howard Durand to Rowan, Dec. 13, 1940; and Good to Rowan, Dec. 26, 1940, all in "St. Martinville P.O.," RG 121, Entry 133, "Embellishment Files," Box 39, NA; and *St. Martinville* (Louisiana) *Weekly Messenger*, Dec. 13, 1940, 6.

34. Durand to Rowan, Dec. 13, 1940; and Good to Rowan, Dec. 26, 1940, in "St. Martinville P.O.," RG 121, Entry 133, "Embellishment Files," Box 39, NA.

35. Beckham, *Gentle Reconstruction*, 96.

Chapter 4

1. "John McCrady," Artists' Files, Department of Curatorials, The Historic New Orleans Collection, New Orleans, La., (hereinafter cited by "artist's name," Artists' Files, THNOC); "910-B FAP," Division of Information, Primary Files, Record Group 69, Records of the Federal Works Agency, National Archives, Washington, D.C., Box 77. For a discussion of McCrady's mural painted for the post office in Amory, Mississippi, see Marling, *Wall-to-Wall America*, 137–38. *Life*, June 26, 1939, 48–49.

2. "John McCrady," Artists' Files, THNOC.

3. Long has been the subject of substantial scholarly examination. Early treatments of his life and career include Harris, *Kingfish*; Kane, *Louisiana Hayride*; and Sindler, *Huey Long's Louisiana*. Since then two excellent if contrasting biographies have appeared. Williams, *Huey Long*, tends to accept Long's methods and applaud his achievements. Hair, *Kingfish and His Realm*, offers a more critical, less flattering portrait. Brinkley, *Voices of Protest*, examines the Long message, especially in its national phase. Recent essay-length assessments of the Long legacy are collected in Jeansonne, *Huey at 100*. The controversy still surrounding Long's assassination is the subject, most recently, of Reed, *Requiem for a Kingfish*.

4. Cahill expressed his views on art and society in numerous published writings, especially six monographs appearing between 1928 and 1936: *George O. "Pop" Hart*; *Max Weber*; *American Folk Art*; *Art in America in Modern Times*; *Art in America*, writ-

ten with Alfred J. Barr Jr.; and the exhibition catalog he wrote for the first large show-ing of FAP work, *New Horizons in American Art*. The origins and organizational struc-ture of the FAP are discussed in McDonald, *Federal Relief Administration and the Arts*, 116–202, 341–421; and Harris, *Federal Art and National Culture*, 28–43. Holger Cahill's background, early experiences, and influences are discussed in McDonald, *Federal Re-lief Administration and the Arts*, 377–79; McKinzie, *New Deal for Artists*, 78–80; and Contreras, *Tradition and Innovation*, 143–48.

5. Cahill, *American Folk Art*, 6.

6. Cahill, *New Horizons in American Art*, 9–11.

7. Ibid.: 11.

8. Ibid.: 11–14.

9. Ibid.: 14–16.

10. Project activities and intentions as explained by FAP personnel are available in O'Connor's, *Art for the Millions* and *New Deal Arts Projects*. The FAP program is outlined in McDonald, *Federal Relief Administration*, 422–82. FAP Community Art Centers are discussed in Harris, *Federal Art and National Culture*, 44–63, and White, *Art in Action*. Details on art lessons at Raiford State Prison and the Bellevue art show are in McDonald, *Federal Relief Administration*, 467, 470–71.

11. Cahill, *New Horizons in American Art*, 18.

12. For the centrality of the print to Cahill's aesthetic philosophy see ibid.: 38–40. Accounts of FAP print-making activities include McDonald, *Federal Relief Administra-tion*, 433–40; O'Connor, *Art for the Millions*, 139–57, and DeNoon, *Posters of the WPA*.

13. Alan Brinkley emphasizes the traditionalism of Long's egalitarian rhetoric in *Voices of Protest*, esp. 36–56. William Ivy Hair offers the closest scholarly reckoning of the division between Long's speech and action in *The Kingfish and His Realm*.

14. Parker is characterized in McKinzie, *New Deal for Artists*, 80–81; Contreras, *Tradition and Innovation*, 161–62.

15. For Woodward's assessment of conditions faced by his former PWAP employ-ees see Ellsworth Woodward to Edward Bruce, Oct. 9, 1934; Woodward to Olin Dows, Aug., 17, 1935, Aug. 26, 1935, Nov. 8, 1935; Woodward to Cecil Jones, May 1, 1936, RG 121, Entry 119, Box 12, NA. See also Holger Cahill to Woodward, Sept. 6, 1935, RG 69, WPA "General Subjects" Series, Art Program, 1935–Feb. 1942, Box 0442, NA; Conrad Albrizio to Thomas Parker, Oct. 24, 1935; A. J. Angman to Cahill, Oct. 26, 1935, Nov. 3, 1935; Ca-hill to Angman, Sept. 26, 1935, *Selected Documents Relating to the Federal Art Project in Louisiana, 1935–1942*, National Archives and Records Service, Washington, D.C., 1970, Louisiana State Archives, Baton Rouge, Louisiana, Reel 1, (hereinafter cited as *Selected Documents*, LSA-BR).

16. Holger Cahill to Gideon Stanton, Sept. 26, 1935, *Selected Documents*, LSA-BR, Reel 1; "Gideon Stanton," Artists' Files, THNOC.

17. "Stanton," Artists' Files, THNOC; *States-Item*, (New Orleans), Nov. 23, 1964; Holger Cahill to Thomas Parker, Oct. 15, 1935; Jacob Baker to Frank Peterman, Nov. 16,

1935; Stanton to Baker, Nov. 21, 1935; Peterman to Baker, Nov. 14, 1935; J. D. Lockwood to Cahill, Dec. 4, 1935, *Selected Documents*, LSA-BR, Reel 1.

18. Smith, *New Deal in the Urban South*, 210.

19. Eloil L. Bordelon to Thomas Parker, n.d.; Gideon Stanton to Holger Cahill, Dec. 10, 1935, Dec. 12, 1935; Stanton to Jacob Baker, Feb. 14, 1936, *Selected Documents*, LSA-BR, Reel 1. For additional criticisms by local artists of Stanton's hiring policies see, Robert V. Fuchs to Thomas Parker, Jan. 20, 1936, Jan. 30, 1936; Parker to Fuchs, Dec. 6, 1935, Jan. 16, 1936, in ibid. "Louisiana: Narrative Report on Accomplishment to May 1, 1939," RG 69, Professional and Service Division, Narrative Reports, Box 8, NA.

20. Stanton to Cahill, Dec. 12, 1935, *Selected Documents*, LSA-BR, Reel 1.

21. Parker to Stanton, Feb. 4, 1936; Parker to Edna Brennan, Feb. 10, 1936; Parker to Brennan, Feb. 11, 1936; Parker to Stanton, Feb. 12, 1936, ibid.

22. Discussion of the Index include Christensen, *Index of American Design*; Tinkham, *Consolidated Catalog to the Index of American Design*; McDonald, *Federal Relief Administration*, 441–58; and Harris, *Federal Art and National Culture*, 85–102.

23. "Index of American Design, Supplement No. 1 to the FAP Manual, Instructions For Index of American Design," RG 69, State Series, Box 0459, NA; Stanton, "Art in the WPA," 9.

24. Thomas Parker to Gideon Stanton, Apr. 26, 1936; Stanton to Parker, May 7, 1936; Parker to Stanton, May 11, 1936; Stanton to Cahill, May 8, 1936; Cahill to Stanton, May 15, 1936; Stanton to Cahill, May 13, 1936; Parker to Stanton, May 16, 1936, *Selected Documents*, LSA-BR.

25. "Report Concerning the Federal Art Project in Louisiana for the Year 1937," RG 69, State Series, Box 49, NA.

26. *Item*, Dec. 14, 1937.

27. Caroline Durieux to Edward Rowan, Oct. 18, 1940, RG 121, Entry 140, Box 49/158, NA; Stanton to Cahill, Dec. 17, 1936, July 6, 1937; Cahill to Stanton, July 13, 1937; Myron Lechay to Cahill, Aug. 20, 1937, *Selected Documents*, LSA-BR, Reel 1.

28. Lechay to Cahill, Aug. 20, 1937, Oct. 5, 1937; Lechay to Ellen Woodward, Aug. 31, 1937, *Selected Documents*, LSA-BR, Reel 1.

29. Ibid., W. F. Oakes to Lechay, Aug. 6, 1937, *Selected Documents*, LSA-BR, Reel 1.

30. Stanton to Parker, Oct. 19, 1937; Lechay to Parker, Oct. 21, 1937; Parker to Stanton, Oct. 22, 1937; Hal J. Wright to David K. Niles, Nov. 23, 1937; Blanche M. Ralston to Ellen Woodward, n.d.; Lawrence Morris to Parker, Nov. 13, 1937; Cahill to Morris, Nov. 16, 1937, *Selected Documents*, LSA-BR, Reel 1.

31. "Douglas Brown," Artists' Files, THNOC; Brown to Cahill, July 6, 1936, *Selected Documents*, LSA-BR, Reel 1.

32. "Brown," Artists' Files, THNOC; William Stuart Nelson to Holger Cahill, n.d., *Selected Documents*, LSA-BR, Reel 1.

33. Stanton to Parker, Sept. 30, 1937; Stanton to Parker, Nov. 26, 1937; Leo Spofford to J. H. Crutcher, Jan. 10, 1938, *Selected Documents*, LSA-BR, Reel 1.

34. Spofford to Crutcher, Jan. 10, 1938; Stanton to Spofford, Jan. 10, 1938; Stanton to Brown, Jan. 10, 1938; Brown to Stanton, n.d.; Crutcher to Ellen Woodward, Jan. 10, 1938; Brown to Stanton, n.d.; Stanton to Brown, Jan. 14, 1938; Crutcher to Woodward, Jan. 14, 1938; Woodward to Roger Bounds, Jan. 25, 1938; Parker to Woodward, Jan. 26, 1938, *Selected Documents*, LSA-BR, Reel 1.

35. Stanton, "Art in the WPA," 7–9; Parker to William J. McHugh Jr., Sept. 15, 1938; Robert Armstrong Andrews to Stanton, Nov. 16, 1938; Andrews to Spofford, Nov. 17, 1938, *Selected Documents*, LSA-BR, Reel 1.

36. Stanton to Andrews, Nov. 28, 1938, *Selected Documents*, LSA-BR, Reel 1.

37. Stanton to Adolf Glassgold, Sept. 27, 1938; Cahill to Stanton, Oct. 20, 1938; Douglas J. Bear to Stanton, Aug. 29, 1938; Stanton to Bear, Sept. 6, 1938, *Selected Documents*, LSA-BR, Reel 1.

38. *Times-Picayune*, Mar. 1, 1939.

39. Woodward Papers, Box 4, TU; Woodward to Cahill, July 19, 1938, RG 69, "General Subjects" Series, Art Program, 1935–Feb. 1942, Box 0449, NA; Woodward to Cecil Jones, May 1, 1936; Woodward to Olin Dows, Aug. 17, 1935; Woodward to Dows, Aug. 26, 1935, RG 121, Central Office Correspondence 1935–1939, Box 12, NA; *Times-Picayune*, Mar. 1, 1939.

40. Andrews to Parker, Dec. 22, 1938; Spofford to Kerr, Feb. 2, 1939; Parker to Durieux, Feb. 7, 1939, *Selected Documents*, LSA-BR, Reel 2; "Caroline Durieux," Artists' Files, THNOC.

41. Cox, *Caroline Durieux*, 2–9; "Durieux," Artists' Files, THNOC; Arts and Crafts Club Notebooks, Department of Curatorials, The Historic New Orleans Collection, New Orleans, Louisiana, (hereinafter cited as "Notebooks," THNOC). "No one better than she . . . " quoted in untitled, unpublished manuscript in Durieux (Caroline Wogan) Papers, Louisiana and Lower Mississippi Valley Collections, Louisiana State University Libraries, Baton Rouge, Louisiana (hereinafter cited as Durieux Papers, LLMVC, LSU). For estimations of Durieux's work, including comments from Beales, Zigrosser, and Rivera, see *Caroline Durieux Papers*, Archives of American Art, Washington, D.C., Reel 1, (hereinafter cited as Durieux Papers, AA).

42. Durieux to Saxon, Feb. 17, 1938, Saxon Papers, Box 5 TU.

43. Durieux to Andrews, Feb. 5, 1939; Andrews to Durieux, Feb. 8, 1939; Durieux to Parker, Mar. 17, 1939; "Report of the Federal Art Project of Louisiana as of May 1, 1939," RG 69, State Correspondence: Louisiana, Box 49, NA.

44. Andrews to Spofford, May 26, 1939; Andrews to Duncan Ferguson, May 26, 1939; Andrews to Brook Duncan, May 26, 1939; Andrews to Fritz Joachim, May 26, 1939; Andrews to Durieux, May 29, 1939; Andrews to MacArthur, June 12, 1939, *Selected Documents*, LSA-BR, Reel 2.

45. Durieux to Andrews, June 16, 1939; Andrews to Durieux, June 21, 1939, *Selected Documents*, LSA-BR, Reel 2. Durieux to Andrews, June 14, 1939, RG 69, State Correspondence: Louisiana, Box 49, NA.

46.McDonald, *Federal Relief Administration*, 228–40; McKinzie, *New Deal for Artists*, 249–72; Contreras, *Tradition and Innovation*, 219–40.

47. For a discussion of the nature and purpose of sponsorship, see McDonald, *Federal Relief Administration*, 267–83; Parker to Cahill, Feb. 16, 1939, RG 69, Central Files, Box 0440, NA; Alma Hammond to Col. Lawrence Westerbrook, Feb. 8, 1940, RG 69, State Series, Box 1430, NA; Andrews to Spofford, July 25, 1939; Andrews to Durieux, Aug. 3, 1939; Spofford to Kerr, Aug. 4, 1939; Durieux to Andrews, Aug. 8, 1939; Parker to Durieux, Aug. 25, 1939, *Selected Documents*, LSA-BR, Reel 2.

48. *States-Item* (Baton Rouge), Aug. 14, 1940; Durieux to Andrews, June 12, 1939; Andrews to Durieux, June 15, 1939; Arthur MacArthur to Andrews, June 12, 1939; Hammond to Cahill, Oct. 24, 1939, *Selected Documents*, LSA-BR, Reel 2; *Item-Tribune*, Oct. 29, 1939; RG 69, WPA Division of Information Clippings File, NA.

49. During its brief existence the New Southern Group included Conrad Albrizio, Douglas Brown, Caroline Durieux, Duncan Ferguson, Boyer Gonzales, Xavier Gonzales, Angela Gregory, John McCrady, Lois Mehier, Paul Ninas, Stuart Purser, Dr. Marion Souchon, Rudolph Staeffel, Juliis Struppeck, Ralph Wickiser, and Julius Woeltz. For biographical information on each see, Artists' Files, THNOC.

50. *Times-Picayune*, Apr. 2, 1939; *Item-Tribune*, Apr. 9, 1939; *States-Item*, Feb. 19, 1939, Mar. 2, 1939, Apr. 9, 1939, Nov. 9, 1939; "Conrad Albrizio," Artists' Files, THNOC; Orillion, *Conrad Albrizio*; Albrizio, "Plastic Arts and the Community," 41.

51. Ford, "Artist in Stone"; "Angela Gregory"; Orillion, *Conrad Albrizio*, 2; *Paintings in the South*, 120; "Angela Gregory," "Conrad Albrizio," "John McCrady," "Caroline Durieux," Artists' Files, THNOC.

52. Julius Struppeck to Edward Rowan, Sept. 22, 1940, RG 121, Correspondence with Artists, 1939–42, Box 3, NA; RG 121, Bulletins of the Section of Painting and Sculpture, Box 1, NA.

53. Robert Andrews to Duncan Ferguson, May 26, 1939; Ferguson to Andrews, Aug. 29, 1939; Weeks Hall to Holger Cahill, July 18, 1940, *Selected Documents*, LSA-BR, Reel 3; Duncan Ferguson to Ed Rowan, Nov. 8, 1940, RG 121, "National Art Week, 1940–1," Box 8, NA.

54. *Item*, June 19, 1941; "Angela Gregory," Artists' Files, THNOC.

55. *Times-Picayune*, July 27, 1941; Alma Hammond to Florence Kerr, Mar. 4, 1942, RG 69, State Series, Box 1426, NA.

56. "Objectives and Plans for Art Week," RG 69, General Subject Series, 1935–44, Box 0454, NA.

57. Ibid.

58. "Service Help Bulletins, 5, 7, 8, 9," RG 69, General Subjects Series 1935–44, Box 0454, NA.

59. "Service Help Bulletin, 6A," ibid.

60. "Report to Members of National Council for Art Week," Box 0454; "Second Report to Members of National Council for Art Week," Box 0454; "Federal Works

Agency Release," Box 0455; "Objectives and Plans for Art Week," Box 0454, all in RG 69, General Subjects Series 1935–44, NA.

61. Alma Hammond to Florence Kerr, Aug. 17, 1940; Kerr to James H. Crutcher, Sept. 11, 1940, RG 69, General Subjects Series 1935–44, Box 0453, NA; *Times-Picayune*, Nov. 22, 1940.

62. A thick file documents the activities of Brett and other organizers of the second Art Week in Louisiana, including reports submitted from local committee chairmen, and newspaper clippings reporting various events and preparations. See, RG 69, General Subject Series 1935–44, Box 0455, NA.

Chapter 5

1. Saxon's life and art are most fully documented in two scholarly biographies. See Thomas, *Lyle Saxon*, and Harvey, "Lyle Saxon." Saxon quoted in Thomas, *Lyle Saxon*, xi.

2. The "Eatin' books" included Saxon's, *Father Mississippi, Fabulous New Orleans, Old Louisiana*, and *Lafite the Pirate*. King and Cable, together with such other turn-of-the-century Louisiana authors as Ruth McEnery Stuart and Kate Chopin, are the subjects of extensive scholarly research. See especially, Rubin, *George W. Cable*; Taylor, *Gender, Race, and Region in the Writings of Grace King, Ruth McEnery Stuart, and Kate Chopin*; and Elfenbein, *Women on the Color Line*. Reviews of the "Eatin' books" are available in Bound Volume #4, Saxon Papers, TU.

3. Lyle Saxon to Cammie Henry, n.d., Federal Writers' Project Collection, Cammie G. Henry Research Center, Northwest Louisiana State University, Natchitoches, Louisiana, Folder 134, (hereinafter cited as FWP Collection, CGHRC).

4. Saxon was fifty-four. For accounts of his death and burial see Robert Tallant to Cammie Henry, Apr. 14, 1946, FWP Collection, Folder 148, CGHRC; Robert Tallant Papers, New Orleans Public Library, New Orleans, Louisiana, Folder 22 (hereinafter cited as Tallant Papers, NOPL); *States-Item* (New Orleans), Apr. 11, 1946; *Times-Picayune* (New Orleans), Apr. 11, 1946.

5. *Shreveport Journal*, Apr. 11, 1946; *New Orleans Item*, Apr. 11, 1946; *Times-Picayune*, Apr. 10, 11, 1946; *Morning Advocate* (Baton Rouge), Apr. 12, 1946; *Louisiana Weekly* (New Orleans), Apr. 20, 1946. For assertions that his WPA work destroyed Saxon's creative talents see especially the *Shreveport Journal* article cited above. See also, Irene Wagner to Cammie Henry, Apr. 30, 1946, Melrose Collection, Cammie G. Henry Research Center, Northwestern Louisiana State University, Natchitoches, Louisiana, Folder 447, (hereinafter cited as Melrose Collection, CGHRC); undated manuscript in Judith Hyams Douglas Papers, Department of Archives and Manuscripts, Louisiana State University, Baton Rouge, Louisiana, Folder 4, (hereinafter cited as Douglas Papers, LSU-BR).

6. "Diaries," Marcus D. Christian Papers, Department of Archives and Manu-

scripts, University of New Orleans, New Orleans, Louisiana (hereinafter cited as Christian Papers UNO).

7. Among the numerous character sketches of Lyle Saxon, the best include Marshall Morgan, "The Voice of Louisiana: Lyle Saxon, Bachelor of Royal Street," a typewritten transcript of an undated radio broadcast in the Lyle Saxon Papers, Department of Archives and Manuscripts, Tulane University, New Orleans (hereinafter cited as Saxon Papers, TU); George Tucker, "Lyle Saxon," an undated newspaper clipping, and two *Herald-Tribune* (New York) columns by Lucius Beebe in Saxon Papers, TU; and Dormon, "Southern Personalities: Lyle Saxon."

8. Tynes, "Talk with Lyle Saxon."

9. Morgan, "The Voice of Louisiana," Saxon Papers, TU.

10. Lucius Beebe quoted in the "Newspaper File" in Saxon Papers, TU.

11. Saxon's early life is discussed in Thomas, *Lyle Saxon*, 1–19. My understanding of modernism is based on a variety of sources. See, for example, Daniel Joseph Singal, "Towards a Definition of American Modernism," in Singal, *Modernist Culture in America*, 1–27. See also Singal, *War Within*. Saxon fits rather neatly into Singal's classification of southerners who were "Modernists by the Skin of Their Teeth." Additionally, with one crucial distinction noted below, he fits the demographic and attitudinal profile Ann Douglas describes in *Terrible Honesty*. Like modernism, modernization is the subject of an extensive and divided scholarly literature. See for example Black, *Dynamics of Modernization*; Brown, *Modernization: The Transformation of American Life*; and Brown, "Modernization: A Victorian Climax." Discussions of the modernizing South include Ayers, *Promise of the New South*, and Kirby, *Rural Worlds Lost*. The relationship between modernism and modernization is discussed in Berger, Berger, and Kellner, *Homeless Mind*. I am indebted to Professor Paul Gorman of the Department of History at the University of Alabama, who has generously shared with me his considerable understanding of these subjects and their literature.

12. Douglas, *Terrible Honesty*, 3–72. For speculations on Saxon's sexual orientation, see Thomas, *Lyle Saxon*, 51.

13. Saxon quoted in "One Is Close to Heaven at Old Melrose," undated newspaper clipping in the Melrose Collection, CGHRC, Folder 1441.

14. Thomas, *Lyle Saxon*, 20–47; Saxon Papers, TU, Box 11, Folder 2, "Notes For 'Children of Strangers.'"

15. On the mulatto colony at Isle Brevelle, see Mills, *Forgotten People*.

16. Saxon's career as a journalist is discussed in Thomas, *Lyle Saxon*, 15–40 ff, and Harvey, "Lyle Saxon." His sense of the past can be traced in Dormon, "Southern Personalities." Saxon's folklore interests are well documented in the FWP Collection, CGHRC, and are the subject of discussion in Jordan and deCaro, "'In This Folklore Land.'"

17. Harvey, "Lyle Saxon," 213.

18. FWP Collection, CGHRC.

19. Saxon's WPA files are the basis of the FWP Collection in Natchitoches, where, in addition, his library of the macabre and exotic is preserved. Saxon, Dreyer, and Tallant, *Gumbo Ya-Ya.*

20. Saxon's short story, "The Gay Dangerfields," first appeared in the *Century Magazine* and was later reprinted in Saxon, *Old Louisiana,* 7–19. Material on Mother Catherine, Mother Shannon, Sister Haycock, and Marie Laveau all appear in the FWP Collection, CGHRC, and in *Gumbo Ya-Ya.*

21. "Historical Source Materials" and "Diaries" in the Christian Papers, UNO; "The Negro in Louisiana," ibid.; FWP Collection, CGHRC.

22. Saxon, *Father Mississippi,* 142.

23. Saxon, *New Orleans City Guide,* 186–98; Lyle Saxon to Paul Brooks, July 27, 1944, and Saxon to Brooks, Mar. 5, 1943, Saxon Papers, TU.

24. Saxon, *Old Louisiana,* 91.

25. Saxon Dreyer, and Tallant, *Gumbo Ya-Ya,* 273.

26. Ibid., 279.

27. Ibid., 287.

28. Stories of this sort abound throughout Saxon's published work and WPA files. See, for example, *Father Mississippi,* 142–58; *Fabulous New Orleans,* 202–17; and *Old Louisiana,* 85–94. Several chapters from *Gumbo Ya-Ya* fit the pattern, especially "Axeman's Jazz," 75–92. Unpublished stories of this type are in the FWP Collection, CGHRC.

29. Saxon, Dreyer, and Tallant, *Gumbo Ya-Ya,* 83.

30. Saxon, *Lafite the Pirate,* ix.

31. Dormon, "Southern Personalities," 26.

32. The details of Saxon's boyhood prank are relayed by Mercedes Garig, his former English teacher, a close friend of the Saxon family to whom Saxon dedicated *Children of Strangers,* in Helen Gilkison, "Lyle Saxon and Ada Jack Carver as Their Old Teachers Remember Them," typed manuscript in the Gilkison (Helen) Papers, Louisiana and Lower Mississippi Valley Collections, Louisiana State University Libraries, Baton Rouge, Louisiana, Box 1 (hereinafter cited as Gilkison Papers, LLMVC, BR). Saxon's most serious symbolist fictional experiment is his short story "The Centaur Plays Croquet," discussed in Thomas, *Lyle Saxon,* 67–77. Saxon and Dreyer, *The Friends of Joe Gilmore* (and *Some Friends of Lyle Saxon*).

33. Saxon, *Fabulous New Orleans,* vii. Saxon's devotion to Mardi Gras is discussed in Saxon and Dreyer, *The Friends of Joe Gilmore,* 177–82. The best recent social analysis of News Orleans Mardi Gras is Mitchell, *All on Mardi Gras Day.*

34. Saxon and Dreyer, *The Friends of Joe Gilmore,* 77.

35. Mercedes Garig to Lyle Saxon, Oct. 19, 1935; Lollie Brousseau to Saxon, Oct. 23, 1935, Saxon Papers, TU, Box 2. Saxon's role in preserving the Quarter and restoring homes there is discussed in Thomas, *Lyle Saxon,* 30–31, 46. His devotion to Melrose and determination to preserve it from modernizing America are best conveyed in Cammie

Henry's diary for 1934 in the Melrose Collection, CGHRC, Folder 1333. Saxon quoted in Lyle Saxon to Laura Gianberry Snow, Oct. 22, 1937, FWP Collection, CGHRC, Folder 39.

36. Saxon to Cammie Henry, Oct. 15, 1935; FWP Collection, CGHRC, Folder 134.

37. Robert Edwards to Saxon, Oct. 18, 1935, WPA Collection, Louisiana State Library, Baton Rouge, File 31, Drawer 4 (hereinafter WPA Collection, LSL-BR); J. M. Rowe to Saxon, Nov. 10, 1935, ibid., File 24; Oliver M. Thompson to Saxon, Mar. 3, 1936, ibid., File 33; Laura Lee Spencer to Saxon, Dec. 25, 1935, ibid., File 39; Carolyn Durieux to Saxon, Feb. 16, 1937, Saxon Papers, TU, Box 2. For Saxon's hiring guidelines, see "Special Instructions, Number One, To State Directors of the Writers' Projects, Works Progress Administration," WPA Collection, LSL-BR, File #17; R. D. Pittman to Lyle Saxon, Oct. 28, 1935, ibid., File 34, Drawer 4; Saxon to Alsberg, Oct. 17, 1935, Administrative Correspondence, 1935–39, RG 69, NA, Box 1. A discussion of the types of people who applied to Saxon for work on his new project appears in Clayton, "History of the Federal Writers' Project in Louisiana," 72–97; Saxon to Cammie Henry, n.d., FWP Collection, CGHRC, Folder 134. In addition to his duties as an FWP state director, Saxon also supervised the Louisiana effort of the Historical Records Survey. For an account of his activities with this organization see Noggle, *Working with History*.

38. Saxon to Cammie Henry, Oct. 16, 1935; Oct. 18, 1935, FWP Collection, CGHRC, Folder 134.

39. Edward Dreyer to Saxon, Nov. 6, 1935, Alsberg Correspondence, WPA Collection, LSL-BR, File 18; Saxon to George Seuzeneau Jr., Oct. 26, 1935, ibid., File 34, Drawer 4; Saxon to Alsberg, Jan. 6, 1936; Mar. 3, 1936, Alsberg Correspondence, ibid., File 18; Dreyer to Cammie Henry, June 28, 1937, Melrose Collection, CGHRC, Folder 344; Saxon to George M. Reynolds, Feb. 9, 1939, FWP Collection, CGHRC, Folder 8; undated Lucius Beebe column in Melrose Collection, CGHRC, Scrapbook #225; Saxon to H. L. Griffin, Sept. 10, 1937, Saxon Papers, TU, Box 3; Dreyer to "Marge," July 8, 1941, ibid., Box 5; Saxon to Edward Tomlinson, July 28, 1942; Saxon to Commander Richard McNulty, June 30, 1942; Saxon to Commander Fender, Sept. 2, 1942; Saxon to Marge Hunter, n.d., ibid., Box 6.

40. Darel McConkey to Henry Alsberg, Feb. 4, 1936, Feb. 5, 1936; Lawrence Morris to Alsberg, Apr. 10, 1936, "Field Reports," RG 69, NA, Box 1; Dreyer to All Project Supervisors, Apr. 7, 1936, WPA Collection, LSL-BR, File 17.

41. Clayton, "Guides and Gumbo." The gubernatorial election is treated in Field, "Politics of the New Deal in Louisiana," 196–260; Darel McConkey to Henry Alsberg, Feb. 4, 1936, Field Reports, RG 69, NA, Box 1.

42. Saxon to Alsberg, Nov. 19, 1935, Alsberg Correspondence, WPA Collection, LSL-BR, File 18; Spiva to Saxon, Dec. 19, 1935, Feb. 28, 1936, Apr. 7, 1936; Saxon to Spiva, Mar. 2, 1936, ibid., File 26, Drawer 4; Saxon to Rougeau, Apr. 30, 1943, Saxon Papers, TU, Box 6; McConkey to Alsberg, Feb. 8, 1936, Field Reports, RG 69, NA, Box 1. The records of each of Saxon's district offices are part of the WPA Collection, LSL-BR. Saxon to

Sweeney, Nov. 19, 1935; Sweeney to Saxon, Dec. 9, 1935, June 10, 1937, Lafayette Correspondence, ibid., File 32; LWP Monthly Reports, RG 69, NA, Box 9; Clayton, "History of the Federal Writers' Project in Louisiana," 49–70, 98–115. Sweeney to Saxon, Mar. 8, 1936, Mar. 25, 1936, Apr. 3, 1936, Apr. 11, 1936; Saxon to Sweeney, Sept. 15, 1936; Cassibry to Sweeney, Sept. 21, 1936; Sweeney to Cassibry, Oct. 10, 1936.

43. Monroe Correspondence, WPA Collection, LSL-BR, File 21; Louisiana Writers' Project, Monthly Narrative Reports, Districts, "June 30, 1937," p. 14, RG 69, NA, Box 1, (cited hereinafter as LWP Monthly Reports).

44. Clayton, "History of the Federal Writers' Project in Louisiana," l48–76; Penkower, *Federal Writers' Project*, 75–95.

45. Christian Diary, Christian Papers, UNO, Box 1. Additional biographical material on Christian appears in Hessler, "Marcus Christian," and Logsdon, "Spiritual Strivings of a Black Poet and Historian in Louisiana."

46. "Historical Source Materials," Christian Papers, UNO, Box 12.

47. Albert J. Bloom to Marcus Christian, Aug. 13, 1941, Christian Papers, UNO, Box 5. The origins of the Dillard Project are traced in Clayton, "History of the Federal Writers' Project in Louisiana," 86–97; Clayton, "Federal Writers' Project for Blacks in Louisiana"; Penkower, *Federal Writers' Project*, 143; Johnson, "Marcus B. Christian and the WPA History of Black People in Louisiana"; Redding, "Dillard Project." Mangione, *Dream and the Deal*, 225–66, treats the relationship between the WPA and the black writer in America without mentioning the Dillard Project.

48. "The Negro in Louisiana" is retained in the Christian Papers, (UNO), Box 36. Citations follow the manuscript, which begins each chapter with page 1. Quoted in "Negro in Louisiana," "Introduction," 1–3. For an account of project activities see "Supervisor's Report of Nov. 27, 1939, Dillard University History Project," Saxon Papers, TU, Box 5.

49. See especially "Chapter Three," 1–23; "Chapter Fourteen," 1–17; and "Chapter Sixteen," 1–22 in ibid. Joan Redding includes a careful accounting of the manuscript's development and disposition in footnote 20 of "Dillard Project," 53–54.

50. Fairclough, *Race and Democracy*, 46–73. "LaFourche Incident," RG 69, NA, State Series, Box 12.

51. Redding, "Dillard Project," 58–62; Hessler, "Marcus Christian," 41.

52. "Me and Lyle Saxon," unpublished manuscript in Christian Papers, UNO, Box 12.

53. Dora Thea Hettwer to Saxon, June 22, 1937, Saxon Papers, TU. For a report on the size and scope of these activities see "Manuscripts originally prepared for the New Orleans Guide," RG 69, NA, Field Reports, 1935–37, Box 15; Saxon to Alsberg, Mar. 10, 1937, RG 69, NA, Editorial Correspondence, 1936–39, Box 45.

54. Saxon to Alsberg, Aug. 7, 1936; Saxon to Alsberg, Nov. 25, 1936, RG 69, NA, Editorial Correspondence, 1936–39, Box 45; Alsberg to Saxon, May 23, 1937, Saxon Papers, TU, Box 3; Clayton, "History of the Federal Writers' Project in Louisiana," 163–76.

Monty Penkower discussed the publication of the guides in *Federal Writers' Project*, 117–35; Mangione, *Dream and the Deal*, 227–30.

55. Saxon, *New Orleans City Guide*, 18.

56. Ibid., 23.

57. Ibid., 28.

58. Ibid., 56.

59. Ibid., 56–66.

60. Ibid., xxxv.

61. Ibid., 43

62. For discussions of the cosmopolitan aspirations of the guide program, see Penkower, *Federal Writers' Project*, vii–viii, and Hirsch, "Portrait of America," 158–213.

63. Saxon, *New Orleans City Guide*, 146.

64. Ibid., 149

65. Ibid., 151–52.

66. Ibid., 56. For editorial comment on the content of Saxon's survey of New Orleans architecture, see Roderick Seidenberg to Henry Alsberg, Jan. 28, 1937, RG 69, NA, "Correspondence and Editorial Reports Pertaining to Architectural Studies, 1935–40," Box 187.

67. Saxon, *New Orleans City Guide*, 219.

68. Edna Ferber to Saxon, Nov. 11, 1940, Saxon Papers, TU.

69. *Washington Post*, Mar. 6, 1938.

70. "American Panorama."

71. Odum, "America."

72. For a discussion of American ideas and society during the 1930s, see Cooney, *Balancing Acts*, esp. 105–90.

73. American Guide Week plans are detailed in "Service Bulletin No. 1," RG 69, NA, Central Files, General Subject Series, Box 0474.

74. Alsberg to Saxon, Jan. 29, 1937, RG 69, NA, Editorial Correspondence, 1936–39, Box 45; "Editorial Report on State Copy," Nov. 13, 1937, ibid.

75. Charles Wood to Henry Alsberg, Nov. 16, 1937; Alsberg to Saxon, Nov. 23, 1937; Saxon to Alsberg, Dec. 10, 1937, ibid.

76. Saxon to Cammie Henry, "Thursday," [May 1936], Melrose Collection, Folder 1279, CGHRC.

77. Saxon to Alsberg, Alsberg Correspondence, WPA Collection, LSL-BR, File 18; Mangione, *Dream and the Deal*, 92.

78. "Publication Report, WPA Writers' Program, Feb. 2, 1942," Saxon Papers, TU, Box 5.

79. Alsberg to Saxon, May 14, 1936; May 19, 1936; June 22, 1936, Alsberg Correspondence, WPA Collection, LSL-BR, File 18.

80. Turner, "Preliminary Report on Louisiana Dummy," Ruth Crawford, "Prelim-

inary Report on Louisiana Guide," RG 669, NA, Editorial Correspondence, 1936–39, Box 45. The New Orleans bias of Saxon's project publications is the subject of Clayton, "Guides and Gumbo," 4–9.

81. Saxon, *New Orleans City Guide*, xxxv–xxxix, 229–69; "Louisiana Plantations," FWP Collection, Folder 17, CGHRC.

82. "Louisiana Capitol," WPA Collection, LSL-BR, Drawer 3, Folder 6: 1–13.

83. Ibid.

84. Shreveport Guide, WPA Collection, LSL-BR, File 31; *Shreveport Times*, June 30, 1937.

85. Saxon, *Louisiana*, 160.

86. The reorganization of the FWP is well treated in Penkower, *Federal Writers' Project*, 201–37. For an account of the demise of Federal One from the perspective of the national FWP office and subsequent difficulties encountered during the reorganization, see Mangione, *Dream and the Deal*, 3–26, 329–48. The difficulties Saxon and his staff encountered completing the Louisiana Guide are documented in the Saxon Papers, TU, Folder 8, and "Louisiana," RG 69, NA, State Series, Box 1432A.

87. Penkower, *Federal Writers' Project*, 211–14, 220–31. Saxon and Alsberg's mutual admiration and comfortable working relationship is well documented in the Alsberg Correspondence, WPA Collection, LSL-BR.

88. Newsom is quoted in and his tenure as national director is discussed in Penkower, *Federal Writers' Project*, 220–21. He is sketched more fully in Mangione, *Dream and the Deal*, 321. A photograph included in Mangione's book provides a vivid contrast between Newsom and Saxon. See p. 331. Saxon to Cammie Henry, Mar. 4, 1941, Melrose Collection, CGHRC, Scrapbook #222.

89. Saxon to "Pete," Sept. 14, 1942, Saxon Papers, Box 6, TU.

90. *Lake Charles American Press*, Mar. 6, 1936, in WPA Collection, LSL-BR, File 31.

91. Saxon diaries, Saxon Papers, TU, Bound Volume #5; Saxon to Barry Benefield, Nov. 1, 1933, Saxon Papers, TU, Box 2. For early examples of Saxon's folklore writings see, *Times-Picayune*, Sept. 20, 1925, and "Voodoo."

92. Saxon to Alsberg, July 7, 1936, Alsberg Correspondence, WPA Collection, LSL-BR, File 18. Most of the materials collected by Saxon's researchers are preserved in more than 600 files in the FWP Collection, CGHRC.

93. Botkin quoted in Banks, *First Person America*, xv.

94. Botkin, "WPA and Folklore Research."

95. Botkin directed FWP folklore researches for one year before transferring to the Library of Congress, where he began to sift through the mammoth files assembled by various writers' projects. Combining this with other materials, he published three major folklore volumes during the 1940s. See Botkin, *Treasury of American Folklore*, *Treasury of New England Folklore*, and *Treasury of Southern Folklore*.

96. Federal Writers' Project, *These Are Our Lives*. See also Terrill and Hirsch, *Such As Us*. Daniel Joseph Singal discusses Couch's modernism in *War Within*, 265–301. See also Stott, *Documentary Expression*, 204–6; and Penkower, *Federal Writers' Project*, 152.

97. "Reports pertaining to Ethnic Studies, Louisiana: Folklore," Box 193; Couch to Saxon, May 12, 1939; Couch to Alsberg, July 21, 1939, RG 69 NA, FWP, 1935–42, Central Files, Box 465.

98. Saxon to Commander Phillip C. Mulchahy, Sept. 2, 1942; Saxon to Commander Fender, Sept. 2, 1942, Saxon Papers, TU, Box 6. For his comments on what the office was like after the departure of Treadway and Dreyer, see Saxon to Marge Hunter, Oct. 8, 1942, ibid.; Saxon to Judith Hyams Douglas, July 22, 1943, Douglas Papers, LSU-BR, Box 1; Saxon to "Pete," Sept. 14, 1942, Saxon Papers, TU, Box 6. For Saxon's appointment as WPA national consultant and his work on the WPA final report, see Walter Kiplinger to Saxon, Apr. 17, 1942, ibid., Box 5; "Merle Colby, February 15, 1942," RG 69, NA, Central Files, General Subject Series, Box 0391; Penkower, *Federal Writers' Project*, 237; "WP Accounting," *Time*, Feb. 15, 1943, 95–96.

99. Tallant's involvement with the project is the subject of Bodet, "Robert Tallant and the Federal Writers' Program." Saxon to Paul Brooks, July 27, 1944; Mar. 5, 1943, Saxon Papers, TU, Box 6.

100. Brooks to Saxon, Mar. 24, 1943; Saxon to Brooks, Feb. 19, 1944, Saxon Papers, TU, Box 6.

101. Saxon, Dreyer, and Tallant, *Gumbo Ya-Ya*, 1.

102. For Saxon's part in coordinating the artistic touches incorporated into the book see Saxon to Brooks, Feb. 19, 1944, Saxon Papers, TU, Box 6.

103. Saxon, Dreyer, and Tallant, *Gumbo Ya-Ya*, 1.

104. Ibid., 138–78.

105. Ibid., 179.

106. Ibid., 182.

107. Ibid., 206.

108. Cooney, *Balancing Acts*, 152–55.

109. Saxon's flood reportage anticipates many of the themes and styles William Stott associates with thirties documentarians. See esp. Stott, *Documentary Expression*, 5–63.

110. Ulrich, "Salvaging Culture for the WPA."

111. The fullest record of Saxon's campaign to purge Mardi Gras of its modern trends and restore the tradition of public masking appears in Scrapbook #225, Melrose Collection, CGHRC.

112. Robert Tallant to Cammie Henry, Apr. 14, 1946, FWP Collection, CGHRC.

Chapter 6

1. Saxon, *Children of Strangers*, 283.

2. Ibid., 293.

3. Ibid., 294.

4. Szarkowski, *Walker Evans*, 13.

5. Investigations into the FSA should begin with Dixon, *Photographers of the Farm Security Administration.* Dixon divides her bibliography into sections treating each of the FSA photographers with subsections including biographical information, interviews, shows, and other uses of the photographer's work. She also includes studies of the Historical Unit, the FSA, and publications that used FSA photography. The standard work on the FSA is Baldwin, *Poverty and Politics.* Early FSA studies and collections of the unit's more celebrated photographs include Hurley, *Portrait of a Decade*; Anderson, *Roy Stryker*; O'Neal, *A Vision Shared*; Stryker and Wood, *In This Proud Land.* A valuable treatment of other government agencies and their uses of photography during the thirties is Daniel et al., *Official Images.*

6. Vachon quoted in White, "Faces and Places in the South in the 1930s."

7. More recent views of the FSA include Stange, *Symbols of Ideal Life*; Curtis, *Mind's Eye, Mind's Truth*; Levine, "Historian and the Icon"; Trachtenberg, "From Image to Story." Race and FSA photography appears in Natanson, *The Black Image in the New Deal.*

8. The backgrounds of FSA photographers are discussed in Peeler, *Hope Among Us Yet*, 72–78, 97–101.

9. An insightful discussion of Lee's Pie Town series is Curtis, *Mind's Eye, Mind's Truth*, 91–122. Other, more general considerations of this topic include Susman, *Culture as History*, and Levine, "American Culture and the Great Depression"; Cooney, *Balancing Acts*, esp. 157–90.

10. The growth and development of the FSA as an information agency are discussed in Stange, *Symbols of Ideal Life*, 89–131; Curtis, *Mind's Eye, Mind's Truth*, 3–20; and Watkins, "Blurred Image," 37–96.

11. The evolution of Stryker's interest in photography and his project to complete a photographic survey of American agriculture are discussed in Hurley, *Portrait of a Decade*, 60–71, and Stange, *Symbols of Ideal Life*, 89–105. Stryker's controversies with Evans, Shahn, and Lange are something of a set piece in FSA writings. See for example Hurley, *Portrait of a Decade*, 60, 68; Stange, *Symbols of Ideal Life*, 114–17; and Curtis, *Mind's Eye, Mind's Truth*, 10–16.

12. For a discussion of documentary photography as a reflection of modern aesthetics and a genre willing to court conflict and stir emotionalism see Stott, *Documentary Expression*, 1–140; Watkins, "Blurred Image," 166–67; and Steichen, "F.S.A. Photographers."

13. Estimations of the file's size vary according to source. The clearest description

of the file, its contents, size, and organization appears in Fleischhauer and Brannan, *Documenting America*, 330–43. For a concise description of a microfiche edition of FSA negatives, *America, 1935–46: The Photographs of the Farm Security Administration and the Office of War Information Arranged by Region and by Subject and Published on Microfiche*, see Noggle, "With Pen and Camera," 200, n. 11. For a discussion of Vanderbilt's role in reorganizing the file see Trachtenberg, "From Image to Story," 51–55.

14. "Speeches," Woodward Papers, TU, Box 7.

15. DeCaro, *Folklife in Louisiana Photography*, 9–56; Vetter, *Fonville Winans' Louisiana*; and Davis, *Clarence John Laughlin*.

16. The movements of Mydans, Rothstein, and Lange can all be traced through *America, 1935–1946*, South, Fiche 1–300. Lange and Taylor, *American Exodus*. Considerations of this work appear in Stott, *Documentary Expression*, 225–31; Meltzer, *Dorothea Lange: A Photographer's Life*, 210–26; and Ohrn, *Dorothea Lange and the Documentary Tradition*, 108–13, 231–40.

17. Walker Evans recalls the experience of living with Shahn in Cummings, *Artists in Their Own Words*, esp. 90–91. How Evans taught Shahn to use a camera appears in O'Neal, *Vision Shared*, 44, and Rodman, *Portrait of the Artist as an American*, 89–90. Additional biographical material on Evans and discussions of his art include Hurley, *Portrait of a Decade*, 44–48; Katz, "Interview with Walker Evans"; Bushnell, "Introduction to Evans' Work and His Recollections"; Stern, "Walker Evans"; Szarkowski, *Walker Evans*, 9–21; Trachtenberg, *Reading American Photographs*, 231–85; and Rathbone, *Walker Evans*. A complete inventory of Evans's FSA work appears in *Walker Evans: Photographs for the Farm Security Administration, 1935–1938*. Shahn's background is treated in Hurley, *Portrait of a Decade*, 48–50; Shahn, *Ben Shahn*, 111–12, 117–21, 133–35, 345–47. Shahn's influence on the social outlook of FSA photography is discussed in Rodman, *Portrait of the Artist as an American*, 89, and Stange, *Symbols of Ideal Life*, 114–20. Shahn's photography is discussed in Weiss, *Ben Shahn, Photographer*, and Pratt, *Photographic Eye of Ben Shahn*. Nicholas Natanson offers an insightful discussion of race in Shahn's southern photography in *Black Image in the New Deal*, 85–112.

18. Lee's background and education are treated in Hurley, *Russell Lee*. Stryker quoted in Roy Stryker to Russell Lee, Feb. 7, 1939, in Roy Stryker Papers, (microform), Sanford, N.C., 1978, Reel 4. Lee's first meeting with Stryker and initial FSA field assignments are discussed in Hurley, *Russell Lee*, 13–18, and Hurley, *Portrait of a Decade*, 80–82, 102–4.

19. Russell Lee to Clara Dean Wakeham, Sept. 12, 1938, Stryker Papers, Reel 4.

20. Lee to Stryker, Sept. 13, 1938, Stryker Papers, Reel 4.

21. Lee's 1938 Louisiana trip can be traced in *America, 1935–46* (microfiche).

22. Stryker quoted in Fleischhauer and Brannan, *Documenting America*, 59.

23. Community thought during the 1930s has a substantial literature. The classic statement of contemporary concern was expressed in Lynd and Lynd, *Middletown in Transition*. The best study of New Deal concerns for and experiments with the commu-

nity remains Conkin, *Tomorrow a New World*. James Curtis traces Lee's understanding of the community as shaped by the writings of J. Russell Smith, Lewis Mumford, and the Lynds in *Mind's Eye, Mind's Truth*, 91–122.

24. Saxon, *Louisiana: A Guide to the State*, 404.

25. Lee to Stryker, Sept. 16, 1938, Stryker Papers, Reel 4.

26. For considerations of Acadian development which either contextualize or focus specifically on "Cajun" adjustments to the modernizing influences of the thirties and forties, see Ancelet, *Makers of Cajun Music*; Ancelet, Edwards, and Pitre, *Cajun Country*; Brasseaux, *Acadian to Cajun*; Conrad, *Cajuns*.

27. This observation came from an FWP writer in 1939 and is quoted in Rushton, *Cajuns*, 5–6.

28. Francois Mignon Diary, Feb. 28, 1940, in the Francois Mignon Papers, Cammie G. Henry Research Center, Northwest Louisiana State University, Natchitoches, Louisiana, Reel 1 (hereinafter cited as Mignon Diaries, CGHRC). Mignon provides additional details of the Historic American Buildings Survey (HABS) work at Melrose in his journal entries of Feb. 27 and Mar. 23, 1940. That Saxon himself was abetting this effort, taking his own snapshots either to supplement previous HABS coverage or to include places not yet visited by them is the subject of Mignon's journal entry for Mar. 4, 1940.

29. Ibid., July 1, 1940; July 12, 1940.

30. Ibid., July 9, 1940.

31. Ibid., July 12, 1940.

32. Ibid.

33. Ibid., July 9, 1940.

34. Post to Roy Stryker, July 1940, Stryker Papers, Reel 5.

35. Saxon, *A Guide to New Orleans*, xxxiv.

36. Trachtenberg, "From Image to Story," 65.

37. See esp. Natanson, *Black Image in the New Deal*, 203–67.

38. There are two groups of New Orleans photos attributed to Post in this period dated, respectively, August 1940 and January 1941. The framing of the photographs suggests a common perspective, and one from the August 1940 group, a "bird's eye" view of the Quarter, is repeated several times in the January series. It is also plausible that the whole New Orleans series was done at the same time—January 1941—and that she simply misdated some of her photos. More extensive discussions of her life and photography appear in Hurley, *Marion Post Wolcott*, and McEuen, *Seeing America*, 126–95.

39. Saxon, *Children of Strangers*, 264–65.

40. Discussions of Vachon's background, his work for FSA beginning as a clerk and ending as a photographer, and subsequent photography career include Vachon, "John Vachon"; Kernan, "John Vachon"; Bennett, "John Vachon"; John Vachon, "Tribute to a Man, an Era, an Art"; Fleischhauer and Brannan, *Documenting America*, 90–

113; Hurley, *Portrait of a Decade*, 147–56; Orvell, "Portrait of the Artist as a Young Man." Vachon quoted in "Tribute to a Man," 99.

Works Cited

Primary Sources

Libraries, Manuscripts, Collections

Department of Archives and Manuscripts, The Historic New Orleans Collection, New Orleans
 Lyle Saxon Papers
 Gideon Stanton Papers
Department of Curatorials, The Historic New Orleans Collection, New Orleans
 Artists' Files
 Arts and Crafts Club Notebooks
Manuscripts Division, Library of Congress, Washington, D.C.
 Work Progress Administration Papers
Department of Archives and Manuscripts, Louisiana State Archives, Baton Rouge
Selected Documents Relating to the Federal Art Project in Louisiana, 1935–1942. Washington, D.C.: National Archives and Records Service, 1970.
Louisiana State Library, Baton Rouge
 WPA Collection
Louisiana and Lower Mississippi Valley Collections, Louisiana State University Libraries, Baton Rouge
 Caroline Wogan Durieux Papers
 Judith Hyams Douglas Papers
 Michael D. Wynne Papers
National Archives, Washington, D.C.
Record Group 69. Records of the Works Progress Administration
Record Group 121. Records of the Public Building Commission
Department of the Registrar, New Orleans Museum of Art, New Orleans
 Newcomb Pottery
Department of Archives and Manuscripts, New Orleans Public Library, New Orleans
 Robert Tallant Papers
Cammie G. Henry Research Center, Northwestern State University, Natchitoches
 Caroline B. Dormon Papers

Federal Writers' Project Papers

Melrose Collection

Department of Archives and Manuscripts, Howard-Tilton Memorial Library, Tulane
University, New Orleans

Lyle Saxon Papers

E. L. Stephens Papers

Ellsworth Woodward Papers

Department of Archives, University of New Orleans, New Orleans

Marcus B. Christian Papers

Microforms

America 1935–1946. Cambridge: Chadwyck-Healey, Ltd., 1980. Microfiche Edition of
the FSA-OWI Classified File.

Caroline Durieux Papers. Washington, D.C.: Archives of American Art, 1970.

Roy Stryker Papers. Sanford, N.C.: Archives of American Art, 1978.

Newspapers, 1890–1945

Advocate, Baton Rouge

Item, New Orleans

Louisiana Weekly, New Orleans

States, New Orleans

Times-Picayune, New Orleans

Published Books and Articles

Albrizio, Conrad. "Plastic Arts and the Community." *Louisiana State University Bul-
letin* 23, no. 18 (Oct. 1936): 41–50.

"American Panorama." *Prairie Schooner* (Summer 1938): 1–2.

"Angela Gregory," *Arts and Antiques* 1 (Nov. 1938): 3–6.

Biddle, George. *An American Artist's Story*. Boston: Little, Brown and Co., 1939.

Botkin, Benjamin A. *A Treasury of American Folklore: Stories, Ballads, and Traditions of
the People*. New York: Crown Publishers, 1944.

———. *A Treasury of New England Folklore*. New York: Crown Publishers, 1947.

———. *A Treasury of Southern Folklore*. New York: Crown Publishers, 1949.

———. "WPA and Folklore Research: Bread and Song." *Southern Folklore Quarterly* 3
(Mar. 1939): 7–14.

Bruce, Edward, and Forbes Watson. *Art in Federal Buildings: Mural Designs, 1934–1936:
An Illustrated Record of the Treasury Department's New Program in Painting and
Sculpture*. Washington, D.C.: Art in Federal Buildings Inc., 1936.

Cahill, Holger. *American Folk Art: The Age of the Common Man in America, 1750–1900*.
New York: Modern Museum of Art, 1932.

————. *American Painting and Sculpture, 1862–1932; October 31, 1932–January 31, 1933*. Rpt. ed. New York: Arno Press, 1969.

————. *American Sources of Modern Art, May 10 to June 30, 1933*. Rpt. ed. New York: Arno Press, 1969.

————. *George O. "Pop" Hart*. New York: The Downtown Gallery, 1928.

————. *Max Weber*. New York: The Downtown Gallery, 1930.

————. *New Horizons in American Art*. New York: Solomon R. Guggenheim Museum, 1985.

Cahill, Holger, and Alfred J. Barr Jr. *Art in America: A Complete Survey*. New York: Reynal and Hitchcock, 1935.

————. *Art in America in Modern Times*. New York: Reynal and Hitchcock, 1934.

Cline, Isaac Monroe. "Contemporary Arts and Artists of New Orleans and Their World." Reprinted from Biennial Report of the Louisiana State Museum, 1924.

Cox, Paul E. "Potteries of the Gulf Coast." *Ceramic Age* (Apr. 1935): 18–19.

————. "Potteries of the Gulf Coast." *Ceramic Age* (May 1935): 155–56.

————. "Newcomb Pottery Active in New Orleans." *Bulletin of the American Ceramic Society* 13 (May 1934): 13–15.

Dormon, Caroline. "Southern Personalities: Lyle Saxon." *Holland's: The Magazine of the South* (Jan. 1931): 26, 65.

Dows, Olin. "The New Deal's Treasury Art Program: A Memoir." *Arts in Society* 2, no.4 (1964): 50–88.

Ford, Frank Eugene. "Artist in Stone." *New Orleanian* 3 (Mar. 1934): 14–16.

Lee, Vernon. *Genius Loci: Notes on Places*. London: G. Richards, 1899.

Looney, Ben Earl. "Historical Sketch of Art in Louisiana." *Louisiana Historical Quarterly* 18 (Apr. 1924): 390.

Lynd, Robert S., and Helen Merrill Lynd. *Middetown: A Study in Contemporary Culture*. Foreword by Clark Wissler. New York: Harcourt, Brace, and Co., 1929.

————. *Middletown in Transition: A Study in Cultural Conflicts*. New York: Harcourt, Brace and World, Inc., 1937, 1965.

Mount, Mary W. *Some Notables of New Orleans: Biographical and Descriptive Sketches of the Artists and Their Work, Illustrated with Extracts from the Works of Poets and Dramatists, Art in Music, Painting, Sculpture, Poetry, and the Drama*. New Orleans: M. W. Mount, 1896.

Murphy, Helen. "Overflow Notes." *Atlantic Monthly* 140 (Aug. 1927): 223–30.

"The Newcomb Art School." *American Magazine of Art* 10 (Oct. 1919): 480.

"The Newcomb Potteries, Where an Industrial Need Has Been Adjusted to Commercial Purpose." *Glass and Pottery* 4 (Jan. 1911): 11–12.

Norvell, Lillian. "Ellsworth Woodward." *New Orleanian* 1 (Aug. 1931): 21–22.

Odum, Howard. "America: States and Regions." *Social Forces* 16 (May 1938): 4.

Paintings in the South. Richmond: Virginia Museum, 1983.

Radcliffe, Anthony. "Some Artists of Louisiana." *Southern Magazine* 4 (June 1937): 11–12, 35.

Rowan, Edward. "Will Plumber's Wages Turn the Trick?" *American Magazine of Art* 27 (Feb. 1934): 81, 83.

Saxon, Lyle. *Children of Strangers.* Boston: Houghton-Mifflin, 1937.

———. *Fabulous New Orleans.* New York: Century Co., 1928.

———. *Father Mississippi.* New York: Century Co., 1927.

———. *Lafite the Pirate.* New York: Century Co., 1930.

———, ed. *Louisiana: A Guide to the State.* New York: Hastings House, 1941.

———, ed. *New Orleans City Guide: Written and Compiled by the Federal Writers' Project of the Works Progress Administration for the City of New Orleans.* Boston: Houghton-Mifflin, 1938.

———. *Old Louisiana.* New York: Century Co., 1929.

———. "Voodoo." *New Republic,* Mar. 23, 1927, 135–39.

Saxon, Lyle, and Edward Dreyer. *The Friends of Joe Gilmore/Some Friends of Lyle Saxon.* New York: Hastings House, 1948.

Saxon, Lyle, Edward Dreyer, and Robert Tallant, eds. *Gumbo Ya-Ya: A Collection of Louisiana Folk Tales.* Boston: Houghton-Mifflin, 1945.

Smith, Kenneth E. "The Origin, Development, and Present Status of Newcomb Pottery." *Bulletin of the American Ceramic Society* 17, no. 6 (June 1938): 2–4.

Stanton, Gideon. "Art in the WPA." *Arts and Antiques* 1 (Nov. 1938): 7–12.

Tynes, Wendell. "A Talk with Lyle Saxon." *Harvester,* Jan. 22, 1933, 4,6.

Ulrich, Mabel S. "Salvaging Culture for the WPA." *Harper's* 178 (May 1939): 653–64.

Watson, Forbes. "The Public Works of Art Project: Federal, Republican, or Democratic?" *American Magazine of Art* 27 (Jan. 1934): 7–9.

"WP Accounting." *Time,* Feb. 15, 1943, 95–96.

Secondary Works

Published Books and Articles

Aaron, Daniel. "An Approach to the Thirties." In *The Study of American Culture: Contemporary Conflicts,* ed. Luther Leudtke. DeLand, Fla.: Evrett/Edwards, Inc., 1977.

Alexander, Charles C. *Here the Country Lies: Nationalism and the Arts in Twentieth-Century America.* Bloomington: Indiana University Press, 1980.

Ancelet, Barry Jean. *The Makers of Cajun Music/Musiciens Cadiens et Creoles.* Austin: University of Texas Press, 1984.

Ancelet, Barry Jean, Jay Edwards, and Glen Pitre. *Cajun Country.* Jackson: University Press of Mississippi, 1991.

Anderson, James C. *Roy Stryker: The Humane Propagandist.* Louisville: University of Louisville Photographic Archives, 1977.

Anscombe, Isabelle. *Arts and Crafts in Britain and America*. New York: Van Nostrand Reinhold Co., 1983, 1978.

Anthony, Arthe A. "'Lost Boundaries': Racial Passing and Poverty in Segregated New Orleans." *Louisiana History* 36 (Summer 1995): 291–312.

Antippas, Andy Peter. "The Newcomb Pot Revolution of 1887." *New Orleans Magazine* 10 (July 1975): 96, 98.

Arnesen, Eric. *Waterfront Workers of New Orleans: Race, Class, and Politics, 1863–1923*. New York: Oxford University Press, 1991.

Ayers, Ed. *The Promise of the New South: Life after Reconstruction*. New York: Oxford University Press, 1992.

Badger, Anthony. *The New Deal: The Depression Years, 1933–1940*. American Century Series. New York: Hill and Wang, 1989.

Baiamonte, John V., Jr. "'Who Killa de Chief' Revisited: The Hennessy Assassination and Its Aftermath." *Louisiana History* 33 (Spring 1992): 117–46.

Baigell, Matthew. *The American Scene: American Painting of the 1930's*. New York: Praeger Publishers, Inc., 1974.

Baldwin, Stanley. *Poverty and Politics: The Rise and Decline of the Farm Security Administration*. Chapel Hill: University of North Carolina Press, 1968.

Banks, Ann, ed. *First Person America*. New York: Norton, 1980.

Banta, Martha. *Taylored Lives: Narrative Productions in the Age of Taylor, Veblen, and Ford*. Chicago and London: University of Chicago Press, 1993.

Barry, John M. *Rising Tide: The Great Mississippi River Flood and How it Changed America*. New York: Touchstone, 1997.

Beckham, Sue Bidwell. *A Gentle Reconstruction: Depression Post Office Murals and Southern Culture*. Baton Rouge: Louisiana State University Press, 1989.

Bender, Thomas. *Community and Social Change in America*. New Brunswick, N.J.: Rutgers University Press, 1978.

———. *Toward an Urban Vision: Ideas and Institutions in Nineteenth Century America*. Lexington: University Press of Kentucky, 1975.

Bennett, Edna. "John Vachon: A Realist in Magazine Photography." *US Camera* (Dec. 1960): 11–12.

Berger, Peter, Brigitte Berger, and Hansfried Kellner. *The Homeless Mind: Modernization and Consciousness*. New York: Random House, 1973.

Berman, Art. *Preface to Modernism*. Urbana and Chicago: University of Illinois Press, 1994.

Berman, Martin. *All That Is Solid Melts into Air: The Experience of Modernity*. New York: Penguin Books, 1982, 1988).

Bernstein, Joel H. "The Artist and the Government: P.W.A.P." *Challenges in American Culture*, ed. Ray A. Browne. Bowling Green, Ohio: Bowling Green University Popular Press, 1970.

Black, Cyril E. *The Dynamics of Modernization: A Study in Comparative History.* New York: Harper and Row, 1966.

Blasberg, Robert W. "Newcomb Pottery." *Antiques* (July 1968): 74–75.

Blassingame, John W. *Black New Orleans, 1860–1880.* Chicago: University of Chicago Press, 1973.

Bodet, Gerald P. "Robert Tallant and the Federal Writers' Program." Unpublished manuscript in possession of the author.

Botein, Barbara. "The Hennessy Case: An Episode in Anti-Italian Nativism." *Louisiana History* 20 (Spring 1979): 261–80.

Brasseaux, Carl A. *Acadian to Cajun: Transformation of a People, 1803–1877.* Jackson: University Press of Mississippi, 1992.

Brenner, Anita. *Idols Behind Altars.* New York: Biblo and Tannen, 1967.

Brinkley, Alan. *Voices of Protest: Huey Long, Father Coughlin, and the Great Depression.* New York: Vintage, 1982.

Brown, Milton W. "New Deal Arts Projects: Boondoggle or Bargain," *ArtNews* 81 (Apr. 1982): 82–87.

Brown, Richard D. *Modernization: The Transformation of American Life, 1600–1865.* American Century Series. New York: Hill and Wang, 1976.

———. "Modernization: A Victorian Climax." *American Quarterly* 27 (1975): 533–48.

Burns, Anna L. "The Gulf Lumber Company, Fullerton: A View of Lumbering During Louisiana's Golden Era." *Louisiana History* 20 (Spring 1979): 197–207.

Bushnell, Peter C. "An Introduction to Evans' Work and His Recollections." *New Republic* 175 (Nov. 1976): 27–29.

Callen, Anthea. *Women Artists of the Arts and Crafts Movement, 1870–1914.* New York: Pantheon Books, 1979.

Cantor, Norman F. *The American Century: Varieties of Culture in Modern Times.* New York: Harper Collins, 1997.

Christensen, Edwin O. *The Index of American Design.* New York: Macmillan Co., 1950, 1967.

Clayton, Ronnie W. "Guides and Gumbo: The LWP's Major Publications." Unpublished manuscript in possession of the author.

———. "The Federal Writers' Project for Blacks in Louisiana." *Louisiana History* 19 (Summer, 1978): 327–35.

Conkin, Paul. *Tomorrow a New World: The New Deal Community Program.* Ithaca: Cornell University Press, 1959.

Conrad, Glenn R., ed. *The Cajuns: Essays on Their History and Culture.* Lafayette: Center for Louisiana Studies, University of Southwestern Louisiana, 1978.

Contreras, Belisario. *Tradition and Innovation in New Deal Art.* Lewisburg, Pa.: Bucknell University Press, 1983.

Cooney, Terry A. *Balancing Acts: American Thought and Culture in the 1930s.* Twayne's American Thought and Culture Series. New York: Twayne Publishers, 1995.

Cox, Richard. *Caroline Durieux: Lithographs of the Thirties and Forties.* Baton Rouge: Louisiana State University Press, 1977.

Coxe, John E. "The New Orleans Mafia Incident." *Louisiana Historical Quarterly* 20 (Oct. 1937): 1067–1110.

Cronon, William. *Nature's Metropolis: Chicago and the Great West.* New York: W. W. Norton and Co., 1991.

Cullison, William R. *Two Southern Impressionists: An Exhibition of the Work of the Woodward Brothers. William and Ellsworth.* New Orleans, 1984.

Cummings, Paul. *Artists in Their Own Words: Interviews with Paul Cummings.* New York: St. Martin's Press, 1979.

Curtis, James. *Mind's Eye, Mind's Truth: FSA Photography Reconsidered.* Philadelphia: Temple University Press, 1989.

Curtis, Michael. "Early Development and Operations of the Great Southern Lumber Company." *Louisiana History* 14 (Fall 1973): 347–68.

Daniel, Pete, et al. *Official Images: New Deal Photography.* Washington, D.C.: Smithsonian Institution Press, 1987.

Davis, Keith F. *Clarence John Laughlin: Visionary Photographer.* Kansas City: Hallmark, 1990.

deCaro, Frank. *Folklife in Louisiana Photography: Images of Tradition.* Baton Rouge: Louisiana State University Press, 1990.

DeNoon, Christopher. *Posters of the WPA.* Introduction by Francis V. O'Connor. Los Angeles: Wheatley Press, in association with the University of Washington Press, 1987.

Dethloff, Henry C., and Robert P. Jones. "Race Relations in Louisiana, 1877–1898." *Louisiana History* 9 (Summer 1968): 301–23.

Dixon, Penelope. *Photographers of the Farm Security Administration: An Annotated Bibliography, 1930–1980.* New York: Garland Publishing, 1983.

Dormon, Robert. *Revolt of the Provinces: The Regionalist Movement in America, 1920–1945.* Chapel Hill: University of North Carolina Press, 1993.

Douglas, Ann. *Terrible Honesty: Mongrel Manhattan in the 1920s.* New York: Farrar, Straus, and Giroux, 1995.

Elfenbein, Anna Shannon. *Women on the Color Line: Evolving Stereotypes and the Writings of George Washington Cable, Grace King, Kate Chopin.* Charlottesville: University Press of Virginia, 1989.

Ettinger, Gary. "John Fitzpatrick and the Limits of Working-Class Politics in New Orleans, 1892–1896." *Louisiana History* 26 (Summer 1985): 341–67.

Everard, Wayne. "Bourbon City: New Orleans, 1878–1900." *Louisiana Studies* 11 (Fall 1972): 240–51.

Eysteinsson, Astrander. *The Concept of Modernism.* Ithaca and London: Cornell University Press, 1990.

Fairclough, Adam. "The Public Utilities Industry in New Orleans: A Study in Capital, Labor and Government, 1894–1929." *Louisiana History* 22 (Winter 1981): 45–66.

———. *Race and Democracy: The Civil Rights Struggle in Louisiana, 1915–1972.* Athens, Georgia: University of Georgia Press, 1995.

Federal Writers' Project. *These Are Our Lives, As Told by the People and Written by Members of the Federal Writers' Project of the Works Progress Administration in North Carolina, Tennessee, and Georgia.* Rpt. New York: W. W. Norton and Co, 1975.

Fischer, Roger A. "Racial Segregation in Ante Bellum New Orleans." *American Historical Review* 74 (Feb. 1969): 926–37.

———. *The Segregation Struggle in Louisiana, 1862–1877.* Urbana: University of Illinois Press, 1974.

Fleischhauer, Carl and Beverly Brannan, eds. *Documenting America, 1935–1943.* Berkeley and Los Angeles: University of California Press, 1988.

Foster, Craig L. "Tarnished Angels: Prostitution in Storyville, 1900–1910." *Louisiana History* 31 (Fall 1990): 387–97.

Freeman, Sandra Draughn. and William Lake Douglas. "Newcomb Pottery." *Garden Design* (Winter 1982): 56.

Gelber, Steven M. "Working to Prosperity: California's New Deal Murals." *California History* 58 (Summer 1979): 98–127.

Goins, Charles Robert, and John Michael Caldwell. *Historical Atlas of Louisiana.* Norman: University of Oklahoma Press, 1995.

Gorman, Paul. "American Modernism as a Culture." Photocopy of manuscript in possession of the author.

Grantham, Dewey. *Southern Progressivism: The Reconciliation of Progress and Tradition.* Knoxville: University of Tennessee Press, 1983.

Green, James. *Grass-Roots Socialism: Radical Movements in the Southwest, 1895–1943.* Baton Rouge: Louisiana State University Press, 1978.

Haas, Edward F. "John Fitzpatrick and Political Continuity in New Orleans, 1896–1899." *Louisiana History* 22 (Winter 1981): 7–29.

———. *Political Leadership in a Southern City: New Orleans in the Progressive Era, 1896–1902.* Ruston, La.: McGinty Publications, Department of History, Louisiana Tech University, 1988.

Hair, William Ivy. *Bourbonism and Agrarian Protest: Louisiana Politics, 1877–1900.* Baton Rouge: Louisiana State University Press, 1969.

———. *Carnival of Fury: Robert Charles and the New Orleans Race Riot of 1900.* Baton Rouge: Louisiana State University Press, 1976.

———. *The Kingfish and His Realm: The Life and Times of Huey P. Long.* Baton Rouge and London: Louisiana State University Press, 1991.

Hale, Grace Elizabeth. *Making Whiteness: The Culture of Segregation in the South, 1890–1945.* New York: Pantheon, 1998.

Harris, Jonathan. *Federal Art and National Culture: The Politics of Identity in New Deal America.* New York: Cambridge University Press, 1995.

Harris, Thomas O. *The Kingfish: Huey P. Long, Dictator.* New York: Pelican Publishing Co.: 1938.

Hessler, Marilyn S. "Marcus Christian: The Man and His Collection." *Louisiana History* 28 (Winter 1987): 37–55.

Hirsch, Arnold. and Joseph Logsdon, eds. *Creole New Orleans: Race and Americanization.* Baton Rouge and London: Louisiana State University Press, 1992.

Hollinger, David A. "The Knower and the Artificer." In *Modernist Culture in America.* American Society and Culture Series, ed. Daniel Joseph Singal. Belmont, Calif.: Wadsworth, 1991. 42–69.

Hurley, F. Jack. *Marion Post Wolcott: A Photographic Journey.* Albuquerque: University of New Mexico Press, 1989.

———. *Portrait of a Decade: Roy Stryker and the Development of Documentary Photography in the Thirties.* Baton Rouge: Louisiana State University Press, 1972.

———. *Russell Lee: Photographer.* Dobbs Ferry, N.Y.: Morgan and Morgan, 1978.

Huyssen, Andreas. After *the Great Divide: Modernism, Mass Culture, and Post-Modernism.* Bloomington and Indianapolis: Indiana University Press, 1986.

Irvin, Hilary S. "The Impact of German Immigration on New Orleans Architecture." *Louisiana History* 27 (Fall 1986): 375–406.

Jackson, Joy J. *New Orleans in the Gilded Age: Politics and Urban Progress, 1880–1896.* Baton Rouge: Louisiana State University Press, 1969.

Jeansonne, Glen, ed. *Huey at 100: Centennial Essays on Huey P. Long.* Ruston, La.: Mc-Ginty Publications, Department of History, Louisiana Tech University, 1995.

Johnson, Jerah. "Marcus B. Christian and the WPA History of Black People in Louisiana." *Louisiana History* 20 (Spring 1979): 113–15.

Jordan, Rosan Augusta, and Frank deCaro. "'In This Folklore Land': Race, Class, Identity and Folklore Studies in Louisiana." *Journal of American Folklore* 109 (1996): 31–59.

Jordy, William H. "Four Approaches to Regionalism in the Visual Arts of the 1930s." In *The Study of American Culture: Contemporary Conflicts,* ed. Luther Leudtke. DeLand, Fla.: Evrett/Edwards, Inc., 1977.

Kane, Harnett T. *Louisiana Hayride: The American Rehearsal for Dictatorship, 1928–1940.* New York: W. T. Morrow and Co., 1941.

Kaplan, Wendy. *The Art That Is Life: The Arts and Crafts Movement in America. 1875–1920.* Boston: Little, Brown, 1987.

Karl, Barry. *The Uneasy State: The United States from 1915 to 1945.* Chicago: University of Chicago Press, 1983.

Katz, Leslie. "Interview with Walker Evans." *Art in America* 59 (Mar.–Apr. 1971): 82–89.

Keller, Morton. *Regulating a New Society: Public Policy and Social Change in America, 1900–1933.* Cambridge, Mass., and London: Harvard University Press, 1994.

Kernan, Sean. "John Vachon—Profile of a Magazine Photographer." *Camera 35* (Dec. 1971): 31–36.

Kingsley, Karen. "Designing for Women: The Architecture of Newcomb College." *Louisiana History* 35 (Spring 1994): 183–200.

Kirby, Jack Temple. *Rural Worlds Lost: The American South, 1920–1960.* Baton Rouge: Louisiana State University Press, 1987.

Lange, Dorothea, and Paul Schuster Taylor. *An American Exodus: A Record of Human Erosion.* New York: Reynal and Hitchcock, 1939.

Lears, T. J. Jackson. *No Place of Grace: Antimodernism and the Transformation of American Culture, 1880–1920.* New York: Pantheon Books, 1981.

Levine, Lawrence. "American Culture and the Great Depression." *Yale Review* 74, no.2 (Jan. 1985): 197–223.

———. *Highbrow/Lowbrow: The Emergence of Cultural Hierarchy in America.* Cambridge, Mass.: Harvard University Press, 1988.

———. "The Historian and the Icon: Photography and the History of the American People in the 1930s and 1940s." In *Documenting America, 1935–1943,* ed. Carl Fleischhauer and Beverly Brannan. Berkeley and Los Angeles: University of California Press, 1988: 15–42.

———. *The Unpredictable Past: Explorations in American Cultural History.* New York: Oxford University Press, 1993.

Lewis, Pierce. *New Orleans: The Making of an Urban Landscape.* Cambridge, Mass.: Ballinger Publishing Company, 1976.

Logsdon, Joseph. "Spiritual Strivings of a Black Poet and Historian in Louisiana." *Black Historical Museum Newsletter* 9 (1981).

Lomax, Alan. *Mister Jelly Roll: The Fortunes of Jelly Roll Morton, New Orleans Creole and "Inventor" of Jazz.* 2d ed. Berkeley: University of California Press, 1973.

Loos, John L. *Oil on Stream: A History of the Interstate Oil Pipeline Company, 1909–1959.* Baton Rouge: Louisiana State University Press, 1959.

MacDonald, Robert R. John R. Kemp, and Edward F. Haas, eds. *Louisiana's Black Heritage.* New Orleans: Louisiana State Museum, 1979.

Mangione, Jere. *The Dream and the Deal: The Federal Writers' Project, 1935–1943.* Boston: Little Brown, 1972.

Marchand, Roland. *Advertising the American Dream: Making Way for Modernity, 1920–1940.* Berkeley, Los Angeles, and London: University of California Press, 1985.

Marling, Karal Ann. *Wall-to-Wall America: A Cultural History of Post Office Murals in the Great Depression.* Minneapolis: University of Minnesota Press, 1982.

McCoy, Garnett. "Poverty, Politics, and Artists, 1930–1945." *Art in America* 53 (Aug. 1965): 88–107.

McDonald, William F. *Federal Relief Administration and the Arts: The Origins and Administrative History of the Arts Projects of the Works Progress Administration.* Columbus: Ohio State University Press, 1969.

McEuen, Melissa A. *Seeing America: Women Photographers Between the Wars*. Lexington: University of Kentucky Press, 2000.

McKinzie, Richard D. *The New Deal for Artists*. Princeton, N.J.: Princeton University Press, 1973.

McWhiney, Grady. "Louisiana Socialists in the Early Twentieth Century: A Study in Rustic Radicalism." *Journal of Southern History* 20 (Aug. 1954): 315–36.

Melosh, Barbara. *Engendering Culture: Manhood and Womanhood in New Deal Public Art and Theater*. Washington and London: Smithsonian Institution Press, 1991.

Meltzer, Milton. *Dorothea Lange: A Photographer's Life*. New York: Farrar, Straus, and Giroux, 1978.

Millet, David J. "Southwest Louisiana Enters the Railroad Age: 1880–1900." *Louisiana History* 24 (Spring 1983): 165–83.

———. "Town Development in Southwest Louisiana, 1865–1900." *Louisiana History* 13 (Spring 1972): 139–68.

Mills, Gary B. *The Forgotten People: Cane River's Creoles of Color*. Baton Rouge: Louisiana State University Press, 1977.

Mitchell, Reid. *All on Mardi Gras Day: Episodes in the History of New Orleans Carnival*. Cambridge, Mass., and London: Harvard University Press, 1995.

Mitchell, William R., Jr. *Classic New Orleans*. New Orleans: Martin-St. Martin Publishing Co., 1993.

Myers, Bernard S. *Mexican Mural Painting in Our Time*. New York: Oxford University Press, 1956.

Natanson, Nicholas. *The Black Image in the New Deal: The Politics of FSA Photography*. Knoxville: University of Tennessee Press, 1992.

Niehaus, Earl. *The Irish in New Orleans, 1800–1860*. Baton Rouge: Louisiana State University Press, 1965.

Nochlin, Linda. "The Invention of the Avant-Garde: France, 1830–80." In *The Avant-Garde: Art News Annual 24*, ed. Thomas Hess and John Ashberry. New York: Macmillan, 1968.

Noggle, Burl. "With Pen and Camera: In Quest of the American South in the 1930s." In *The South Is Another Land: Essays on the Twentieth-Century South*, ed. Bruce Clayton and John A. Salmond. Westport, Conn.: Greenwood Press, 1987.

———. *Working with History: The Historical Records Survey in Louisiana and the Nation, 1936–1942*. Baton Rouge: Louisiana State University Press, 1981.

Norwood, Stephen H. "Bogalusa Burning: The War Against Biracial Unionism in the Deep South, 1919." *Journal of Southern History*. 63 (Aug. 1997): 591–628.

O'Connor, Francis V., ed. *Art for the Millions: Essays from the 1930s by Artists and Administrators of the WPA Federal Art Project*. Greenwich, Conn.: New York Graphic Society, Ltd., 1973.

———, ed. *The New Deal Arts Projects: An Anthology of Memoirs*. Washington, D.C.: Smithsonian Institution, 1972.

Ohmann, Richard M. *Selling Culture: Magazines, Markets, and Class at the Turn of the Century*. London and New York: Verso, 1996.

Ohrn, Karin Becker. *Dorothea Lange and the Documentary Tradition*. Baton Rouge: Louisiana State University Press, 1980.

O'Neal, Hank. *A Vision Shared: A Classic Portrait of America and Its People, 1935–1943*. New York: St. Martin's Press, 1976.

Orillion, Kathleen. *Conrad Albrizio, 1894–1973*. Baton Rouge: Louisiana State University Press, 1986.

Ormond, Susan, and Mary E. Irvine. *Louisiana's Art Nouveau: The Crafts of the Newcomb Style*. Gretna, La.: Pelican Publishing Co., 1976.

Orozco, Jose Clemente. *Jose Clemente Orozco: An Autobiography*. Trans. Robert C. Stephenson. Austin: University of Texas Press, 1962.

Orvell, Miles. "Portrait of the Artist as a Young Man: John Vachon and the FSA Project." In *A Modern Mosaic: Art and Modernism in the United States*, ed. Townsend Ludington. Chapel Hill: University of North Carolina Press, 2001. 306–33.

Ostransky, Leroy. *Jazz City: The Impact of Our Cities on the Development of Jazz*. Englewood Cliffs, N.J.: Prentice-Hall, 1978.

Park, Marlene, and Gerald Markowitz. *Democratic Vistas: Post Offices and Public Art in the New Deal*. Philadelphia: Temple University Press, 1984.

Peeler, David C. *Hope Among Us Yet: Social Criticism and Social Solace in Depression America*. Athens: University of Georgia Press, 1987.

Penkower, Monty Noam. *The Federal Writers' Project: A Study of Government Patronage of the Arts*. Urbana: University of Illinois Press, 1977.

Poesch, Jessie. *Newcomb Pottery: An Enterprise for Southern Women, 1895–1940*. Easton, Pa.: Schiffer Pub., 1984.

Pratt, Davis. *The Photographic Eye of Ben Shahn*. Cambridge, Mass.: Harvard University Press, 1975.

Rabinowitz, Howard N. *Race, Ethnicity, and Urbanization: Selected Essays*. Columbia: University of Missouri Press, 1994.

———. *Race Relations in the Urban South, 1865–1890*. New York: Oxford University Press, 1978.

Rankin, David C. "The Impact of the Civil War on the Freed Colored Community of New Orleans." *Perspectives in American History* 11 (1977–78): 379–415.

———. "The Origins of Black Leadership in New Orleans During Reconstruction." *Journal of Southern History* 40 (1974): 417–40.

Rathbone, Belinda. *Walker Evans: A Biography*. Boston: Houghton-Mifflin, 1995.

Redding, Joan. "The Dillard Project: The Black Unit of the Louisiana Writers' Project." *Louisiana History* 32 (Winter 1991): 47–62.

Rodman, Seldon. *Portrait of the Artist as an American: Ben Shahn, A Biography in Pictures*. New York: Harper and Brothers, 1951.

Romero, Ginger. *The Louisiana Strawberry Story*. Natchitoches, La.: Northwestern State University Press, 1984.

Rose, Al. *Storyville, New Orleans*. Tuscaloosa: University of Alabama Press, 1974.

Rosenberg, Daniel. *New Orleans Dockworkers: Race, Labor, and Unionism, 1892–1923*. Albany: State University of New York Press, 1988.

Ross, Dorothy, ed. *Modernist Impulses in the Human Sciences, 1870–1930*. Baltimore: Johns Hopkins University Press, 1994.

Rubenstein, Erica Beckh. "Government Art in the Roosevelt Era: An Appraisal of Federal Art Patronage in the Light of Present Needs." *Art Journal* 20 (Fall 1960): 2–8.

Rubin, Louis D., Jr. *George W. Cable: The Life and Times of a Southern Heretic*. New York: Pegasus, 1969.

Rushton, William Faulkner. *The Cajuns: From Acadia to Louisiana*. New York: Farrar, Straus, and Giroux, 1979.

Schuller, Gunther. *Early Jazz: Its Roots and Musical Development*. Oxford: Oxford University Press, 1968.

Scott, Bonnie Kime. *The Women of 1928*. Vol. 1 of *Refiguring Modernism*. Bloomington and Indianapolis: Indiana University Press, 1995.

Shahn, Bernarda Bryson. *Ben Shahn*. New York: Harry N. Abrams, 1972.

Shanabruch, Charles. "The Louisiana Immigration Movement, 1891–1907: An Analysis of Efforts, Attitudes, and Opportunities." *Louisiana History* 18 (Spring 1977): 203–26.

Sindler, Allan P. *Huey Long's Louisiana: State Politics, 1920–1952*. Baltimore: Johns Hopkins University Press, 1956.

Singal, Daniel Joseph, ed. *Modernist Culture in America*. American Society and Culture Series. Belmont, Calif.: Wadsworth, 1991.

———. *The War Within: From Victorian to Modernist Thought in the South*. Chapel Hill: University of North Carolina Press, 1982.

Smith, Douglas L. *The New Deal in the Urban South*. Baton Rouge, Louisiana State University Press, 1988.

Smith, Terry. *Making the Modern: Industry, Art, and Design in America*. Chicago and London: University of Chicago Press, 1993.

Somers, Dale A. "Black and White in New Orleans: A Study in Urban Race Relations, 1865–1900." *Journal of Southern History* 40 (Feb. 1974): 19–42.

———. *The Rise of Sports in New Orleans, 1850–1900*. Baton Rouge: Louisiana State University Press, 1972.

Stange, Maren. *Symbols of Ideal Life: Social Documentary Photography in America, 1890–1950*. New York: Cambridge University Press, 1989.

Stansky, Peter. *William Morris*. Oxford and New York: Oxford University Press, 1983.

Starr, S. Frederick. *Southern Comfort: The Garden District of New Orleans, 1800–1900*. Cambridge, Mass.: MIT Press, 1989.

Steichen, Edward. "The F.S.A. Photographers." *US Camera Annual, 1939* (1939): 43–66.

Stern, James. "Walker Evans (1903–75): A Memoir." *London Magazine* 17 (Aug./Sept., 1977): 5–29

Strasser, Susan, Charles McGovern, and Matthias Judt, eds. *Getting and Spending: European and American Consumer Societies in the Twentieth Century.* Cambridge, Eng., and New York: Cambridge University Press, 1998.

Stott, William. *Documentary Expression and Thirties America.* Chicago: University of Chicago Press, 1973, 1986.

Stryker, Roy E., and Nancy Wood. *In This Proud Land: America as Seen in the FSA Photographs.* New York: Galahad Books, 1973.

Susman, Warren. *Culture as History: The Transformation of American Society in the Twentieth Century.* New York: Pantheon, 1984.

Szarkowski, John. *Walker Evans.* New York: Museum of Modern Art, 1971.

Taylor, Helen. *Gender, Race, and Region in the Writings of Grace King, Ruth McEnery Stuart, and Kate Chopin.* Baton Rouge: Louisiana State University Press, 1989.

Taylor, Joe Gray. *Louisiana Reconstructed, 1863–1877.* Baton Rouge: Louisiana State University Press, 1974.

Taylor, S. W. *The Citizen's League: A History of the Great Reform Movement.* Baton Rouge: Louisiana State University Press, 1965.

Terrill, Tom E., and Jerrold Hirsch, eds. *Such As Us: Southern Voices of the Thirties.* Chapel Hill: University of North Carolina Press, 1978.

Thomas, James W. *Lyle Saxon: A Critical Biography.* Birmingham, Ala.: Summa, 1991.

Thompson, E. P. *William Morris: Romantic to Revolutionary.* London: Merlin Press, 1977.

Tichi, Cecelia. *Shifting Gears: Technology, Literature, Culture in Modernist America.* Chapel Hill and London: University of North Carolina Press, 1987.

Tinkham, Sandra Sheffen. *The Consolidated Catalog to the Index of American Design.* Cambridge, Eng.: Chadwyck-Healey; Teaneck, N.J.: Somerset House, 1980.

Trachtenberg, Alan. "From Image to Story: Reading the File." In *Documenting America, 1935–1943,* ed. Carl Fleischhauer and Beverly Brannan. Berkeley: University of California Press, 1988: 43–72.

———. *Reading American Photographs: Images as History, Mathew Brady to Walker Evans.* New York: Hill and Wang, 1989.

Vachon, Brian. "John Vachon: A Remembrance." *American Photographer* (Oct. 1979): 34–45.

Vachon, John. "Tribute to a Man, an Era, an Art." *Harper's* (Sept. 1973): 96–99.

Vance, Mary A. *The Arts and Crafts Movement: Monographs.* Monticello, Ill.: Vance Bibliographies, 1984.

Vandal, Gilles. "Black Utopia in Early Reconstruction New Orleans: The People's Bakery as a Case Study." *Louisiana History* 38 (Fall 1997): 437–52.

———. *The New Orleans Race Riot of 1866: Anatomy of a Tragedy.* Lafayette: Center for Louisiana Studies, University of Southwestern Louisiana, 1983.

Vetter, Cyril E. *Fonville Winans' Louisiana: Politics, People, and Places.* Baton Rouge: Louisiana State University Press, 1995.

Vitz, Robert C. "Struggle and Response: American Artists and the Great Depression." *New York History* 17 (Jan. 1976): 80-98.

Walker Evans: Photographs for the Farm Security Administration, 1935–1938; a catalog of photographic prints available from the Farm Security Administration collection in the Library of Congress. Intro. by Jerald C. Maddox. New York: Library of Congress. Prints and Photographs Division, 1973.

Weiss, Margaret. *Ben Shahn, Photographer: An Album of the Thirties.* New York: De-Capo Press, 1973.

Wertheim, Arthur. "Constance Rourke and the Discovery of American Culture in the 1930s." In *The Study of American Culture: Contemporary Conflicts*, ed. Luther Leudtke. DeLand, Fla.: Everett/Edwards, Inc., 1977.

White, John Franklin. *Art in Action: American Art Centers and the New Deal* (Metuchen, N.J., and London: Scarecrow Press, Inc., 1987.

White, Robert C. "Faces and Places in the South in the 1930s: A Portfolio." *Prospects* 1 (1975): 415–29.

Williams, T. Harry. *Huey Long.* New York: Knopf, 1969.

Dissertations and Theses

Banta, Brady M. "The Regulation and Conservation of Petroleum Resources in Louisiana, 1901–1940." Ph.D. diss., Louisiana State University, 1991.

Barkmeyer, Estelle. "Ellsworth Woodward and His Work." M.A. thesis, Tulane University, 1942.

Boyer, Lillian Francis. "The Etchings of Ellsworth Woodward: A Catalogue Raisonne." M.A. thesis, Louisiana State University, 1982.

Clayton, Ronnie W. "A History of the Federal Writers' Project in Louisiana." Ph.D. diss., Louisiana State University, 1974.

Field, Betty Marie. "The Politics of the New Deal in Louisiana, 1933–1939." Ph.D. diss., Tulane University, 1973.

Harvey, Catherine Chase. "Lyle Saxon: A Portrait in Letters, 1917–1945." Ph.D. diss., Tulane University, 1980.

Mitchell, Jerry Jack. "An Analysis of the Decorative Styles of Newcomb Art Pottery." M.A. thesis, Louisiana State University, 1972.

Watkins, Charles A. "The Blurred Image: Documentary Photography and the Depression South." Ph.D. diss., University of Delaware, 1982.

Index

of, 109–10; conservative reaction to FAP, 113–14; populist views on American art of, 110–14, 260n; and print-making as democratic form, 113–14. *See also* Bruce, Edward; Federal Art Project; Treasury Section of Painting and Sculpture

Cajun(s), 101, 104, 162, 193–94, 222, 225, 241, 245. *See also* Acadians

Calhoun, John C., 28

Canal Street (New Orleans), 3, 160, 166

Cane River, 159–60, 163, 166, 195, 206, 225–26, 230, 235. *See also* Melrose Plantation; Saxon, Lyle

Cantor, Norman, 13–14

Capone, Al, 4

Carnival, 3, 26, 157, 165–66, 178, 180, 197. *See also* Mardi Gras

Catholic University (Washington, D.C.), 239

Cawn Pone and Pot Licker (Oliver), 170

Cement Plant (Crawford), 67

Central Business District (New Orleans), 26, 160

Charleston, S.C., 115

Chicago, Ill., 6, 168

Chicago Art Institute, 83, 138

Chicago Public Library, 32

Child of the Fortuna Family, A (Shahn), 212, 214

Children of Strangers (Saxon), 156–57, 162, 166, 168, 198–99, 235; as plea for racial tolerance, 163. *See also* Saxon, Lyle

Children of the Fortuna Family, a Family of Strawberry Pickers (Shahn), 212, 214

Choctaw Club, 26

Christian, Marcus D., 123, 162, 172–75; and Dillard History Unit, 172–74; laments Jim Crow, 172; meets Lyle Saxon, 172; speculates on Saxon's divided self, 175

Cimarron Co., Okla., 155

Cincinnati, Ohio, 37

Cincinnati Art Academy, 37, 41

City Park (New Orleans), 51, 181

Civil War, 17, 50, 111, 241

Civil Works Agency (CWA), 53

Civilian Conservation Corps (CCC), 61, 77

Coffee-Pepper Bill, 132

"Cognitive modernists," 7. *See also* Modernist(s)

Coldfield, Rosa, 211

Collier, John, 201

Colonial Williamsburg (Va.), 115, 155

Columbus, Christopher, 4

Community, concern for during 1930s, 217–18

Compressor Gas Treatment of Rice, The (Lee), 220

Congo Square (New Orleans), 158–59, 177–78

Corner of Dauphine and St. Phillip Sts., N.O. (Ninas), 151

Corner of Street (Frere), 147, 149

Cotton Industry, The (Heldner), 150

Cotton Time (Curry), 71–73, 77

Couch, William T., 191; modernist folklore of, in *These Are Our Lives*, 191

Courbet, Gustave, 49

Covington, La., 88–89, 105–6, 134

Cox, Paul, 38–39, 42

Cram, W. C., 55–56

Cramer, Konrad, 215

Crawford, Josephine: modern style and industrial subjects in paintings by, 64, 66–70; as PWAP artist, 64–70

Creole(s), 4, 17–18, 28, 162, 178, 193–94, 245; reaction of, to George

Durieux, 132; and struggle to establish Community Art Center in New Orleans, 129–31; work by Easel Unit of, in New Orleans, 146–53. *See also* Art; Bruce, Edward; Cahill, Holger; Durieux, Caroline Wogan; Gregory, Angela; Index of American Design; Localism; Parker, Tom; Stanton, Gideon; Woodward, Ellsworth

Federal Emergency Relief Administration (FERA), 117, 168, 170

Federal One, 118, 136–37, 187

Federal Theater Project, 136

Federal Works Agency, 91, 93, 137

Federal Writers' Project (FWP), 154, 156, 178, 182, 187, 195–96, 223; B. A. Botkin as director of Folklore Unit, 190–91; closing New Orleans office of, 192; creation and flow of "state guide copy," 170–72; Dillard History Project, 172–74; establishment and expansion of, complicated by state politics, 169; and *Louisiana: A Guide to the State*, 184–89; modernist values in Guides of, 178; national reorganization of, 1939, 187–88; and *New Orleans City Guide*, 176–84; organization and operation in Louisiana, 167–75; resistance to and scandal alleged at Shreveport office, 169; smooth operation of, contrasted to Louisiana FAP, 174. *See also* Christian, Marcus D.; Dillard History Project; *Gumbo Ya-Ya*; *Louisiana: A Guide to the State*; "Negro in Louisiana, The"; *New Orleans City Guide*; Saxon, Lyle

Fehr, Richard, 30

Ferber, Edna, 181

Ferriday, La., 91, 96

Filling Packages with Rice at the State Rice Mill (Lee), 221

Fine Arts Club (New Orleans), 51

Fireplace and Mantel in an Old Plantation House, A (Lee), 228

Fitzpatrick, J. Kelly, as PWAP artist, 64–70

Flint, Alice, 98–100, 102, 105; awarded Arabi commission, 98; similarity of Section designs, 100

Folklore, 28; "living lore" likened to American Scene painting and Federal Art Project, 190–91; and modern "living lore," 190–91; post-Reconstruction interest among New Orleans Creoles, 28; pursuits of Lyle Saxon, 161–62, 189–97, 198. See also *Gumbo Ya-Ya*; Saxon, Lyle

Ford, Henry, 12

Fort Rosalie Massacre, 163

Fortier, Alcee, 18, 28

48 States Competition, 80, 83, 97

Four Stations of the Day, The (Brown), 128

Fowler, Alice, 147

France, 36

Franck, Charles L., 207

Franck, Jerome, 46

French Market (Old) (New Orleans), 58, 181

French Opera House (New Orleans), 22

French Quarter, 19, 35, 40, 51, 64, 123, 127, 137, 157, 160–61, 165–66, 177, 181, 185, 193, 195, 225, 234–35, 240. *See also* Vieux Carre

French-Catholic, 222

Friends of Joe Gilmore, The (Saxon and Dreyer), 165

Freud, Sigmund, 7

FSA. *See* Farm Security Administration

96; original sketch of, for postmaster, 95–96; second design by, and local reactions to completed mural, 96

Holiday, Billie, 247–48

Hollinger, Donald, 7

Homer, Winslow, 111

Honore, Paul, 48

Hoover, Herbert, 170, 244

Hopkins, Harry, 55, 174

Houma, La., 145, 216

Houston, Sam, 4

Howard University, 128

Howell, Catherine, 61

Huey P. Long Bridge, 181

Huyssen, Andres, 7

Iberia Parish, 135, 137

Ice House Stack (Schoenberger), 146–47, 153

Ill Fares the Land (McWilliams), 79

Illinois Central Railroad, 25, 211

Index of American Design, 118, 120–22, 129, 132, 178; Gideon Stanton's enthusiasm for, 120–21; intent and purpose of, 120; radical and conservative aspects of, 121

Interior of Strawberry Grower's House, The (Shahn), 213–14

Irish Channel (New Orleans), 194

Iroquois (club) (Chicago), 26

Isle Brevelle, 160, 166, 237

Italy, 46, 61

Izvolsky, George, 147

Jackson, Miss., 62, 91

Jackson Square, 51, 181, 211. *See also* Place d' Armes

Jacomest, John, Jr., 55

Jamestown, N.Y., 41

Jamestown, Va., 5

Javillee, John, 198

Jazz, 27–28, 239–40, 245, 247

Jeanerette, La., 77, 96, 216

Jefferson, Thomas, 4

Jefferson Island, La., 216

Jim Crow, 18, 123, 125, 157, 162, 172, 174, 193; attacked by Myron Lechay, 125; and Marcus Christian, 172; difficult establishment of, in racially mixed New Orleans, 18; and Dillard History Project, 172–74; and Lyle Saxon, 157, 161–63; undermined by modernity and modernism, 17–18, 27–28

Jones, Joe, 215

Joyce, James, 8, 204, 208, 239

Kansas City, Mo., 27

Karl, Barry, 4

Katrina, Hurricane, 245–46, 248

Kazin, Alfred, 14

Kearney, Warren, 55

Keller, Morton, 15

Kelly, Jack, 61

King, Grace, 18, 156

Kingfish, 18, 107, 109, 114. *See also* Long, Huey

Kinsey, Alberta, 58, 162

Knight, Hy, 91, 93

Knoblock, Kenneth, 64

Krauss, Alison, 248

Krewe of Rex, 27

Ku Klux Klan, 18

Labiche, Emmeline, 101

LaDelta, 225

Lafayette, La., 34, 135, 137, 145, 169, 185

Lafite, Jean, 155, 157, 161, 165

Lafourche, James B., 173–75

Lake Charles, La., 145, 189

Lake Maurepas, 211

Lake Ponchartrain, 25, 88, 211

Lake Providence, La., 225

Lomax, John, 190

Lombardo, Guy, 239

London, Jack, 110

Long, Huey, 4, 18, 58, 101, 107–9, 114, 156, 158, 169, 185–86, 188; assassination depicted by John McCrady, 107–9; and bifactional politics, 25; challenge to Louisiana social and political elites, 5, 109; as mass communicator, 109; and modernizing Louisiana politics and society, 4–5; opposition to FDR, 4–5; racial beliefs, private and political, 18

Longfellow, Henry Wadsworth, 100–1

Look, 12, 203

Lorentz, Pare, 206, 237

Los Banos, Calif., 97

Louisiana, 3, 4, 19, 20, 22, 24–29, 52, 77, 107, 116, 126, 129, 135–38, 140, 144–45, 147, 155–59, 162–63, 166, 169–71, 175, 184–85, 187, 190–92, 193, 199, 206–8, 211, 214–17, 222–25, 230, 234, 237–39, 243; as American crossroads, 4; as American exception and microcosm, 3–4; "Americanization" of, 24–29; challenge of New Deal art patronage to political and social elites in, 18–19; demographic and cultural diversity of and class and ethno-cultural relations in, 4, 22, 24; Farm Security Administration photography of, 198–242; Federal Art Project in, 107–54; Federal Writers' Project in, 155–97; late 19th century agricultural base of, 24–25; oil and gas industry in, 25; politics in, 25–26, 41; Public Works of Art Project in, 45–70; race relations in, 25; survey of art institutions and conditions for artists in 1933, 50–51; timber industry in, 24–25; Treasury Section murals in, 71–106; as "uneasy" state during 1930s, 4

Louisiana: A Guide to the State: publication of, 188; Saxon's frustrations with, 187–89; as voice for Saxon's anti-modernism, 185–86, 88–89

Louisiana Art Project. *See* Federal Art Project

Louisiana Association of the American Folk-Lore Society, 18, 28

Louisiana Avenue (New Orleans), 128

Louisiana Bayou (Rohland), 90

Louisiana Farm (Lewis), 81

Louisiana Guide, 80. See also *Louisiana: A Guide to the State*

Louisiana Pageant, 98–99

Louisiana State Art Commission, 134, 136–37

Louisiana State Museum, 51

Louisiana State University (LSU), 50, 79, 138, 170

Louisiana Weekly, 173–74

Louisiana Writers' Programs, 134, 156–57. *See also* Federal Writers' Project

Louisville, Ky., 230

Lubin, Arthur, 247

Luks, George, 111, 138

Lumberton, La., 208

Lynd, Robert, 205

Lytle, Andrew, 207

MacArthur, Arthur, 135

MacLeish, Archibald, 79

Madison Avenue, 13

Maestri, Robert, 135, 176

Magnolia Cemetery (Baton Rouge), 156

Magnolia Street Housing Project (New Orleans), 134

Manhattan (N.Y.), 9, 158

Mapplethorpe, Robert, 19

Mardi Gras, 165, 177, 181, 188, 197. *See also* Carnival

and Douglas Brown, 128–29; and disappointment with FAP in New Orleans, 119–20, 125–26; in Myron Lechay affair, 125–29; and previous work with Holger Cahill, 115. *See also* Federal Arts Project

Paul, Elliott, 247

Pennsylvania Academy of Fine Arts, 133

Pensacola, Fla., 115

People's Community Center (New Orleans), 134

Perdido Street (New Orleans), 193

Pere Augustin, 225

Perkins, Frances, 46

Philadelphia Museum of Art, 205

Photography: criticisms by Ellsworth Woodward, 21–22, 205–6, 211; of Farm Security Administration in Louisiana, 198–242; interests in and uses of, by Lyle Saxon, 21–22, 199, 205–6, 226–37; in Louisiana prior to 1935, 207. *See also* Evans, Walker; Farm Security Administration; Lee, Russell; Post Wolcott, Marion; Shahn, Ben; Vachon, John

Pie Town, N.Mex., 155, 217

Pierce, Harold K., 152–53

Pineville, La., 91, 185

Place d' Armes, 177. *See also* Jackson Square

Plantation Scene (Flint), 99

Plaquemines Parish, La., 207, 211

Polishing Rice at the State Rice Mill (Lee), 220

Ponchatoula, La., 163

Populist, 25

Post Wolcott, Marion, 201, 203, 206, 237; characterizes Francois Mignon, 230; Melrose series, 225–34; in New Orleans, 1940–41, 234–37; as prolific FSA photographer in Louisiana, 225;

tension between Saxon's purposes for and ultimate results of Melrose series by, 230–31. *See also* Farm Security Administration

Pottery, in turn-of-the-century New Orleans, 34–35. *See also* Newcomb Pottery

Pound, Ezra, 8

Prieur Street (New Orleans), 133

Privatization: and Hurricane Katrina disaster (2005), 246–47; and race in contemporary America, 246–48

Progressivism, 15–16, 28–29; and challenge to local autonomy, 16, 28; in Louisiana, 28–29; as means of managing modernity, 15–16

Pulling Down Rice from the Decorated Concession Stand at the National Rice Festival (Lee), 224

Public Works of Art Project (PWAP), 21, 73–74, 106, 115, 117, 118, 138, 141, 147; allocating art, 60; American Scene genre as aesthetic orthodoxy, 48–50; closing, accomplishments, and aftermath, 60–70; controversy between national administrators and proposed projects of Region Six artists, 56–60; Corcoran Gallery Show, 61; determination to transform artists' social role, 48; establishing Region Six headquarters in New Orleans, 51–53; and industrializing art production, 63–64; as initial attempt to create national art community, 63; political implications of defending skill over need, 55; organizational meeting for and establishment of, 46–47; organizational structure and intentions, 47–48; reaction of New Orleans artists to, 61–62; reassignment of Region Six artists

to CCC camps, 61; reception of Region Six work shown in New Orleans, 62; as reflection of Edward Bruce's beliefs and experience, 47; and revolutionizing society by rationalizing American art market, 47–48; significance as first experiment in federal art patronage, 62–70, 74; significance of differing styles of Josephine Crawford and J. Kelly Fitzpatrick, 64–70; tension between artistic skill and economic need, 53–54; wage scale for Region Six artists, 51. *See also* Bruce, Edward; Federal Art Project; Treasury Section of Painting and Sculpture; Woodward, Ellsworth

Puritans, 5, 110

Purser, Stuart, 96, 106; adopts and executes second, industrial, design, 91–93; awarded Ferriday post office commission, 91; impact on race relations suggested in completed mural, 93; original design, based on Panola Plantation, 91–92

Quakers, 110

Quarter (journal), 127

Quarter. *See* French Quarter

Race relations: in *Children of Strangers*, 163; and Dillard History Project, 172–74; explored in Louisiana Treasury Section murals, 72, 90–96; explored in work of New Southern Group, 138–40; in Louisiana and New Orleans, 17–18, 25, 28, 250n; and national politics in 1927 flood aftermath, 244; and Marion Post photographs at Melrose, 226–34; and privatization in Contemporary America, 246–48; as

sensitive subject in *New Orleans City Guide*, 182; and Southern society, 17; in values and art of Lyle Saxon, 162–63. *See also* Creole; Dillard History Project; Jim Crow; Mulatto; "Negro in Louisiana, The"

Raceland, La., 216

Raft, George, 214

Raiford State Prison, 112

Ralston, Blanche, 126

Ramp Boats under Construction at the Higgins Shipyards (Vachon), 236

Rampart Street (New Orleans), 158

Randolph, Adelaide, 162, 235

Randolph, Guy, 198

Readers' Digest, 130

Reconstruction, 4, 25, 241

"Red Light District, The" (Saxon), 182

Red River, 24

Reddick, Lawrence, 173

Reed, Gardner, 62

Region Six (PWAP), 21, 50–51, 55, 62. *See also* Bruce, Edward; Public Works of Art Project; Woodward, Ellsworth

Regular Democratic Organization, 26

Reicke, Albert, 52, 58, 61

Reinike, Charles, 149

Removing Impurities from Rice Before Polishing (Lee), 219

Reserve, La., 134

Reynaud, Louis, 52, 58

Rhode Island School of Design, 29, 138

Rice (Lee), 218

Richards, I. A., 11

Richmond, Va., 115

Richmond Art Institution, 115

River, The (Lorentz), 206

River, The (Negueloa), 94

Rivera, Diego, 127, 134

Robert, L. W., 55, 61

Rookwood Pottery, 37, 41

project administrators, 174–75; and relationship with Edward Dreyer, 167–68; as "reluctant modernist," 158–59, 166–67, 199, 266n; resists "living lore" methods of Benjamin Botkin and W. T. Couch, 191; ruminated on, by Marcus Christian, 175; sense of alienation from mainstream society, 161, 175; sexuality of, 159; significance of French Quarter and Cane River country in life, identity, and art, 159–60; significance of "masking," 165–66, 197; and strategies of narrative voice, 164–65; struggle to preserve identity against modern development and modernist ideas, 195–97, 235–36; tension between localism of and Post photographs at Melrose and in New Orleans, 226–37; unmasked by modernist portrait of modernized America, 240–41

Schexnayder, Olide, 207

Schoenberger, Edward, 147, 193

Schriever, La., 225

Scott, Bonnie Kime, 8

Scott, La., 216

Screwball comedy, 13

Second Louisiana Purchase, 18

Segregation. *See* Jim Crow

Shahn, Ben, 200–1, 203, 206; compared to Walker Evans, 208; FSA photography in Louisiana, 211–15. *See also* Farm Security Administration

Sheerer, Mary, 37–38

Shooting of Huey Long, The (McCrady), 107–9

Shreveport, La., 51, 62, 135, 144, 169, 186, 188

Shushan Airport (New Orleans), 83

Sicily, Italy, 237

Sieur d'Bienville, 107

Sieur de La Salle, 90

Sign of Welcome—in the Outskirts, A (Lee), 218

silk screen process, 113, 141; as logical result of Holger Cahill's artistic populism, 113

Singleton, Zutty, 247

Siqueiros, Donald Alfaro, 127

Sister Haycock, 162

Sloan, John, 111, 138

Small Town Shop Front in Louisiana, A (Evans), 210–11

Smith, Alice Ward, 173

Smith, Flossie, 199

Smith, Harry, 199

Smith, Terry, 12

Social Realism, 201

Society of American Mural Painters, 48

Solomon, Clark, 177

Sophie Newcomb College. *See* Newcomb College

South, 17, 114, 115, 116, 163, 194–95; and commitment to localism, 17; and difficulty of New Southern Group to retain regional autonomy, 137–40; and modernists and modernizers, 17, 194–95

Southern Confederacy, 4

Southern Crescent, 45

Southern Pattern, 92

Southern States Art League, 33, 132

Southwestern Training Institute, 34

Spanish Arsenal (New Orleans), 64

Spiva, Henry, 169

Spofford, Leo, 126, 129

St. Charles Avenue (New Orleans), 26

St. Gaudens, Homer, 47

St. James Episcopal (Baton Rouge), 156

St. Martinville, La., 100–2, 104, 185, 216, 222; local reaction to *Evangeline's Return*, 102–4

St. Tammany Parish, 35

Standard Oil of New Jersey, 17, 25

Stanton, Edwin, 116

Stanton, Gideon, 21, 53, 132–33, 141, 145, 156; applauds PWAP, 61; background, temperament, and early career, 116–17; conflicts with FAP national administrators, 117–31; conflicts with Myron Lechay, 123–26, 129; as critic of modern art, 118; and enthusiasm for Index of American Design, 120–22; fires Douglas Brown, 127–29; friendship and association with Ellsworth Woodward, 117–19; opposes FAP Community Art Center in New Orleans, 129–31; resigns from FAP, 131. *See also* Federal Art Project

State Mill (Lee), 221

Stein, Gertrude, 9, 10

Steinbeck, John, 79

Stephens, E. L., 34, 36, 41, 252n

Sterne, Maurice, 46, 48

Stolen Harmony, 214

Stone, Harlan Fiske, 46

Storyville, 26, 160, 180

Stove in the Home of a Strawberry Picker, A (Shahn), 213–14

Strawberry Farming (Gonzales), 83–88

Struppeck, Julius, 140

Stryker, Roy, 200, 202, 207, 222, 234, 237, 239; as director of Historical Unit, Information Division, FSA, 200; nostalgia for small town America, 217; relations with various FSA photographers, 203; and relationship with Russell Lee, 215–16. *See also* Farm Security Administration

Stuart, Ruth McEnery, 28

Sugar Industry, The (Heldner), 151

Sunday Afternoon (Post Wolcott), 233

Survey Graphic, 12, 203

Sweeney, Mary Jane, 169

Tallant, Robert, 157, 192, 197

Tallulah, La., 93, 96; reaction of local blacks to new post office mural, 95–96

Tammany Hall (New York), 26

Tangipahoa Parish, 211

Tarrawa, 237

Taylor, Francis Henry, 143–44

Taylor, Paul, 208

Tempora Mutantur et Nos Mutamur (Flint), 99

Tennessee Valley Authority (TVA), 77

Terrebonne, 225

Texas and Pacific Railroad, 101

These Are Our Lives (Couch), 191

Thibodaux, La., 207

Thompson, Lucky, 247

Three Members of the Roque Family, Which Ranks among the Oldest Families of the French-Mulatto Colony in the Cotton Plantation Region (Post Wolcott), 231

Threshing Rice in Louisiana (Lee), 219

Tichi, Cecelia, 8

Time Magazine, 130

Tolouse Street (New Orleans), 137

Trachtenberg, Alan, 205, 230

Treadwell, Joe, 192

Treasury Relief Art Project (TRAP), 46, 77, 83

Treasury Section of Fine Arts. *See* Treasury Section of Painting and Sculpture

Treasury Section of Painting and Sculpture, 21, 138, 223, 235, 237; administration, intentions, and operation of, 73–76; decorations as therapy for Depression anxieties,

75–76; democratic nature of program explained by Edward Bruce, 74–75; didacticism of designs, 75–76; mural art in Louisiana, 71–73, 77–106; paradoxical nature of, 76–77; as primary sponsor of New Deal murals, 73. *See also* Bruce, Edward; Murals; Rowan, Ed

Triggs, C. E., 137

Tugwell, Rexford, 46–47

Tulane University, 28, 29, 43, 51, 141, 168

Tung Oil Industry (Gonzales), 88–89

Twain, Mark, 186

Two Women of the French-Mulatto Colony near the John Henry Plantation (Post Wolcott), 231

Tyler, Henry, 198–99, 235

Ullman, Doris, 206

Ulysses (Joyce), 8

Uncle Joe Roque (Post Wolcott), 232

Union Station (New Orleans), 45

Vachon, John, 201, 203, 239, 240; and nationalizing trends of New Orleans photographs, 237–38; in New Orleans, 237–38. *See also* Farm Security Administration

Vanderbilt, Paul, 205, 230; FSA photographic classification system reorganized, 230; impact on reorganized file system on Melrose photographs, 230–34. *See also* Farm Security Administration; Post Wolcott, Marion; Saxon, Lyle

Veblen, Thorstein, 111

Venneman, Alan, 247

Victorian(s), 11, 158, 162, 164, 166, 180; values compared to Modernists, 10–12. *See also* Modernism

Vidal, Famie, 162, 198–99, 235. See also *Children of Strangers*

Vienna, Austria, 9

Vieux Carre, 57, 163, 179, 188, 216, 235, 245. *See also* French Quarter

Ville Platte, La., 105

Voodoo, 161–62, 164, 178, 245; as form of black resistance explained in "The Negro in Louisiana," 173

Warren, Robert Penn, 11

Washington, D.C., 45, 52, 55, 57, 59–60, 69, 74, 97, 115, 125, 128–29, 130–31, 136, 171, 193, 222, 225

Waterfront Warehouses in Louisiana (Evans), 209

Watson, Forbes, 47, 49, 57, 59; attacks on conservative critiques of American Scene painting, 49. *See also* Public Works of Art Project

Watson, Thomas J., 144

Weber, Max, 7

Weiss, Carl, 107

Welles, Gideon, 116

Welles, Orson, 247

Werlein, Reverend Phillip, 156

West, Rebecca, 8

Wheelahan, L., 152

Whistler, James McNeill, 111

White City, 11

White supremacy, 17; and local autonomy, 28

Wilkes, Melanie, 104

William, Eugene, 173

Williams, William Carlos, 8

Winans, Fonville, 207

Winnfield, La., 185

Wolcott, Marion Post. *See* Post Wolcott, Marion

Wood, Charles, 183

Woodward, Ellen, 125, 129

Woodward, Ellsworth, 19, 36–39, 41–42, 44–45, 47–48, 50–51, 56–60, 63, 69, 77, 112–13, 115–16, 118–19, 133, 138, 140–41, 153–56, 167, 239, 240–41; aesthetic philosophy, 30–35; aesthetic values, challenged by modern art, 153–54; appointed director, Newcomb School of Art, 29; and Arts and Crafts Movement, 33–34; association with Gideon Stanton and influence on FAP in New Orleans, 117–19; birth and education, 29–30; with Edward Bruce, discusses tension between skill and need when hiring artists, 53–54; commitment to artistic localism and "genius loci," 32–33; compared to Holger Cahill and FAP intentions, 112–14, 115–16; compared to Lyle Saxon, 19–23; comparison of PWAP experience with aesthetic values and career, 64, 69–70; concern for needy artists, 53; contrasting styles of PWAP artists and implications for artistic localism, 64–70; death of, 132–33; defends traditional association between art appreciation and social rank, 54; difference between American Scene genre and aesthetic localism, 69; differs with Bruce over meaning of "region," 56, 59; as director, Region Six, Public Works of Art Project, 45–71; explains "industrial commercialism," 41–42; as FAP critic, 132; gender assumptions, 36, 43; as hesitant PWAP administrator, 51–55; implications of Treasury Section murals for aesthetic localism, 105–6; and Newcomb Pottery, 34–44; opposes permanent federal support for art, 132; retirement, 43; and service

to New Orleans Art institutions, 50; significance of PWAP projects proposed, 56–60; support for Index of American Design, 132; teaching style, 29–30; tension between centralizing tendencies of PWAP and genius loci, 63; threatens resignation from PWAP, 58–59; views on art and industrialism, 30–32; views on photography as art, 21–22, 205–6, 211. *See also* Newcomb Pottery; Public Works of Art Project

Woodward, Mary, 30

Woodward, William, 29, 34

Woolf, Virginia, 8

Work Progress Administration (WPA), 21, 52, 73, 79, 101, 104, 120, 123, 125–26, 128, 136–37, 156–57, 160–62, 165, 167–69, 170, 175, 184, 192, 196, 206. *See also* Federal Art Project; Federal Writers' Project

World War I, 10, 16, 42

World War II, 20, 241

Wright, Richard, 174

Young, Sterling, 174

Yucca Plantation, 198–99, 235, 237. See also *Children of Strangers*; Henry, Cammie G.; Henry, John H.; Melrose Plantation

Zigrosser, Carl, 134

Zimple Market (New Orleans), 29